Turner's Classical Landscapes

Myth and Meaning

Turner's Classical Landscapes

Myth and Meaning

KATHLEEN NICHOLSON

PRINCETON UNIVERSITY PRESS

Copyright © 1990 by Princeton University Press
Published by Princeton University Press,
Princeton, New Jersey
In the United Kingdom: Princeton University Press, Oxford

This book has been composed in Baskerville

Library of Congress Cataloging-in-Publication Data
Nicholson, Kathleen Dukeley.
 Turner's classical landscapes: myth and meaning / Kathleen Nicholson.
 p. cm.
 Includes bibliographical references.
 ISBN 0-691-04080-X (alk. paper) :
 1. Turner, J. M. W. (Joseph Mallord William), 1775–1851—Criticism
and interpretation. 2. Landscape in art. 3. Romanticism in art—
England. 4. Mythology, Classical, in art. I. Title.
 ND497.T8N5 1990
759.2--dc20 89-28301
 CIP

Editorial and Production Services by Fisher Duncan,
10 Barley Mow Passage, Chiswick, London W4 4PH, UK
Printed in the United Kingdom

Contents

List of Illustrations

Unless otherwise indicated, works are by Turner and are located in the Turner Collection, Tate Galley, London. Complete information is provided for each illustration in its caption.

The catalogue number assigned to each painting in the Butlin and Joll catalogue raisonnée, *The Paintings of J. M. W. Turner* (1984), is indicated by the abbreviation BJ in this list, the text, and the captions to illustrations.

Sketches from TB XC, "Studies for Pictures, Isleworth" have been grouped in a black and white plates section to give a sense of the artist's working method within a single sketchbook.

Figures

List of Turner Sketchbooks

Turner's sketchbooks and drawings consulted for this study are listed below. They are designated by the abbreviation TB (for Turner Bequest), with the number, sketchbook or group title (in quotation marks, when assigned by the artist himself), and date provided by A.J. Finberg in *A Complete Inventory of the Drawings of the Turner Bequest* (London, 1909) or as revised by Andrew Wilton, Keeper, the British Collection, Tate Gallery. My thanks to Andrew Wilton and Ann Chumbley for their kind assistance.

TB XXXIII, Watercolours &c.: Finished and Unfinished, 1796–1797.

TB XXXVII, Wilson Sketchbook, 1797

TB XL Dinevor Castle Sketchbook, 1798

TB XLVII, Fonthill Sketchbook, c. 1799–1805

TB XLIX, Salisbury Sketchbook, 1799–1800

TB LI, Miscellaneous (2)

TB LXI, Jason Sketchbook, 1801

TB LXIX, "Studies for Pictures," 1800–1802

TB LXX, Miscellaneous Watercolours and Drawings, 1800–1802

TB LXXII, "Studies in the Louvre," 1802

TB LXXVII, Rhine, Strassbourg and Oxford Sketchbook, 1802

TB LXXX, Drawings Connected with the First Swiss Tour, 1802

TB LXXXI, Calais Pier Sketchbook, c. 1799–1805

TB XC, "Studies for Pictures. Isleworth," 1804–1806

TB XCIII, Hesperides (1) Sketchbook, c. 1805–1807

TB XCIV, Hesperides (2) Sketchbook, 1805–1807

TB XCVII, "Windsor, Eaton," 1807

TB XCVIII, "Wey, Guil[d]ford," 1807

TB CIII, Tabley Sketchbook No. 1, 1808

TB CXI, Hastings Sketchbook, 1809–1811

TB CXIV, Windmill and Lock Sketchbook, 1810–1811

TB CXVIII, Liber Studiorum Drawings c. 1813

TB CXX, Miscellaneous: Black and White (2), 1802–1810

TB CXXII, Finance Sketchbook, 1807?–1814

TB CXXIII, Devonshire Coast No. 1 (interleaved copy of Coltman's *British Itinerary*, 1811

TB CXXIX, Woodcock Shooting Sketchbook, 1810–1812

TB CXXXIX, Hastings Sketchbook, 1814–1816

TB CXL, "Richmond Hill. Hastings to Margate," 1815–1816

TB CXLIII, Liber Notes (2) Sketchbook, 1815–1816

TB CXLIV, "Yorkshire 1," 1815–1816

TB CLIVa, Liber Notes (2) Sketchbook, 1816–1818

TB CLXXI, "Route to Rome," 1819

TB CLXXVI, "Venice to Ancona," 1819

TB CLXXVII, "Ancona to Rome," 1819

TB CLXXIX, Tivoli and Rome Sketchbook, 1819

TB CLXXXII, "Albano, Nemi, Roma," 1819

TB CCII, Ports of England Sketchbook, 1822–1823

TB CCIV, "River," 1823–1824

TB CCXXVII(a), East Cowes Castle, 1827

TB CCXXXVII, Roman and French Notebook, 1828

TB CCLX, Pencil and Ink on Blue Paper: Mostly Connected with the "French Rivers" Series, 1826–1833

TB CCLXIIIa, Miscellaneous Black and White 1820–1830

TB CCLXXVIII, Mouth of the Thames Sketchbook, 1832

TB CCCXLIV, Miscellaneous Drawings c. 1825–1841

Introduction

J.M.W. Turner's art provoked two contrasting reactions in the early nineteenth century that underlie our modern-day response to his work. On the one hand, critics as sharp as William Hazlitt were exasperated by the seeming indeterminacy of the artist's images. Hazlitt's famous charge that Turner was painting "pictures of nothing and very like" (a complaint lodged as early as 1817) signaled a wariness of the artist's liberal experimentation with the immediate visual impact of color, light, and atmospheric effect treated as independent qualities—precisely the formal orientation that makes Turner's art seem so extraordinary today. Assailing the artist from the other side were critics who felt Turner allowed too much "content" to get in the way of his presentation of nature. An anonymous writer complained in 1804 about Turner's unnecessary imposition of often arcane subject matter. Expressing consternation over historical references in the marine view *Boats Carrying Out Anchors and Cables to Dutch Men of War, in 1665*, the author argued: "Why the scene before us should be placed so far back as in 1665 it is difficult to conceive, except by referring to that affectation which almost invariably appears in the work of the Artist. There is nothing in the subject to excite an interest."[1] Twentieth-century esteem for Turner's evanescent late works and his "color beginnings"—watercolor studies with no more than a hint of what subjects they might have become—perpetuates the view that Turner's narrative interests are an unnecessary distraction from the formal coherency of his painting.

This study will argue, to the contrary, that the investigation of history, literature, religion, and artistic tradition that informed the painter's themes and structured his narrative was far too persistent and well researched to merit dismissal as an affectation, then or now. As the artist announced through frequently long, precise titles and accompanying citations of verse, the imagery of his landscapes is charged with concern for human conduct and nature's role in affecting that conduct. The paintings themselves provide object lessons in the way that nature—and the artist—can shape our understanding of experience. Turner's understanding of how imagery functions to convey meaning was particularly cogent.

His method becomes clearer when seen in the context of a body of references more familiar than seventeenth-century Anglo–Dutch naval history. Classical themes allowed the artist to articulate a formal and narrative program that could forcefully argue the significance of landscape painting as a modern means of expression. Numbering over fifty major oils and several hundred sketches and drawings, his works treating subjects from mythology, epic, and ancient Greek and Roman history appeared with notable regularity from the beginning to the very end of Turner's career, often at critical points in his artistic development. As a group, his classical paintings elaborate his professional aspirations for the art of landscape, offering it as an effective challenge to history painting. At the same time, they weave out of their narrative threads one of the more intimate and accessible "portraits" of Turner that we can hope to have. Notoriously private, the artist revealed something of his inner self through his continual reinterpretation of stories concerning his preferred cast of ancient characters.

Since Turner's first extensive presentation to an American audience at the Museum of Modern Art in 1966, a setting that could not help but call attention to the abstract rather than narrative tendencies of his work, scholarship has gradually shifted toward a reconsideration and rediscovery of the extra-formal meaning of Turner's painting. It is assuring to see that the artist is now assumed to

have had "a wonderful range of mind," since my own reading of his meaning (and it *is* offered as a reading in the literary critical sense, rather than as an art *historical* certainty) was formulated prior to the general acknowledgement that Turner's imagery, and particularly his poetry, indeed make sense. To the extent that such an awareness has become part of the Turner canon, the thrust of this study will seem familiar. However, the particular virtue of concentrating on the classical works in this endeavor is that they offer a dual tradition within and against which to place the artist. First, tales from Ovid, from the classical epics, or from ancient history constitute a body of subject matter long used by painters, a thematic heritage with which Turner was entirely conversant. His works can thus help to gauge one Romantic's reading of antiquity—a critical transformation of the classical world into modern terms, and a fairly elaborate, coherent transformation at that. Second, Turner's choice of subject matter was entirely bound up with the particular tradition of seventeenth- and eighteenth-century landscape painters and their use of similar subjects in conjunction with the conventions of composition considered "classical" for their formal coherency, sobriety, and order. His visual dialogue with the styles of Claude Lorrain or Nicolas Poussin became one of the artist's themes in its own right, interrelated with the topics of a hero's quest or a mythological lover's yearning. This study will emphasize Turner's calling into question the way that formal conventions embody meaning. By exploring the values communicated by idealized nature in landscape art of the past, he could reinvest nature with new meanings appropriate to his own times and thus accomplish a genuinely modern revision of classical landscape in the early nineteenth century.

The book proceeds in a loosely chronological fashion in order to develop the thematic emphases of the classical subjects as they shifted or deepened over time. The study begins by reviewing the status of classical landscape in eighteenth-century England in order to situate Turner's point of departure. The perspective then broadens to consider Turner's narrative apprenticeship, a learning process in visual storytelling that culminated in 1806 with the *Goddess of Discord Choosing the Apple of Contention in the Garden of the Hesperides*, his early paradigm for imparting meaning to landscape. Subsequent chapters focus on specific topics within Turner's classical oeuvre. The fourth chapter deals with the artist's understanding of the lessons of ancient history and, by extension, eighteenth-century neoclassical history paintings, forcefully rethought in *Snowstorm: Hannibal and His Army Crossing the Alps*, and amplified through the first appearance of his poem, the "Fallacies of Hope." The fifth chapter considers Turner's equation of style and meaning revealed through his sensitive interpretation of Ovid and the theme of love. To complement the study of the artist's response over time to a single author, one whose imagery had long functioned as a favorite source for the visual arts, the following chapter considers Turner's formal reinterpretation of one of the masters of Ovidian landscape and mainstays of inspiration for the Romantics, Claude Lorrain. The book concludes with Turner's reading and revision of each of the four major ancient epics, the *Iliad*, the *Odyssey*, the *Argonautica*, and the *Aeneid*.

While tracing the artist's growing awareness of the ways in which meaning can be generated and manipulated in landscape painting, this study largely refrains from seeking one uniform iconographical reading of Turner's references to antiquity. It takes its cue from his own avoidance of symbolic systems and hence explores the artist's habits of working out his imagery respectful of the occasional change of mood, the passing whim, or factual "lapse." There are instances when Turner was crystal clear about what his

images mean and instances when he was maddeningly opaque. Ruskin's interpretations of the paintings chart that variability, but in a less than exemplary manner: when the critic could elaborate a symbolic structure, he did so brilliantly and at great length; when the imagery did not inspire him or meet his expectations, Ruskin dismissed it and the paintings alike as just so much "nonsense." Though his iconographical inquisitiveness ultimately provided the inspiration for my own inquiry, the idiosyncracies in his reading of Turner engendered a mistrust reflected here in the spare and infrequent references to *Modern Painters*.

My own preference has been to track the artist to his literary and artistic sources (they are usually multiple), and to trust his juxtapositions and his formal and iconographical quotes (as well as misquotes) for what they are: the signs of Turner's conscious immersion in the process of inter-pretation. In assimilating the classical tradition and modifying its thematic and artistic vocabulary, the artist avoided both conventional moral didacticism which subordi-nates the elements of landscape to its lessons, and a portrayal of nature that is comfortingly idealized but mute. Searching for ways that the representation of nature could embody a complex of meanings through his choice of themes and compositional types, he made the finest of his classical works into critical constructs that persuade his viewer to re-examine moral certitudes and assumptions about the natural world and our place in it. The real emphasis of this study, then, is on Turner's process of understanding how meaning works in a painted version of the natural world. By following the ways in which he developed specific imagery in key paintings, I hope to show that the artist came to consider interpretation itself as a constant, if not primary, theme. Turner's approach to narrative in landscape underscores his awareness of the ambiguous and unstable nature of meaning, even where it concerned the time-honored legacy of the classical world. It is that awareness, finally, that endows his images with a provocative power above and beyond their stunning visual appeal.

Introduction: Notes

1. From an anonymous review published in the *Sun*, May 10, 1804.

I The Romanticizing of Classical Landscape

Early in his career, J.M.W. Turner painted *Aeneas and the Sibyl, Lake Avernus* in an open gesture of affiliation with seventeenth- and eighteenth-century classical landscape (c. 1798; fig. 1). Its restrained description of generalized natural elements embellished with historical anecdote contrasts strikingly with his contemporary *Buttermere Lake, with part of Cromackwater, Cumberland, a Shower*, exhibited in 1798 (fig. 2). Responding to a place he had visited first-hand, the artist captured the drama of nature in all its showy display. Even the wordy title argues for the authenticity of the artist's experience in representing a notable locale in the Lake District. The future direction of landscape painting in the nineteenth century is foretold by *Buttermere Lake, with part of Cromackwater, Cumberland, a Shower*. Yet for Turner the appeal of classical landscape would remain equally strong. Rather than simply paying homage to idealized nature in passing, he embraced it as an integral part of his oeuvre. *Aeneas and the Sibyl, Lake Avernus* stands as the first in a long sequence of paintings that invoke the dual heritage of antiquity, wistfully recollected in modern terms, and of the Old Master tradition that had taken its inspiration from the classical past. Through his classical landscapes the Romantic artist could define his place in relation to his artistic predecessors as well as structure a discourse about the progress of his art. From the outset, he planned an ambitious, inclusive agenda for landscape painting.

Pragmatism played no small part in Turner's respect for the classical tradition. The young artist recognized the need for a strong defense against the low esteem in which landscape painting had been held in England. During the reign of neoclassical history painting, nature commanded little respect as an object of representation unless it was idealized in the manner of Claude Lorrain or Nicolas Poussin. Turner understood the degree to which late eighteenth-century connoisseurs preferred to have their experience of the out-of-doors mediated and their learned-ness confirmed. A painting like *Aeneas and the Sibyl, Lake Avernus* could meet those tastes on their own terms, offering balanced composition, careful handling, and sober demeanor in the manner of the eighteenth-century adaptations of seventeenth-century landscapes already lining his patrons' walls. His first classical work effectively summarized the sources and guiding principles of English landscape to that date.

In particular *Aeneas and the Sibyl, Lake Avernus* acknowledged the example of Richard Wilson, founding father of British landscape painting. Wilson's Italian views, real or imagined, as well as the reputation and income they secured for him initially, inspired Turner's endeavor directly. The elder artist's tactful idealization of a touristic locale like *The Lake of Nemi, or Speculum Dianae* (1758; fig. 3) finds its echo in the orderliness, symmetry and scenic elaboration of Turner's work. The link between the two generations even plays itself out in the episode Turner added to his own view of Lake Avernus. The theme of Aeneas seeking to learn the future by consulting the shade of his father appropriately (if unconsciously) underscores the painter's gesture in trying to learn from Wilson's formal model.

The younger artist's quest quickly brought him to a fundamental dilemma bequeathed by Wilson: how, in fact, to reconcile a landscape painter's first-hand experience of nature with the dictates of the imagination necessary for the production of high art. Sir Joshua Reynolds had under-scored the basic quandary confronting landscapists as early as 1788, when, in his Fourteenth Discourse, he judged Wilson's *The Destruction of Niobe's Children* (1760), to be unsuccessful in its attempt at the much-desired Grand

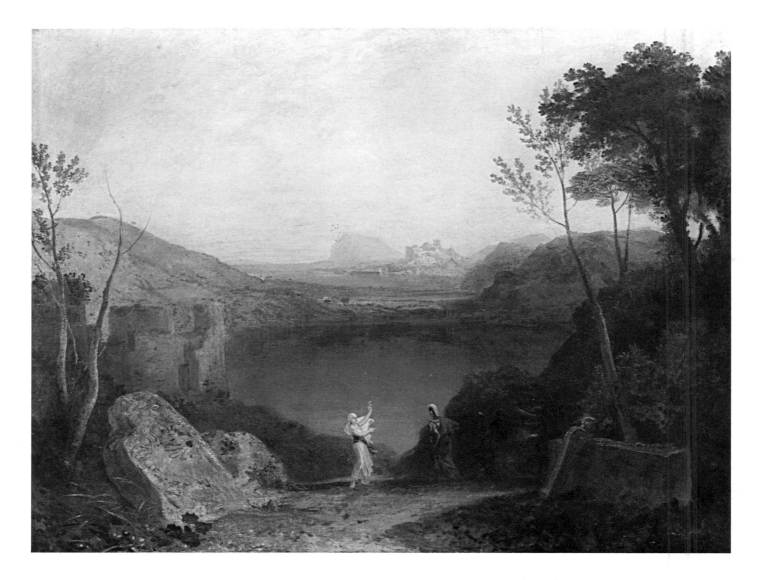

Figure 1. J.M.W. Turner, *Aeneas and the Sibyl, Lake Avernus*, c. 1798. Oil on canvas, $30\frac{1}{8} \times 38\frac{3}{4}$ inches (76.5 × 98.5 cm), Turner Collection, Tate Gallery (BJ 34).

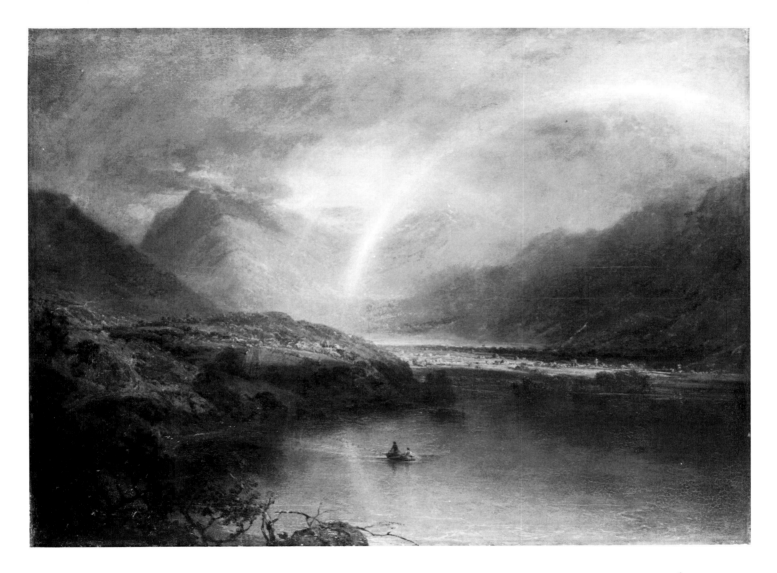

Figure 2. J.M.W. Turner, *Buttermere Lake, with part of Cromackwater, Cumberland, a Shower*, 1798. Oil on canvas, $36\frac{1}{8} \times 48$ inches (91.7 × 122 cm), Turner Collection, Tate Gallery (BJ 7).

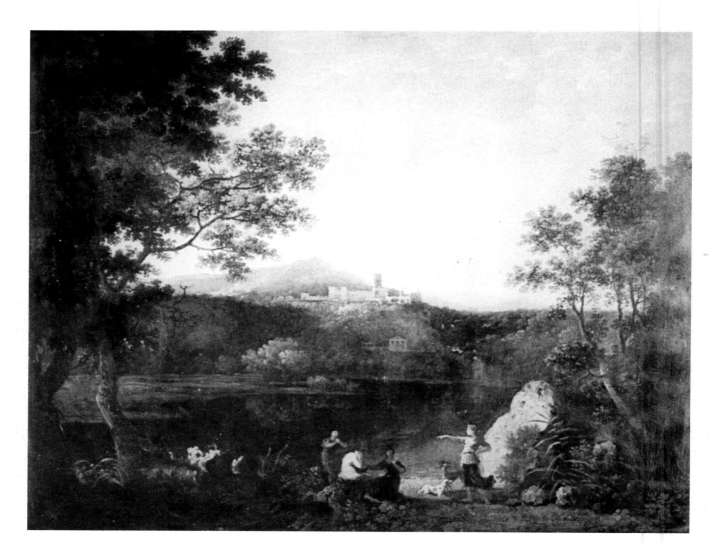

Figure 3. Richard Wilson, *The Lake of Nemi or Speculum Dianae*, 1758. Oil on canvas, $29\frac{3}{4} \times 38\frac{1}{4}$ inches (75.6×97.1 cm), Trustees of Jane, Lucy and Charles Hoare, on loan to the National Trust, Stourhead.

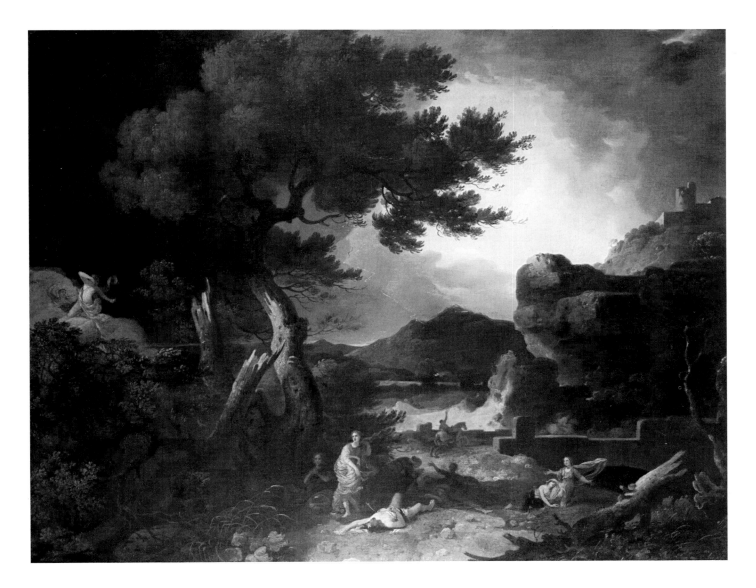

Figure 4. Richard Wilson, *The Destruction of Niobe's Children*, 1760. Oil on canvas, 58 × 74 inches (147.3 × 187.9 cm), Yale Center for British Art, New Haven, Paul Mellon Collection.

Manner (fig. 4). Wilson had not sufficiently idealized the setting for such a dramatic subject, his landscape being "too near common nature to admit supernatural objects."[1] In hindsight, that was something of a compliment, since the flaw Reynolds perceived—Wilson's tendency toward naturalistic representation (though hardly in evidence here)—became one of the critical lines of development for nineteenth-century landscape painting.

Objectively speaking, Wilson's pursuits *were* antithetical. The two realms, natural and "supernatural," demanded contradictory approaches as well as different skills in handling, as the next generation of artists would quickly discover. To portray the natural world with any credibility, painters had to break with traditional habits of composition and rendering, and trust their powers of perception and transcription. In that respect Girtin, Turner, and Constable succeeded in extending the boundaries of observation— literally seeing more of what was around them than had Wilson. At the same time, the sensitivity with which they portrayed the natural world protected them from accusations of having merely imitated its surface appearance. Their route was entirely uphill; Constable, in particular, expended no small amount of effort justifying the journey.

Hard as Turner worked to legitimize the role of "common nature" in art with paintings like *Buttermere Lake, with part of Cromackwater, Cumberland, a Shower*, he could not afford to ignore the challenge posed by Reynolds' comments. By idealizing, he stood to gain distinction of a higher order than that usually accorded painters of local or foreign topography—a distinction Wilson had sought and which Reynolds threatened to deny him. And as Turner's audience increasingly came to value the role of imagination in art *and* life, the artist found new justification for exploring the expressive possibilities of landscapes of affect. In the way that classical landscape combined fanciful stories with

an appealing or heightened image of nature, it presented a ready-made demonstration of the means to transcend everyday reality. But before Turner could avail himself of the genre, he first had to rescue it from the less-than-ideal state into which it had fallen since Wilson's days.

Reynolds had cautioned that an imaginative interpretation of nature required refined taste and an extraordinary creative ability, the measure of success being less objective than for the faithful reproduction of the perceivable world. Still speaking of *The Destruction of Niobe's Children*, he warned that "To manage a subject of this kind, a peculiar style of art is required; and it can only be done without impropriety, or even without ridicule, when we adapt the character of the landskip, and that too, in all its parts, to the historical or poetical representation. This is a very difficult adventure, and it requires a mind thrown back two thousand years, and as it were naturalized in antiquity . . . to achieve it."[2] Anything less and the work would fail to possess the "romantick character which is appropriated to such a subject, and which alone can harmonize with poetical stories."[3]

Fortunately, as Reynolds went on to explain, good examples were right at hand. Decrying the practice of representing nature with "all the truth of the *camera obscura*," he urged Academy students to idealize their scenes in the manner of the seventeenth-century masters of classical landscape. In his opinion, unenhanced observation was "little and mean" in comparison with their imaginative projections. He encouraged his audience to adopt classical subject matter as well, for an artist's superiority would be proven if, like Poussin, "he transports us to the environs of ancient Rome, with all the objects which a literary education makes so precious and interesting to man; or, like Sebastian Bourdon, he leads us to the dark antiquity of the Pyramids of Egypt; or, like Claude Lorrain, he

conducts us to the tranquillity of Arcadian scenes and fairy land."[4]

The invocation of those names was a familiar rhetorical exercise in eighteenth-century England.[5] But Reynolds was implicitly criticizing classical landscape in Britain for evolving away from the serious import of Poussin or the delicate reveries of Claude (to refer to him on the same first-name basis as many eighteenth- and early nineteenth-century artists often did). To give Wilson his due, the problems to which Reynolds alluded belonged more properly to Wilson's predecessors as well as to his immediate followers, Wilson's own efforts to maintain standards having been suitably inspired. Earlier eighteenth-century landscape painters, by contrast, had fastened onto the easily reproducible set of formal conventions the Old Masters' works offered, while paying scant attention to their iconographical intent or narrative development. Although English artists appreciated the stylistic diversity of the seventeenth-century masters, perfectly summarized in James Thomson's often-repeated lines

> whate'er Lorraine light-touched with softening hue
> Or savage Rosa dash'd, or learned Poussin drew

in practice they sought a mean.[6] Painters like John Wootton (d. 1759) and George Lambert (1700—1765) combined something of Poussin's geometry, something of Claude's delicately rendered light and atmosphere, and, occasionally, a zestful effect reminiscent of Rosa into a predictable arrangement of harmoniously modulated landscape components (figs. 5 and 6). Through the reiteration of similar motifs they came to constitute a handsome, large-scale emblem of the venerable golden age of antiquity made familiar through the equally venerable language of art. The closest and most useful model in fact proved to be Gaspard Dughet, whose works provided ample demonstration of the basic conventions, conventionalized (fig. 7). When Richard Wilson was asked his opinion of the best landscape painter, he is reported to have replied, "Why Sir, Claude for air and Gaspar for composition and sentiment," models he himself followed.[7]

The benign, circumscribed, and essentially static view of the natural world offered by Gaspard Dughet accorded with the well-known definition of landscape painting issued by painter and connoisseur Jonathan Richardson in 1722. He considered the genre to be the equivalent of pastoral poetry, its imagery restricted to an "Imitation of Rural Nature."[8] As Alexander Pope had explained in his 1717 *Discourse*, pastoral poems should offer an image of the Golden Age and dwell on the tranquillity of country life, exposing the best side of a shepherd's life and concealing its miseries.[9] Hence the inappropriateness of Wootton or Lambert including tragic episodes from ancient literature in their landscape settings. Richardson, in any case, had declared the addition of "Figures" optional: they were to be included only if they remained subservient to the overall scene. "Otherwise," he cautioned, "the Picture loses its Denomination, it becomes a History, a Battel-piece, &C. or at least 'tis of an Equivocal kind."[10] He elsewhere rated landscapes a poor third in stature behind history painting and portraiture because "they cannot improve the mind, they excite no noble sentiment."[11] Given the limitations he imposed, that would have been a rather difficult task.

Commentators like Richardson were so fixed in their ideas about landscape painting they even generalized away the specific subject matter used by the seventeenth-century masters, describing that narrative content simply as "thoughts" or "expressions." For example, Richardson characterized Claude as the painter having "the most Beautiful and Pleasing Ideas; the most Rural, and of our own Times," without further elaboration on the artist's

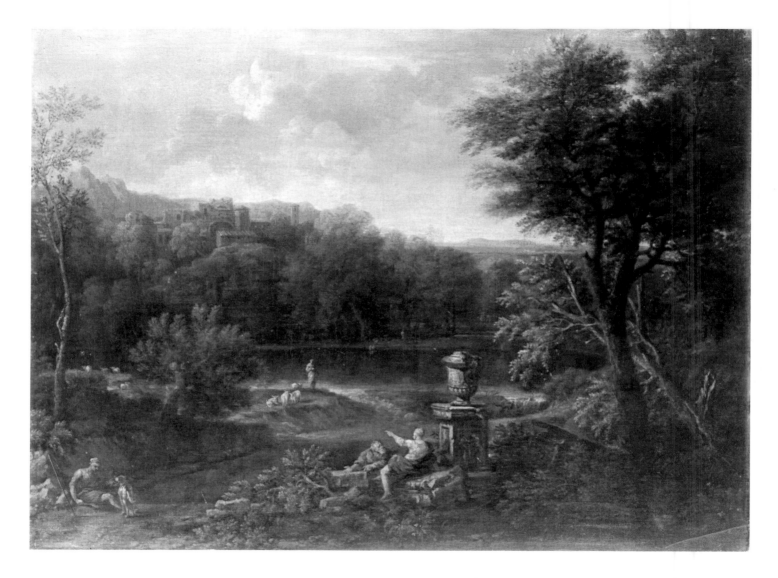

Figure 5. John Wootton, *Classical Landscape*, 1730s. Oil on canvas, $32 \times 42\frac{1}{2}$ inches (81.3×107.9 cm), Fitzwilliam Museum, Cambridge, England.

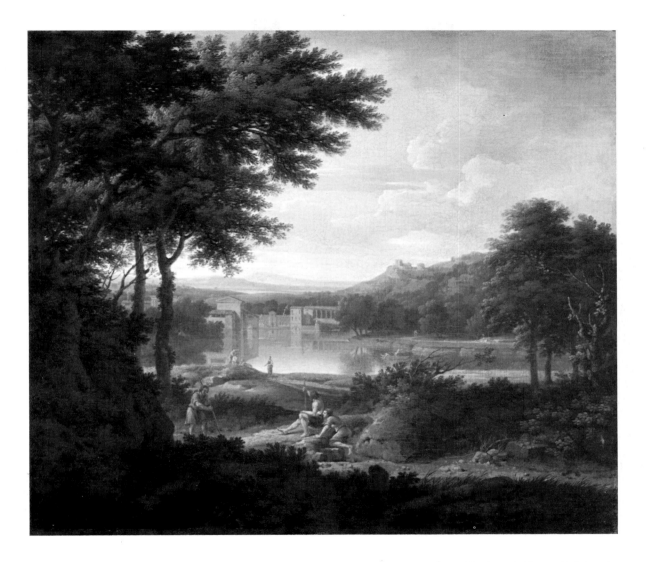

Figure 6. George Lambert, *Classical Landscape*, 1745. Oil on canvas, $40\frac{3}{4} \times 46$ inches (103.5×116.8 cm), Tate Gallery.

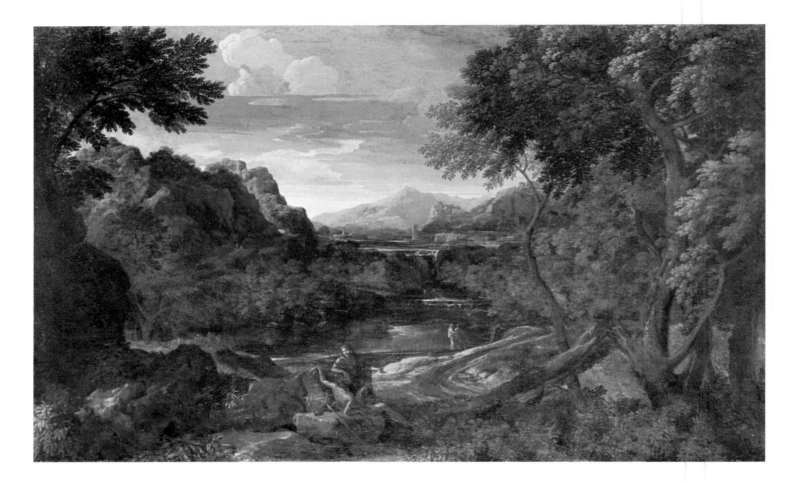

Figure 7. Gaspard Dughet, *An Italian River Valley*, 1657. Oil on canvas, $37\frac{7}{8} \times 60\frac{1}{2}$ inches (96.2 × 153.6 cm),

Figure 8. James Norie, *Classical Landscape with Trees and Lake*, 1736. Oil on canvas, $25\frac{1}{2} \times 52$ inches (64.8 × 132 cm), National Gallery of Scotland, Edinburgh.

Figure 9. James Norie, *Classical Landscape with Architecture*, 1736. Oil on canvas, $25\frac{1}{2} \times 52$ inches (64.8 × 132 cm), National Gallery of Scotland, Edinburgh.

choice of themes or their possible meaning.[12] Early eighteenth-century landscape painters accordingly refrained from thematic elaboration in their works. They responded to the tastes of a patron fresh from the Grand Tour and filled with nostalgia for the glories of the Mediterranean past, or at least for days recently spent in Italy in pleasant leisure, by providing him or her with anodyne arcadian views lacking specific narrative additions.[13] While classical landscapes like Lambert's or Wootton's might inspire meditation about rural harmony in a generic golden age, they did not require prolonged iconographical analysis or a strong antiquarian background to be understood.

The aspiring but short-lived artist Jonathan Skelton (c. 1735–1759) described the intended effect of such works in relating plans for a landscape painting of his own. He wanted to depict an old man with a book, leaning on a mossy stone, amid a composed group of identifiable Roman ruins. "One may draw many pleasing reflections from those venerable relics of Antient Roman Grandeur composed in this manner," he commented. "They show how Time erases everything; for those noble and immense edifices were certainly (by their manner of building) intended to stand for ever."[14] Where eighteenth-century poets may have dwelt upon the moral lessons conveyed by ruin, painters solicited little beyond those "pleasing reflections." Even when the cherished past was set against the harsher present, as in pendants like those by James Norie (1736; figs. 8 and 9), any hint of didacticism was subordinated to a larger decorative effect. Indeed, Norie barely distinguished ancient from modern. Ruins are more prominent in the present-day scene, while the age of antiquity appears somewhat more verdant overall, but it is finally the dress of the modern-day swains (engaged in discourse just like the toga-clad philosophers of the past) that separates the two eras. A painter might encourage the direction of his

viewer's reveries in this manner, but the exercise of imaginative flight into a fully reconstructed arcadian world remained the viewer's responsibility.

To his credit, Richard Wilson recognized that the Old Masters' lessons covered more than dash, delicate coloring, and learned drawing. Whether he came to that realization on his own, through the example of the continental artists who encouraged him, or through the insights of his more learned patrons is uncertain. He definitely had the good fortune to receive, early on, commissions that asked more of a landscape painter than usual. In 1752 Ralph Howard, a young man of twenty-eight making the Grand Tour and eager to buy pictures, gave Wilson the opportunity to produce not only fashionable, sensationalizing *banditti* escapades, but sobering, stoic themes like *The Summons of Cincinnatus* or *The Departure of Regulus* (fig. 10).[15] Both kinds of subject matter required that the artist consider how best to integrate narrative elements into an appropriate outdoor setting. In *The Departure of Regulus* he matched the somber mood of the story to a stately landscape, enlarging the size of the figures relative to the landscape so that no one aspect dominates. He had no desire to lose "the denomination" of his chosen field by "straying too far" in the direction of history, to recall Richardson's interdiction. When he drew up the bill, he forthrightly referred to the classical works as "2 Landskips with historical compositions," rather than the other way around.[16]

As a rule, Wilson preferred to spell out consequences rather than investigate causes or implications. Given an unfolding human disaster like Niobe's punishment for hubris, or Ceyx's death by drowning, he responded with vigor, pairing nature's sublime fury with its counterpart in human violence. He would have learned from Claude Joseph Vernet that the combined spectacle of fierce storms, crashing seas, or a tumbling cascade and figures responding

Figure 10. Richard Wilson, *The Departure of Regulus*, 1752. Oil on canvas, 29 × 39 inches (73.6 × 99 cm), Collection of Augustine Ford.

Figure 11. Richard Wilson, *Cicero and His Friends at His Villa in Arpinum*, c. 1769–1770. Oil on canvas, $48 \times 68\frac{3}{4}$ inches (122×174.6 cm), Art Gallery of South Australia, Adelaide, Morgan Thomas Bequest Fund 1948.

histrionically to misfortune appealed to a wide audience.[17] In such works he diminished the scale of the human actors in order to underline their helplessness in face of an inexorable power. The figures for *The Destruction of Niobe's Children* carry a singular prestige in having been modeled on the famous ancient statuary group of the same subject. That pedigree heightened the seriousness of the "story" vis-à-vis the landscape—enough to have caught Reynolds' critical eye.[18] The successful circulation of engravings after the narrative paintings suggests that Wilson had found one means to renew the popularity of classical landscape in its most ambitious form.

He made a second contribution to the genre's viability by adopting the Claudean (and Grand Tour takers') practice of establishing the legendary or eponymous history of a place. For example, Wilson included figures of Diana and Callisto in views identifiable as Lake Nemi, a locale associated since Roman times with the goddess (fig. 3).[19] Such landscapes reinforced a traveller's memories of a given setting and confirmed his or her learnedness, bringing the vignette—and antiquity—to life, as it were. By contrast, generalized scenes like Wootton's, Lambert's, or Gaspard Dughet's share compositional features that promote the eye's passage through the landscape, into the distance. In that sense they are uninhabited green spaces used to open up the interiors in which they were hung. In Wilson's *Cicero and His Friends at His Villa in Arpinum* (c. 1769–1770), one sees the philosopher and his companions enjoying the pleasures of the landscape, much as the eighteenth-century tourists who flocked to Arpinum and to the site of Cicero's second villa at Tusculum expected to do (fig. 11).

Nearly seventy years later Turner would undertake the same subject, inspired by Wilson's deft merging of historical reference and contemporary experience (fig. 60). When he finally made his first tour of Italy in 1819, he even sought out the area he assumed Wilson had depicted in the Cicero painting, querying in his sketchbook, "If Tusculum, where is Wilson's Picture taken from[?]."[20] That interest in seeing just what his "mentor" had seen attests to Wilson's equally substantial achievement in promoting naturalistic observation in British landscape painting. Wilson had been one of the first northerners to feel the liberating effects of extended, first-hand experience of the Mediterranean region. From his and other artists' commentary and sketches, it is clear their generation reveled in discovering the extent to which seventeenth-century classical landscapes had been inspired by actual topography. Viewing Tivoli, Jonathan Skelton was delighted to find that it had been "the only school where our two most celebrated Landscape Painters Claude and Gaspar studied."[21] In his subsequent description of the scenery, Skelton filtered his perceptions through a mental Claude glass, turning the Campagna into a series of classical compositions. Another young artist, John Plimmer (d. 1760/1761) enthusiastically assured his patron that his studies were advancing properly, explaining that, "As to what you recommend in the management of the leafing of Trees, I have endeavored to imitate Claude and Nature with as much care as I possibly could ever since Mr. Wilson left Rome and I have been my own master."[22]

Wilson charted an exemplary course between seventeenth-century precedent and the actual Italian landscape. In his best views of the Roman countryside, he enlivened the traditional compositional format of accessible foreground, repoussoir trees, and gentle, orderly recession into far distances by the introduction of topographically correct scenery and sensitively observed light and atmosphere. *Ego Fui in Arcadia*, 1755 (fig. 12), strikes a perfect balance between what a cultured English nobleman would see on his tour through Italy (in this case, a view of the Roman Campagna), and the way he would want to remember it

Figure 12. Richard Wilson, *Ego Fui in Arcadia*, 1755. Oil on canvas, $43 \times 53\frac{1}{2}$ inches (109.2 × 135.9 cm), Trustees of Viscount Enfield.

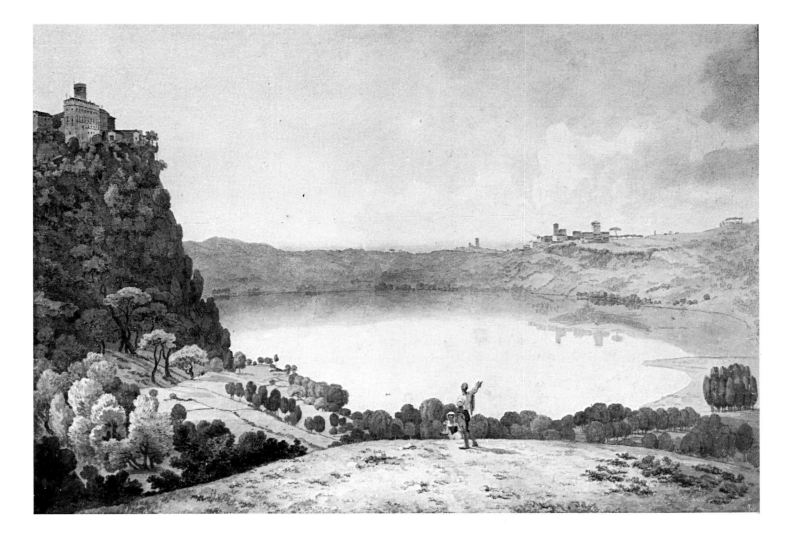

Figure 13. William Pars, *The Lake of Nemi, Italy,* c. 1770. Watercolor, Whitworth Art Gallery, University of Manchester, Manchester, England.

Figure 14. John Robert Cozens, *Lake and Town of Nemi*, 1791. Watercolor, $14\frac{1}{2} \times 20\frac{15}{16}$ inches (36.9×53.2 cm), Birmingham Museums and Art Gallery, Birmingham, England.

afterward, in the context of tasteful "high" art. The toga-clad figures standing before a fragment of ancient sculpture call forth the prescribed act of nostalgic meditation, while the Latin inscription that gives the painting its title employs the perfect tense (instead of the more traditional *Et in Arcadia Ego*) to deliver an appropriately literal meaning for the real viewer: "I have been in Arcadia," but am no longer.

Wilson maintained his idealizing style when he returned to Britain in the late 1750s, employing it in one form or another until late in his active career. By the 1770s, however, he was equally intrigued by nature as he found it. At that point, classical landscape of an ambitious, highly narrational order faced extinction—assailed on the one side by increased naturalism, and on the other by the arch seriousness of history painting, also just coming into its own in England. Greater fidelity to the natural motif was even extended to views of famous touristic sites in Italy. Painters like William Pars (1742–1782), who had gained experience as an expedition artist in Asia Minor and who resided in Rome after 1775, set a standard for truthfulness with carefully rendered, topographically oriented watercolors, like his view of Lake Nemi (c. 1770; fig. 13).[23] Wilson's backward-glancing, idealizing sensibility has been stripped away in favor of clarity, detail, and an emphatic sense of the present moment signaled by the modern figure actively viewing the panorama. John Robert Cozens would point the direction for Turner's generation with his equally contemporary, though much more evocative and atmosphere-laden approach to many of the same places (fig. 14). His watercolors offered a powerful object lesson in how to capture the "spirit of the place" without recourse to ancient staffage or scattered ruins.

To meet a growing archaeological interest in antiquity fostered, in part, by history painting's self-proclaimed authenticity, Pars, Thomas Patch, William Marlow, or

Francis Towne also produced studies of the relics of Italy and Greece—and in great numbers, moreover (fig. 15). Their sensitive documentation of architectural and sculptural remains emphasized the compelling presence of the monuments as artifacts rather than simply as touchstones to meditation. Those who could not travel to the famous sites, the amateurs and armchair antiquarians, sent to the public exhibitions painting after painting of unidentified *Ruins*, a branch of landscape with its own longstanding tradition. Even Thomas Girtin experimented with the genre, if more decoratively and at second hand, making several copies of Marco Ricci *capriccios* for what may have been his own amusement (fig. 16).

Landscape painters of more pretension—in particular Wilson's pupils—found themselves in a difficult position. The economic reversal their master suffered in his last years would have served to warn them off Grand Manner landscape.[24] Those who chose to continue found themselves frustrated more often than not by the combination of changing tastes and their own aptitude. One of Wilson's more promising students, Thomas Jones (1742–1803), by his own account was not comfortable painting figures and relied on his friend John Mortimer to put them in for him.[25] Two heads were not necessarily better than one when the problem involved reading the implications of a tragic moment into, or out of, a landscape, witness their collaborative effort in *The Death of Orpheus* (1770; fig. 17). Rather than being integrated with the carefully detailed setting, the knot of gesticulating figures remains very much in the foreground vying for attention with the serene, placid view that stretches back and to the right.[26]

Nor did such endeavors counterbalance the growing importance of history painting. Jones lamented in his memoirs that just when he was ready to make his move in the field of Grand Manner landscape, he found himself

Figure 15. Francis Towne, *The Claudian Aqueduct, Rome*, 1785. Watercolor, pen and ink, over pencil, $17 \times 23\frac{1}{4}$ inches (43.2 × 59 cm), Yale Center for British Art, New Haven, Paul Mellon Collection.

Figure 16. Thomas Girtin, *Classical Composition*, c. 1798. Copied from D.S. Fossati, *XXIV Tabulas a Marco Ricci*, Venice, 1763. Watercolor, $12\frac{1}{2} \times 18\frac{3}{8}$ inches (31.7 × 46.7 cm), Whitworth Art Gallery, University of Manchester, Manchester, England.

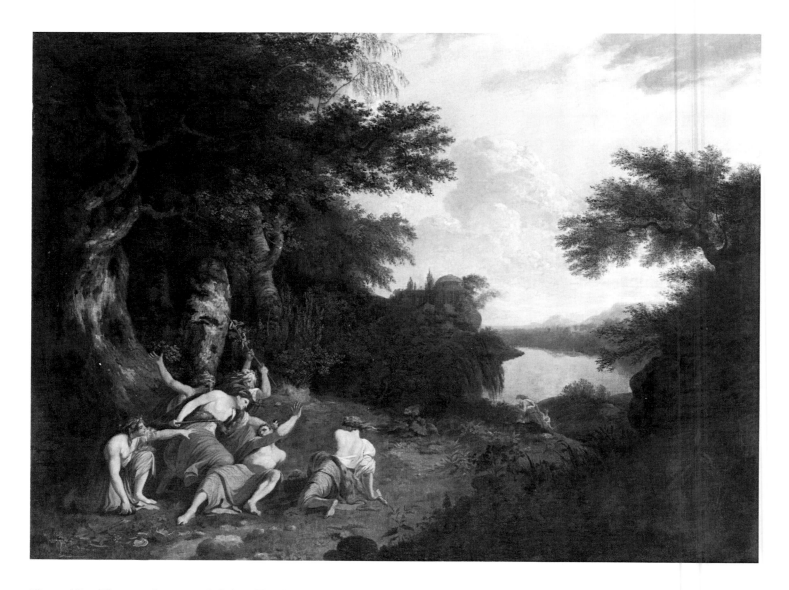

Figure 17. Thomas Jones and John Hamilton Mortimer, *The Death of Orpheus*, c. 1770. Oil on canvas, $37\frac{1}{2}\times51$ inches (95.25×129.5 cm), Yale Center for British Art, New Haven, Paul Mellon Collection.

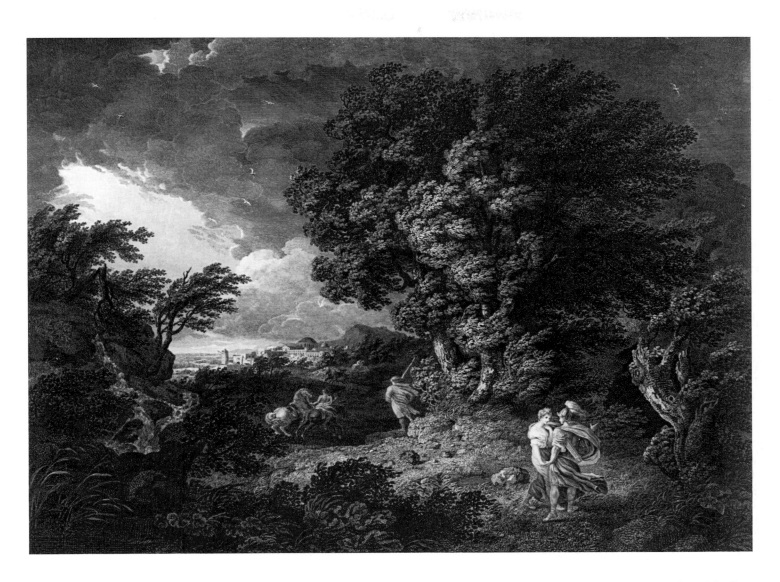

Figure 18. Thomas Jones and J.H. Mortimer, *Dido and Aeneas Taking Flight after the Storm* (1769) engraved by William Woollett and F. Bartolozzi, published February 1, 1787 by Elizabeth Woollett. $18 \times 22\frac{1}{8}$ inches (45.7×56.2 cm), Courtesy of the Trustees of the British Museum, London.

thwarted by changing tastes. He had expected to win fame through the circulation of a print after his handsome (and more resolved) *Dido and Aeneas Taking Flight after the Storm* (1769; fig. 18) but found that the most capable engraver, "little Woollett, as if satiated with the character of being the first Landscape-Engraver in the world, must needs try his hand at historical subjects, and having succeeded in his first Essay ([Benjamin West's] *The Death of General Wolfe*) beyond perhaps his own Expectations, abandoned landscape and devoted himself to History."[27] Jones eventually persuaded William Woollett to take on the job, but the print was not issued until 1787, two years after the engraver's death.

Very few landscape painters rose to the challenge posed by history painting, and those who did were hardly rewarded for their efforts. Both Alexander and John Robert Cozens experimented with ancient historical subject matter, and both abandoned the cause after an initial try. The senior Cozens sent his sole offering, *A Historical Landscape Representing the Retirement of Timolean* (now lost), to the Free Society in 1761. He also attempted to lay out a program of "historical landscape" in a series of thumbnail sketches grouped under four headings, "Egyptian Age," "Grecian Age," "Roman Age," and "Modern Age," but it is nearly impossible to distinguish how the very abbreviated compositions of one "age" differed from the next, and as with so many of his nascent theoretical constructs, Cozens did not elaborate on his plan.[28] In 1776, his son John submitted *A Landscape, with Hannibal in his March over the Alps Showing to His Army the Fertile Plains of Italy* to the Royal Academy in hopes that the oil would bring him professional stature and perhaps even Academy membership. When his ambitious bid was rejected in a rough parallel to the *affaire Greuze* in France, he dispensed with further historical efforts and refrained from exhibiting at the Academy altogether.[29]

His painting, which has also not survived, was much admired by the succeeding generation, and by Turner in particular.

Landscape had the potential to underwrite history's lessons, to be sure. Benjamin West, the perfect barometer of fluctuations in taste, proved as much when he experimented with ancient historical episodes set out-of-doors in the 1770s.[30] But even he did not resolve the basic incompatibility between the prevailing stylistic conventions for landscape and the severe moralizing tone of neoclassical history subjects.[31] Had Nicolas Poussin been the preeminent model for English eighteenth-century landscape painters, rather than Claude or Gaspard Dughet, then perhaps they would have been able to keep pace thematically with their colleagues in history painting. Exhibition records indicate that those landscape artists who chose to pursue high(er) art preferred lighter Ovidian subject matter, which from the seventeenth century had proved to be perfectly consonant with idealized natural settings.

Their paintings' titles (many of the works have disappeared) suggest that the role played by the narrative elements remained secondary to the depiction of the landscape, as if the figures, and hence the subject matter had been inserted after the fact. Works entitled "Landscape, with . . ." (Jupiter and Io, Venus and Adonis, or some other mythological couple) appeared with regularity at the annual public exhibitions. More ambitious artists might call attention to particular natural effects, as in *Sunset, with Alpheus and Arethusa* (by Thomas Jones), or *A Romantic View, with a Rainbow, with the Story of Perseus and Andromeda* (by Jared Leigh).[32] A delightful example of this ordering of priorities seen through impressionable American eyes was provided by the young Washington Allston in his 1805 *Diana in the Chase (Swiss Scenery)* (fig. 19). The goddess and her entourage are relegated to the lower right corner of an

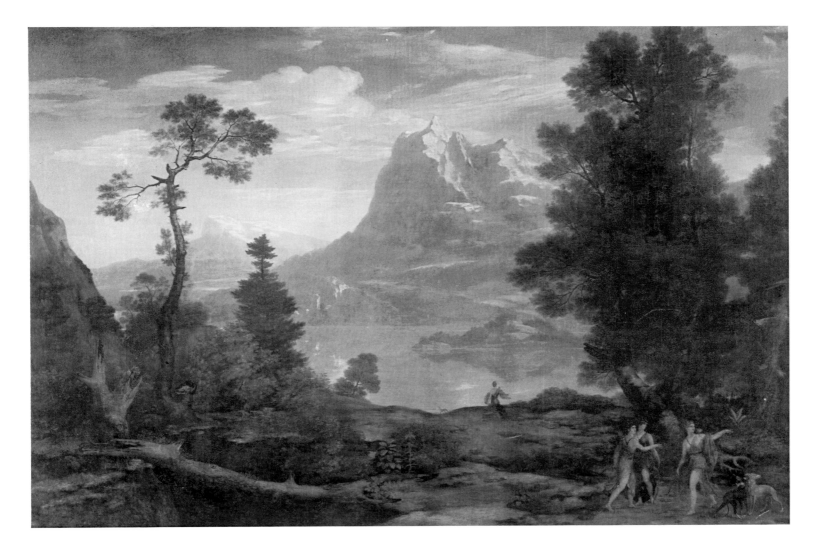

Figure 19. Washington Allston, *Diana in the Chase (Swiss Scenery)*, 1805. Oil on canvas, $65\frac{5}{8} \times 97\frac{5}{8}$ inches (166.7×248 cm), Courtesy of The Harvard University Art Museums (Fogg Art Museum), Cambridge, Massachusetts, Gift of Mrs. Edward Moore.

artfully arranged landscape forthrightly identified as Switzerland, not Arcadia. Allston simply amalgamated the immediate experience of his travels through the Alps with a reference to the classical heritage awaiting him at his eventual destination, Rome.

In contrast, history painters tended to become thoroughly involved in their chosen narratives, constantly plundering new and increasingly esoteric sources for ancient subjects in a direct appeal to the viewer's erudition. A painting like Benjamin West's *Agrippina Landing at Brundisium with the Ashes of Germanicus* included an array of archaeological details in the name of historical fidelity and didactic conviction (fig. 20). As with the best topographical views of sites or monuments, West's scene allowed a viewer to experience, albeit second hand, the venerable wonders of antiquity. Classical landscape as practiced in the late eighteenth century instead attempted to access something ineffable—a concept of an harmonious golden age handed down without having been rethought. Unfortunately, the seductiveness of the dream depended wholly on the subtlety of its visualization and on the painter's capacity for imaginative projection.

Even in the works of an acclaimed classical landscape painter like Jacob More (1740–1793), the "fairy land" to which Reynolds wished to be conducted, was rarely attained (fig. 21).[33] The figures in More's *Rape of Dejanira* politely accent a decorous view of cascading river, distant temple, and ancient (but not blasted) trees. The painter cast the classical world as a place of abiding order undisrupted by the passion of the mythic episode. The relatively high degree of finish and attention to particularities (for example, the gnarling of the trees) underscores Reynolds' critique of the genre. Naturalistic detail allows a sense of everyday reality to intrude on one's incipient reverie about Arcadia. The viewer remains at a tactful distance, looking on; he or she cannot enter into the painting's thematic realm.

Young artists like Turner, or, later, John Martin and Francis Danby bridged that distance by reintroducing engaging narratives and taking care to make their imagined locales correspond in tone. A critical change in the value of classical landscape vis-à-vis history painting certainly aided their efforts to reinvest the genre with powers of enchantment. The "revolution" started by Benjamin West's landmark *The Death of General Wolfe* (1771) caused paradoxical repercussions. West's move toward historical correctness and contemporaneity threatened to lose for history painting its premier position in England's artistic hierarchy. As the level of factuality increased, proponents of history ceded the license for embellishment to painters who worked from the imagination. Henry Fuseli elaborated on the distinction in a lecture on "Invention," delivered at the Royal Academy in 1801, identifying three categories of subject matter: "*epic* or sublime, *dramatic* or impassioned, *historic* or circumscribed by truth. The first *astonishes*; the second *moves*" and the third, he claimed, "*informs.*"[34] As he went on to explain, "History, strictly so called, follows the drama: fiction now ceases, and invention consists only in selecting and fixing with dignity, precision, and sentiment, the moments of reality."[35]

The territory withdrawn from the domain of history painting had been surveyed and named a few years earlier by the Reverend Robert Anthony Bromley in his controversial treatise, *A Philosophical and Critical History of the Fine Arts* (1793–1795).[36] Starting from the premise that the duty of history painting was to instruct, and to do so with maximum attention to factual truth, Bromley proceeded to define its opposite case: painting created through the workings of the imagination and designed to give pleasure. Calling the latter category "poetic painting," he assigned to its domain "arbitrary circumstances, visionary allusions, and extrinsic adoptions, all intermixture of fable where the painting has assumed a known matter of fact, all personifi-

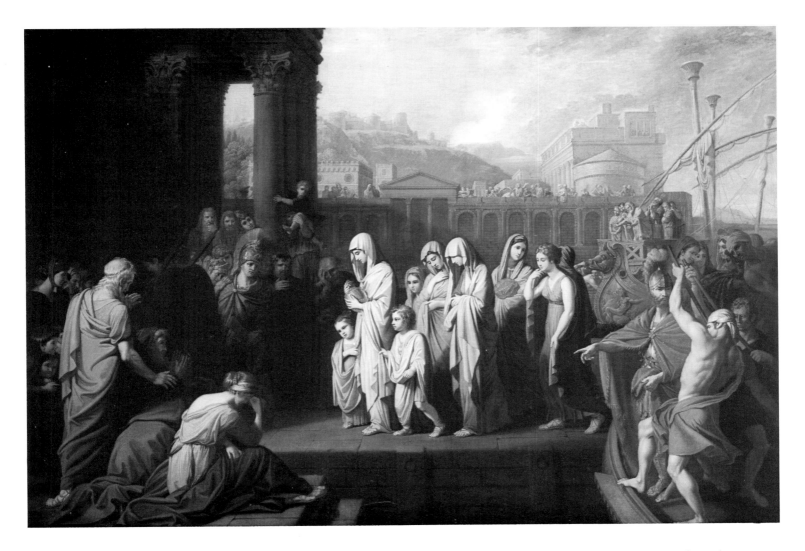

Figure 20. Benjamin West, *Agrippina Landing at Brundisium with the Ashes of Germanicus*, 1768. Oil on canvas, $64\frac{1}{2} \times 94\frac{1}{2}$ inches (164 × 240 cm), Yale University Art Gallery, New Haven, Gift of Louis M. Rabinowitz.

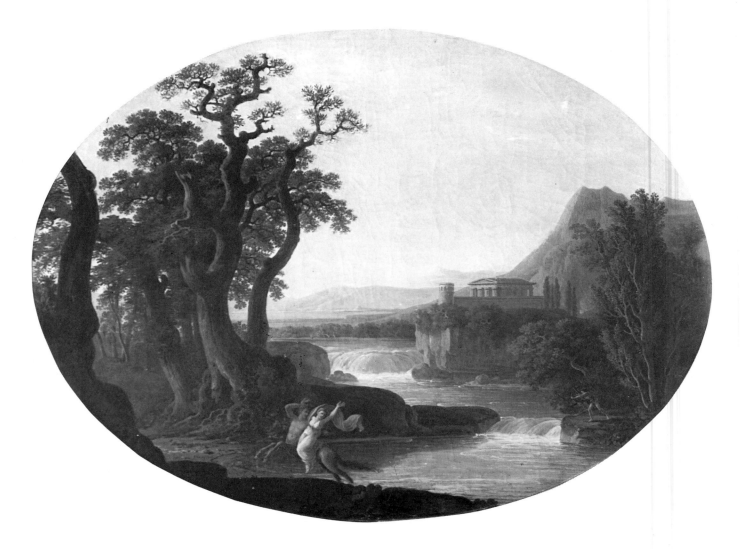

Figure 21. Jacob More, *Rape of Dejanira*, 1786, Private Collection.

cations of inanimate nature."[37] Thus classical epic, heretofore a traditional source for history painters, became the province of the poetic painter because such legendary stories did not suffice as proper historical accounts in Bromley's mind.[38] He had no intention of denying history painting its primacy—he mainly wanted to defend West's use of contemporary dress and to disparage Winckelmann's allegorically weighted notion of history painting—but his elaborate argument had the effect of granting poetic painting equal status. His primary requirement was that both categories avoid sheer frivolity and address questions of morality.[39]

When he identified Poussin with poetic painting, Bromley gave late eighteenth-century classical landscape a decided boost in status. Initially, he had deliberated over how to characterize Poussin's works, and in particular the *Death of Phocion*: was it a history painting or a landscape with an inappropriately tragic historical vignette? The best way to resolve the dilemma, Bromley felt, was to reclassify the work as poetic.[40] He could have pointed to Sir Joshua Reynolds for support. In the Thirteenth Discourse, Reynolds had already placed landscape painters on an equal footing with both painters of history and poets, provided they idealized formally and explored antiquity thematically. He explained that

> a landskip thus conducted, under the influence of a poetical
> mind, will have the same superiority over the more ordinary
> and common views, as Milton's *Allegro* and *Penseroso* have over
> a cold prosaick narration or description; and such a picture
> would make a more forcible impression on the mind than the
> real scenes, were they presented before us.[41]

However conventional the basic observation, Reynolds justified the place of imaginative flight in the creation of serious landscape by according it the honor of being poetic —the key word for the early nineteenth century. At about the same time, renewed interest in the theory of association encouraged an even more active role for narrative elements in landscape painting. The Reverend Archibald Alison's *Essays on the Nature and Principles of Taste*, published in 1790, considered how perceptions of the natural world are affected by the emotional and mental qualities brought to bear on them.[42] The philosopher developed much of his argument on the example of the fine arts, and landscape painting in particular. He was impressed with an artist's ability to elicit profound responses from a viewer by informing natural scenery with meaningful incidents. In his description of the process by which a sensitive person comes to appreciate nature, Alison, too, provided strong justification for the aesthetics of classical landscape. His account is quoted here at length because it summarizes so much of the underlying rationale for a poeticized vision of Arcadia:

> In most men, at least, the first appearance of poetical imagina-
> tion is at school, when their imaginations begin to be warmed
> by the descriptions of ancient poetry, and when they have
> acquired a new sense as it were, with which they can behold
> the face of nature.
>
> How different, from this period, become the sentiments with
> which the scenery of nature is contemplated, by those who
> have any imagination! The beautiful forms of ancient
> mythology, with which the fancy of poets peopled every
> element, are now ready to appear to their minds, upon the
> prospect of every scene. The descriptions of ancient authors,
> so long admired, and so deserving of admiration, occur to them
> at every moment, and with them, all those enthusiastic ideas
> of ancient genius and glory, which the study of so many years
> of youth, so naturally leads them to form. Or, if study of
> modern poetry has succeeded to that of the ancient, a thousand
> other beautiful associations are acquired, which instead of
> destroying, serve easily to unite with the former, and to afford
> a new source of delight With such images in their minds,
> it is not common nature that appears to surround them. It
> is nature embellished and made sacred to the memory of

Theocritus and Virgil, and Milton and Tasso; their genius
seems still to linger among the scenes which inspired it.[43]

A definition of landscape painting based on Alison's view would be the antithesis of Richardson's. The scenes Alison would have artists evoke were fully populated by significant beings with intriguing stories to tell.

The various proposals put forward by Reynolds, Bromley, and Alison for infusing painting with poetic sentiment met with a warm reception by artists. As usual, Benjamin West placed himself in the forefront, identifying one of his 1799 Royal Academy submissions as *The Bath of Venus, a Poetic Landscape* (fig. 22).[44] Its pretensions to poetry may be more self-proclaimed than actual, deriving from its "luxuriant" display of classical figures set against (not yet *in*) a moody outdoor setting. The eighteenth-century reviewer who provided the above characterization went on to commend what he perceived to be liberties taken with the landscape. "In a picture that professes to represent *Poetical Nature*, and that introduces ideal characters," he explained, "it would be absurd to expect the scenery that pleases the mere vulgar spectator."[45] The memory of Reynolds' criticism of Wilson must never have been out of mind.

The younger generation of landscape painters—those who came of age just at the turn of the century—immediately took advantage of their newfound liberty. They began by asserting a more catholic concept of their genre, announced in the bewildering array of new designations. In place of the more familiar "classical" landscape, they variously proclaimed their endeavors to be "epic," "heroic," "elevated," or "historical," without the slightest concern for the semantic confusion these terms might cause art historians.[46] The important thing was to get on with the business of improving the art of landscape itself. Hence, Thomas Girtin could form the "Brothers" sketching club

in 1799 for the proudly stated purpose of "establishing by practice, a school of Historic landscape, the subjects being original designs from poetic passages," without worrying over any inherent contradictions.[47] For one evening's exercise the "Brothers" might select lines from *Ossian*, and for the next, a poem by David Mallet. Taking inspiration from literature and inventing appropriate imagery on the spot must have proved satisfying, since the club remained in existence, with various reorganizations and changes of membership, for fifty years.[48]

Although Turner did not participate in his friends' sketching sessions, he certainly shared their desire to elevate landscape beyond its status as "mapwork."[49] He too explored the interrelationships of poetry and painting, and evaluated the role of association in developing his imagery. Being elected an associate member of the Royal Academy in 1799 added professional impetus to his pursuit of the higher branches of his art. And just as his career blossomed, he also witnessed a heartening reappraisal of Wilson's accomplishment. An article dating from 1794 regretted the passing of Wilson (and Gainsborough), for with him, the author feared, the last vestiges of the tradition of Claude, Poussin, and Rosa had gone as well.[50] The charge to maintain that heritage thus fell to the next generation.

In fact Wilson's stature continued to grow, even earning him a place above Claude, if for reasons of wartime chauvinism. Wolcot (Peter Pindar), in the supplement to the 1798 edition of Pilkington's *Dictionary*, compared the two artists and found the French master wanting. "Claude," he stated in summation, "was rather the plain and minute historian of landscape, Wilson was the *poet*" [*my emphasis*].[51] What heady praise when Turner saw himself, as early as 1799, placed on a par with both predecessors.[52] No wonder he felt compelled to take up the challenge of classical landscape in *Aeneas and the Sibyl, Lake Avernus*.

Figure 22. Benjamin West, *The Bath of Venus, a Poetic Landscape* (subsequently titled *Venus and Adonis, with Cupids Bathing*), 1799. Oil on canvas mounted on panel, $28\frac{3}{4} \times 39\frac{1}{4}$ inches (73×99.7 cm), Alexander Gallery, New York.

The painting constituted a bold step for several reasons. Turner had not yet schooled himself in classical conventions to any great degree. The models for his formal investigation of Wilson's style had been restricted to the picturesque idiom of mist-shrouded mountains in Wales and a selection of Italian views. Consonant with his own travel experience, he emulated the former and copied the latter, including Wilson's scene of Lake Nemi with its figures of Diana and Callisto, illustrated earlier (fig. 3).[53] Study of Claude he kept to a minimum, as if aware that he should master the less complicated artist first (though he would shortly devote a fair amount of effort to defining his relationship to Claude). Nor did Turner's personal and intellectual background predispose him to turn to antiquity for imagery compatible with his ideas about landscape. He acquired his classical tastes over time, through a process of patient self-education. The artist even seemed wary of succumbing too readily to the Mediterranean region's fabled allure. An otherwise enthusiastic traveller, he postponed his first extended tour of Italy until 1819, a delay that the continental wars cannot completely explain. Having been offered the chance to accompany Lord Elgin to Greece to sketch the Parthenon in 1799, he let financial considerations outweigh curiosity and declined that opportunity as well.[54]

Turner found the right ambience in which to develop an understanding of classicism closer to home. Since the mid-1790s, he had enjoyed an acquaintance with the noted antiquarian, Sir Richard Colt Hoare and his famous estate, Stourhead.[55] Stourhead's gardens had been designed by Henry Hoare in the 1750s–1760s to allude to passages of the *Aeneid*, the scenes "visualized" along the lines of Claudean landscapes.[56] The elder Hoare had also assembled a fine collection of paintings, among them Wilson's *The Lake of Nemi, or Speculum Dianae*. Richard Colt Hoare inherited the estate, a patron's instincts, and his

relative's taste for classical learning. He had made the Grand Tour, noted historical and mythological associations where appropriate, and had even sketched the more memorable sites—Lake Avernus among them. He offered that unembellished topographical drawing, and no doubt the careful notes he had made in 1787–1788 about the fine points of the scenery, for Turner's use in developing *Aeneas and the Sibyl, Lake Avernus*. But what the young artist made of these resources depended as much on his artistic sensibility as on the tutelage of even so well-informed a patron. Stourhead and Richard Colt Hoare met his needs with regard to classical landscape and the idea of antiquity, rather than initiated his interest in them.

One might even say that Turner developed his ideas about the classical past, as well as the quality of his classicism, in spite of his patrician tutor.[57] During the 1790s Richard Colt Hoare's taste in art was the more limited. He preferred straightforward topographical work, accurate in detail, such as the drawings of Salisbury he ordered from Turner at the time.[58] Nor is there evidence that Hoare had commissioned *Aeneas and the Sibyl, Lake Avernus* or showed any interest in acquiring it. In the painter's initial conception of Lake Avernus (fig. 23), he immediately distanced himself from Hoare's descriptive, accurate sketch by adding elements that transform an observed, contemporary view into an embellished *capriccio*. The Wilson-like fragments, herm, and sarcophagus in the now-prominent foreground not only evoke the ancient past, they set the stage for action. Hoare's record of place gave way to Turner's scenic conceit.

In the finished painting Lake Avernus has become the locale where Aeneas encounters the Cumaean Sibyl. By incorporating an episode from Virgil's *Aeneid*, Turner offered the viewer a way to recoup the past and relive a moment of ancient piety and valor. In effect, the artist's

Figure 23. J.M.W. Turner, *Lake Avernus*, TB LI, N, c. 1798. Pencil, $14\frac{3}{4} \times 21$ inches (37.5 × 53.3 cm), Turner Collection, Tate Gallery.

Figure 24. J.M.W. Turner, *Lake Avernus: Aeneas and the Cumaean Sibyl*, 1814–1815. Oil on canvas, $28\frac{1}{4} \times 38\frac{1}{4}$ inches (72×97.1 cm), Yale Center for British Art, New Haven, Paul Mellon Collection (BJ 226).

imagination responded to the delicate interplay of landscape and literary associations that Henry Hoare had built into his Virgilian garden. When the artist read the Sibyl's words, "Procul, o procul, profane," inscribed on the Temple of Flora at Stourhead, in his mind's eye he must have seen Aeneas step forward to begin his quest. But in visualizing that moment in the painting, he acted not on a tourist's penchant for colorful anecdote, but on his Royal Academy training, with its firm grounding in the history of the Grand Manner.[59]

A comparison of the character of Richard Colt Hoare's antiquarianism may prove helpful in understanding Turner's conception of the theme. Presumably the two men discussed the way the legend of Aeneas at Lake Avernus had been incorporated into the iconographic program of the garden at Stourhead. However, Richard Colt Hoare (as distinct from his forebear, Henry) assigned priority to *where* an event might have taken place, not *why* Virgil might have set his hero on a particular task. In 1815 he purchased an updated version of *Aeneas and the Sibyl, Lake Avernus* from Turner (titled *Lake Avernus: Aeneas and the Cumaean Sibyl*, fig. 24). When Hoare catalogued the work two years later, he included an appropriate citation from the *Aeneid* identifying Lake Avernus as the gateway to the underworld, but only as an afterthought.[60] In a subsequent publication he referred to the painting simply as a "Classical subject," while amplifying the accompanying travel notes he had made about the area.[61] And even as he ordered the 1815 work from Turner, it would seem Hoare lent his same, original sketch of Lake Avernus to Francis Nicholson, so that the patron might have a topographical view closer in detail and demeanor to his own as well (fig. 25).[62]

Turner, however, had read Virgil closely and followed the indications of the text in imagining the episode. Where he embellished, he did so in order to stress Aeneas' sense of purpose in pursuing his destiny. To identify the moment, he placed the legendary golden bough required for Aeneas' passage to the underworld in the Sibyl's upraised hand. As the young hero strides purposefully into the landscape, to his right, obscured figures sacrifice at an altar. Although they are difficult to see, they do not merely fill space or look on as members of the entourage; their concentrated and somewhat mysterious activity engages the viewer's curiosity and encourages one to recall that in the *Aeneid* the Sibyl required Aeneas to make oblations beforehand. The attendant figures, thus engaged, reflect upon the young man's characteristic obedience and piety.[63] By thinking through the elements of the story, Turner presented the episode in a more engaging, animated way than even Claude Lorrain in his versions of the subject. In *Coast View with Aeneas and the Cumaean Sibyl* (seen here the way Turner might first have known it—through Richard Earlom's 1777 mezzotint), the figures have a prominence that renders them emblematic of passage (fig. 26).[64] Turner, in however rudimentary a fashion, tried to characterize the event as well as to integrate the figures *into* the scene of Lake Avernus. The downward trajectory that the eye follows toward the lake for example would seem to intimate the hero's descent into the underworld.

It is tempting to think that Turner might have painted *Aeneas and the Sibyl, Lake Avernus* as a trial diploma piece for the Royal Academy. Its records indicate that upon his election to full membership in 1802, he submitted two works—*Dolbadern Castle* and another, unidentified, painting —so that the august body might choose the one that best represented their standards of professionalism.[65] In the end, Turner might have recognized that despite its statement about affiliation, heritage, and ambition in landscape painting, a work as prosaic as *Aeneas and the Sibyl, Lake Avernus* did not do him, or the tradition to which he

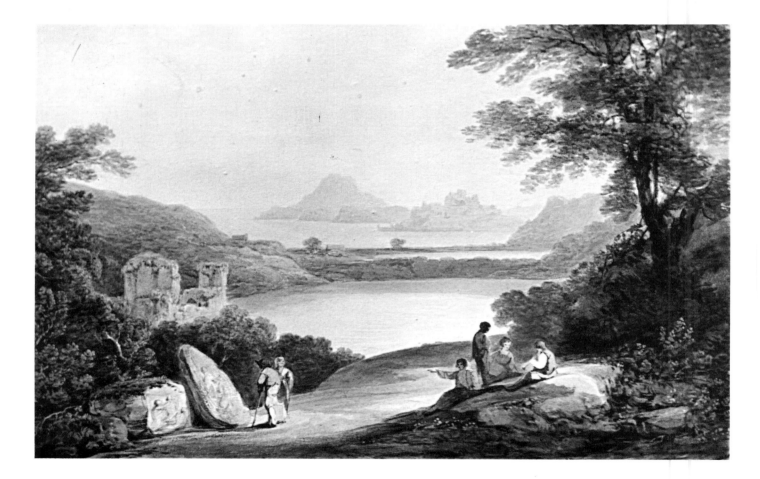

Figure 25. Francis Nicholson, *Pastoral Landscape*, c. 1813–1815. Watercolor, $13\frac{11}{16} \times 20\frac{1}{2}$ inches (34.8×52.2 cm), Birmingham Museums and Art Gallery, Birmingham, England.

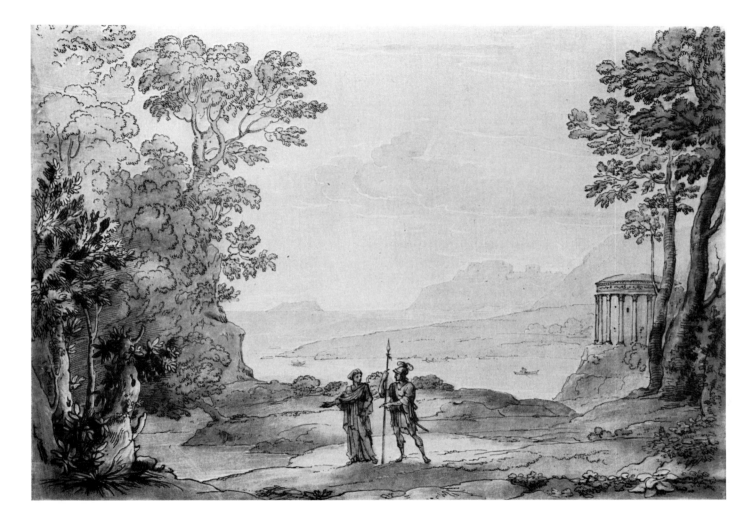

Figure 26. Claude Lorrain, *Coast View with Aeneas and the Cumaean Sibyl*, Liber Veritatis 183, 1673. Mezzotint by Richard Earlom, published 1777, Norton Simon Museum, Pasadena.

appealed, full justice. *Dolbadern Castle* was at once more representative of his formal powers, more contemporary in taste, and more "poetic" in its overall realization. However, he soon learned how landscape can function narratively to capture the mythic dimension of antiquity. Turner's self-education into the structures of meaning available to a painter of nature was thoughtful, adept, and rapid. His subsequent classical landscapes register that progress.

Chapter I: Notes

1. Sir Joshua Reynolds, *Discourses on Art*, ed. Robert Wark (San Marino: Huntington Library, 1959), p. 255; Discourse Fourteen, delivered December 10, 1788.

2. Ibid., pp. 255–56.

3. Ibid., p. 256.

4. Ibid., p. 237, Discourse Thirteen, December 11, 1786. Reynolds' thinking had been anticipated by Solomon Gessner in "Letter to M. Fuselin on Landscape Painting," appended to his *New Idylles*, London (1776), pp. 87–107. Gessner advised young painters to follow the example of the Old Masters, and for many of the same reasons: "A poetic genius united in the two Poussins all that is great, all that is noble. They transport us to those times for which history, and especially poetry, fill us with veneration; into those countries where nature is not savage, but surprising in her variety; where, under the most happy sky, every plant acquires its utmost perfection. The buildings that adorn the pictures of those celebrated artists are in the true taste of the antique architecture. The figures have a noble air, and a firm attitude. It is thus the Greeks and Romans appear to us, when our imagination, render'd enthusiastic by their great actions, transports itself to the ages of their prosperity and glory. Repose and amenity reign throughout all the countries the pencil of Lorrain has created" (p. 97).

5. The most comprehensive survey of the influence of the Old Masters is still Elizabeth Manwaring's *Italian Landscape in Eighteenth-Century England* (1925; reprinted New York: Russell & Russell, 1965). Their impact has been studied subsequently by Luke Herrmann, *British Landscape Painting of the Eighteenth Century* (New York: Oxford University Press, 1974), particularly pp. 9–26 and 49–90.

6. The verse is from the *Castle of Indolence*, Canto I. Turner knew the lines, for he paraphrased them in one of his Royal Academy lectures on perspective: "and the charms of Claude and all that learned Poussin drew is to [be] rated [?] without prejudice;" transcribed by John Gage in *Color in Turner* (New York: Frederick Praeger, 1969), p. 213.

7. Quoted in W.T. Whitley, *Artists and Their Friends in England, 1700–1799*, 2 vols. (London: The Medici Society, 1928), 1, p. 330. For Gaspard Dughet's influence on British art see Anne French, *Gaspard Dughet* (London: Greater London Council, 1980). Wilson availed himself of Dughet's *Ideal Landscape* for a compositional assist more than once, as revealed by David H. Solkin, "Richard Wilson's Variations on a Theme by Gaspard Dughet," *Burlington Magazine* 123 (1981), pp. 410–14. Turner's strategy was to investigate each artist separately, moving from Wilson's revision of Claude in *Aeneas and the Sibyl, Lake Avernus* to Rosa, in *Jason*, 1802, and Gaspard Dughet with *Narcissus and Echo*, 1804. The painting by Gaspard Dughet illustrated here (fig. 7) was

owned by Turner's friend and patron, H.A.J. Munro of Novar.

8. Jonathan Richardson, *An Account of the Statues, Bas-reliefs, Drawings and Pictures in Italy, France &c* (London, 1722), pp. 186–87.

9. Alexander Pope, *Pastoral Poetry and an Essay on Criticism*, ed. E. Audra and Aubrey Williams (London: Methuen & Co., 1969), pp. 25–26. For a discussion of the implications of the pastoral mode for early eighteenth-century landscape, see John Barrell, *The Dark Side of the Landscape* (Cambridge: Cambridge University Press, 1980), pp. 15–16.

10. Richardson, *An Account of the Statues*, p. 186.

11. Jonathan Richardson, *The Connoisseur: An Essay on the Whole Art of Criticism as It Relates to Painting* (London, 1719), pp. 44–45.

12. Richardson, *An Account of the Statues*, p. 187. Deborah Howard, in "Some Eighteenth-Century English Followers of Claude," *Burlington Magazine* 111 (169), p. 732, suggested that Claude's iconography was often too complicated for eighteenth-century tastes.

13. For a sociopolitical interpretation of eighteenth-century arcadian landscape, see David H. Solkin, *Richard Wilson* (London: The Tate Gallery, 1982), pp. 37–55. He argued that such works reinforced the conservative, elitist values of the landed patricians by providing a demonstration of the peace and prosperity their class alone could insure in eighteenth-century English society.

14. "The Letters of Jonathan Skelton Written from Rome and Tivoli in 1758," ed. Brinsley Ford, *Walpole Society* 36 (1958–1959), p. 45. The same sentiment was expressed by a writer for the *London Journal* of August 26, 1727. Though he felt that landscapes offered the least entertainment, they could be heightened by the judicious use of figures, "in order to give us Opportunity of employing our Reflections", quoted by Manwaring, *Italian Landscape*, p. 24.

15. The paintings, seven in all, were documented and discussed by Brinsley Ford, "Richard Wilson in Rome, I," *Burlington Magazine* 93 (1951), pp. 157–66. In addition to the fanciful scenes (*Landscape with Banditti round a Tent*, and *Landscape with Banditti—The Murder*) and the ancient historical subjects, Wilson also tried two mythological subjects, *Narcissus*, and *Venus and Satyr*, both of which are primarily figural compositions. Howard's interest in stoic themes was shared by his countryman Joseph Leeson, who, in 1745, ordered a copy of Rosa's *Death of Atilius Regulus* from Claude Joseph Vernet. That painting is now in the National Gallery of Ireland; see Michael Wynne, "A Copy by Joseph Vernet of Salvator Rosa's *Atilius Regulus*," *Burlington Magazine* 113 (1971), p. 543. The heroism of Cincinnatus and Regulus was extolled by James Thomson in *The Seasons*, "Winter," and *Liberty*, Pt. III, noted by Ann Livermore in "J.M.W. Turner's Unknown Verse-book," *Connoisseur Year Book*, 1957, p. 81. Livermore established the extent to which Turner knew Thomson's poetry, and the ways in which he paraphrased his verse.

16. W.G. Constable, *Richard Wilson* (Cambridge: Harvard University Press), 1953, pp. 31, 158–59.

17. For the c. 1769 *Meleager and Atalanta*, Wilson set the episode in front of a rushing waterfall—an element of the scenery not specified by Ovid.

18. The figures in the first version of *The Destruction of Niobe's Children* may have been painted for Wilson by Placido Costanzo, perhaps resulting in the lack of cohesion which bothered Reynolds; Constable, *Richard Wilson*, pp. 160–63. In his 1790 biography of the artist, William Hodges stated that Wilson added figures to his landscapes mainly to give a more agreeable air to the composition; "An Account of

Richard Wilson Esq. Landscape Painter, F.R.A.," *European Magazine and London Review* 27 (1790), p. 403. The "staffage" notion originated from the belief of eighteenth-century painters that Claude's figures were miserably drawn and therefore not of any importance. Manwaring, *Italian Landscape*, p. 37, quoted *The Critical* for February, 1759, which reported that Claude was "remarkable for having left his figures tame and unfinished, that they might not conflict with the general effect of his landscapes." According to John Constable, Wilson had cautioned artists not to "fall into the common mistake of objecting to Claude's figures," C.R. Leslie, *Memoirs of the Life of John Constable* (London: Phaidon, 1951), p. 308.

19. Lake Nemi had been known as *Speculum Dianae* because a sanctuary dedicated to Diana was nearby; Constable, *Richard Wilson*, pp. 164–65. Claude provided an example of how to match story to locale in his *Landscape with the Nymph Egeria Mourning over Numa*, LV 175 (Museo e Gallerie Nationali di Capodimonte, Naples). According to Ovid, Numa's tale took place near Diana's Lake Nemi sanctuary, which indication Claude followed; see Marcel Roethlisberger, *Claude Lorrain: The Paintings*, 2 vols. (New Haven: Yale University Press, 1961), 1, pp. 409–12.

20. Turner Bequest, CLXXXII, "Albano, Nemi, Roma" sketchbook, 15a. References to the Turner Bequest will hereafter be abbreviated as TB. William Chubb, "Turner's *Cicero at His Villa*," *Burlington Magazine* 123 (1981), pp. 417–23, explored Turner's reliance on Wilson in this instance. Chubb pointed out that Turner's misidentification of the scenery in Wilson's painting resulted from a common alteration of Wilson's original title: by 1790, the correct location of the villa represented—Arpinum—had become Tusculum in various records. See Constable, *Richard Wilson*, pp. 168–69. Ironically, Wilson's setting derives from a drawing of scenery in northern Wales and a healthy measure of idealization based on Claude's *Landscape with St. George and the Dragon* according to David H. Solkin, "The Battle of the Ciceros: Richard Wilson and the Politics of Landscape in the Age of John Wilkes," *Art History* 6 (1983), p. 407. Wilson's synthesis was obviously convincing enough to have persuaded Turner of the landscape's factuality.

21. "The Letters of Jonathan Skelton," pp. 42–43. Skelton died the following year, leaving behind only a small number of competent topographical watercolors. Thomas Jones, who was in Rome in the 1770s, made a similar observation from perhaps the same spot, recorded in his "Memoirs," *Walpole Society* 32 (1946–1948), pp. 66–67.

22. John Plimmer to Henry Hoare, June 9, 1759, quoted by Kenneth Woodbridge, *Landscape and Antiquity* (Oxford: Clarendon Press, 1970), p. 46.

23. In 1764 Pars won a third premium for history painting at the Free Society, but concentrated on archaeological and topographical views thereafter. See *The Age of Neoclassicism* (London: Arts Council of Great Britain, 1972), p. 392.

24. Barrell, *The Dark Side of the Landscape*, pp. 19ff., argued that social realities ranging from an unavoidable awareness of the true state of the rural poor to pre-war chauvinism contributed to the inappropriateness of the classical manner toward the end of the century.

25. Thomas Jones, "Memoirs," *Walpole Society* 32 (1946–1948), pp. 19–20.

26. For a commentary on the collaboration of Jones and Mortimer in the *Death of Orpheus* see Robin Smith, "Richard Wilson's Meleager and Atalanta,'" *Burlington Magazine* 123 (1981), p. 417.

27. *The Age of Neoclassicism*, p. 20. Another collaborative effort between Jones and Mortimer, the painting entered the collection of the Catherine the Great.

28. The sketches are part of a four-sheet study of "Principles of Landskip," now in the British Museum. For each "age" there are sixteen numbered sketches, arranged in rows of four. One sheet is illustrated in Leslie Parris, *Landscape in Britain c. 1750—1850* (London: The Tate Gallery, 1973), p. 50.

29. The painting and Cozens' expectations were discussed by Lynn Matteson, "The Poetics and Politics of Alpine Passage: Turner's *Snowstorm: Hannibal and His Army Crossing the Alps*," *Art Bulletin* 62 (1980), pp. 386—87.

30. In particular, *Cyrus Liberating the Family of Astyages* and *The Wife of Arminius Before Germanicus*, both in the Royal Collection, Kensington Palace. West returned to the combination of history and landscape in 1797, and then again in 1811; see below p. 90.

31. An article on "Landscape" in *The Artist's Repository and Drawing Magazine* 1 (1788), pp. 197—225 began by claiming that the genre "has many advantages over historical painting; its subjects being more familiar to the spectator; consequently more impressive and more immediately understood by him, and its errors less apparent." The author then posited "Historical Landscape" as the epitome of nature painting since it "proposes as its object the sublime and grand," and impresses vigorous sensations on the spectator's imagination through its depiction of "noble fabrics, temples, palaces," and "ruins of capital buildings" (p. 199). Narrative elements are once again given short shrift, however. While the author recommended adding figures to the composition, and "would have them neither insipid nor indifferent," yet they only "contribute to raise an interest in the spectator, whether by relating some familiar history; or some distinguishing incident appropriate to the subject" (p. 212).

Turner's fulfillment of the promise of "Historical Landscape" is treated in Chapter IV.

32. Jones' painting was sent to the Society of Artists in 1769 (no. 73), and Leigh's to the Free Society in 1765 (no. 130); Algernon Graves, *The Society of Artists of Great Britain 1760—1791 and the Free Society of Artists 1761—1783* (London: G. Bell & Son, 1907).

33. More's reputation was discussed by David Irwin in "Jacob More, Neo-Classical Landscape Painter," *Burlington Magazine* 114 (1972), pp. 775—80. In fact, the artist rarely dealt with specific classical themes. Two others he treated were *Silenus Drinking from a Cup* and *Eruption of Mt. Etna with the Story of the Pious Brothers of Catania*, exhibited in 1788. The *Rape of Europa* had as a pendant a scene of the *Rest on the Flight*. The pairing is interesting in light of Turner's 1841 religious/mythological pendants the *Dawn of Christianity* and *Glaucus and Scylla*.

34. Henry Fuseli, *Lectures on Painting* (London, 1801), p. 123.

35. Ibid., pp. 142—43.

36. R.A. Bromley, *A Philosophical and Critical History of the Fine Arts*, 2 vols. (1793—1795; reprinted New York: Garland Publishing, Inc., 1971). In part because Bromley had referred to Fuseli as a madman, the latter led a vote to ban the second volume of Bromley's study from the Royal Academy library on the grounds that the book was full of factual errors and its author a mere country rector with no particular expertise. Copley too was offended, but for personal reasons: Bromley had chosen West's *Death of General Wolfe* as the example of correct history painting rather than a work by Copley. The controversies over the book were made public and given high visibility by both sides through a series of letters and articles to various newspapers. Bromley replied to his detractors in a prefix to the second volume.

37. Ibid., 1, p. 46.

38. Ibid., 1, pp. 63—85. Bromley used as examples subjects like the battle between Aeneas and Turnus, or Dido's discovery of Aeneas' departure, both of which Turner would later treat.

39. Others did take sides, however. A 1789 review of the competing Macklin's Poet's Gallery and the Boydell Shakespeare Gallery (the latter dedicated to promoting historical painting), proclaimed that "the higher branch of the arts seems to be Mr. Macklin's; to give representation to the poetic flights of fancy is a more arduous undertaking than merely to embody the historical scene; the former surprises and elevates, the latter may be beheld with unimpassioned emotion," Victoria & Albert Museum Volumes of Press Cuttings from 1686—1835, 2, p. 479. Hereafter cited as V & A Press Cuttings. For further discussion of Macklin's role in the development of poetic painting, see Kathleen Nicholson, "Turner, Poetry, and the Transformation of History Painting," *Arts Magazine* 56 (April, 1982), pp. 92—97.

40. Bromley, *A Philosophical and Critical History*, 1, p. 73.

41. Reynolds, *Discourses on Art*, p. 238. His insistence on the *combination* of formal and thematic idealizing applied even to one of his chosen models, Claude Lorrain. Warming up for his critique of Wilson's *The Destruction of Niobe's Children* in Discourse Fourteen, Reynolds first commended Gainsborough as an artist, who, having "never attempted the heroick style, so neither did he destroy the character and uniformity of his own style, by the idle affectation of introducing mythological learning in any of his pictures." He then reiterated that the "practice is hardly excusable, even in Claude Lorrain, who had shewn more discretion, if he had never meddled with such subjects," ibid., p. 255.

42. For Alison's influence on the fine arts see G.L. Hersey, "Associationism and Sensibility in Eighteenth-Century Architecture," *Eighteenth-Century Studies* 4 (1970—1971), pp. 71—89, and Ralph N. Miller, "Thomas Cole and Alison's Essay on Taste," *New York History* 37 (1956), pp. 281—99. Fuseli reviewed the book favorably in the *Analytical Review* 7 (1790), pp. 26—32. He printed a number of lengthy excerpts including the one quoted here; noted in Eudo C. Mason, *The Mind of Henry Fuseli* (London: Routledge and Kegan Paul, 1951), p. 357.

43. Archibald Alison, *Essays on the Nature of and Principles of Taste* (Edinburgh, 1790), pp. 43—44.

44. Allen Staley proposed that *The Bath of Venus, A Poetic Landscape* was at some point rechristened *Venus and Adonis with Cupids Bathing*, by which name it was sold in 1829; Helmut von Erffa and Allen Staley, *The Paintings of Benjamin West* (New Haven and London: Yale University Press, 1986), p. 226.

45. V & A Press Cuttings, 3, p. 791.

46. Edward Dayes, in an essay on composition in landscape, contrasted the pastoral mode with the "heroic," which he deemed the higher style since it was composed of "temples, pyramids, ruins of ancient palaces," *The Works of the Late Edward Dayes* (London, 1805), p. 196. John Varley, in *A Treatise on the Principles of Landscape* (London, 1816), n. pag., chose the term "Epic" to refer to classically designed scenes, again in distinction to "pastoral" views. Turner's *Liber Studiorum* categories included "Historical" landscape and the mysterious "E P," which could have been epic or elegant or elevated pastoral. See p. 165.

47. Their "manifesto" was written out on the back of a drawing made the first evening, now in the Victoria & Albert Museum. For a history of the group see Dr. Guillemard,

"Girtin's Sketching Club," *Connoisseur* 67 (1922), pp. 189—95, and David Winter, "Girtin's Sketching Club," *Huntington Library Quarterly* 37 (1973—1974), pp. 123—49.

48. The progress of the club was charted by Jean Hamilton, *The Sketching Society 1799—1851* (London: Victoria & Albert Museum, 1971).

49. He remarked on the "mapwork" issue (which had recently been raised by Fuseli) in a letter to John Britton, written in November, 1811; see the *Collected Correspondence of J.M.W. Turner*, ed. John Gage (Oxford: Clarendon Press, 1980), pp. 50—51.

50. "The Arts," from an unidentified source, in the V&A Press Cuttings, 1, 138. The writer commented

 "Historical Painting, both in the Classical and other elevated walks, has attained great perfection in this country; but, when contemplating the exquisite attractions of Landscape, we lament the death of a Wilson and a Gainsborough, who had the happiness of commanding
 Whate'er Lorraine light-touched with softening hue
 Or savage Rosa dash'd, or learned Poussin drew.'

51. Matthew Pilkington, *Dictionary of Painters* 3rd ed. (London, 1798), p. 824. This judgment would be reiterated well into the nineteenth century. For example, an article entitled "Remarks on the Past and Present State of the Arts in England" possibly written by Leigh Hunt, in the *Reflector* 1 (1812), p. 216, explained that "Gainsborough was easy, picturesque, and excelled in select combination; but Wilson was a great genius, and by giving classical and impassioned subjects to his landscapes, animated them with thought and with historical interest. For the delicate effect of some of his paintings he has been compared to Claude; but he seems to have been altogether a nobler artist. Claude's excellence was in repose, in tenderness of scenery, and in a kind of Arcadian luxury, but his introduction of human accidents was uninventive, and his figures are lame and pitiable. Wilson's fancy and execution were of a higher and more extensive order: he excelled as much in violence as in repose." John Hoppner, defending Wilson against Reynolds' criticisms, explained that his landscapes "were distinguished by an unusual elevation of style and character. The glowing and rich scenery of Italy, with its numerous classical remains, warmed into action the latent feelings of a cultivated and elegant mind, and he viewed nature at once with the enthusiastic eye of a poet," *John Hoppner's Essays on Art*, ed. Frank Rutter (London: Francis Griffiths, 1908), p. 75.

52. *The True Briton* for April 29, 1799, praised Turner's *Harlech Castle* for combining the best of Claude and Wilson. In 1802 a critic stated that given Turner's genius, he could even become the next Claude; British Museum, Whitley Papers, p. 1515. Similar comments were offered in the *British Press* for May 3, 1803; see *Turner 1775—1851* (London: Tate Gallery, 1974), p. 51.

53. For Turner's copies and works in the manner of Wilson see Martin Butlin and Evelyn Joll, *The Paintings of J.M.W. Turner*, revised ed., 2 vols. (New Haven and London: Yale University Press, 1984) 1, pp. 23, 33. In the sketchbook Turner labeled "Wilson" (TB XXXVII, 1797), he made three copies of Italian scenes by Wilson, interesting for their notoriety: the *Temple of Clitumnus* (leaves 78—79), *Bridge at Rimini* (leaves 86—87), and *Convent on the Rock* (leaves 98—99). A fourth composition on leaves 92—93 was incorrectly identified as a copy of *Morning*, by A.J. Finberg, in *A Complete Inventory of the Drawings of the Turner Bequest* 2 vols. (London: H.M. Stationery Office, 1909), 1, p. 81. It perhaps documents a lost Wilson. Versions of *Bridge at Rimini* and the *Temple of Clitumnus* were owned by an associate of Farington and were the source of considerable interest to the diarist when they were sold in 1814. A version of *Convent on the Rock* had belonged to Benjamin West, who, according to Farington, "dwelt upon his little picture . . . by Wilson saying it was colored equal to Cuyp or Both and in part like

Titian." Both were discussed by Constable, *Richard Wilson*, p. 198. Another Wilson copy is TB XXXIII, 1.

54. For Turner's association with Lord Elgin, see William St. Clair, *Lord Elgin and the Marbles* (Oxford: Oxford University Press, 1967).

55. John Gage assessed Hoare's role in "Turner and Stourhead: The Making of a Classicist?" *Art Quarterly* 37 (1974), pp. 59–87. Turner's classicism was also treated by Jerrold Ziff, "Turner and Poussin," *Burlington Magazine* 105 (1963), pp. 315–21; Adele Holcomb, "A Neglected Classical Phase of Turner's Art: His Vignettes to Rogers' Italy," *Journal of the Warburg and Courtauld Institutes* 32 (1969), pp. 405–10; and Philipp Fehl, "Turner's Classicism and the Problem of Periodization in the History of Art," *Critical Inquiry* 3 (1976), pp. 93–129.

56. The history and symbolism of Stourhead were discussed by Kenneth Woodbridge, *Landscape and Antiquity*, and J. Turner, "The Structure of Henry Hoare's Stourhead," *Art Bulletin* 61 (1979), pp. 68–77.

57. I take issue here with Gage's characterization of the relationship as one of considerable dependency by Turner, the pupil, on Richard Colt Hoare, the tutor; "Turner and Stourhead," in passim.

58. Woodbridge, *Landscape and Antiquity*, p. 184.

59. During Turner's student days, the Academy maintained professors of ancient history and ancient literature on its roster. Edward Gibbon served in the former post from 1787–1794 and Bennet Langton in the latter, from 1787–1802. The Academy also continued to reinforce the authority of antiquity by selecting ancient historical subjects for student competitions. See Sidney Hutchinson, *A History of the Royal Academy*, 1769–1968 (London: Chapman and Hall, 1968), p. 237.

60. The entry for the painting reads:

> The lake of Avernus near Naples, comprehending the Temple on its banks, the Monte Vuovo, the Lucrine lake, the Castle of Baiae, the promontory of Misenum, and the distant island of Capri, from a sketch taken on the spot, by Sir R.C. Hoare, by J.M. Turner, R.A.
>> The Story of Aeneas and the Sibyl is here introduced:
>> "Fly, ye prophane! far, far away remove,
>> "Exclaims the Sibyl, from the sacred grove,
>> "And thou, Aeneas draw thy shining steel
>> "And boldly take the dreadful road to hell.
>> "To the great task, thy strength, and courage call,
>> "With all thy powers: this instant claims them all."

The translation, from Book IV, was by Christopher Pitt. Hoare published the catalogue of his collection in *Annals of the Fine Arts* 2 (1817), pp. 270–73, to prove that English patrons were supporting modern art. Obviously by 1815 his tastes had changed sufficiently for him to purchase not only a "classical" Turner, but a classical composition by A.W. Callcott as well; Woodbridge, *Landscape and Antiquity*, p. 245. Butlin and Joll, *The Paintings*, 1, pp. 24–25 and 135–36, discussed the rather puzzling circumstances surrounding the two versions of *Aeneas and the Sibyl, Lake Avernus*. Hoare no doubt wanted a nearly identical scene from Turner because it ultimately had been based on his own artistic endeavor.

61. Richard Colt Hoare, *A History of Modern Wiltshire*, 2 vols. (London, 1822), 1, p. 76.

62. There is a receipt in the Wiltshire County Record Office (T(ST) 3834) for Colt Hoare's purchase of "Two Views in Italy" from Nicholson sometime between 1813 and 1815. I am identifying the Birmingham watercolor as one of them.

63. Gage, "Turner and Stourhead,", p. 73, identified the third

auxiliary figure in the 1815 version as Chryses, and suggested Turner included him because both he and Deiphobe were in the service of Apollo, for whom the offering is intended. According to Gage, the presence of Chryses allowed Turner to allude to a light/dark symbolism, which interested him at the time. Virgil indicates that the offerings were for Hecate and Proserpine.

64. Claude's painting, LV183, is now lost, but was extant in the nineteenth century, along with the *Liber Veritatus* drawing from which Earlom's mezzotint was made. There are six drawings connected with the painting. One at Chatsworth (MRD 1115) includes the figures of Achates and two other soldiers accompanying Aeneas when he is first received by the Sibyl, but the figures are even more static than those in LV 183. On the drawings see Marcel Roethlisberger, *Claude Lorrain: The Drawings*, 2 vols. (Berkeley: University of California Press, 1968), 1, pp. 410–11. When, in 1799, Turner copied Claude's *Landscape with the Landing of Aeneas in Latium* (LV 185; TB LXIX, "Studies for Pictures," 1800–1802, 122), he omitted the figures and ship necessary to the narrative, as if unwilling to be influenced by Claude's thematic conception.

65. A.J. Finberg, *Life of J.M.W. Turner, R.A.*, 2nd ed., revised by Hilda Finberg (Oxford: Clarendon Press, 1961), p. 77.

II "Imaginative Conjecture"—Meaning in Landscape

Between 1798 and 1805 Turner's art underwent a critical transformation. As his appreciation of nature's grandeur intensified, his technical mastery encouraged him to shift from "correct" picturesque description to a remarkable formal loosening and breadth of characterization that in its initial stages can be identified with the Sublime.[1] Those contrasting modes of representation dictated equally divergent approaches to subject matter. By showing nature in its wilder, more extreme state, Turner could provoke feelings of awe in the viewer and call up the conceptual frame of Sublime theory and its approved range of themes and motifs. But even that agenda placed a limit on landscape's affective power—if at its emotionally exalted end. The basic problem still obtained: how to invest landscape painting with the intellectual probity that Reynolds had recommended? When John Constable asserted in 1802 that "there is room enough for a natural painture," he tacitly acknowledged Turner's equally pressing goal in creating a modern version of Grand Manner landscape.[2]

In truth it was one goal among many. The daunting range of Turner's work attests to his fascination with nature in all its variety. Thinking about appropriate subject matter and finding an effective means for its narration stimulated his development during this period as much as experimenting with watercolor or visiting new places. However, the special value of his narrative concerns lay in addressing the fundamental issue of landscape's capacity to convey meaning. For Turner chose to explore not only how a natural element like light falls, refracts or appears under differing conditions, but also what that element can signify, and in how many different ways.

His study of landscape painting as a vehicle for extra-natural content followed a logical course, the stages of which are here outlined, and then examined in detail below. To distance his art from its topographical origins, Turner first forged an alliance between poetry and painting. Juxtaposing citations of verse with his paintings, he added resonance to the immediate visual appeal of the scenery represented. The figurative language of Turner's poems induces the viewer to look beyond the *transcription* of a setting sun, for example, and seek in the painting an *understanding* of nature's transience. Assessing the similarities and differences between literary and visual form and imagery, Turner, in the process, trained himself to be master of both.

To expand the range of his expression he studied the art of the Old Masters and painted works "in the manner of" his artistic forebears. Turner needed to learn how predecessors like Poussin, Titian, or Claude had transformed literary ideas into visual imagery if he was to carry their tradition forward, as well as add something of his own to it. With a secure understanding of his sources, whether a literary text or another artist's portrayal of a legend, he could pursue the implications of a story or scene for his own thematic purposes. Later in his career Turner occasionally made an issue of influence by emphasizing both the origin of a given source as well as his departure from it. It would seem to be a general condition of his art that it was always, in some measure, a narrative of its making, as well as an inquiry into the nature of representation itself.

The artist complemented his efforts to renovate Grand Manner landscape by experimenting in his sketchbooks with a wide range of potential subjects. With an eye toward historical or mythical episodes that related the workings of nature, he engaged in a thoughtful comparative study, evaluating the ways events and characters from different literary sources might fit a particular composition or elaborate a common topic. As his handling of narrative progressed, Turner generally chose to layer or juxtapose

ideas, themes, and literary or visual sources rather than focus on specific allegorical references that would limit meaning. The term he used to describe the response that serious art elicits, "imaginative conjecture," best explains the mental processes his own allusive images call forth from the viewer.[3] His penchant for analogy and his attention to narrative detail (even when one least expects it), provokes an expansive "reading" of his themes, one that opens an event or scene to speculation about its significance or outcome.[4] His awareness of the viewer as interpreter and respondent would become a distinctive shaping factor for his art.

The artist referred to a number of symbolic systems through his imagery, ranging from alchemy to natural philosophy, politics, and religion. In some cases he invoked more than one at a time. They functioned to lend order to inchoate nature, or to imply a connecting force beneath nature's outward appearance, thereby shielding landscape painting from the charge of being purely mimetic. However, no one symbolical or allegorical program underwrites or effectively explains Turner's will to meaning, nor did any of them sustain his interest for very long—except myth, which had the status of an overarching narrative construct (rather than as a set of meanings). Taking its cue from the artist's own emphases, this study will substantiate his involvement in the *process* of interpreting a theme, and track his method of investing an image with multiple layers of meaning.[5]

The evidence of Turner's work suggests his long-term objective was to understand nature's order—and disorder—both for itself and for the insights it might provide into human actions and shortcomings. Where artists like Wilson had correlated the emotional pitch of a given human drama with an appropriate natural display, Turner tried to explain or comprehend that behavior in terms of the cycles or forces of nature. He quickly realized that ancient myth exemplified the relationship between human action and natural process, myth being a paradigm of interpretation in the way it explains phenomena through suggestive correspondences. The story of Proserpine's return from the underworld, for example, both symbolizes, and accounts for, the arrival of spring each year. In a similar manner, Turner's mythic stories are not *set in* the landscape, but become a fully integrated *part of* the natural matrix. By asking the viewer to comprehend an episode in terms of nature's patterns, and natural processes in terms of an animating incident, the artist established a basis for questioning not only what we know about ourselves and the world around us, but *how* we know it. Landscape painting thereby becomes a model critical construct. It is telling that his paintings do not offer pat morals that can be comprehended in an instant (or disregarded altogether). Instead, Turner presented circumstances and issues that must be pondered or resolved in relation to the larger drama of the natural setting.

Classical themes allowed the artist to address the nature/humankind equation on a level that was simultaneously primal and sophisticated. Nor was he alone in exploring the power of myth to reveal the meaning of natural phenomena. The scholarly investigations of ancient legends and religion by Richard Payne Knight[6] paralleled Turner's early attempts to exploit the various levels of signification in subjects like Apollo's confrontation with Python (traditionally interpreted as the triumph of the God of light—and art—over darkness or base matter) or the death of Adonis (the sun of summer, killed by a boar signifying winter).[7] However, relating natural history through divine personification was only a limited, passing interest for Turner. He preferred to imbue the elements of nature with mythic meaning directly. The same year that he portrayed

Apollo in human form, bathed in his own radiance after having conquered the monster Python in *Apollo and Python* (1811; fig. 41), he also depicted the god allegorically, as glowing sunlight—Apollo's attribute—in the watercolor entitled *Chryses* (fig. 143). Through such demonstrations Turner deepened his understanding of the essential inter-relatedness of nature and art embodied in landscape painting. And as he mastered the subtleties of nature's meaning(s), he also comprehended the extent to which his art was a parallel act of creation. During his period of apprenticeship, his endeavor may have been somewhat more modest, but it was still remarkable for its diligence and inventiveness.

Poetry and Painting

Late eighteenth- and early nineteenth-century literature on the Sister Arts usually portrayed the relationship between poetry and painting as a healthy sibling rivalry, with one or the other art form deemed "higher," depending on the interlocutor. Turner, by contrast, thought of them as equal and correlative, describing their interaction with a freighted simile: the two arts, he posited, flowing "from the same fount mutually by vision . . . reciprocally improved, reflect, and heighten each other's beauties like . . . mirrors."[8] He matched theory with practice by comparing and linking visual and verbal imagery throughout his career. Indeed, the poetry he read, cited, and wrote offers a rare insight into his artistic thinking. Given the essentially literary basis of his ancient subjects, and the fact that his own epic poem, the "Fallacies of Hope," made its debut in the context of a classical theme, the role of Turner's poetry will become a recurrent topic.

In his formative period, the painter traced a rapid progression from open paraphrase (borrowing verse that matched his visual imagery) to clever emendation (writing his own poems to extend or enhance the meaning of a painting's imagery). Circumstance, not theory, prompted him initially. In 1798 the Royal Academy Council decided to make some "improvements" to their annual exhibition handlist. The committee agreed to allow each artist to "give in writing such description of his Performance as he thinks proper for insertion in the annual exhibition catalogue, but . . . confined to as few words as are absolutely necessary."[9] The painters and sculptors interpreted "description" to mean citations of verse, short excerpts from novels, or at least an explanatory *vide* to a work of literature. Perhaps they considered this literal association of text and image an easy way for a visual work of art to become "poetic." Turner responded enthusiastically; indeed he behaved as if the regulation had been written expressly for him. Of the ten landscapes he exhibited at the Royal Academy in 1798, five had verse quotations.[10] No one else that year matched him in the number of quotations. He also seems to have been the only landscape painter to take advantage of the new regulation. Other exhibitors who helped initiate the use of poetic citations either ranked as history painters or worked within the genre of literary or fancy pictures.

Turner further distinguished himself by taking liberties with his borrowed poems, editing the verse to fit his imagery. He may have wanted to avoid any possibility that his paintings be construed simply as illustrations of their literary source. Artists like William Hamilton, already well-practiced in the art of poetic illustration, or E. A. Rigaud, whose works would seem to have fallen into the category of fancy pictures, adopted a more conventional approach to the pairing of image and verse. Hamilton's exhibits in 1798 included scenes titled *Winter* and *Spring* inspired by

descriptions of rural activity in James Thomson's *Seasons* and accompanied by corresponding passages from the poem that relate the actions of its characters.[11] Rigaud similarly captioned her now-lost depiction of the lovers *Celadon and Amelia* (also based on the *Seasons*) with two dramatic and correctly transcribed lines from "Summer" that encapsulate the human tragedy: "Mysterious Heaven! that moment to the ground / A blacken'd corpse was struck, the beauteous maid." A fair idea of the intended effect can be gained by reading those same lines in connection with an existing (but unexhibited) version of *Celadon and Amelia* by Hamilton from 1793 (fig. 27).[12]

Turner also quoted from the *Seasons* for four of his entries, but he specifically avoided references to the human episodes in favor of lines describing nature itself. He selected and amalgamated verse from different sections of the work, thereby producing new, hybrid poems. Through his splices and ellipses, he robbed Thomson's poem of its integrity as a separate work of art—or, rather, he "reciprocally improved" it by putting the verse into rapport with his independently conceived visual imagery. In return, the poems' verbal allusions complemented and inflected the landscapes and natural effects Turner presented to the viewer.[13] The paintings to which he appended these renovated poems in 1798 provided a comprehensive catalogue of weather and times of day, from sunrise to sunset, shower to calm after a squally night. The poetic citations call attention to the various ways qualities of light might be described or portrayed. For example, Turner used Thomson's personification

—But yonder comes the powerful King of Day,
Rejoicing in the East: the lessening cloud,
The kindling azure, and the mountain's brow
Illumin'd—his near approach betoken glad.

to celebrate the bright sun rising in *Norham Castle on the Tweed, Summer's Morn*, while for *Buttermere Lake, with part of Cromackwater, Cumberland, a Shower* (fig. 2) he let a rapid verbal flow suggest the transience of the moment depicted:

Till in the western sky the downward sun
Looks out effulgent—the rapid radiance instantaneous strikes
Th'illumin'd mountains—in a yellow mist
Bestriding earth—the grand ethereal bow
Shoots up immense, and every hue unfolds.

In patching together his own revised poem the artist judiciously deleted from Thomson's imagery those effects that he might not be able to reproduce visually.[14] Because the representation of sequential changes of light—and time's passage—were still beyond his grasp, he relied on poetry's ability to convey verbally a sense of temporality.

Another tactic involved using the verse to move the viewer from the immediate perception of place or weather (emphasized in Turner's descriptive titles) towards the intensely felt experience of the Sublime. The quotation for *Dunstanborough Castle, N.E. Coast of Northumberland. Sun-Rise after a Squally Night* (fig. 28) coerces a range of emotional responses through its language:

The precipice abrupt,
Breaking horror on the blacken'd flood,
Softens at thy return.—The desert joys,
Wildly thro' all his melancholy bounds,
Rude ruins glitter; and the briny deep,
Seen from some pointed promontory's top,
Far to the blue horizon's utmost verge,
Restless, reflects a floating gleam.

Without the verse, the coastal view might seem tame and static; with it, the memory of a squally night, now past, lingers in the viewer's mind, underscoring the changing moods of the sea. The fifth painting with a citation, *Morning*

Figure 27. William Hamilton, *Celadon and Amelia*, 1793. Oil on canvas, $60\frac{3}{4} \times 48\frac{1}{2}$ inches, (154.3 × 123.2 cm) © The Detroit Institute of Arts, Founders Society Purchase.

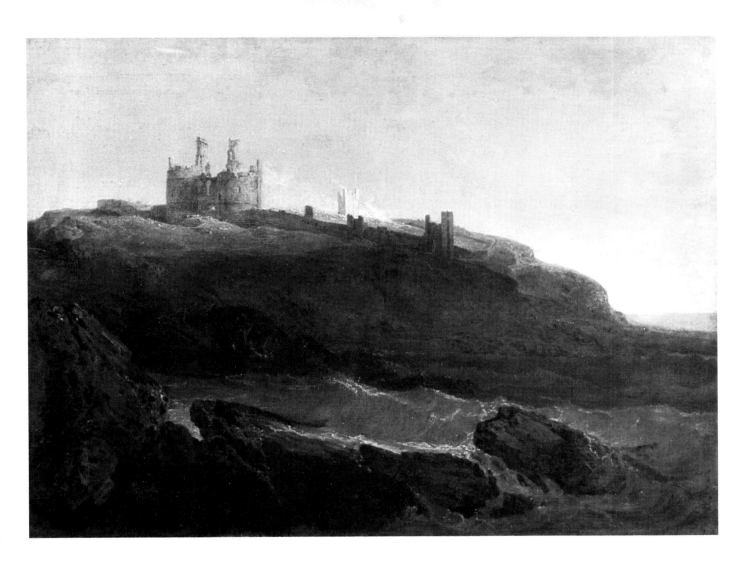

Figure 28. Dunstanborough Castle, N.E. Coast of Northumberland. Sun-Rise after a Squally Night, 1798. Oil on canvas, $36\frac{1}{4} \times 48\frac{1}{2}$ inches (92.3×123.2 cm), Reproduced by permission of the National Gallery of Victoria, Melbourne, Australia, presented by The Duke of Westminster, 1888 (BJ 6).

amongst the Coniston Fells, Cumberland, enlisted the elevated diction and imagery of John Milton to outdistance its topographical origins.[15] Turner heightened the mysterious power of a misty morning at a cascade with a reverential reminder provided by lines from *Paradise Lost* that the *other* "great Author," the Deity, was responsible for such displays of natural beauty.

The following year, 1799, when Fuseli had opened his Milton Gallery, the young artist demonstrated the deftness and range of his own response to the poet. He invoked Miltonic fury for his depiction of man-made cataclysm, choosing vivid lines about the combat between Satan and the angels from Book VI of *Paradise Lost* for his first attempt at a scene from contemporary history, the *Battle of the Nile, at 10 o'clock when the L'Orient blew up, from the Station of the Gun Boats between the Battery and Castle of Aboukir*. If, judging from the title and critical reaction, the painting tended toward the documentary (its present location is unknown), the accompanying verse cleverly invested the battle with cosmic power and epic majesty:

> —Immediate in a flame,
> but soon obscur'd with smoke, all heav'n appear'd.
> From these deep-throated engines belch'd whose roar
> Imbowel'd with outrageous noise the air,
> And all her entrails tore, disgorging foul
> Their devilish glut, chain'd thunderbolts and hail
> Of iron globes.[16]

From the choice of lines, one might think Milton had been describing a naval battle. Turner was equally ready to show Milton's less dramatic poetic language to be at a disadvantage in comparison with the evocative qualities of landscape painting that he was now achieving. The soft pastel colors of the sky, diffused and reflected in the water below, in *Harlech Castle, from Twgwyn Ferry, Summer's Evening, Twigh-*

light, surpass the initial image of its accompanying verse: "Now came still evening on, and twighlight grey, / Had in her sober livery all things clad" (from *Paradise Lost*, Book IV). Turner here retailored Milton's poem to remove references that might compete with his increasingly subtle evocation of shifting light.[17]

In this second year, a number of artists adopted Turner's idea of pairing landscapes with verse in their catalogue citations.[18] He increased his versatility by citing from a wider range of poets (now including David Mallet and Dr. John Langhorne) and experimenting with a variety of themes derived from medieval English history, Ossian, the Bible, and classical literature. In the diversity of his narrative interests he easily surpassed forerunners in landscape like Wilson or Philip James de Loutherbourg. The overall thematic breadth of the latter's work undoubtedly influenced Turner, in some instances providing a specific model for a given subject. Tellingly, the younger artist refrained from the generalized theatrics of the *banditti* scenes that de Loutherbourg continued to exhibit into the 1790s. He was equally careful to avoid too straightforward or prosaic a depiction of historical events or literary subjects, from whatever period.

Initially Turner approached the introduction of specific subject matter with caution, alluding to a larger story rather than enacting it in detail. With *Caernarvon Castle*, a watercolor (fig. 29), and *Dolbadern Castle*, both exhibited in 1800, he chose not to risk the criticism that had befallen Wilson for combining dramatic historical figures with naturalistic landscape in *The Destruction of Niobe's Children*. Instead, Turner introduced historical interest into the two scenes by letting verse explain the relatively inactive, anachronistic figures he placed in his emphatically contemporary landscape settings. In *Caernarvon Castle* an untroubled landscape stretches before the eye. Hovering in the middle distance,

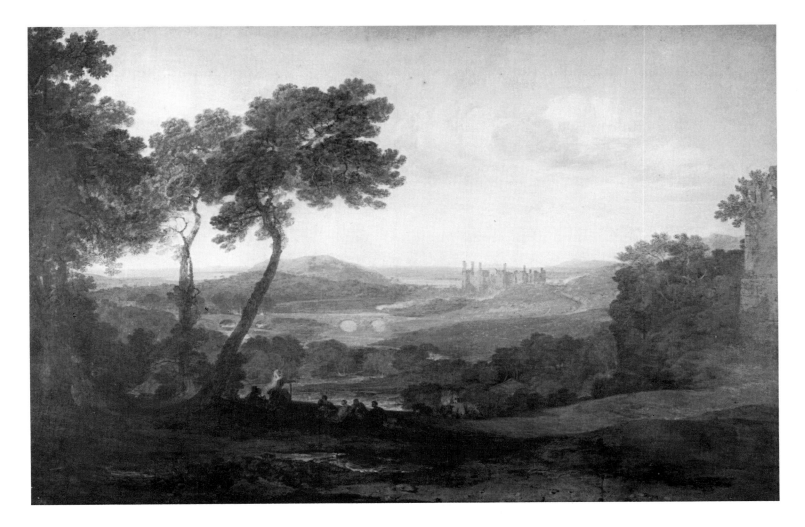

Figure 29. J.M.W. Turner, *Caernarvon Castle*, TB LXX, Miscellaneous Watercolours and Drawings, M, 1800–1802. Watercolor, $26 \times 39\frac{1}{2}$ inches (66×100.3 cm), Turner Collection, Tate Gallery.

the castle is both a destination for the contemporary tourist/ viewer and a relic of times past. At the right edge of the painting, the corner of an unidentified ruin acts as a temporal marker that verifies the viewer's perspective: we contemplate Caernarvon Castle as an embodiment of history from the vantage point of our own modern times. In effect Turner literalized the process of association for the viewer.

The specific event that he would have us recall as we view the tranquil scene is spelled out in the accompanying poem. It chronicles the terrible destruction that had once been visited upon the place:

> And now on Arvon's haughty tow'rs
> The Bard the song of pity pours,
> For oft on Mona's distant hills he sighs,
> Where jealous of the minstrel band,
> The tyrant drench'd with blood the land,
> And charm'd with horror, triumph'd in their cries,
> The swains of Arvon round him throng.
> And join the sorrows of his song.

The poem takes an active role in the narrative program by reminding us that Bards like the one now singing to his circle of listeners in the left foreground had been exterminated by Edward I in his campaign against Welsh nationalism. The subject of the persecuted Bard had long been popular with painters for the opportunity it provided to portray a heroic figure in extreme and desolate scenery. In the 1780s, de Loutherbourg perfectly encapsulated the story and character of the Bard by setting him on a wind-swept promontory defiantly playing his harp (fig. 30).[19] Turner chose to downplay the Bard's action in favor of an allusion to the episode's significance. He inscribed the historical moment in a scene of temporal continuity as if to suggest that the lesson about loss of liberty should not

be forgotten—that it can still apply centuries later.[20] In that respect, he followed the spirit of Gray's concept of the Bard as a prophet who sees the future unroll before him. The small scale of the castle and figures relative to the broad, deep landscape suggest that for Turner, the progress of human striving must be inscribed within the larger context of nature and its enduring presence.

The poem seems to have been Turner's own. He was in all probability the first artist to compose verse for the catalogue, though others quickly followed his example. Where Turner's citations from noted poets might seem a resourceful way for him to relate his art to respected thematic frameworks (the seasons' unfolding, or, in the case of Milton, God's creation), his introduction of original verse substantiates that his verbal expression does not simply "add" to the meaning of the visual image; rather, the two modes, visual and verbal, become a new, unified form of expression in which the one helps situate the other interpretively, thus foregrounding the question of how differing contexts, when juxtaposed, shape the meaning we find in works of art. Turner's poetic fragments, whether borrowed and systematically rearranged or newly composed, stand as a critical first step towards the explicit thematization of interpretation through landscape by making us aware of the various kinds of information with which we are presented and prompting us to "read" the painting's imagery more closely to discover its meaning.

At this stage in his development, the artist attempted a more visually explicit narration of historical events only when nature itself could take the role of active protagonist. Erring on the side of caution and formality, he appropriated the stylistic dignity and restraint of Nicolas Poussin for his overall approach. And instead of citing poetry for these works, he invoked the authority of the Bible, quoting chapter and verse. His first amalgamation of story and

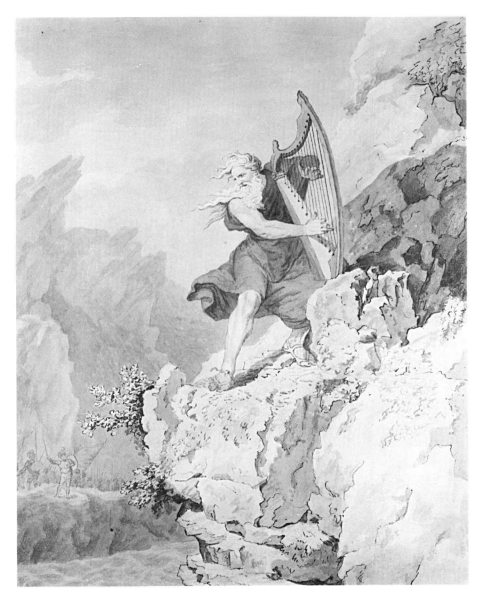

Figure 30. Philip James de Loutherbourg, *The Bard*, c. 1780. Grey wash on paper, $10\frac{7}{8} \times 8\frac{5}{16}$ inches (27.6 × 21.1 cm), Courtesy of The Lewis Walpole Library, Yale University.

Figure 31. J.M.W. Turner, *The Fifth Plague of Egypt*, 1800. Oil on canvas, 49 × 72 inches (124.5 × 183 cm), © Indianapolis Museum of Art, Gift in memory of Evan F. Lilly (BJ 13).

landscape involved the Seventh Plague—an affliction of thunder, hail, and fire that ran along the ground—though he titled it *The Fifth Plague of Egypt* when he exhibited the painting in 1800 (fig. 31). The turbulent sky and eerie light literally narrate the episode, rendering the figures in the foreground insignificant. In the now-lost 1801 *Army of the Medes Destroyed in a Whirlwind*, Turner showed a great cloud of dust sweeping across the scene, apparently obscuring altogether whatever human action would have been going on behind it.[21] By 1802, in his painting *The Tenth Plague*, the artist felt bold enough to interpret a subject less amenable to the language of landscape. He relegated Pharoah's murder of the first-born to a small-scale scene of human havoc in the distant middle ground, letting brooding skies convey the magnitude of the disaster as well as pose their own threat to the grieving mothers. The press praised the ambition of these works, acknowledging that "Forests, cities, and storms are combined to excite the idea of grandeur"—quite an accolade for the genre of landscape painting.[22]

A History of Styles

With the exhibition of *Jason* in 1802 (fig. 32), Turner returned to ancient subject matter and commenced a dialogue with the tradition of classical landscape that would help him understand how stylistic conventions carry an expressive power or meaning of their own. To his repertory of arcadian calm learned from Wilson (and by extension, Claude) in *Aeneas and the Sibyl, Lake Avernus*, and the orchestrated catastrophe of the Poussinesque plague scenes, he added the idiom of the horrific Sublime in the manner of Salvator Rosa, the third member of landscape's holy trinity. While a promising young artist might try out the styles of

the Old Masters as a matter of course, Turner distinguished his efforts at assimilation by conducting them in full public view year after year. He wanted to make his mark on history literally and figuratively in redoing past artists. In the process he not only demonstrated his fluency with the academic tradition in which he had been schooled, but redefined its conventions and added something of his own to the genre of landscape painting. The combined gesture of homage and differentiation in *Jason* constituted an imperative step in his overall program.

Rosa had provided him with a direct precedent with which to work in this instance. *Jason Charming the Dragon* (c. 1670) had been in English collections since the eighteenth century and from 1765 had circulated in engraved form (fig. 33). Rosa set the two adversaries in an arabesque of confrontation at the center foreground of an abbreviated, rocky landscape that throws into high relief the dragon's fearsomeness and Jason's stealth. Turner revised both the narrative moment and the scale. His hero—Rosa's figure of Jason miniaturized and seen from behind—gingerly approaches a dragon of undetermined size. In the foreground a pile of bones testifies to the peril that awaits him. The enormous blasted trees and the wall of stone that closes off the background dwarf them both.

For all its seeming departures, Turner's scene effectively summarized those qualities of Rosa's style which fired the darker side of the Romantic imagination. Connoisseurs like Richard Payne Knight magnified what they saw in Rosa's art to suit their own level of excitement. As Knight explained, "Scenery . . . to be really sublime, should be, not only wild and broken, but rich and fertile: such as that of Salvator Rosa, whose ruined stems of gigantic trees proclaim at once the vigour of the vegetation . . . and of the tempests that have shivered and broken them."[23] To achieve this intensity Turner adroitly synthesized features from the full

Figure 32. J.M.W. Turner, *Jason*, 1802. Oil on canvas, $35\frac{1}{2} \times 47\frac{1}{8}$ inches (90.2×119.5 cm), Turner Collection, Tate Gallery (BJ 19).

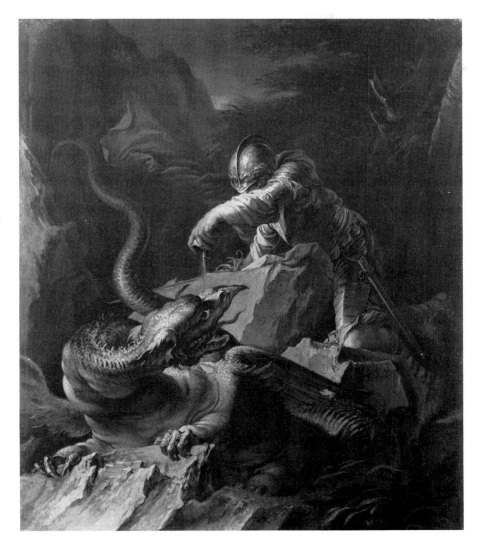

Figure 33. Salvator Rosa, *Jason Charming the Dragon*, c. 1670. Oil on canvas, $30\frac{5}{16} \times 25\frac{5}{8}$ inches (77×65 cm), Collection of the Montreal Museum of Fine Arts, Montreal, Quebec, Canada, donation of Miss Olive Hosmer.

repertory of Rosa's landscape ideas. From other paintings he borrowed the dark tonality and crushing scale, then heightened these features for maximum effect. The oppressive diagonal rock face that dominates Turner's composition resembles the settings of Rosa's *Landscape with St. Anthony and St. Paul* or its pendant, *Romantic Landscape with Two Figures*, but is rendered still more extensive and foreboding.[24] Turner used the desolation of his landscape to attest to the power and dreadfulness of the partially revealed dragon. Like Jason, we can only imagine how large or formidable the dragon will prove to be.

For the narrative development of the theme, Turner improved upon Rosa by going directly to the classical source. The experience of reading and (re)writing poetry for his earlier paintings had been excellent preparation for the task of interpreting both the "text" of Rosa's imagery and the original ancient poetry. The translation of the *Argonautica* of Apollonious Rhodius which Turner owned recounts the tale vividly. The artist seems to have followed the poem's description of the monster who "wreathed his huge length and gather'd fold in fold," while Jason "advanc'd with awe, with awe beheld / The dreaded dragon by her [Medea's] magic quell'd."[25] The important point is that Turner *was* reading. He may have started with a desire to work in the manner of Rosa, but he did not let pastiche or even emulation become an end in itself. The story required as fresh an interpretation as did the formal conventions of the landscape. For Turner, that meant rethinking the material—visual and narrative—to arrive at a sufficiently deep understanding of its implications.

Rosa had conflated episodes when he armed Jason with the magic potion that was properly Medea's, for in the *Argonautica* it was she who had put the dragon to sleep, enabling Jason to steal the golden fleece it guarded. The resulting visual image is an iconic portrayal that pivots on the specific detail of the liquid being poured. Turner generalized the theme of confrontation by elaborating the setting and omitting any identifying attributes like the magic potion. But for the title, his scene could represent Cadmus or Hercules, questing heroes who similarly encounter dragon-like opponents. Indeed, Turner's interest in another related legend, Apollo's battle with the serpent Python (which he worked up in the same sketchbooks containing ideas for *Jason*), suggests that he was thinking about the larger confrontation between man and nature allegorized by each of those heroes' episodes.[26]

One of the drawings for the landscape in *Jason* is especially compelling in the way it communicates nature's destructive energies through bold hatching and the energetic line (fig. 34). The broken trees and slithering snake in the foreground anticipate a menace as yet undefined. The area that will be commanded by the guardian dragon in the oil painting (and the writhing Python in *Apollo and Python*) remains a highly charged but essentially blank space in the drawing. Turner gave concrete form to the danger—and the ravaging power of nature—through the agency of classical myth. He was then set free to augment its terror through his handling of the landscape in the finished painting.

The genesis of Turner's imagery is more complicated than this example suggests, and one can quickly become immersed in a chicken-or-egg argument trying to determine whether the landscape setting or his interest in the legend— or in Rosa—preceded. It might be argued that a landscape painter would necessarily think first about the setting and then worry about how to populate it. However, there are enough instances of the reverse situation in Turner's work to urge caution, instances where the beauty of a myth or the fascination of its cast of characters prompted him to create the local for a story's unfolding.[27] To separate an episode from the landscape in which it is enacted and

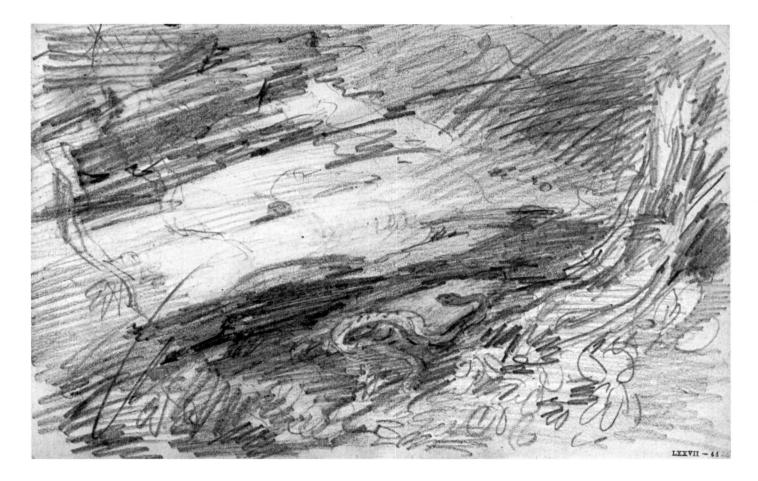

Figure 34. J.M.W. Turner, TB LXXVII, Rhine, Strassbourg and Oxford Sketchbook, 44, c. 1802. Pencil, $6\frac{1}{16} \times 9\frac{1}{2}$ inches (15.4 × 24.1 cm), Turner Collection, Tate Gallery.

attempt to order the priority of their inspiration is to miss the point of Turner's sustained gesture of juxtaposing verse and image, present and past, nature and history. The artist consistently exploited the tension between orders of expression—rather than subordinating one to the other—to attain the densest possible meaning in his work. Deciding a painting's intention solely on the basis of one system of understanding—in this case, the sequence of its inspiration—is to ignore Turner's persistent demonstration of the need to admit a variety of systems for ordering experience and arriving at an understanding of events or places. The sketches for *Jason* provide just such an object lesson. In the one illustrated here, dark and wild natural forces would seem to be in search of a culminating form. In another (the contemporaneous Calais Pier Sketchbook, TB LXXXI, c. 1799—1805, 7), only the figure of Jason appears, looking for a foe—and landscape—to conquer.[28]

When Turner re-exhibited the painting a number of years later he invited the viewer to participate in the interpretation of his scene by expanding the title in the catalogue of the British Institution's exhibition of 1808 to *Jason from Ovid's Metamorphoses*. The citation was deliberately misleading.[29] Ovid's account is largely a first-person lament by Medea on her divided loyalties, the poet reducing the episode of the Golden Fleece to two unimpassioned lines that make it seem like a case of harmless pilfering.[30] Since Turner was just then researching the relationship between the Sister Arts in preparation for his Royal Academy lectures, he would have realized the extent to which, in this instance, the contrast between the literary account and his visual presentation would have been flattering to himself. His scene was easily the more suspenseful, having been designed to engage the viewer's imagination and sense of anticipation. At the same time, the reference to Ovid's account calls up the larger history and ramifications of the episode represented in the painting. The artist kept Medea's side of the affair in mind, rectifying his slight to the heroine of the legend twenty years later with the *Vision of Medea* (color plate 8).

If Turner counted on his audience knowing their classical literature well enough to recognize the disparity between the visual imagery and its verbal "source," he was not disappointed. John Landseer, in an 1808 review, described how he had searched in vain through the *Metamorphoses* for the moment presented in the painting. Having applauded the latter as "a scene of romantic and mysterious solitude, of a highly poetic character," he concluded that the artist's departure from the text made his image all the more captivating. He then paid Turner's handling of the story the ultimate accolade by allowing that "It may be the more what Ovid would have done, had he expressed himself in another art, and painted, instead of writing, his Jason."[31]

Turner had reinforced his pursuit of the "higher departments" of the art of landscape manifested in *Jason* during his 1802 continental tour.[32] As a complement to his own efforts with narrative, he took the opportunity to school himself in the styles and conventions of the Old Masters he examined first-hand. In front of the Titians and other Italian masters looted by Napoleon and on view in the Louvre, he studied expression, deportment, and the development of narrative as assiduously as he did color and composition. Turner found Titian's *Martyrdom of St. Peter* exemplary in the way it combined high drama with landscape. In his notes he remarked, "The figure wonderfully expressive of surprise and its concomitate [sic] fear. . . . The affrighted Saint has a dignity even in his fear" (TB LXXII, "Studies in the Louvre," 28a-28). Viewing Titian's *Entombment*, he carefully analyzed the sentiments conveyed by each of the figures (TB LXXII, "Studies in the Louvre," 31a-29a). He could also be critical about the

way a story had been told. Guercino's *Virgin and Child* disappointed him because: "Here the characters are poor, the Child assuming a grave air . . . but without grace or meekness or sensibility. The mother rather inanimate and listless, and attempts attention and adoration of his supposed sagacity" (TB LXXII, "Studies in the Louvre," 36a).

Turner tested his own powers of expression in the 1803 *Holy Family* and the nearly contemporary *Venus and Adonis* (fig. 35).[33] In dealing with the two subjects, he contrasted not only the sacred with the profane, but modesty with luxury, piety with playfulness, and parental tenderness with passion. In his initial sketches the artist attempted to fit both stories to the composition Titian used in his *Martyrdom of St. Peter* (TB LXXXI, Calais Pier Sketchbook, 50, 63). Preferring Titian's vertical format for the scene of the lovers' parting, Turner developed it as a compendium of Old Master motifs. Its flower-strewn bower, fluttering amorini, eager hounds, and the charming detail of the putto attempting to restrain Adonis by grasping his heel derive from versions of the theme by Poussin, Rubens, and Titian.[34] His extensive borrowings seem entirely appropriate since the episode of Adonis' leave-taking does not derive from a literary source but from the fine arts.[35] For *The Holy Family* he took his inspiration from Titian's own *Holy Family and a Shepherd*, but unfortunately not well enough to convince the critics. More than one suggested he rethink his ambitions and concentrate on landscape.[36]

The artist's emulation of Old Masters in 1803 also led him to pay homage to Claude in the lavish *Festival upon the Opening of the Vintage at Macon*, and to contrast nature's moods in the manner of Nicolas Poussin with the serene *Châteaux de St. Michael, Bonneville, Savoy*, and the stormy, dramatic watercolor of *St. Hughes Denouncing Vengeance on the Shepherd of Cormayer, in the Valley of d'Aoust*. The following

year, 1804, the press was quick to point out that he had attempted something "a little in the style of G. Poussin [Gaspard Dughet]" in his version of *Narcissus and Echo* (fig. 36).[37] Gaspard Dughet was just then the object of renewed interest among artists.[38] Turner complicated the process of working from a given "source" by courting resemblance almost as a provocation, then taking care to stop well short of dependence or complete derivation. In this case he used Gaspard Dughet's conception of landscape as a means to revise Claude's treatment of the mythological story in *Landscape with Narcissus and Echo* (1644; fig. 37), owned by Sir George Beaumont.

Turner's adjustments to Claude's portrayal of the legend confirms his growing sensitivity to narrative meaning in an image, and to how it might be nuanced. His predecessor's scene boasts two competing distractions: an eye-catching nymph sleeping in the foreground (not sanctioned by the poem) and the equally seductive vista stretching into the far distance.[39] Turner positioned the figure of Echo where Claude's nymph had been, but now looking into the landscape, facing Narcissus. As in *Jason*, the act of perceiving becomes a theme within the larger mythological narrative: the figure in the landscape views the moment and sets the appropriate emotional tone—in this case encouraging melancholic meditation.

Turner gently coerced such a response by redesigning the setting to focus attention on Narcissus' self-absorption and by using verse to tinge the moment with its sentiment. Instead of following Claude's virtuoso display of delicate atmospheric recession, he constructed a dense wall of greens and browns in the manner of Gaspard Dughet. The feeling of enclosure and sense of stillness causes us to linger at the water's edge to "hear" the faint, sad echoing recounted in the lines Turner quoted from Ovid's *Metamorphoses* (3, 601—612):

Figure 35. J.M.W. Turner, *Venus and Adonis*, c. 1803–1805. Oil on canvas, 59 × 47 inches (149.8 × 119.4 cm), Private Collection, Caracas, Venezuela (BJ 150).

Figure 36. J.M.W. Turner, *Narcissus and Echo*, 1804. Oil on canvas, 34 × 46 inches (86.3 × 116.8 cm), on loan from the Tate Gallery to the National Trust at Petworth House (BJ 53).

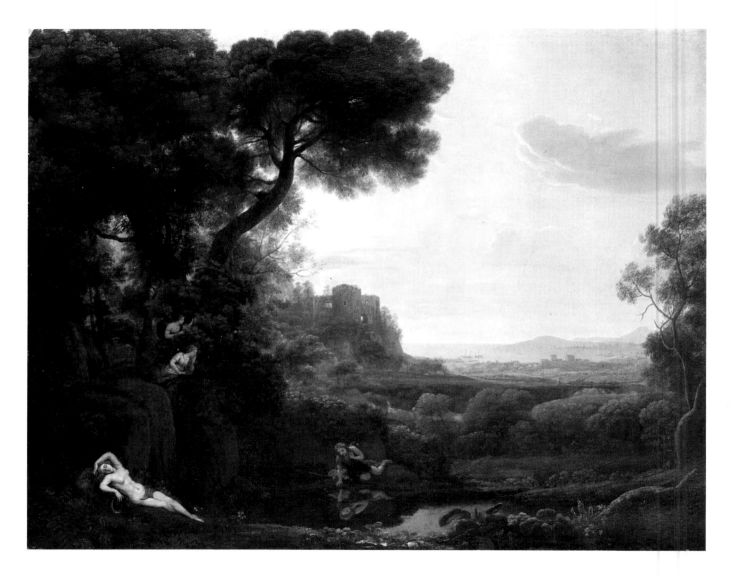

Figure 37. Claude Lorrain, *Landscape with Narcissus and Echo* (LV 77). Oil on canvas, 1644, $37\frac{1}{4} \times 46\frac{1}{2}$ inches (94.6×118 cm), Reproduced by Courtesy of the Trustees, The National Gallery, London.

So melts the youth, and languishes away;
His beauty withers, and his limbs decay;
And none of those attractive charms remain
To which the slighted Echo su'd in vain.
She saw him in his present misery,
Whom, spite of all her wrongs, she griev'd to see:
She answer'd sadly to the lover's moan,
Sigh'd back his sighs, and groan'd to every groan:
'Ah youth! belov'd in vain,' Narcissus cries;
'Ah youth! belov'd in vain,' the nymph replies.
'Farewell' says he: the parting sound scarce fell
From his faint lips, but she reply'd 'farewell!'

If we have difficulty locating the thinly painted Narcissus in the sombre light of the painting, as Turner's critics complained they did, perhaps it is because we do not simply witness an emblem of vanity, but trace the *story* of the young man's languishing away. The quote from Ovid animates the scene through its own narrative unfolding—a verbal assist that exasperated one contemporary reviewer who complained about having to read "another long translation from Ovid, to point out that in the picture which without it would never have been found."[40] That process of engaging the viewer in both the telling of the tale and a sustained perception of the landscape would seem to have been Turner's prime objective, however annoying it might be to some viewers initially.

A Study of Themes

During the first years of the nineteenth century Turner had entered into a felicitous working relationship with both the art of the Old Masters and the literature that had inspired them. He never really tired of learning from, or about, his beloved predecessors in painting. He would be as willing in 1840 to redo Titian (in his own version of *Bacchus and Ariadne*, figs. 90 and 92) as he had been in 1803, and with more panache.[41] The stylistic vocabulary that he acquired, and the insight into narrative approaches that he gained from his early homages set him in good stead for exploring the intricacies of serious subject matter. Characteristically, he conducted his search for themes suitable to his conception of nature and the art of landscape painting with energy and insight. In the Calais Pier Sketchbook (TB LXXXI), for example, Turner experimented with subjects ranging from the Deluge to contemporary shipwreck to intriguing notations for "William Tell escaping from the Boat" or "Water turned to Blood." Classical themes appeared there as well, among them Jason, the parting of Venus and Adonis, the death of Adonis, Hannibal, and Hero and Leander.[42]

The anthology of ancient subject matter that Turner compiled in his sketchbooks was particularly rich and inventive. His notations took various forms. There are lists of prospective episodes, only some of which he actually attempted (plate 13). Other themes were blocked out in rough drawings requiring captions to fix the moment or characters in Turner's mind (fig. 138). Some studies were sure enough in their visualization to remain ready for use as much as a quarter of a century later (fig. 142). As a body, this material constitutes one Romantic's wholehearted infatuation with the ancient past. But it is equally telling that Turner's study of classical themes coincided with his attempt to establish a theoretical grounding for the art of landscape. His interest in narrative and narration was supported by extensive reading in the history of art and by his endeavor with complementary modes of expression

(he was writing poetry on a regular basis). Through these combined inquiries the artist would discover the means by which the representation of nature can become a powerful tool of interpretation. Turner's cogent interrogation of structures of meaning led him to put mythic themes and classical compositions in close rapport with drawings of observable scenery (classical seaports alternating with views along the Thames in the "Studies for Pictures. Isleworth" sketchbook (TB XC), for example (plates 4–5)). He was demonstrating to himself the value and impact of differing landscape ideas, perceiving the ways such opposite approaches might be mutually reinforcing.

Perhaps the most striking feature of the sketchbook material is that the stories and the artist's responses to them derived from his familiarity with literary texts rather than from prototypes in painting. The incidents that intrigued Turner were not unknown in the history of art, but neither did they fall into the category of old favorites (the one exception being Venus and Adonis). Nor did he simply cast a landscape painter's eye to appropriately leafy scenes. For the classical episodes, Turner poured through the major epics, the *Metamorphoses*, and works by lesser known authors like Musaeus and Callimachus, fascinated by the heroics and tales of heartbreak they recounted. He once even tried to learn Greek, presumably to read some of the texts in their original language.[43] In those instances when the artist seemed thoroughly absorbed in a particular story— when ideas flowed in sequence and forms could not be put down quickly enough (figs. 68–70)—one can sense how potent and creative the interaction of verbal suggestion and visual imagery was for him.

Turner's thoughtfulness as a reader becomes clear from the way he clustered themes or considered alternative situations for use in the same composition. The parallel between Jason's encounter with a dragon and Apollo's with the serpent Python is but one example. Elsewhere he dwelt on the hopes and dreams of prospective brides: the caption of one sketch equates the procession of Dido and Aeneas on the morning of their "marriage" (*Aeneid*, Book IV) with the young maiden Nausicaa ceremoniously displaying her future nuptial robes (*Odyssey*, Book VI; plate 9).[44] The 1811 oil painting *Mercury and Herse* also depicts a train of joyous young virgins in a distantly related composition.

When Turner envisioned an ancient barque with two prominent standing figures, his thoughts ran from the "Meeting of Pompey and Cornelia at [?]" and the "Parting of Brutus and Portia," to "Cleopatra [sailing?] down to [?]," titles he recorded on the margin of the sketch (plate 1). Once engaged in re-creating the past, he mentally weighed the merits of the appropriate historical episodes, deciding, in the end, that the most intriguing story in this case involved Anthony and Cleopatra (plate 16). Turner's elaboration of the ship and harbor in this latter drawing is an index of his own capacity for "imaginative conjecture." He did not need to work his way to the image through a series of exploratory sketches, but could put the scene of pomp and ceremony down all at once, in all its detail. Although the actions of the principal characters, as well as the moment depicted, have become less specific, one should not assume that the story had simply become secondary to the visual interest of the ship, crowds, and port—or garbled in the artist's mind. Such seeming indeterminacy would later become a critical narrative feature of some of Turner's most poignant classical subjects—*Regulus* for example. Deprived of a clearly identifiable main character, the viewer is encouraged to think through the story and read its implications in the larger landscape setting.

Once acquainted with his characters, the artist tended

to follow their progress or ponder the consequences of their deeds in subsequent works. At least two years after painting *Jason* he sketched the young man's triumphant return home with the Golden Fleece (plate 8), adding a long note on the facing page about the episode (see p. 268 below for a transcription). In one sketching session he considered Adonis' parting with Venus, as well as the young hunter's demise; in another, at a later date, the artist traced back to the circumstances of Adonis' birth (fig. 72).[45] Turner's longest association was with Aeneas, however. From the hero's first appearance with the Cumaean Sibyl in the oil of c. 1798 to his last, with Dido, half a century later in the quartet of Carthage paintings with which Turner ended his career, the artist mused over Aeneas' exploits in sketches as well as oils, trying to understand the competing claims of love and duty that his story epitomized.

Each of the three avenues of exploration just discussed represented an attempt to enrich the practice of landscape painting and expand its range of meaning. Turner's desire to go beyond the appearance of nature into a multi-faceted realm of ideas accessed through poetry, through the history of art as an on-going tradition, and through myth and legend testifies to the imperative need he felt for a new definition of landscape painting—as well as to his commitment to articulating it. Landscape, as he conceived of it, constituted picture-making at its most complex: his scenes were at one and the same time a record of place (real or imagined), an instigation to thoughtful meditation through literary or historical references, and the locus for a continual investigation of the phenomenon of visual expression. In the work considered to this point, such a weighty program was still in an embryonic stage. By 1806, however, Turner was ready to put his preparation into practice. The artist's period of narrative apprenticeship culminated in *The Goddess*

of Discord Choosing the Apple of Contention in the Garden of the Hesperides, which will be discussed in the following chapter. To develop its iconography, Turner made reference to a variety of textual and visual sources but altered and subordinated those references to create a meaning the thrust of which exceeds the themes of its components. He exploited each source for a portion of his story, but the resulting configuration is literally original: there are no precedents for the specific event that Turner finally represented—an event that is, moreover, inextricably linked to the landscape itself.

Chapter II: Notes

1. John Gage charted the change in "Turner and the Picturesque," *Burlington Magazine* 107 (1965), pp. 16–25, 75–81. A thorough discussion of Turner's relationship to the theory and practice of the Sublime was provided by Andrew Wilton, *Turner and the Sublime* (London: British Museum Publications, 1980).

2. *John Constable's Correspondence*, ed. R.B. Beckett, 6 vols. (Suffolk: Suffolk Records Society, 1962–1968) 2, p. 32.

3. The phrase comes from Turner's discussion on Poussin's *Deluge*, in his Royal Academy lecture series, transcribed by Jerrold Ziff, in "'Backgrounds, and Introduction of Architecture and Landscape,' A Lecture by J.M.W. Turner," *Journal of the Warburg and Courtauld Institutes* 26 (1963), p. 144. Immediately before, when Turner analyzed

Poussin's *Saving of the Infant Pyrrhus*, he described the abbreviated description of a river in the middle ground as an "allegorical stream," and also praised the French artist's "uncommon abilities in detailing his history and his ruling passion for the antique and allegorical allusion," though he did not elaborate upon the meaning of those allegories (p. 143).

4. A case in point is the 1804 *Boats Carrying Out Anchors and Cables to Dutch Men of War, in 1665*, the historical references of which an early nineteenth-century critic considered just so much "affectation" in a marine subject (cited above, p. xiii). Modern scholars have debated whether the artist erred in identifying the date of the event. Evidence now suggests that Turner selected an obscure but factually correct incident involving the Dutch fleet in 1665 that could serve as an appropriate analogy for the military situation in Europe in 1804. See the discussion in Butlin and Joll, *The Paintings*, 1, pp. 40–41.

5. John Gage made a compelling case for Turner's fascination with alchemy in *Color in Turner*. In my view, alchemy offered Turner a system of explanation which was of the same condition, but not of the same status, as myth. It expanded the meaning of natural appearances through its mysterious and non-scientific processes (treating nature in a distinctly non-topographic way), but its complex symbology was too specific, too limiting, to have remained useful to the artist once his understanding of, and artistic control over, the natural world increased. Moreover, references to alchemy in Turner's work never quite add up to a consistent, recurring system, and indeed diminish after the first decade of the century, whereas his reliance on myth, with its inclusive meaning and narrative capacity, persists. Hence I see the artist's alchemical references not as an explanation of the meaning of his imagery, but an enhancement to his investigation of meaning per se.

6. Knight's research was discussed in *The Arrogant Connoisseur: Richard Payne Knight*, ed. Michael Clarke and Nicholas Penny (Manchester: Manchester University Press, 1982). See, in particular, the essay contributed by Peter Funnell, pp. 50–64. Knight's publications included *A Discourse on the Worship of Priapus*, 1786, *Specimens of Ancient Sculpture*, 1809, and *An Inquiry into the Symbolical Language of Ancient Art and Mythology*, 1818. For Turner's acquaintance with these works, see William Chubb, "Minerva Medica and the Tall Tree," *Turner Studies* 1, no. 2 (1981), pp. 33–35.

7. John Bell's *Bell's New Pantheon*, 2 vols. (London, 1790), one of the more popular classical dictionaries, explained that "By Adonis, the mythologists mean the Sun, who during the signs of Summer, is with Venus; that is, with the earth we inhabit; but, during the rest of the year, is in a manner absent from us. Adonis is said to be killed by a boar, that is, winter, when his beams are of no force to expel the cold, which is the enemy of *Adonis and Venus* or beauty and fecundity"; 1, p. 13. Turner considered the theme of Adonis' death in both drawings and a small oil sketch; see note 45, p. 75.

8. The citation, from Turner's first perspective lecture, is an "awkward paraphrase of Akenside" according to Jerrold Ziff, "J.M.W. Turner on Poetry and Painting," *Studies in Romanticism* 3 (1964) p. 203.

9. Royal Academy of Art Minutes, 2, p. 353, for January 20, 1798. The suggestion to improve the catalogue had been made at a meeting on December 16, 1797, in the face of a decision to charge sixpence for the publication instead of distributing it free; Minutes, 2, p. 345. In the period from 1769 to 1798 an artist would occasionally cite his or her source, or include a modest quotation in the Academy

catalogues, but that latter option was specifically, though inexplicably, disallowed by the Academy Council in 1786; Minutes, 2, p. 26, entry for April 17.

10. The most convenient list of Turner's exhibition citations can be found in the appendix to Finberg, *Life of J.M.W. Turner, R.A.* Poetry cited in the present study is transcribed directly from the original exhibition catalogues. Jack Lindsay, *The Sunset Ship* (London: Scorpion Press, 1968), included Turner's unpublished verse as well as the Academy inserts, but his transcriptions of the former are occasionally problematic. He also organized the free-flowing verse into separate works, and assigned titles on the basis of his own sense of composition.

11. The two paintings were numbers 23 and 24 in the Royal Academy catalogue. For *Winter*, Hamilton cited the following lines from the corresponding section of the poem:

> Meanwhile the cottage swain
> Hangs o'er th'enlivening blaze, and taleful there
> Recounts his simple frolic: much he talks,
> And much he laughs; nor recks the storm that blows
> Without, and rattles on his humble roof.

He altered only the first line, substituting "Meanwhile" for Thomson's "while," in order to start the sentence more intelligibly.

12. The painting illustrated here was one of a set Hamilton had provided for the folio edition of *The Seasons* engraved by Tompkins and Bartolozzi and published in 1797.

13. Jerrold Ziff, in "Turner's First Poetic Quotations: An Examination of Intentions," *Turner Studies* 2, no. 1 (1982), pp. 2–11, explained that the artist did not treat the poetry

as an afterthought, but as a guide to his transformation of topographical views into elaborate landscape paintings. By revising the verse Turner diminished its recognizability as such an aid, however. For an analysis of the same early poetry as an expression of Turner's interest in the doctrine of *ut pictura poesis* see Nicholson, "Turner, Poetry, and the Transformation of History Painting," pp. 92–93.

14. As Lawrence Gowing demonstrated in his analysis of Turner's revisions to Thomson in "Turner and Literature," *Times Literary Supplement* (July 10, 1981), p. 783, the artist dropped words that would be difficult to represent—for example, "fluid," from "illum'd with fluid gold," in the quote for *Norham Castle on the Tweed, Summer's Morn.*

15. The lines are from *Paradise Lost*, Book V:

> Ye mists and exhalations that now rise
> From hill or streaming [steaming, in Milton] lake,
> dusky or gray.
> Till the sun paints your fleecy skirts with gold,
> In honour to the world's great Author, rise.

16. One reviewer stated matter-of-factly that "Mr. Turner has compleatly failed in producing the grand effect which such a spectacle as the explosion of a ship of the line would exhibit," quoted in Butlin and Joll, *The Paintings* 1, p. 7.

17. His full citation continues:

> —Hesperus that led
> the starry host rode brightest 'till the moon
> Rising in clouded majesty unveiled her peerless light.

The quotation was a composite of lines 588–89, 605–607, and part of 608. Over a decade later, Turner addressed the difficulties in finding visual equivalents for poetic description, using the example of matching Milton's "grey" in the lines cited here (British Museum Add. MS. 46151

N, reprinted in Gage, *Color in Turner*, pp. 199–202 and discussed by Ziff in "J.M.W. Turner on Painting and Poetry," p. 201). Turner recommended fellow artists seek aid from nature directly, "and not pursue an humbler quarry," presumably by copying effects described in literary sources. In "Turner's First Poetic Quotations," pp. 6–8, Ziff suggested that the artist had recognized the error of his own earlier use of poetic inspiration in so commenting. Turner's practice of editing argues that the relation between his visual images and the verbal texts was never one of simple dependence, however. The poems yielded to the paintings more than the latter could be said to have conformed to literary suggestion. An unattributed article, "Retrospect of the Fine Arts" for 1810, recorded in the V & A Press Cuttings, 3, p. 835, had cautioned those artists who "are fond of painting poetical subjects" that "No painter, we will venture to say, ever succeeded in a subject from Pope, or Thomson's Seasons . . . [because] Painting has the privilege of the eye only."

18. The adventuresome artists in 1799 included J. Phillips, who exhibited a *Scene in the Grison Country* (no. 849), with lines from Thomson's "Autumn"; T. Taylor, *Storm Coming On*, and *Morning* (nos. 866 and 872), both with citations from the *Seasons*; and A. Watte, *Woodland Retreat, from Thompson* [sic] (no. 389), with five lines. The popularity of including quotations steadily increased among all exhibitors year by year, with an attendant growth in the length of the material cited. At least initially, the indented verse could catch a reader's eye, and thereby single out the artist—which advantage Turner seems to have been ready to exploit. By the 1840s, the catalogue took on the appearance of a literary anthology. The range of works quoted was wide, serving as many different purposes as there were artists. In some cases the quotes simply identified the subject of a painting or the source of the imagery; in others they complemented or matched visual imagery independently conceived.

19. A partial list of artists who produced Bard scenes before 1800 includes Thomas Jones (1774), William Blake (1785 and 1809, in addition to the series of illustrations from c. 1800), and Richard Westall, whose version was the first entry in the 1798 Royal Academy catalogue, complete with the opening eight lines from Thomas Gray's 1757 poem, "The Bard." For the history of the subject see F.I. McCarthy, " 'The Bard' of Thomas Gray, Its Composition and Its Use by Painters," *National Library of Wales Journal* 14 (1965), pp. 105–13. There is an oil version of the de Loutherbourg in the National Museum of Wales, Cardiff.

20. Turner had worked on a more explicitly military scene set in the mountains that may refer to Edward's campaign, and by analogy, to Napoleon's first invasion of Switzerland (TB LXX Q, "A View in the Welsh Mountains with an Army on the March," 1800–1802). However, he chose not to exhibit it. See Matteson, "The Poetics and Politics of Alpine Passage," p. 398.

21. For contemporary criticism describing the painting see Jerrold Ziff, "Proposed Studies for a Lost Turner Painting," *Burlington Magazine* 106 (1964), pp. 328–33.

22. Butlin and Joll, *The Paintings*, 1, p. 17.

23. Manwaring, *Italian Landscape*, p. 51. She also quoted a late eighteenth-century poem on Rosa that closely matches Turner's imagery as well:

> How drear the scenes that Rosa chose!
> Naught but the dark and dreary pine,
> Or rocks immense, of heights sublime.
> Co-aeval they with hoary Time,
> The marks of Pow'r Divine.

The author was George Monck Berkeley, 1763–1793, whose mother published his poems privately in 1797.

24. Both works had been in the collection of the Dukes of Bedford at Woburn Abbey since 1741—1742. Turner may have been following the example of de Loutherbourg, who had earlier revised Rosa's *banditti* scenes for the English market. De Loutherbourg had painted the Jason theme and a related *Cadmus Destroying the Dragon*, both as yet untraced. For a discussion of their potential influence on Turner see Gage, *Color in Turner*, pp. 137—38.

25 Book 4, lines 153—80, translated by Francis Fawkes, and included in Turner's set of Robert Anderson, *A Complete Edition of the Poets of Great Britain*, 14 vols. (London, 1792—1795; 1807); 13, p. 302. The collection included the best-known translations of a wide selection of classical texts in addition to the standard survey of English literature. John Gage first proposed the Fawkes translation as Turner's literary source in *Color in Turner*, p. 139.

26. Three related compositions occur in TB LXXVII, Rhine, Strassbourg and Oxford Sketchbook, 1802, leaves 43a—45. According to A.J. Finberg, *A Complete Inventory*, 1, p. 206, the sketchbook was at some point dismantled and the original sequence of drawings lost. Finberg chose to ignore Ruskin's notation that all three were preparatory to *Apollo and Python*, and identified only 43a as a study for the 1811 painting. He recorded 44 as a possible study for *Jason*, and 45 as a study for the 1806 *Goddess of Discord*; p. 208. The latter sketch, with its assortment of skulls and bones in the foreground, is closer to the Apollo composition, and perhaps is even its first draft. TB LXXXI, the Calais Pier Sketchbook, has sketches treating both the figure of Jason (7), and the 'Death of Python' (so labeled; 68).

27. Turner's habit of making lists of potential themes is one indication of his narrative preoccupation; see p. 137, note 33, and p. 165 and 214, note 23 below.

28. Butlin and Joll, *The Paintings*, 1, p. 18, considered as another possible sketch TB LXI (Jason Sketchbook), 60 verso, but it seems to share much more affinity with the subject of Hannibal crossing the Alps.

29. One might object that in invoking Ovid, Turner was once again simply being careless with his references, having earlier misnamed *The Fifth Plague of Egypt*, and cited the wrong chapter of Jeremiah for the *Army of the Medes* (XV, instead of XXV—though the latter may have been a typesetter's error). However, the gesture of citing a dubious source is consistent with Turner's adjustment, conflation, and/or embellishment of narrative in paintings ranging from the *Goddess of Discord Choosing the Apple of Contention in the Garden of the Hesperides* to the *Vision of Medea* (1828) and to his 1850 sequence on Dido and Carthage.

30. The description is in Book 7, 156—57: "While the soft guest his drowsy eyelides seels [sic] / Th'unguarded golden fleece the stranger steals." I am citing the eighteenth-century translation used by Turner: Ovid, *Metamorphoses*, ed. Samuel Garth et al. (London, 1717). For a discussion of this translation, see below p. 145. Line numbers cited throughout this study are taken from a four-volume, 1794 edition of the above translation, also published in London.

31. John Landseer, "British Institution," *Review of Publications in Art*, 1 (1808), pp. 84—85. Perhaps on the strength of the compliment paid him in the last line, Turner, in 1815, could refer to *Jason* as an "old favorite with some," in a letter to Ambrose Johns; *Collected Correspondence of J.M.W. Turner*, p. 64. In another 1808 review, Landseer developed a comparison between the ancient poets and Turner, first ranking Virgil over Ovid for excelling "in the delicate taste he discovers in the arts of poetical indication, or suggestion," then granting Turner, in his Ovidian works, the same honor.

The complaint against Ovid, Landseer explained in a footnote, was that he needed fifty lines to describe something, where Virgil could manage handsomely in two; "Mr. Turner's Gallery," *Review of Publications in Art* 1, (1808), p. 161.

32. The term had been used by de Loutherbourg for a publication entitled *Studies for Landscape Painters in the Higher Departments of Art*, advertised in the back of M. Reichard's *Itinerary of Italy* (London, 1818). There seems to be no trace of this book. Perhaps it was comprised of separate plates, no one set of which has survived intact with its wrapper.

33. Butlin and Joll, *The Paintings*, 1, pp. 114−15 discussed the various proposals for the dating of *Venus and Adonis*. They assigned it to c. 1803−1805.

34. Venus' "rosy bed beneath the myrtle shade" (*Metamorphoses*, 10, 536) set in a shallow landscape appears in Poussin's *Venus and Adonis* (Rhode Island School of Design, where the couple is depicted as still asleep), and in Rubens' version in the Uffizi, from which Turner borrowed the putto restraining Adonis by his heel. Titian's masterful composition (in the Prado) includes the hunting dogs. The subject may have appealed to Turner because it also could be construed as a personification of seasonal change; see p. 70, note 7, above.

35. The origin of the subject was discussed by Erwin Panofsky, *Problems in Titian* (New York: New York University Press, 1969), pp. 152−54.

36. The *True Briton* for May 6 considered the painting a "barbarous and clumsy imitation." For similar remarks, see Butlin and Joll, *The Paintings* 1, p. 39. Perhaps the critical rebuff sharpened the artist's sensitivity to how other artists had treated the subject, for he recognized that a Rembrandt belonging to Richard Colt Hoare and identified by him as "A Moonlight, in which some gypsies are reposing by a fire-side" was in fact a scene of the Holy Family. Noted by John Gage in *Turner: Rain, Steam and Speed* (London: The Penguin Press, 1972), p. 49 and p. 80, note 39.

37. *St. James Chronicle* for May 12−15, 1804, noted by Finberg in the typescript of his *Life of J.M.W. Turner, R.A.*, p. 344.

38. Farington recorded a dinner conversation from June 18, 1804 in which fellow artists Lawrence, Smirke, and Daniell agreed that they preferred Gaspard Dughet to Claude, their discussion then continuing with references to Turner. The diarist noted that "Lawrence particularly dwelt upon His [Turner's] powers as being of an extraordinary kind": *The Diary of Joseph Farington*, eds. Kenneth Garlick and Angus McIntyre; Katherine Cave, 16 vols. (New Haven and London: Yale University Press, 1979−1984), 6, p. 2355. Farington had a special interst in Gaspard Dughet. On May 31, 1804, West told him his two landscapes in the Royal Academy exhibition "would hereafter be regarded as *works of art* that might be hung against pictures of Gaspar Poussin," ibid., 6, p. 2336.

39. Roethlisberger, *Claude Lorrain, The Paintings*, 1, pp. 222−23, suggested that the figure may refer to Liriope, Narcissus' mother. Such unidentified nymphs also appear in Titian's and Poussin's versions of the theme. In Claude's scene, Echo is in the tree, behind and to the left.

40. Butlin and Joll, *The Paintings*, 1, p. 42.

41. Turner also felt comfortable exhibiting *Venus and Adonis* for the first time in 1849, when he sent it, and the c. 1807 *Wreck*

Buoy, to the Royal Academy as his sole entries for the year.

42. The Calais Pier Sketchbook (TB LXXXI) is in fact the most varied in its inclusion of subjects. It contains preparatory work for *Sun Rising Through Vapour*, the *Holy Family*, and *The Vintage at Macon* as well. The sketchbook is large, $17\frac{1}{8} \times 10\frac{3}{4}$ inches. Most of the sketches were done in black and white chalk.

43. According to Walter Thornbury, Turner traded lessons in painting for lessons in Greek with his friend, the Reverend Trimmer; *Life of J. M. W. Turner, R.A.*, 2nd ed., (New York, 1877), p. 225.

44. The annotation reads "Dido and Aeneas" and "Nausicaa going to [?] with the Nuptial Garments".

45. TB LXXXI (Calais Pier Sketchbook), 48 and 52 deal with Adonis' death. Turner blocked out a slightly different composition in a small oil sketch (BJ 151) that Butlin and Joll dated c. 1804; *The Paintings*, 1, p. 115.

III *Discord in the Garden: Toward a Modern Classical Iconography*

The erudition displayed in the title *The Goddess of Discord Choosing the Apple of Contention in the Garden of the Hesperides*, 1806 (color plate 1), announces the seriousness of Turner's program for investing landscape painting with narrative meaning. A story derived from ancient legend is elaborated into a theme *about* interpreting or reading landscape, Turner using the painting and the contemporary *Fall of the Rhine at Schaffhausen* (fig. 38) to underscore the nature of representation in landscape painting. His concept was bold: for *The Goddess of Discord Choosing the Apple of Contention in the Garden of the Hesperides* he invoked the dual authority of antiquity and the tradition of classical landscape only to update and personalize both. In putting together the story's complicated iconography, Turner perfected his procedure for controlling and manipulating the meaning of natural imagery.

The artist exhibited the painting in 1806 at the inaugural show of the British Institution, the newly organized rival of the Royal Academy. The Institution's conservative, opinionated Board of Directors held high expectations for their organization. The group of collectors and connoisseurs paradoxically proposed to raise the status of contemporary English painting (a goal they felt the Royal Academy had failed to reach) by promoting respect and admiration for the Old Masters. No doubt Turner considered very carefully how he should be represented at their initial exhibition, since some of the British Institution's sponsors, Sir George Beaumont in particular, numbered among his most hostile critics. Classical landscapes like *The Goddess of Discord* and his only other submission, *Narcissus and Echo*, would show to advantage the fundamental propriety, learnedness, and originality of his art.

The formal pedigree of *The Goddess of Discord Choosing*

the Apple of Contention in the Garden of the Hesperides was itself impeccable. The painting bears a distinct family likeness to Poussin's *Landscape with Polyphemus*—a resemblance contemporaries both noticed and praised.[1] Its subject matter, too, seemed designed to appeal to connoisseurs schooled in the lessons of antiquity. However, an attentive classicist would have recognized something amiss in the concatenation of the Goddess, a choice involving the fated apple of Paris' judgment, and the Garden of the Hesperides. The separate pieces are all "authentic"—it is Turner's novel combination that gives pause.[2] According to ancient sources, the Goddess of Discord threw an apple inscribed "to the fairest" into the midst of the wedding party of Peleus and Thetis in retaliation for being excluded from the festivities. As one of his twelve labors, Hercules sought golden apples growing in the Garden of the Hesperides. However, no source, ancient or modern, literary or visual, indicated that these two fabled sets of fruit shared a common origin.[3]

Turner's proposition that Discord's notorious apple would have been picked from a tree made famous by Hercules was more than a means to tie up the loose ends of an elaborate narrative. In having Discord visit the garden, the artist fashioned an altogether new story that not only required a grandiloquent landscape setting, but gave natural elements a significant role to play. From an art-historical point of view, the most familiar episode connected with Discord's apple would be the subsequent "Judgment of Paris," a congenial subject for history and figure painters. Turner's invented prelude develops a theme much more appropriate to a painter of landscape: the disruption of ideal natural harmony by an outside force.

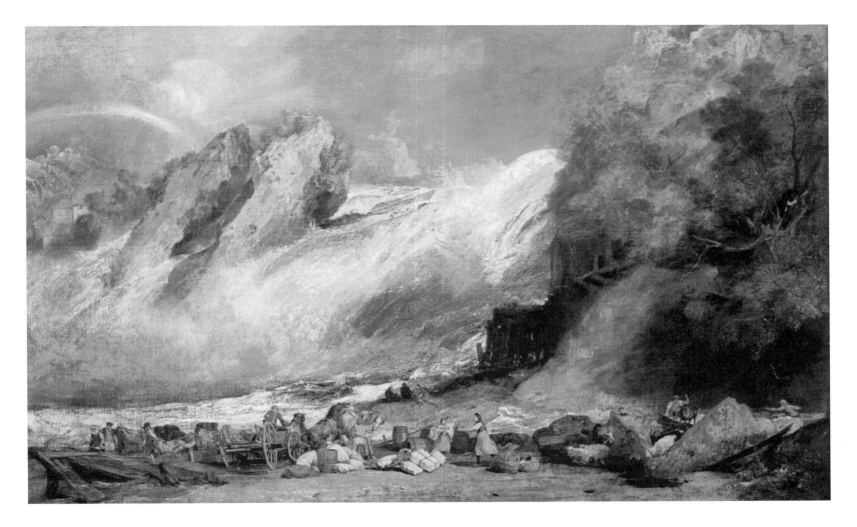

Figure 38. J.M.W. Turner, *Fall of the Rhine at Schaffhausen*, 1806. Oil on canvas, $58\frac{1}{2} \times 94\frac{3}{4}$ inches (148.5 × 239.8 cm), Courtesy, Museum of Fine Arts, Boston, Bequest of Alice Marian Curtis, and Special Picture Fund (BJ 61).

He assembled his own collection of historical "facts" precisely to tease new meaning out of them, nuancing his interpretation of the tale through references to a variety of sources that included Homer's *Iliad*, Ovid's *Metamorphoses*, and Milton's *Comus* and *Paradise Lost*. The multiplicity of these sources insures that the meaning of the story only coalesces *within* the painting, through the artist's orchestration of the landscape imagery.

To that end, Turner created a setting worthy of the Hesperidean garden's legendary beauty. Milton had sung the praises of its enticing perpetual summer in the epilogue to *Comus*, a work Turner gives evidence of having read.[4] In visualizing the garden, Turner imagined it as a verdant, reposeful retreat, with a calm stream and refreshing spring at which graceful nymphs fill jugs. The distant passage behind them even approaches the lyrical, the figures in the meadow just free touches of pale pink and light blue. The notion of the garden as a protected place originated with Ovid, who recounted that its enclosing mountains were formed when Atlas, the former keeper, was turned to stone for being inhospitable to a guest (*Metamorphoses*, Book 4).

Ovid also mentioned the presence of a guardian dragon, but neither delineated its features nor indicated its whereabouts. The suggestion was enough to catch Turner's fancy, however, prompting a demonstration of his own ability to effect a metamorphosis. A darkened area of rocky outcropping that he had observed and recorded in one of his Swiss watercolor sketches (TB LXXX, Drawings Connected with the First Swiss Tour, 1802, D) was transformed through imaginative projection into the spiny dragon perched on high in the painting.[5] His mythic beast breathes fire and has glowing red eyes, but it has nonetheless been delinquent in protecting the garden below.[6] Not only has it let Discord slip through, it is also unmindful of a more potent intrusion—the ominous storm cloud rolling in behind it. That impending threat to eternal summer develops the larger theme of the painting. It was one element that stemmed from Turner's observation of nature, rather than from any of his texts or sources. The contrast between the composed, summery calm of the garden and the dramatic scenery of the distant, wintry mountains insinuates the supersession of the old order by a new force. It also underwrites an instructive opposition at work between types of landscape and the ideas or sentiments they evoke.

Turner interwove the various elements of his narrative in drafts of a poem composed and reworked in the privacy of his sketchbook. The verse elaborates upon his visual imagery and documents the traditions on which he drew to magnify the sense of loss or destruction of an ideal:

> Discord, Dire Sister of Etherial Jove
> Coeval . . . hostile even to heavenly love,
> Ranckling with rage, unask the feast to share
> For Psyche['s] marriage rites. Divinly fair
> Rush'd like [a] noxious blast of wintry skies
> O'er the [?] Hesperian garden rise
> The far stretch dragon in himself a host
> Aw'd by her presence, slumbered at his post.
>
> The timid sisters fear'd her wrathfull ire
> Proffered the fatal fruit told prophetic fire
> With vengfull pleasure, the golden apple took
> Love felt the wound and Troy's foundation shook
> What mischief would insure. The goddess heard
> With wan pleasure that her choice prefered.
> Then shrug mischief to herself she took
> Love felt the wound and Troy's foundation shook.[7]

However awkward and labored his use of language, the artist succinctly related Discord's story from cause to effect. Two models lay behind his poem: Pope's translation of the *Iliad* and Milton's *Paradise Lost*. In an inspired moment Turner borrowed ideas from each to arrive at his own sense

of the events. The relevant lines from Homer present a case of obvious cribbing on the artist's part:

> And *Discord* raging bathes the purple Plain:
> Discord! dire Sister of the slaught'ring Pow'r,
> Small at her Birth, but rising ev'ry Hour,
> While scarce the Skies her horrid Head can bound,
> She stalks on Earth, and shakes the World around.
> —(IV, 501−505)[8]

To complement the ancient view of Discord, Turner selected from Milton stirring lines about Eve accepting the apple:

> So saying, her rash hand in evil hour
> Forth reaching to the Fruit, she pluck'd, she eat:
> Earth felt the wound, and Nature from her seat
> Sighing through all her Works gave signs of woe,
> That all was lost.[9]

Turner composed his own repeated last line so that it was love that "felt the wound" and Troy's foundation that had been shaken. His substitution of Troy for Homer's world at large rightfully connected the Goddess of Discord with the instigation of the Trojan War. Replacing Milton's "Earth" with "love" was a thoughtful change that in one deft stroke alluded to all the lovers connected with the episode: Paris and Helen, Turner's Psyche (and Cupid), and, by analogy, Milton's Adam and Eve.[10]

In the painting, the impending loss of harmony does not predicate any particular historical consequences. The garden's perfection is marred only by the intrusive storm cloud (a "fierce noxious blast of wintry skies"), the broken fruit tree, and the goddess herself. According to classical sources, destruction attended her wherever she went. By having Discord work her damage in the Hesperidean garden Turner further nuanced the tale by invoking an association between his episode and the Biblical Fall. In *Paradise Lost* Milton described Eden and its golden fruit as "*Hesperian* Fables true" (IV, 250), and a note in Fawkes' *Argonautica* (IV, 1651) explains that "the fable of the serpent who guarded the golden apples and was said to have been slain by Hercules, derives its origin from the Mosaic account of the fall."[11] Turner strengthened the allegorical play between the two gardens, and thus the significance of his story, by making their fates more nearly parallel: Discord's capricious choice of an apple thus assumes the implications of Eve's temptation.

Turner's progression from narrative derived from a literary text to pictorial narrative—wherein the images that make up the painting, even if assembled from elsewhere, combine to create a new "text"—constituted a critical improvement to the art of landscape. The elements of nature not only participate in the narration, they begin to constitute the story itself, a story about conceptual difference in the representation of landscape. In this instance the artist hedged by elaborating the immediate episode about a threatened earthly paradise in his poem, though in the end he chose not to make the written version, with all its historical detail, public. But with *The Goddess of Discord Choosing the Apple of Contention in the Garden of the Hesperides* he had nonetheless devised a model for manipulating narrative meaning to the advantage of a painter of landscape. While the viewer might recognize familiar aspects of the legend as having come from outside sources, those references are subsumed in a new iconographical system which the artist formulated in landscape's terms—and before our eyes, as it were.

Turner demanded a great deal of his audience. It indeed takes time to "read" his imagery and discover the path(s) he followed through the various traditions, poetic and artistic, that are summoned by the painting and poem. However, he orchestrated those parts such that one need

not arrive at a single, conclusive message to have "understood" the scene. The artist's synthesis of elements and motifs by its very nature allowed for some variation or slippage at the points of connection between the parts. Ruskin could search out the lineage of each of the characters in *The Goddess of Discord Choosing the Apple of Contention in the Garden of the Hesperides*, appreciate their separate allegorical possibilities (the natural equivalencies of the Hesperidean nymphs, for example), and arrive at a moral very different from the one proposed here about the nature of representation in landscape painting. To Ruskin, the sum of the parts yielded Turner's "first great religious picture," wherein the dragon became "the British Madonna," a "sea-serpent" spoiling both England's and the Hesperidean beauty with its gloomy presence.[12] The artist's combination of mythologized nature and naturalized myth results in a layering of meanings that not only tolerates more than one interpretation at a time, but seems to encourage mental parrying.

The painting's imagery operates on several levels simultaneously: as ordered landscape in the hallowed tradition of Poussin; as a retelling of Discord's legend in the spirit of neoclassical history painting; as a universalizing allegory about the loss of an ideal (or a more pointed caution about choices and values directed toward the British Institution); or as a demonstration of the *way* imagery becomes invested with meaning. John Landseer intimated in his review of the painting that not everyone will be comfortable with so much license. After criticizing Turner for overpopulating the garden with too many nymphs, he defended the whole conception, arguing that "It is however a highly poetical scene, and its terrible acclivities, its lofty trees, its crystal fountains, and its golden fruits cannot fail to delight those minds which Mr. Turner here means to address."[13] Presumably Landseer and Turner counted on there being

viewers who would find the *process* of interpretation an appealing aspect of one's appreciation of art.

Turner's narrative strategy in *The Goddess of Discord Choosing the Apple of Contention in the Garden of the Hesperides* becomes even more pointed when set against the contrary ambitions for landscape that he demonstrated that same year. Since his 1802 Swiss tour, when the artist had ventured into new territory literally and figuratively, he had begun to exploit the genuinely modern aspects of his art: an energy of brushwork, innovative composition, and a directness of response to nature in all its variety. These qualities can first be observed in the large-format watercolors from the Swiss tour and then in seascapes beginning in 1803. The critical reaction had not been encouraging, however. Perhaps to blunt further attacks he placed innovative paintings like *The Shipwreck* (1805), with its roiling water and dramatic display of human anguish, in tandem with large, formal scenes of *The Deluge* and *The Destruction of Sodom* when he made the bold move of exhibiting outside the Royal Academy in his own gallery. The latter works, reminiscent of Poussin in his most dignified manner, portrayed natural cataclysm, death, and dying in a way sanctioned by the history of art. They established the roots of *The Shipwreck*'s modern sensibility—where catastrophe occurs without the comforting excuse of a sacred cause—as well as provided a measure of Turner's stylistic departure.

In a similar way, *The Goddess of Discord Choosing the Apple of Contention in the Garden of the Hesperides* provided a foundation for, and counterpoint to, *Fall of the Rhine at Schaffhausen*, shown at the Royal Academy in 1806. This was the first major exhibited oil to convey the full impact of the Swiss tour. Earlier works like the 1803 *Châteaux de St. Michael, Bonneville, Savoy* (fig. 39) had been carefully organized and tactfully restrained in their portrayal of Alpine scenery, reflecting Turner's misgiving (confided

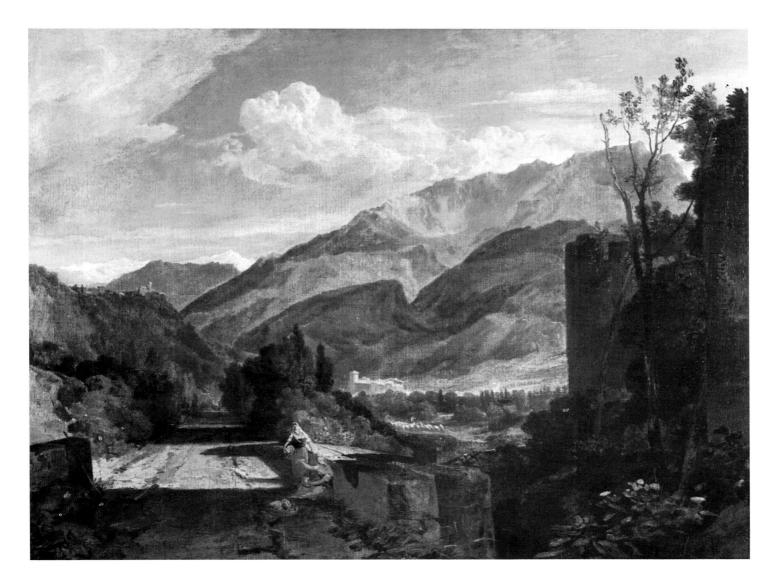

Figure 39. J.M.W. Turner, *Châteaux de St. Michael, Bonneville, Savoy,* 1803. Oil on canvas, 36 × 48 inches (91.5 × 122 cm), Yale Center for British Art, New Haven, Paul Mellon Collection (BJ 50).

to Joseph Farington) that the topography of Switzerland was "too broken" for serious landscape painting.[14] Such endeavor demanded that the scenery of *Châteaux de St. Michael, Bonneville, Savoy* partake of order and geometry by incorporating Poussin's "rules of parallel perspective" in order to "produce propriety," as Turner had elsewhere explained.[15] While *The Goddess of Discord Choosing the Apple of Contention in the Garden of the Hesperides* continued to defer to Poussinesque principles, *Fall of the Rhine at Schaffhausen* revised them decisively.

To portray the falls' awesome display, a painting true to their impact needed a very different approach, and by 1806, the artist was ready to abandon his prior reservations about depicting the Swiss landscape. Comparison of Turner's scene with a reasonably faithful view of the falls by de Loutherbourg from 1788 (fig. 40) immediately points up the vigor of his response. Turner radically compressed space, moving to the side of the river, and to a slightly lower perspective that emphasizes the wall of water rushing past. The figures strung out in a horizontal line in the foreground seem impeded by the voluminous flow, which registers on the viewer as a compelling, dense mass of whites and greys. In the action of the brushwork, we see the water tumbling in all its force and power. At Schaffhausen, nature's grandeur threatened to outdistance even the Romantics' love of sublimity (compare the equally enthusiastic reaction of the Wordsworths or Goethe). Turner accepted the challenge to the *modern* artist to exalt that power and magnificence. The sensations he tried to communicate were so potent and raw that even his portrayal of intellectualized realms like the Hesperidean garden felt the repercussion. The cloud on the horizon of idealized nature was there to stay.

As Turner would go on to demonstrate, he had no intention of abandoning the protected realms of antiquity altogether. Rather, *The Goddess of Discord Choosing the Apple of Contention in the Garden of the Hesperides* and *Fall of the Rhine at Schaffhausen* present two complementary ways of representing the world around him. The idealized scene traces a legend, searching deep into the past for first causes. Its narrative imparts order to a collation of events and forms the background to our understanding of still wider circumstances beyond the moment depicted. It is a learned painting, one that satisfies intellectually. Its careful, detailed brushwork, polished surface, and its deep, rich coloring adds a formal dignity as well. In contrast, *Fall of the Rhine at Schaffhausen* describes immediate experience: it is a moment emphatically without reference to any prior history. Even the clues to the town's past that could be recorded through its architecture have been downplayed. The contemporary figures in the foreground do not enact an existing story, nor are they even linked by some common activity in the present moment. Divided into separate groups, each attends to its own concerns without regard for the others. There is no background to *Fall of the Rhine at Schaffhausen*, figuratively or literally. We are kept in the foreground, at the surface, with nothing to assimilate but the sheer energy and elemental force of the paint/water.

In effect, both paintings told their respective stories innovatively: *Fall of the Rhine at Schaffhausen* through its freedom from formal or thematic constraints, *The Goddess of Discord Choosing the Apple of Contention in the Garden of the Hesperides* through its editing and reconfiguration of traditional components. Though Turner never treated them as pendants physically, the two works interrelate in a number of ways, from size (about 60 × 90 inches each; 152 × 229 cm) and shared design features (the inclined rock formation and broken trees at the right edge), to the conceptual and formal paradigms they call to mind. In addition to the polemic of real versus ideal that harkens back to

Reynolds and Wilson, the two paintings could also fit the categories of the Sublime and the Beautiful, or even the eighteenth century's moralizing comparison of present and past. Those structures of meaning may simply have been so ingrained in late eighteenth-century thinking that they were a constant aspect of landscape. However, Turner signalled their conventionality when he added the cautionary notes to his view of the past and its idealizing mode of representation. His Discord threatens not only the garden, but the sanctity of the classical heritage, since he can alter its legends at will. She and her attendant storm cloud likewise challenge the old order of classical landscape, countering with a reckless unleashing of nature's disorder.

Perhaps Turner designed *The Goddess of Discord Choosing the Apple of Contention in the Garden of the Hesperides* as a warning to connoisseurs who could not see their way beyond the Old Masters' conventions to the future of art. They repeatedly refused to see the merit of modern works like *Fall of the Rhine at Schaffhausen*. Contemporary response to it was uniformly an expression of shock: Turner and his painting variously accused of being incoherent, wild, intoxicated, or altogether mad.[16] By contrast, *The Goddess of Discord Choosing the Apple of Contention in the Garden of the Hesperides* was accepted virtually without comment, subsequently winning praise from John Landseer when he reviewed it in Turner's gallery in 1808.[17] He commended Turner's "loftiness of thought," and lauded the painting for its overall effect: "The imagination of the artist, whether painter or poet, when thus raised, or—in the language of the poets—exalted by the Muse, looks down upon Nature and the nether world, revolves its creative energies, and accomplishes its lofty purpose with a power of volition which conquerors might envy and angels might admire."[18]

These creative energies and lofty purposes gave Turner's artistic identity its special complexion. No matter how compelling he found "pure" nature, he continued to value the breadth of expression afforded by his version of classical landscape. After all, his audience still upheld the distinction between "Portraitures of common nature and scenes from classical lore fraught with poetic feeling" stressed by Sir Joshua Reynolds.[19] Through mythologized, idealized nature, Turner could attain a highly imaginative level of expression and affective power. One reviewer had even declared him "our only landscape painter that can always venture successfully and at will, out of landscape portraiture into poetry, or in other words, that can give a classical character, a superior beauty, or sublimity to the materials of landscape."[20] The complex iconographical gamesmanship in *The Goddess of Discord Choosing the Apple of Contention in the Garden of the Hesperides* suggests how very much he enjoyed the exercise of that poetical sensibility.

Over the course of just a few years, Turner had progressed from being a reciter of myth to an interpreter of myth and thence to myth maker. In *Apollo and Python*, exhibited in 1811 at the Royal Academy (but perhaps painted earlier), the artist's confidence shines out quite literally (fig. 41). The god of art, poetry, and light has met and vanquished a mighty adversary: a serpent described by the ancients as having been generated from the mud and stagnant waters left after the mythological flood of Deucalion—that is, a symbol of the earth (or nature) itself. The painting reads as a statement of narrative ends achieved; it by-passes the suspenseful storytelling of *Jason* and the complicated iconographical didacticism of *The Goddess of Discord Choosing the Apple of Contention in the Garden of the Hesperides* in favor of an emblematic celebration of prowess. We are called upon to contemplate the victor and his foe, radiance bathing the young god and transmuting an act of valor into an allegory of the conquest of light over darkness. But the accompanying poem printed in the

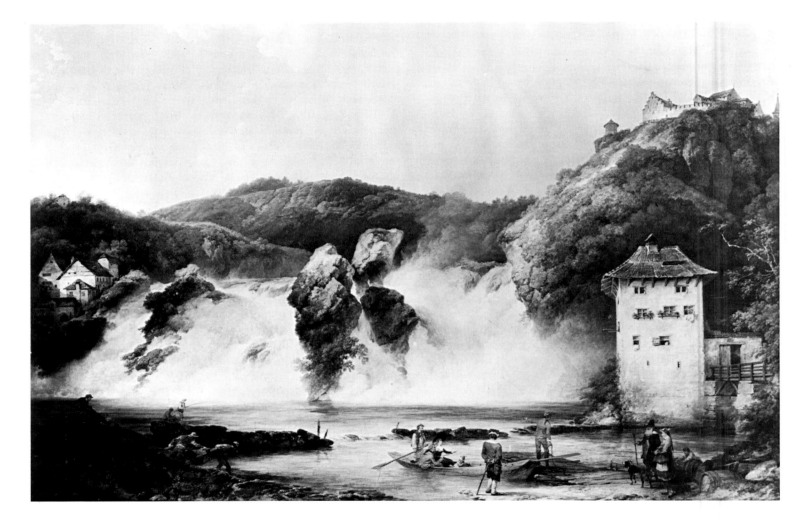

Figure 40. Philip James de Loutherbourg, *The Falls of the Rhine at Schaffhausen*, 1788. Oil on canvas, 53 × 78 inches (134.6 × 198.1 cm), By Courtesy of the Board of Trustees of the Victoria & Albert Museum, London.

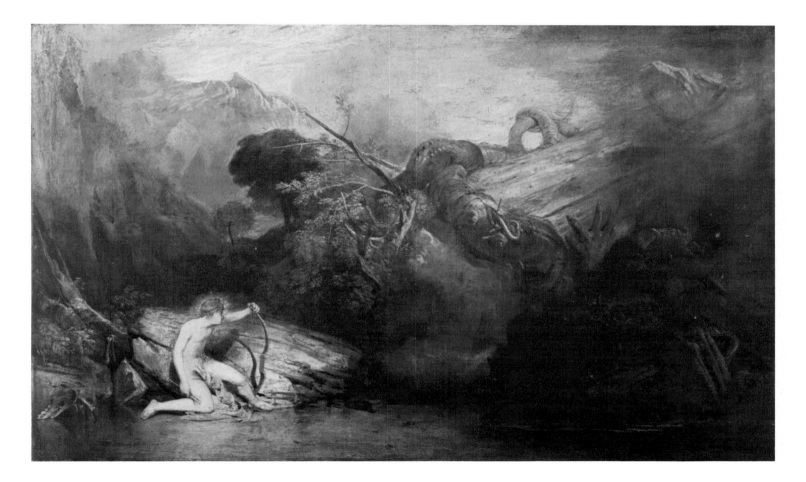

Figure 41. J.M.W. Turner, *Apollo and Python*, 1811. Oil on canvas, $57\frac{1}{4} \times 93\frac{1}{2}$ inches (145.5 × 237.5 cm), Turner Collection, Tate Gallery (BJ 115).

exhibition catalogue and the detail of a smaller serpent emerging from Python's wound once again contest the authority of the classical ideal to which the painting ostensibly adheres. In Turner's pantheon, even a god like Apollo could not triumph entirely over nature's primal forces.

His verse for *Apollo and Python* acts as the first caution against a too limited or straightforward reading of a painting's imagery. Though he cited the "Hymn of Callimachus" as the poem's source, the lines are in fact his own *inversion* of the ancient song of praise to the Sun God. Instead of vaunting the deity's prowess, the verse concentrates on the monster's final agony:

> Envenomed by thy darts, the monster coil'd
> Portentous horrible, and vast his snake-like form:
> Rent the huge portal of the rocky den
> And in the throes of death he tore,
> His many wounds in one, while earth
> Absorbing, blacken'd with his gore.[21]

This revision of the classical paean finds its visual counterpart in the small snake (or worm?) issuing from the monster, the image of regeneration confounding the certainty of the immediate victory.[22] The motif calls up the fundamental necessity of interpreting the scene and the episode for viewer and artist alike. Turner embedded theme within theme here (serpent within serpent), as if to remind us that the narrative process is unending, that understanding comes gradually, and that meaning is fugitive, one aspect of a story necessarily leading to the discovery of another. The contrast between old and new or between the ideal and the natural transposed into the more resolutely anthropomorphic terms of Apollo and the Python may seem less appropriate to the larger issue of meaning in landscape than the narrative of *The Goddess of Discord Choosing the*

Apple of Contention in the Garden of the Hesperides in conjunction with *Fall of the Rhine at Schaffhausen*. But by persisting in the gesture of juxtaposition—text with image, the god embodying art and poetry with the serpent sprung from base matter, light with dark—the artist foregrounded as an essential aspect of the painting's theme the question of how landscape acquires and conveys meaning.

Chapter III: Notes

1. John Landseer, "Mr. Turner's Gallery," pp. 167–69; see also John Ruskin, *Notes on the Turner Gallery at Marlborough House*, 1856, in *The Works of John Ruskin*, ed. E.T. Cook and Alexander Wedderburn, 39 vols. (London: George Allen, 1905–1912), 13, pp. 114–15.

2. In his review of the painting, Landseer questioned which source Turner was following, and went on to engage in iconographic one-upmanship by quibbling about the correct number of Hesperidean maidens that should be present; "Mr. Turner's Gallery," p. 169.

3. The Goddess of Discord is described as the embodiment of dissension and strife by Homer, *Iliad*, IV, 501–507, and Virgil, *Aeneid*, VIII, 702ff; her disruption of the wedding feast of Peleus and Thetis is recounted by Hyginus, *Fab.* 92, and Apuleius, *Metamorphoses*, 10. Her link to the Judgment of Paris is mentioned in the entry for "Discord," in the standard late eighteenth-century classical dictionary, a copy of which Turner owned, Jean Lemprière's *Bibliotheca Classica* (London, 1788), 2nd ed. 1792, p. 209. Descriptions of the Garden of the Hesperides deal primarily, if not exclusively, with Hercules' visit there to obtain the apples: Lemprière, "Hesperides," pp. 273–74; Hyginus, *Fab.* 30. In the

Argonautica, IV, 1650−1662, Jason and his entourage visit the Garden and the story of Hercules is recalled. One possible model for Turner's conflation of stories, according to Ruskin, *Works*, 7, p. 407, may have been Spenser's *Faerie Queene*, Book 2, vii, where the poet strung together a number of episodes about golden apples, including Discord's. Spenser indicated that all the fruits had come from a single tree in the garden of Prosperpina, which the poet described as a forbidding place.

4. Ralph Wornum first compared Turner's scene to the description in *Comus* in *The Turner Gallery* (London, 1875), p. 9.

5. The connection between the dragon and the detail of the watercolor was made by Lawrence Gowing in a paper presented at the J.M.W. Turner Symposium, The Johns Hopkins University, April 1975. Ruskin had suggested more generally that the dragon originated in Turner's observations of alpine glaciers, *Works*, 7, p. 402; 13, pp. 114−15.

6. Perhaps Turner had noticed a note to Fawkes' translation of the *Argonautica* specifying red eyes for dragons. The writer drew an analogy: as in watch towers a lamp was kept burning, so the eyes of a dragon were like windows in the uppermost part of the building, through which fire appeared; Anderson, *A Complete Edition*, 13, p. 283, note to 11, line 535. Fawkes was in fact paraphrasing an entry in Jacob Bryant's *A New System or the Analysis of Ancient Mythology*, 3 vols. (London, 1774). See Gage, *Color in Turner*, p. 139, for a possible alchemical parallel.

7. This draft is found in the "Windsor, Eaton" sketchbook, TB XCVII, 1807 (or earlier), 83−83a. A more polished version copied by Turner in his verse notebook was printed in Butlin and Joll, *The Paintings*, 1, p. 45. It omits the reference to "wintry" skies.

8. Anderson, *A Complete Edition*, 12, p. 24.

9. First noted by Gage, *Color in Turner*, p. 137; the citation is from *Paradise Lost*, Book IX, 780−84.

10. The wedding couple should have been Thetis and Peleus, not Psyche. Gage, *Color and Turner*, p. 139, would have Turner following an alchemical program whereby he transposed to Psyche the allegorical values of "Vesta, the fourth Hesperid . . . for both Vesta and Psyche, according to Pernety [*Les Fables egyptiennes et grecques*, 1785], were symbolic of mercurial water." I believe that in this instance Turner was less intrigued by arcane symbolism than simply guilty of reading on too far in *Comus*. After describing the garden, Milton continued with the following lines:

> But far above the Garden of Hesperides in spangled sheen
> Celestial Cupid her [Venus'] famed son advanced,
> Holds dear Psyche sweet entranced
> After her wandering labors long
> Till free consent the gods among
> Make her his eternal bride
> And from her fair unspotted side
> Two blissful twins are to be born,
> Youth and Joy, so Jove hath sworn−(1003−1011).

11. Anderson, *A Complete Edition*, 13, p. 322.

12. Ruskin, *Works*, 7, pp. 407−408.

13. Earlier in the discussion Landseer had described the dragon as "looking out in such a way as leads imagination far beyond the limits of the picture"; "Mr. Turner's Gallery," pp. 168−69.

14. I take it as significant that Turner never exhibited the c. 1803−1804 oils, the *Pass of St. Gothard* and the *Devil's Bridge at St. Gothard* (BJ 146 and 147). If the explanation is that

they were commisions and thus left his studio directly, still he chose not to follow their commercial success with similar Alpine scenes in oil; see Butlin and Joll, *The Paintings*, 1, pp. 111–12.

15. Ziff, "'Backgrounds,'" p. 143. Turner was discussing Poussin's *Landscape with a Roman Road* (Dulwich), deeming it a "powerful specimen of Historic Landscape," in which "a road terminates in the middle of the picture and every line in it tends to that centre." Butlin and Joll (*The Paintings*, 1, pp. 39–40) noted that the Poussin had been exhibited in 1802 and that it was the likely model for *Châteaux de St. Michael, Bonneville, Savoy*.

16. The critical response, in all its vigor, was recorded by Farington and reprinted in Butlin and Joll, *The Paintings*, 1, pp. 48–49. Paradoxically, the *Fall of the Rhine at Schaffhausen* found an owner in Sir John Leicester, who exchanged the 1805 *Shipwreck* for it in 1807. *The Goddess of Discord* remained unsold.

17. Sir George Beaumont could find something negative to say about Turner even when the work in question met (or should have met) his standards. Though he was one of the staunchest proponents of Old Master emulation at the British Institution, in 1806 he found both *The Goddess of Discord* and *Narcissus and Echo* to be "like the works of an old man who had ideas but had lost the power of execution," *The Diary of Joseph Farington*, 7, p. 2710, entry for April 5, 1806.

18. Landseer, "Mr. Turner's Gallery," p. 168.

19. Quoted from an anonymous announcement of the work on view in Turner's "Private Gallery"; V & A Press Cuttings, 3, p. 854.

20. V & A Press Cuttings, 3, p. 1185.

21. Turner copied Matthew Prior's translation of Callimachus' "Hymn to Apollo," found in Anderson, *A Complete Edition*, 7, p. 455, into his "Hastings" Sketchbook (TB CXI, 1809–1811, 70a). Butlin and Joll, *The Paintings*, 1, p. 82, listed other drafts of the poetry. In the drawings related to the painting, Turner's fascination in fact lay with the monster. TB LXXVII, 43a (Rhine, Strassbourg and Oxford Sketchbook) concentrates on its writhing form, while TB LXXXI, 68 (Calais Pier Sketchbook), labelled 'Death of Python,' leaves Apollo out altogether.

22. Cosmo Monkhouse, *Turner* (London, 1879) p. 68, connected the image of the emerging worm with Ovid's description of Cadmus's battle with his dragon, in Book 3 of the *Metamorphoses*. Turner seems to have carried over a number of features of that story into his version of the Apollo episode.

IV Landscape as History

For all of Turner's accomplishment in the art of landscape during the first decade of the nineteenth century, he still had to confront history painting's continued superiority among the genres. Even into the 1820s, exhibition reviews tenaciously preserved the seventeenth-century academic hierarchy of the arts. No matter how questionable an individual's merit might be, history painters were the first to be lauded since they were presumed to have made the greatest contribution to the glory of British art. Next in order reviewers praised poetic painting, the one real change to the system. Initially championed for the challenge it made to history painting's supremacy, nonetheless the new category ended in second place. The discussion of landscape occurred still later in the course of a review. Although landscape painters had helped to establish poetic painting as a viable genre, they were excluded from its higher status.[1]

Discriminatory attitudes against the representation of nature might surface anywhere. Until 1810, for example, the British Institution would not allow paintings that included even so much as landscape *backgrounds* to be entered in their annual competitions for "Historical or Poetical Compositions."[2] In 1811 Turner complained to John Landseer about a prejudicial law preventing landscape painters from being Visitors in the Royal Academy schools, arguing that the regulation should be repealed. The low status of his chosen field clearly irked Turner to the point of obsession, for as Landseer soon learned from Joseph Farington, no such law had ever existed.[3]

To redress these inequities (real or imagined) and meet history painting head on, the artist needed to demonstrate the capacity of landscape painting to treat serious issues in a thought-provoking manner. An initial, generalized conception of "historical landscape" put forward in his *Liber Studiorum* project (begun c. 1806), would be redefined by 1812 and *Snowstorm: Hannibal and His Army Crossing the Alps* (color plate 2), into a powerfully analytic working relationship between the two genres. Turner had presented the *Liber Studiorum's* series of engravings as a kind of primer to inform the viewing public about landscape's formal variety. Within the set he designated six categories of landscape types or approaches: "Marine," "Mountainous," "Architectural," "Pastoral," "E P" (perhaps signifying epic, elevated, or even elegant pastoral), and "Historical."[4] By the latter term he meant something like the late eighteenth-century notion of poetic painting, or Girtin's program for the "Brothers" sketching society—a range of themes with an essentially literary pedigree. The subjects grouped under the *Liber Studiorum* "Historical" classification included the Biblical plagues depicted in his early oils, Ovidian tales like *Cephalus and Procris*, and subjects as disparate as *Jason*, *Christ and the Woman of Samaria*, *Rispah*, and a cryptic scene entitled *From Spenser's Fairy Queen*.

Missing from the list are themes drawn from the annals of history per se, perhaps because they would have introduced a temporal specificity and attention to correct narrative detail at odds with the eternalizing, and almost anodyne nature of the scenes assembled for the *Liber Studiorum*. Turner's early exhibited oils treating factual historical episodes also would have upset the series' stylistic or formal coherence, had they been engraved for inclusion. *The Battle of Trafalgar, as seen from the Mizen Starboard Shrouds of the Victory* (fig. 44) or *Snowstorm: Hannibal and His Army Crossing the Alps*, or, one presumes from its description, even the lost *Battle of the Nile, at 10 o'clock when the L'Orient blew up, from the Station of the Gun Boats between the Battery and the Castle of Aboukir* (1799) employ far more complex visual effects and much less "readable" compositions than an

emblematic work like *Jason*. In that respect they also constituted a radical departure from contemporary history painting. When depicting historical events, whether from antiquity, from the seventeenth century, or from his own era, Turner devised a new mode of "historical landscape" compelling enough to confront traditional history painting on its own terms and with its own materials.

The timeliness of Turner's ambitions for a marriage of landscape and history is confirmed by Benjamin West's renewed interest in such a genre. West's own efforts, while impressive, had tended to be sporadic. Some twenty years had lapsed between his early attempts in the 1770s and the exemplary *Cicero, with the Magistrates of Syracuse, Discovers the Tomb of Archimedes* of 1797. Lest anyone miss his intention in combining an historical subject with an extensive out-of-doors setting, West identified the painting as "an historical landscape" in the Royal Academy exhibition catalogue.[5] But he did not repeat the experiment until over a decade later. His *Escape of Lot and His Family from the Destruction of Sodom and Gomorrah* (1811) was described without further elaboration in one review as "a very fine composition . . . [which is] in the style, and ranges under the class, of Historical Landscape."[6]

West subsequently called attention to the special nature of such dual imagery the following year (when Turner showed *Snowstorm: Hannibal and His Army Crossing the Alps*), by forthrightly titling his work *Historical Landscape; Saul before Samuel and the Prophets* (fig. 42). The handsome natural setting reminiscent of Poussin in its careful recession and solidity of form lends dignity to the drama of Saul prophesy-ing in the center foreground. Although West treated narrative and landscape more as coequals than as a unified entity (his attention to the stone slabs in the foreground suggests a stage set with an accompanying scenic backdrop), he achieved an impressive overall breadth in setting the episode out-of-doors. Divine inspiration seems likely to come from the light-filled open sky, the sacredness of the moment reverberating through the natural panorama.[7] The direction in which West and Turner were trying to take landscape (or history painting?) met with approbation. A review of the British Institution's 1814 exhibition commented, with what sounds like relief, "even landscape we think is at length giving way to history and contrast."[8]

The appointment of an "Historical Landscape Painter" to Prince Leopold and Princess Charlotte in 1816 consti-tuted another mark of recognition for the genre, although the honor went to a relative newcomer in the field, John Martin, rather than to Turner or West.[9] Perhaps Turner felt a twinge of jealousy over the appointment, for he subsequently advertised himself in a similar way. The journal *Annals of the Fine Arts* published the names and addresses of the "principal living artists . . . with the Line of Art they profess" in the back of each year's volume. In the journal's first issue, for 1816, Turner gave his "line" simply as "Landscape." From 1817 to 1819, in lists that had been "corrected," he appeared in all his professional regalia as

> Turner, Joseph Mallord William R.A.
> Professor in Perspective in the Royal Academy
> Sandycombe Lodge, Twickenham and Queen Anne St. West
> Historical Landscape &c[10]

The artist also may have been vexed by news that foreigners were more openly appreciative of landscape's capacity to attain lofty ends than were his own countrymen. A report in the 1817 issue of the *Annals of the Fine Arts* announced that the King of France had recently founded Historical Landscape as a class of painting worthy of encouragement by prizes.[11]

Turner's French contemporaries in landscape, Bertin,

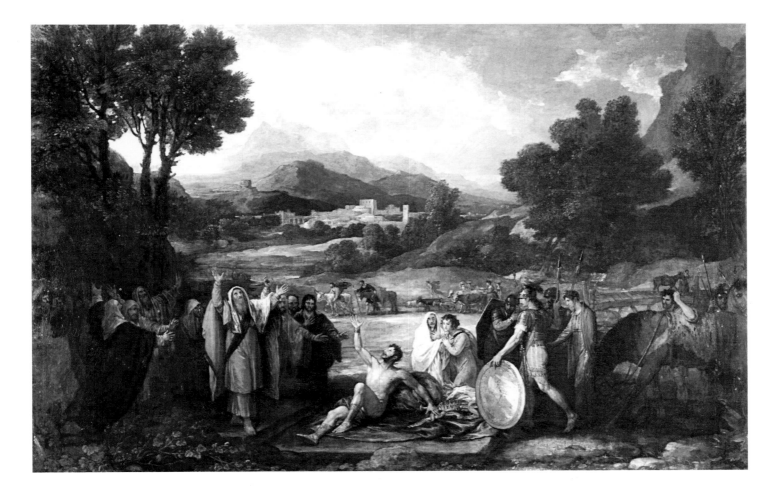

Figure 42. Benjamin West, *Historical Landscape: Saul before Samuel and the Prophets*, 1812. Oil on canvas, 64 × 101 inches (162.5 × 257 cm), The Henry E. Huntington Library and Art Gallery, San Marino, California, Gift of the Virginia Steele Scott Foundation.

Figure 43. Jean-Victor Bertin, *Socrates on the Banks of the River Ilissos*, c. 1810. Oil on canvas, $12\frac{7}{8} \times 16$ inches (32.7 × 40.6 cm), Private Collection, Paris.

Michallon, or Valenciennes, promoted the nobility of landscape in rather more traditional terms than West or Turner. In Jean-Victor Bertin's *Socrates on the Banks of the River Ilissos* (c. 1810; fig. 43) the formal conventions of seventeenth-century classical landscape predominate, the artist adding a new lushness to the setting but downplaying the narrative component in the process. Once located and identified, the figure of Socrates expounding to a pupil in the lower left imparts a venerable dignity to the landscape while his gesture carries the eye toward the building and figures in the middle ground, signalling the diagonal emphases within the composition. In effect Bertin decorated his scene with the historic figures; we observe where Socrates is and take note of how he conducts himself, rather than question the circumstances that brought him there. Bertin's conception of historical landscape would be passed on nearly intact to his pupils, one of whom, Achille-Etna Michallon, took first prize in the initial 1817 competition (a *Prix de Rome* instituted for students at the Ecole des Beaux-Arts) with a scene of Democritus and the Abderans equally attentive to the elaborate setting as its primary interest and just as indebted to the heritage of Claude, Poussin and Gaspard Dughet for its overall look and demeanor.[12]

Turner, too, followed the example of the seventeenth-century masters for his later historical landscapes (beginning with *Dido Building Carthage*), but from the very outset he was thoroughly intrigued by questions of historical cause and effect. He answered Reynolds' misgivings about the capacity of landscape painting to address significant issues by reconstruing history. In his chronicle, nature ceases to function as the setting for historical events and instead becomes the key to understanding history's lessons—if not becoming the fundamental lesson itself. Turner clearly recognized that nature's continuity bridges the distance between past and present. At its most superficial level, this insight ordained a favorite early nineteenth-century preoccupation: citing historical incidents that could provide instructive parallels to modern-day dilemmas. The difficult and perplexing events of the first two decades of the nineteenth century—the rise and fall of Napoleon, the uncertain fate of modern Greece—made the search for precedents seem imperative. If the lessons of antiquity seemed particularly pertinent to such discussions, perhaps it was because of the magnitude of both ancient ambition and ancient failure. Turner himself was hardly immune to the conceit, but at the same time, he was sensitive to its limitations.

The following discussion assumes that he developed his historical themes in response to specific social or political issues of the day but it does not track or privilege those issues because the complexity of the narratives again argues against seeking a definitive explanation grounded on only one kind of evidence. Suffice it to say that the artist paid the same keen attention to current events as he did to literature, music or the history of art and incorporated references to them in his imagery, sometimes featuring one such source of inspiration, sometimes another. The larger context of his widely varying oeuvre suggests that he considered painting as a form of cultural chronicle to which he contributed with a thorough sense of purpose—indeed multiple purposes. The overarching theme of his work remained the nature of representation itself, and the role of landscape in elaborating that cultural chronicle.

Turner occasionally portrayed contemporary events (for example, *The Field of Waterloo*, 1818), but he preferred to avail himself of the greater license for interpretation possible with episodes from the past. Rather than research pertinent events he selected many of his subjects directly from the repertory of eighteenth-century English neoclassical history

painting. In that way he could invoke—and manipulate—the artistic tradition against which landscape had struggled, while at the same time exploring the ancient record for its ambiguities and inconsistencies. A number of Turner's themes had enjoyed wide currency in the visual arts precisely because they offered clear-cut examples of virtue, folly, or the fortunes of empire. Using their very familiarity as a foil, he reinterpreted the incidents to fit the Romantic tenor of his own times. Like others of his generation (Shelley, for example), he did not hesitate to render obvious morals unclear and pointed didactic messages uncertain.[13] Instead, he stressed the complexity of human aspiration, took account of the unpredictable leaven of fate, and, most important of all, introduced nature as an active agent into the larger picture.

Turner's extensive study of the theory and history of art in preparation for his Royal Academy lectures during the first decade of the century had helped him arrive at that more catholic interpretive approach. In his private reading notes he argued the validity of giving "as much allurement to the higher walks of Landscape as Historical"—by which he meant something a good deal more complicated than getting his facts straight in appropriately sylvan settings.[14] In his inaugural address as Professor of Perspective, Turner explained that "History suffers only by a union with commonality. Whatever is little, mean, and commonplace enters not, or ought not, the landscape of History as an assistant or as a Historical landscape or Architecture or Sculpture. Each, tho' separately drawn from the same source, yet should be considered separately for its subject by combining what is truly dignified and majestic and possessing Nature of an elevated quality."[15] When representing nature, either in service to history, or as part of history, artists should avoid the prosaic—an admonition echoing late eighteenth-century concerns, but tailored to

the character of Turner's art. In the course of his lecture he elaborated by reviewing the patrimony of landscape painting. What emerges from his tributes to past masters is respect for narrative and scenic development very like Alberti's *historia*, that is, a noble "telling" to go with a noble tale.

Fuseli had considered much the same idea in his own Royal Academy lectures on epic painting. Essentially recapitulating Reynolds' Fourth Discourse, Fuseli argued that the aim of epic was "to impress one general idea, one great quality of nature or mode of society, some great maxim, without descending to those subdivisions, which the detail of character prescribes: . . . the visible agents are only engines to force *one* irresistible idea upon the mind and fancy."[16] Hence, an epic painter would handle a subject like the death of Germanicus by conveying "the highest images of a *general* grief which impresses the features of a people or a family at the death of a beloved chief or father," while the painter of history, treating the same subject, would restrict himself or herself to "the real modifications of time and place" and the "physiognomic character" of the principal figures.[17]

One of the first works to fulfill Fuseli's requirements for so sweeping a presentation was Turner's *The Battle of Trafalgar, as seen from the Mizen Starboard Shrouds of the Victory* (1806; reworked 1808; fig. 44). The perspicacious Landseer even heralded it as the first true "British epic picture," explaining that "It was the practice of Homer and the great epic poets, in *their* pictures, to detail the exploits or sufferings of their heroes, and to generalize or suggest the rest of the battle, or other accompaniment, and Mr. Turner, in the picture before us, has detailed the death of *his* hero, while he has suggested the whole of a great naval victory, which we believe has never before been attempted, in a single picture."[18] The artist would not attempt so ambitious an

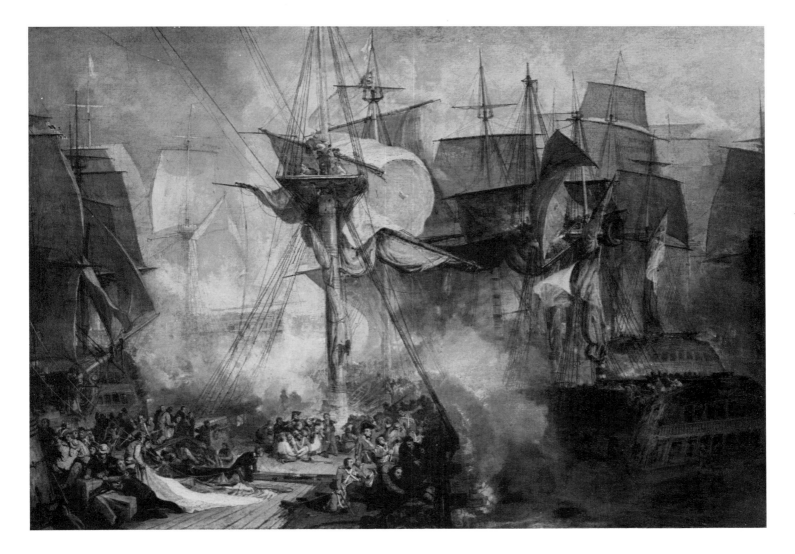

Figure 44. J.M.W. Turner, *The Battle of Trafalgar, as seen from the Mizen Starboard Shrouds of the Victory*, 1806; reworked 1808. Oil on canvas, $67\frac{1}{4} \times 94$ inches (171 × 239 cm), Turner Collection, Tate Gallery (BJ 58).

historical landscape again until 1812, at which time he selected his material from the heroic deeds of antiquity. With episodes from ancient history he could imagine and edit rather than painstakingly reconstruct a scene (note the painstaking precision of the sails and rigging in *The Battle of Trafalgar, as seen from the Mizen Starboard Shrouds of the Victory*) —and no eyewitnesses could contradict the results.[19] Moreover, he could select from the neoclassical roster of historical events those in which nature had played a significant but as yet unacknowledged part.

The narrative strategy of Turner's history subjects remained distinct from the focussed recounting of *Jason* or the extended exposition of later mythic episodes like *The Parting of Hero and Leander—from the Greek of Museaeus*. In *Snowstorm: Hannibal and His Army Crossing the Alps*, *Regulus* (1828), or *Ancient Rome: Agrippina Landing with the Ashes of Germanicus* (1839), Turner carried the prescription for epic described above to an extreme, generalizing an event almost beyond recognition. His titles announce a specific incident in the life of a noted individual, but his imagery refuses to yield to normal exegesis. We are asked to consider the principal character's plight, but then can neither securely locate him or her in the scene nor be certain about which moment we in fact witness. The meaning that we are invited to find in the picture must then coalesce from a recollection of the historical record (with reminders of the necessary details provided by Turner), amended through reflection on circumstances presented not simply as *past fact*, but as an interrelationship of past events, a present reality, and future possibility.

Turner knew his history. He provided evidence of his historical acumen and his capacity for thoughtful research in his accompanying poetry, in his visual imagery, particularly in details, which function like footnotes to an historical text, and in straightforward verbal reports like the one

issued in the extended full title of *The Decline of the Carthaginian Empire* in 1817. However, the artist was astute enough to leave the prose of history *as prose*. Applying his sensitivity as an acute observer of nature to his analysis of human conduct, Turner offered lessons that do not simplify into traditional aphorisms because he recounted the episodes in terms of the implacable forces and eternal time of nature, a perspective that alters them and imparts a different kind of universality to their morals. He also tempered the notion of historical truth through his awareness of the competing claims of chronicled "fact" and the poetic fictions of myth or legend, particularly in the case of Carthage. Perhaps for that reason he did not insist on specific equivalencies between past and present, since they would have a narrow and perhaps dubious applicability. We are left to draw and redraw analogies where we will in his stories of thwarted expectations, the ravages of time, and the cheat of fate. However, it would be a mistake to assume that by not setting limitations in precisely those instances where historical certitude would seem to matter most, the artist was negligent or unconcerned about his meaning.

I am arguing here against a critical attitude that had its start in the hostile commentary of the press in the 1830s and to which even the devoted Ruskin was not immune: that any failure of understanding on *our* part is unconditionally the fault of the painter and/or his work. In the first volume of *Modern Painters* Ruskin dismissed without elaboration a group of paintings that included several of Turner's ancient history themes: "the Caligula's Bridge, Temple of Jupiter, Departure of Regulus, Ancient Italy, Cicero's Villa, and such others, come from whose hand they may, I class under the general head of 'nonsense pictures.' There never can be any wholesome feeling developed in these preposterous accumulations, and where

the artist's feeling fails, his art follows."[20] In effect, Ruskin resisted those images that he could not interpret to his satisfaction. Certainly the artist made "mistakes" (calling the Seventh Plague the Fifth) that confound understanding, but one should not hastily translate discomfort with an alternate version of the "facts" into a presumption either of the inconsequentiality of those facts to the meaning of the scene or of habitual carelessness on Turner's part. The artist often began with the most accurately researched material, subsequently choosing to revise or subvert it. The point at which the process of subversion becomes "nonsense" resides in the eye/mind of the critical beholder.[21]

Turner commenced his public exposition of ancient history commandingly with *Snowstorm: Hannibal and His Army Crossing the Alps*, exhibited at the Royal Academy in 1812 (color plate 2). His innovation can be seen in the painting's impressive vortical composition, in the epic unfolding of its narrative, and in the thoughtful interplay of its appended poem. Like *The Goddess of Discord Choosing the Apple of Contention in the Garden of the Hesperides*, the painting traffics with a number of concerns, from comparison of the Beautiful and the Sublime (sunny Italy versus the frigid Alps), to political commentary on Napoleon, to an historic turning point in a hero's or nation's fortunes. However, there is a critical difference between the way Turner crafted his meaning(s) in *The Goddess of Discord Choosing the Apple of Contention in the Garden of the Hesperides* and the way he manipulated it/them in *Snowstorm: Hannibal and His Army Crossing the Alps*. Dealing with myth, the artist felt free to mythologize too, and created his own legends about nymphs or goddesses. He did not take similar liberties with Hannibal's story. Rather, he respected history's authority regarding the factual details of the event even if he did not capitulate to its claim of truth in reporting the results. In *Snowstorm: Hannibal and His Army Crossing the Alps*,

Turner brought all his formal and narrative invention into play, developing within a single work a fully articulated construct for understanding the world through the agency of modern art—in the form of landscape painting.

His interest in Hannibal was longstanding (the first sketch relating to the subject dates from 1798) and was fueled by a variety of sources, including literary texts and visual works of art. In whichever medium, accounts of Hannibal's passage traditionally emphasized his triumph over adversity. Oliver Goldsmith's *History of Rome*, a copy of which Turner owned and annotated, described the Alpine ascent as an ordeal plagued by unforeseen terrors through which Hannibal remained steadfast in purpose and courage.[22] John Robert Cozens' now-lost 1776 painting *A Landscape, with Hannibal in his March over the Alps Showing to His Army the Fertile Plains of Italy*, also celebrated the hard-won victory, as its title suggests. Turner supposedly idolized the work; in his own early drawing he followed received opinion and set a commanding figure at the crest of a slope, his travails behind him, looking out across the distant landscape (fig. 45).

The artist subsequently abandoned the narrative clarity of a hero emblematically poised at the summit in favor of a faint, schematic, multifigured scene of combat drawn in white chalk, but firmly labeled in ink with the general's name along the upper right edge (fig. 46). He may have changed his initial conception of the episode under the influence of yet another source—a literary corruption of history—Ann Radcliffe's novel, the *Mysteries of Udolpho* (1794), which included an account of the Alpine passage at odds with tradition.[23] The author's heroine imagines the disasters that befell Hannibal's troops, in particular an attack on the weary caravan by native mountain-dwellers, "perched on the higher cliffs, assailing the troops below with broken fragments of the mountain."[24] The narrator

Figure 45. J.M.W. Turner, TB XL, Dinevor Castle Sketchbook, 67, 1798. Pencil, $3\frac{7}{8} \times 5\frac{1}{4}$ inches (9.9 × 13.3 cm), Turner Collection, Tate Gallery.

Figure 46. J.M.W. Turner, TB LXXXI, Calais Pier Sketchbook, 38–39, c. 1799–1805. White chalk on rough grey paper, $17\frac{1}{8} \times 10\frac{3}{4}$ inches (43.5 × 27.3 cm), Turner Collection, Tate Gallery.

is filled with horror at the thought of soldiers and elephants "tumbling head long down the lower precipices"—all as a prelude to acknowledging her own terror of the dizzying height of the Mount Cenis pass.

If Turner started with Radcliffe's description of an act of association on the part of her narrator, he transformed the thrilling, tumultuous scene she projected into a thought-provoking commentary on ambitions and expectations when he finally developed his finished version a decade later. Where the novel's heroine regains her self-awareness and resumes the story of her own distress after a moment's colorful, historical imagining, Turner's viewer-cum-narrator is coerced through careful design of both verbal and visual imagery into prolonged contemplation of Hannibal's fate and its consequences. Radcliffe had neither dwelt on the general's role, nor addressed the historical implications of this rear guard defeat in her description of the Alpine passage. Turner, by contrast, considered the immediate incident in its widest possible context.

No small part of the painting's genesis was his experience in 1810 of an extraordinary storm in Yorkshire that immediately brought the image of Hannibal to his mind.[25] The artist's own exercise in association having been provoked by something so fugitive, elemental, and independent of historic significance of place, he chose not to exploit the precipitousness of the Alps when setting the scene of Hannibal's passage. Instead, he opted for a breadth and openness that lends magnitude to the man-made and natural chaos. Turner had insisted that the panoramic painting (57½ × 93½ inches; 146 × 237.5 cm) be positioned at eye level in the Royal Academy exhibition, no doubt to promote the feeling of being swept up in the turbulence and seeming confusion of the moment. Scanning the foreground, one can neither isolate a central focus to the action nor find a discernible protagonist to mediate the mayhem.[26] The vignettes of human destruction taking place below vie for attention with the cataclysmic sky, punctuated by the compelling yellow disc of the sun. In both human and natural terms, the event unfolds with epic fury.

The means to comprehend the scene are provided in the form and imagery of Turner's first "excerpt" from his "M.S.P. Fallacies of Hope." The "manuscript" so identified has no existence beyond the printed Royal Academy catalogue citations that would appear over the next thirty-eight years. Drafts for it do not appear in his sketchbooks, nor does stringing together all the various installments yield a unified poem, or even a semblance of one. The work's purported existence nonetheless served Turner well. First, the "excerpts" cannot be judged as autonomous works of art because they are offered only as fragments of a larger whole. By the same token, the continually somber warnings they deliver induce one to imagine that the complete poem must be very powerful indeed—epic in its own scope. The very title, "Fallacies of Hope," conditions one's expectations of its sentiment or message, in some cases falsely.

The verse for *Snowstorm: Hannibal and His Army Crossing the Alps*, though awkward in phrasing and overly derived from James Thomson and/or the Reverend Gisborne in style, reviews the historical facts and imparts order to the on-going event:

> Craft, treachery, and fraud—Salassian force,
> Hung on the fainting rear! then Plunder seiz'd
> The victor and the captive,—Saguntum's spoil,
> Alike became their prey; still the chief advanc'd,
> Look'd on the sun with hope;—low, broad, and wan;
> While the fierce archer of the downward year
> Stains Italy's blanch'd barrier with storms.
> In vain each pass, ensanguin'd deep with dead,
> Or rocky fragments, wide destruction roll'd.
> Still on Campania's fertile plains—he thought
> But the loud breeze sob'd, 'Capua's joys beware!'
> —M.S.P. Fallacies of Hope

The intent of Turner's earlier poetry reaches its fruition here, for the lines not only document the battle, they interact closely with the visual imagery to bring about a comprehensive understanding of the episode's meaning. The verse deftly connects the present moment with other times and places by reinserting the missing main character into our frame of reference and by sensitizing us to the conflicting points of view operating here. Most important of all, the poem underscores Turner's canny integration of historical incident with nature's powerful display. To give his literary efforts the full benefit of the doubt, one might even say that the very words and phrases, uncontrolled by the strange punctuation, come on like the blinding snowstorm that befell the ancient hero.

The commotion and carnage depicted in the painting is brought into sharp focus by the reference in the first line to the perpetrators of the violence. Neither Radcliffe nor Goldsmith had identified the native mountain dwellers— the Salassians—by their proper name. In so doing, Turner situated the historical moment precisely, as well as forced consideration of *all* its players, so often left anonymous. He then provided a quick synopsis of their rear guard attack for those who might not remember why the Salassians are important to the account ("Hung on the fainting fear! then Plunder seiz'd / The victor and the captive"). Mention in the third line of "Saguntum's spoil" recalls the instigation for the second Punic war here in progress and introduces the bitter irony that pervades the rest of the story, since the plunder that Hannibal won sacking the Spanish city of Saguntum in his first campaign is now being lost to the Alpine warriors.

The spatial play between near and far in the painting reiterates the connections developed in the poem between past, present, and future. The crimes charged at the opening of the poem call attention to the violence taking place in the foreground, the harsh words mocking the success that Hannibal, somewhere in the middle distance in the painting, expects to enjoy in the future ("still the chief advanc'd, / Look'd on the sun with hope").[27] The shift from foreground to background in the composition is encouraged by the poses of the nearest figures, one of whom is in the act of viewing ascribed to the general. Where Hannibal envisions a promise of a springtime triumph in Rome—we, along with the foreground figure, comprehend its fallaciousness as we see the sun of fairer seasons about to be obscured and engulfed by the winter cloud. Its arching movement returns the eye to the action in the foreground. In effect, time's passage has acquired physical form as one looks at the picture, while the painting's spatial effects take on a narrative role in conjunction with the events recounted in the poem. The simple description of weather and action given in the painting's title is thus fleshed out in the combined visual/verbal work of art into synchronous, contradictory perspectives—human and natural—that lend epic scope to the historical account.

The extent to which one judges the success of the military campaign according to one's *perception* of the episode is underlined in the painting by the noticeable absence of a hero. Though we cannot "see" Hannibal in all his warrior-like glory (presumably he is somewhere in the midst of his thronging troops), his central presence in the verse persuades us to internalize the problems that confront him. The process by which Turner transferred the impact of an historical event from its protagonist to the viewer would be brought to an exquisite end point much later, in *Regulus*. Here, our awareness of Hannibal's expectations alerts us to differing realizations about his fate, from the Salassians' savage wisdom to our own more encompassing, privileged view. The multiplicity of stories related in both painting and poem warn that the historical record is a matter of interpretation, not indisputable fact, and should be treated accordingly.

Turner once again emphasized the equivocation in his interpretation by rendering Hannibal's saga in terms of broad polarities: light versus dark, winter versus summer, victory versus defeat, hope versus hopes dashed. Negotiating between those juxtaposed polarities for a conclusive moral proves to be a frustrating task, for the resolution each seems to offer is immediately suspended by that of its converse. As the relationship between the poem and the painting illustrates, the meaning of a theme must constantly be readjusted in light of the larger context that acts as its background (the identification of the Salassians; the artistic and literary traditions concerning Hannibal; the modern-day viewer's tendency to separate form from content). But that context is not fixed; it alters in response to each revised understanding of the theme. In the terminology of hermeneutics, Turner's depiction of Hannibal's story dramatizes the play between theme and horizon. The *process* of understanding or interpreting that the painting/poem elicits is in fact comparable to the notion of the hermeneutic circle—itself an early nineteenth-century structure of inquiry.[28]

Because an understanding of the work of art entails an evaluation of its parts—parts that can only be understood in the light of the whole that forms their horizon of meaning—the process of hermeneutic understanding is unending and the attainment of a definitive conclusion impossible. As Turner so carefully demonstrated by means of Hannibal's story, an apparent victory can appear from another point of view to be a defeat, and that negative outcome, in turn, may appear a positive end result from the larger perspective of history. The artist himself refused to choose between these positions and structure his painting to render fallacious our hope of privileging one assessment over another. After all, does *Snowstorm: Hannibal and His Army Crossing the Alps* preach against vain hopes or does it commiserate with the general over his ill-fated aspirations? The "loud breeze"

sobs its warning in the last line of the poem, but for whom is it sorrowing?

Turner realized that to understand present realities in the light of history, as well as to reconstruct the past with an awareness of current events, in good hermeneutic fashion, one must exercise due circumspection.[29] The uncertainties and reversals marking the campaigns of Napoleon, Hannibal's modern-day counterpart, provided ample grounds for his wary exposition of the ancient leader's "triumphs." That Napoleon had fostered an association between himself and Hannibal (by means of the inscription of Hannibal's name in David's 1802 equestrian portrait of Napoleon, seen by Turner in the French painter's studio) added authenticity to Turner's proposition about the uncertainty of expectations. Sir Joshua Reynolds had posited in his lectures that "anxiety for the future" was one of the most prevalent of human passions.[30] By building that anxiety into the chronicle of the ancient past Turner could use it to point up the ultimate irony of a tale like Hannibal's. In the wisdom of an astute landscape painter, the general's fate was entirely predictable—writ large for anyone to see in the example of nature and its cycles.

The model that natural law provides is announced in the predominating circular form of both the painting's composition and the rhetorical structure of the poem. The cycle of loss to victory to loss—the reverse (once again) of an ancient paean—recapitulates the vortical movement of the storm around the clearing sky in the painted scene. That shape graphically inscribes in our minds the larger cyclicality of nature, to which the human events, past, present, and future, conform. Turner reinforced the link between man and nature by verbally and visually reiterating the theme of seasonal progression, and by playing on multiple meanings where he could. The word "force," for example, connects the verbal image of a cascade of Salassians with

the icy mountain waterfalls at the right of the painting.

In artistic terms, Turner was demanding that history painting take account of the more lasting "text" that nature offers.[31] Having unsettled the viewer's confidence in historical truth by confounding victory with defeat, he offered landscape painting as a more reliable source from which to acquire understanding of human aspirations. In effect nature subsumes history under its authority in his paintings. Nature's cyclicality underscores the ultimate (in)significance of the endless roll call of dates, battles, and leaders that normally constitutes an historical narrative.

Towards a Revised Ancient History

Turner's study of history did not abate with *Snowstorm: Hannibal and His Army Crossing the Alps*, however apparent and immutable its lesson. The artist continued to muse about the fate of the ancient Carthaginian empire, putting together over the course of his career a rather complete, and certainly thoughtful, account of its rise and fall. He also reviewed the annals of ancient Rome, focusing on the travails of some of Rome's most notable citizens: Regulus, Ovid, Cicero, and Agrippina. Ancient Greece inspired a pair of early paintings that compare the past and present state of popular customs and architectural monuments, and one late work pitting philosophy against art in somewhat humorous terms. As a group the historical paintings reiterate the general message of *Snowstorm: Hannibal and His Army Crossing the Alps* without hardening it into dogma. Turner's attention to the critical process by which one investigates and understands the past insured that each work would review the facts anew and that nature would continue to function as the key text in the endeavour.

Ancient Carthage

Turner's account of Carthage was a composite of myth and documented fact. In the course of ten paintings done over a period of nearly forty years, he explored the legendary founding of the city, treated events connected with each of the three Punic Wars, and detailed both the historic and mythic end of the empire.[32] The artist resisted a programmatic approach, though at some point he did list several of the subjects on the inside cover of his copy of Goldsmith.[33] The order of his paintings in no way corresponds to the correct historical sequence of the events depicted, nor are there any features or details in the settings to establish any narrative continuity from painting to painting. Rather, with Carthage, Turner let his thoughts take him where they would, back and forth across the boundaries between myth and recorded history. By so doing, he created his own expanded version of an epic, one in which the consequences of heroic questing have a bearing on the real world.

Turner did maintain a fundamental distinction between the legendary world of Dido and the historic Carthage: in the mythic realm virtue is intact and hope still possible until the artist's final revision of Dido's story in 1850. While there are allusions to a less-than-happy future in *Dido and Aeneas* (1814; fig. 118), and *Dido Building Carthage* (1815; fig. 47), they are of the gentlest sort: crumbly remains of a bridge where none should be in a newly founded city, a smoking volcano, a haunting inscription to the dead (the paintings based on the *Aeneid* and other ancient epics are treated as a group in Chapter VII). The legendary empire in effect provided the interpretive horizon for the factual record, which in Turner's revised ancient history tallied as one disappointment after another. But the paintings do not

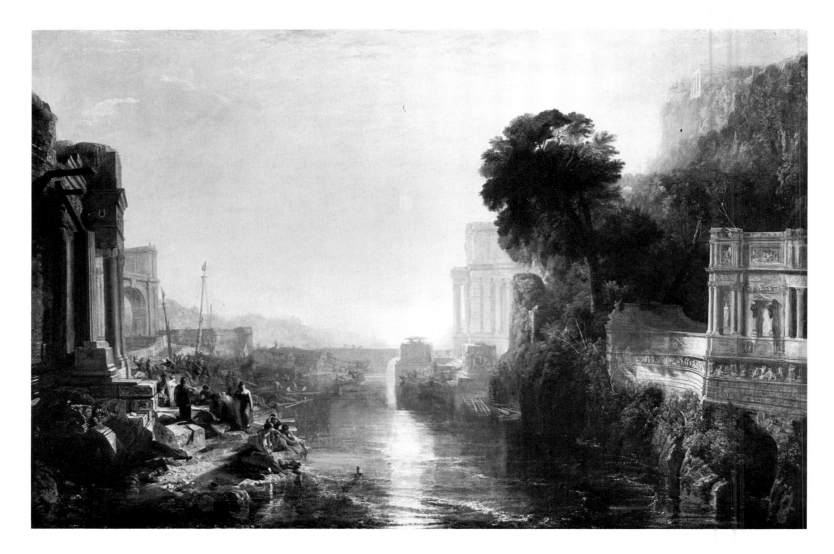

Figure 47. J.M.W. Turner, *Dido Building Carthage*, 1815. Oil on canvas, $61\frac{1}{4} \times 91\frac{1}{4}$ inches (155.5×232 cm), Reproduced by Courtesy of the Trustees, The National Gallery, London (BJ 131).

correspond to a simple "before and after" or myth-versus-reality presentation. Each work is a separate investigation of ambitions and expectations that can corroborate its real or mythic counterpart when juxtaposed with it.

The relationship between *Dido Building Carthage* and *The Decline of The Carthaginian Empire* (1817; color plate 3) embodies just such an interpretive tension. Forming the public centerpiece of Turner's early career, the two paintings, however familiar, bear reinvestigation. The history of their respective sketches establishes that the two compositions were conceived independently. If Turner accorded them the status of pendants in his first will, drawn up in 1829, he subsequently revoked it.[34] Yet the mythic scene functions both as counterpoint and key to its "sequel," painted two years later. A warm sun shines on the legendary rising Carthage, where, following the description of bustling activity in Book I of the *Aeneid*, citizens busily engage in their labors amidst scattered building materials (fig. 48). By contrast, *The Decline of the Carthaginian Empire* is bathed in the lurid light of a sinking sun, which many of the figures in the painting idly turn to watch. An overall feeling of languor replaces the sense of purpose that animates the earlier work. Even the curvilinear forms of the architecture seem to contribute to the melancholy and listlessness that mark the historical Carthage. The one cliché Turner studiously avoided was the symbolization of decline through the presence of ruins; if anything, the "real" city shows all the signs of improvement for which Dido and her followers had striven.[35] The issue that concerned him was moral, not physical, distintegration.

In his view, historical Carthage lacked fortitude and commitment, a shortcoming he adumbrated in the scene of the legendary empire. Dido's vow to found a new city in memory of her dead husband would be tested once Aeneas entered her life. References in *Dido Building Carthage* to the past and future suggest her dilemma. The inscription of her spouse's name, Sychaeus ("SICHAEO"), on the curving wall near the right edge of the painting, recalls her pledge; the prominent, helmeted figure seen from behind on the left side of the composition may be Aeneas, already invading her world (compare his similar costume in *Dido and Aeneas*). In *The Decline of the Carthaginian Empire*, failure to persevere has exacted its price. Its lengthy title reads like a Teletype news report, factual and objective: *The Decline of the Carthaginian Empire—Rome being determined on the Overthrow of Her Hated Rival, demanded from her such Terms as might either force her into War, or ruin her by Compliance: the Enervated Carthaginians, in their Anxiety for Peace, consented to give up even their Arms and their Children*. In fact, it provides an accurate synopsis of the long account in Goldsmith detailing the end of the Third Punic War.[36] For the painting's imagery Turner restricted himself to the latter half of the events narrated in the title. The Carthaginians are shown at their weakest moment, relinquishing the future life's blood of the country. The hopeful ambition embodied in the detail of young boys launching toy boats in the right foreground of *Dido Building Carthage* becomes cruel irony when it is the young men of Carthage who are carried off in Roman vessels.

Turner alluded to the futility of the Carthaginians' concession in verses published in the Royal Academy catalogue. Though not identified as coming from the "Fallacies of Hope," the lines share its general presentiment, the sinking sun at the poem's close marking more than just the day's end:

> At Hope's delusive smile
> The chieftain's safety and the mother's pride,
> Were to th'insidious conqu'rors grasp resign'd;
> While o'er the western wave th'ensanguined sun,
> In gathering haze a stormy signal spread,
> And set portentous.

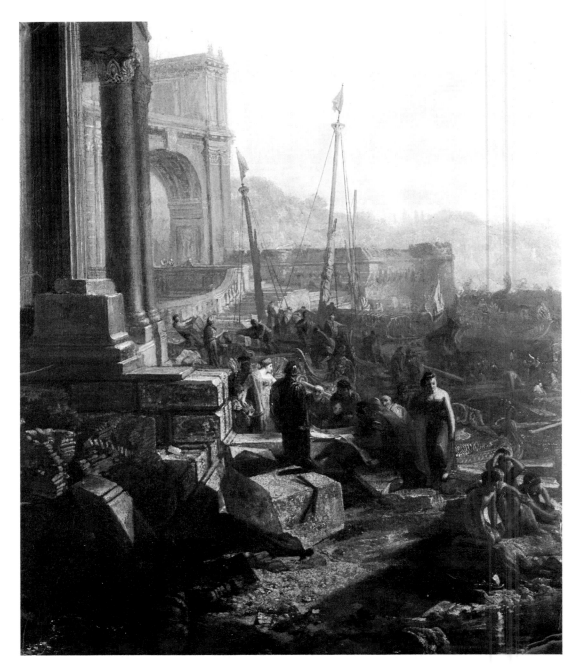

Figure 48. J.M.W. Turner, detail, *Dido Building Carthage*, 1815, Reproduced by Courtesy of the Trustees, The National Gallery, London.

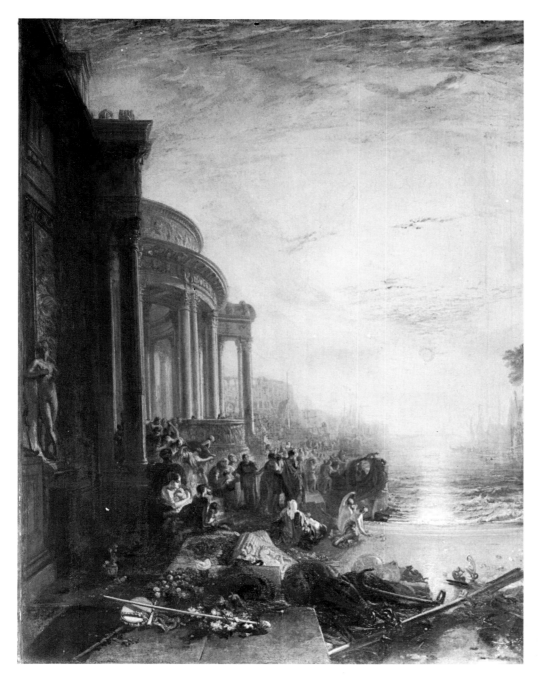

Figure 49. J.M.W. Turner, detail, *The Decline of the Carthaginian Empire*, 1817, Turner Collection, Tate Gallery.

Visual images also menace the scene. A snake slithers through the left foreground still life, just below the fragment of an equestrian frieze (fig. 49). At the left edge of the painting a large statue of Mercury, turned toward the viewer, catches the light. The messenger god had boded ill for the legendary Carthage, since at his insistence Aeneas took his final leave of Dido. Instrumental in one disastrous departure, Mercury's marble image presides over yet another prelude to defeat, his transformation here into a work of sculpture acting as a metaphorical reminder of the eternalizing power of art. Other details in the foreground are teasingly enigmatic. The gold crown encircling an oar near the center might be a visualization of "ruler of the seas." A sleeping dove (just to the left of the frieze fragment), the flowers and melons just below it, the gargoyle (or monkey?) opposite the little statuette of a crouching Venus (near the center foreground), or the sheath of arrows (just right of center) tantalize with their promise of elaborating upon a meaning. Behind the statue of Mercury is a mural that never quite composes into a readable image. It occupies the place where, in *Dido Building Carthage*, Turner had inscribed the painting's title, his name, and date on the unclad wall.

The wealth of symbolic detail and the scene's focus on the setting sun as a natural metaphor for a civilization's fall solicit a broader allegorical reading of the episode. The working analogy in contemporary discourse between Carthage and Rome, and England and France was so natural given the shared, long-standing animosity, that the parallels were drawn in everything from political commentary, to travel literature, to opera. But which modern nation most resembled Carthage, and which one Rome, depended on who was insisting on the resemblance with whom.

Consequently, being identified with one *or* the other could be taken either as an insult or a compliment. The contra-

dictory status of the analogy suggests that Turner's broadly allusive imagery was not only appropriate, but perhaps necessary. The instability of meaning in this case being commonplace, the artist chose to express himself in a corresponding manner.

The most desirable association was obviously with the winning side of the ancient/modern parallel. Not surprisingly, both England and France claimed affiliation with the positive aspects of ancient Rome. According to a favorite fiction, Great Britain had been founded by one of Aeneas' descendants, making it legitimate heir to the glory of the greatest empire of antiquity—an especially useful boast when at war.[37] The French styled themselves Rome's inheritors as well, Napoleon's conquests validating their claim. Occasionally the British would turn French pomposity back on itself. An 1813 review of the popular travel book, Eustace's *Classical Tour through Italy* (which exhorted England to be mindful of Carthage's decline), argued that the modern French had succeeded to the worst qualities of the ancient Romans. "The tyranny of both is stamped with the same features of deformity," the reviewer argued, the most prominent of which was an "unbounded and unprincipled lust of dominion" that made the two civilizations "the disturbers of human repose." The writer later referred to the Romans as the descendants of Romulus—not Aeneas—thus denying France and England a common ancestry.[38]

Given the defeat and total disappearance of ancient Carthage, it was hardly a desirable model for either modern nation. The French apparently had been quick to seize on the analogy of Carthage and England as naval powers, much to the latter's annoyance.[39] Some commentators specified a comparison between Carthage and London on the basis of their mutual reputations for financial enterprise. Goldsmith had argued that the ancient empire was ulti-

mately weakened by its commercial strength and over-abundant material wealth. That observation provided French critics with the basis for a pointed taunt about the modern British city.[40]

Walter Thornbury, Turner's early biographer first proposed that the artist intended the fate of Carthage as a warning to his countrymen.[41] While it is reasonable to assume that *Dido Building Carthage* embodies a general caution about ambition appropriate to events up to 1815, it is much less evident how the message of *The Decline of the Carthaginian Empire* might be applicable. By 1817, the artist would have to have been overly dour, if not downright unpatriotic to have pursued such an analogy. The painting's themes of cowardice and resignation would have sounded a highly inappropriate warning following England's triumph over her old adversary. The British nation was neither guilty of the extreme lack of resolve in dealing with Napoleon shown by the ancient empire in bargaining away its most precious commodity—its sons—nor was it on the short end of the terms set forth in the Treaty of Paris. And years of war and sacrifice had diminished the aptness of Goldsmith's observation about the flaw of wealth. Carthage may have used its money to buy peace rather than work for it, but England certainly had not.

It seems just as likely (if not more so) that in musing on the conditions of surrender and the downward course of empire, Turner had in mind Napoleon and his shattering defeat. The painting's imagery is sufficiently open to support an analogy with France. The lavish still life in the foreground of *The Decline of the Carthaginian Empire* can allude to the pillage and stolen art long at issue, while inscriptions (barely visible in the painting today) echo the link between Carthage and France forged by Napoleon when he had David equate his own alpine heroics with those of Hannibal —an association that, after Waterloo, would have seemed all the more ironic. The name [H]"AMILCAR K" appears in *The Decline of the Carthaginian Empire* along the top of the rectangular portico, beyond the circular temple on the left, while on the wreathed altar to the right are "HANN"[ibal] and an indecipherable word or phrase ("AL CAMMAE SICHII" [?]).

These references to heroes (and events?) of the past are counterparts to the plaque bearing Sychaeus' name in *Dido Building Carthage* but they carry a somewhat more jeering effect. The Carthaginians are in trouble precisely because they did not heed their leaders. They neither maintained the enmity against Rome that Hamilcar, their great general, had urged on his son Hannibal, nor supported the latter once he had crossed the Alps. And when Hannibal failed, his countrymen forced him into exile.[42] Turner, like many Britons, felt some compassion toward Napoleon. Both his 1815 *The Battle of Fort Rock, Val d'Aosta, Piedmont, 1796* and *War, The Exile and the Rock Limpet* (1842) derive from a heartfelt concern for the banished and unrewarded.[43] But if the artist sought to openly instruct "as Carthage, so France," would he have gone so far as to characterize the Romans (and thus, by analogy, the British) as "insidious conqu'rors" in his poem?

Determining the intended references and the exact mood of the painted scene proves to be difficult because Turner developed its imagery following the lesson about interpretation he had learned from *Snowstorm: Hannibal and His Army Crossing the Alps.* He assessed the historical evidence mindful of the differing points of view of the affected parties, ancient, and by association, modern. Hence, the painting stops short of chastising the Carthaginians for their laxness. Its title reminds us that Rome was an implacable foe and that the Carthaginians acted "in their Anxiety for Peace." To see in the theme only a warning about lack of fortitude is to miss the larger point about the folly of warfare.

We have a privileged view into Turner's musings on the historical episode since in this case he worked through his response verbally, in drafts of poetry related to the painting. There, he overlooked the issue of culpability and instead treated ancient Carthage as the injured party, pondering how

> With worse than Punic faith perfidious Rome
> Held forth the peaceful olive or myrtle but round
> The stem insidious twined the asp.

That image is recalled in the painting in the form of a caduceus lightly drawn on the flat surface of the wall's end, just behind the grieving woman in the lower right corner. In other lines of verse he concentrated on the mothers' sorrow and characterized Carthage as "undefending . . . unconscious of the guile," and possibly even as "unoffending."[44] In his poetry Turner projected himself into the historical moment, imagining the losers' perspective. In the painting, he moved to a position somewhere in between the objectivity of the work's full title and the subjectivity of his verse (both private and printed)—between factual and emotional considerations. Having considered all the facets of the issue, he was not disposed to pass a hard and fast judgment. It becomes the viewer's quandary how to define and then apply any secure moral.

Which is not to say that Turner refrained from all comment. An argument developed by James Thomson in his poem "Liberty" might inform Turner's personal interest in the story he told. The poet blamed Carthage for introducing the Romans to "Luxury," which he styled the worst of evils, because its "false joys" resulted in neglect for the arts—the "nobler faculties of bliss."[45] Pointing to the failure of a government or its people to support the fine arts would be an artist's duty after the recent Elgin and Aegina marbles controversies in England. Among the objects in the foreground of *The Decline of the Carthaginian Empire* are musical instruments, statues, garlands, and the fragment of relief suspiciously like the Parthenon frieze. One of the more beautiful details in the painting is the carefully rendered black-figure Greek vase holding flowers in the shadows on the extreme left. And presiding over all these manifestations of the arts is the figure of Mercury, both messenger god *and* patron deity of painters and sculptors.[46] The majority of the Carthaginians are physically removed from the elegant debris and are largely unmindful of it, thus quite literally "neglecting" these manifestations of the arts.

The image of Carthage's decline remains a perplexing one. The inevitability of the portentously setting sun gives this story its fuller dimension and moral resonance, just as seasonal progression and the engulfing storm did that of Hannibal. Hope and ambition, we are reminded, are delusive traps. But at the same time we become aware of the full range of emotions behind the recitation of historical facts, emotions felt as acutely by the nameless as by the notable heroes of the past. That recognition confounds the usefulness or propriety of any admonition against vain aspirations a history painting might deliver. In his presentation of the story, Turner expanded the allegorical mode of representation to include the shifting, personal perspectives that characterize the modern era. Instead of fortifying us with the stern wisdom of an analogy about past and present, he confronts us with the tragedy of impending loss. The very lavishness of Turner's ancient city induces regret that so much beauty and accomplishment cannot somehow prevail.

Ancient Rome

The futility of human striving is a theme that runs through the rest of Turner's ancient history subjects, all of which date from much later in his career. *Regulus* (1828; reworked 1837), *Ancient Italy: Ovid Banished from Rome* (1838), *Ancient Rome: Agrippina Landing with the Ashes of Germanicus*, and *Cicero at His Villa* (both 1839), commemorate individuals who served their state honorably, but did not receive their just rewards. Possibly the artist felt himself in danger of falling into the same situation. In meditating on the progress of civilization as it impinges on the personal level, he repeatedly juxtaposed nature's constancy and intimated the critical role art could, or should, play to ameliorate the sorry state of human affairs. The didactic touch is sometimes light, sometimes heavy, but in either case Turner remained wary of the limitations of historical "fact" and simple moral truisms. His skepticism inspired some of his most poignant paintings.

The artist had come to a conclusion about the lesson of history as it applied on an individual level fairly early in life. He encapsulated it in a rough draft of a poem or essay written sometime around 1810 or 1811 which he titled "The Fate of Man." It began

> Homer a beggar. Plautus turned a mill.
> Terrance a slave. Essop d[itt]o. Boethius
> died in gaol. Paul Borghese had to [?]
> and starve. Tasso was[47]

In Turner's historical tally the rewards for service, genius, or creativity were ingratitude and abuse. All the achievement of the past, all its supposed greatness, was checked by the ignominious ends suffered by those who had contributed so much to it.

Brooding over that injustice led him in later life to revise even the one positive assessment he had allowed himself when young. In another 1811 poem, Turner had lauded the Roman general Regulus' staunch bravery and patriotism in first refusing to bargain for the enemy and then submitting to their punishment:

> Oh! powerful beings, hail! whose stubborn soul
> Even o'er itself to urge our [?] self control.
> Thus Regulus, whom every torture did await,
> Denied himself admittance to the gate
> Because a captive to proud Carthage power,
> But a fierce [?] soul would not the Romans lower.
> Not wife or children dear, or self, could hold
> A moment's parley,—love made him bold,
> Love of his country; but not for aught beside
> He loved,—but for that love he died.[48]

Where this verbal account celebrated the stoic bravery that Wilson and West had illustrated in their paintings of the story (fig. 10), Turner's later painting of the episode insists on a heightened awareness of the general's death at the hands of his captors (fig. 50). The lesson about selflessness in the poem gave way to an expression of pain and sadness, just as the 1828 version of *Regulus* disappeared beneath scumbled and driven layers of white paint in 1837.[49]

To some extent Turner's changed perception about Regulus was in keeping with Romantic attitudes. When popular author Lady Sydney Morgan commented on Salvator Rosa's *The Death of Atilius Regulus* (fig. 51) in her 1824 biography of the Italian artist, she responded to the emotional impact of the general's grisly end, rather than mused about his valor or stoicism. Although she argued for the nobility of Rosa's depiction of the final punishment —Regulus was sealed in a spike-lined barrel—her very language suggests a much more lurid fascination:

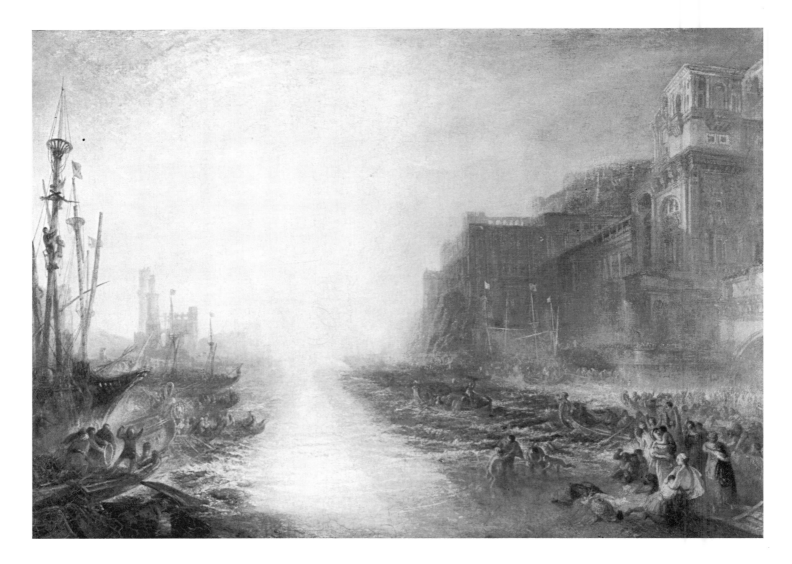

Figure 50. J.M.W. Turner, *Regulus*, 1828, reworked 1837. Oil on canvas, $35\frac{1}{4} \times 48\frac{3}{4}$ inches (89.5 × 123.8 cm), Turner Collection, Tate Gallery (BJ 294).

Figure 51. Salvator Rosa, *The Death òf Atilius Regulus*, c. 1652. Oil on canvas, $62\frac{5}{8} \times 86\frac{3}{8}$ inches (159×219.5 cm), The Virginia Museum of Fine Arts, Richmond.

The story of Regulus, the horrible destiny of a virtuous man and a patriotic citizen, is one of those satires on human society which history unconsciously records but which the genius of Salvator instinctively selected, as accordant with his own views and feelings. In contemplating such scenes, as they are faintly depicted in the page of the annalist, the spirits droop and the heart sickens at the wayward destinies of man; but in gazing on the splendid horrors of the Regulus of Salvator, the spectator revolts from the belief in such atrocities, and taking shelter in the classic skepticism of the age, adds the death of this hero to the list of those "historic doubts," which the more scrutinizing logic of modern criticism raises in the perusal of whatever approaches in its character to the marvelous.[50]

Turner, too, subscribed to the "scrutinizing logic" of his day and thus replaced the sensationalizing horror of Rosa's work with a far less specific, but more disturbing, evocation of the hero's ordeal.

Once again the main character is withheld from our immediate view, leaving us to reconstruct the moment, rather than comprehend the event from the expression or gesture of a prominently placed figure. In *Snowstorm: Hannibal and His Army Crossing the Alps*, Turner allowed us some critical distance since we perceive from a safe remove what the hero could not. In *Regulus*, we lose our status as spectators and become victims too, nature conspiring with the vengeful Carthaginians against us.[51] The first torture they had devised for the general was to cut off his eyelids and then force him to stare into the sun's rays until blinded. In the absence of Regulus we confront the glowing sunlight directly, made acutely conscious of the act of viewing by the quality of the painted surface and the radiant light that at the same time seems to deny its nature as paint. If Turner had read James Thomson's *Liberty* closely, he might even have invested his natural imagery with a double significance, for the poet refers to Rome as "this sun, this centre

of mankind."[52] We would therefore face both the symbolic cause for which Regulus sacrificed himself, and its perversion into the instrument of his torture.

That Turner meant to co-opt us, meant us to share the sensation of being blinded by the light, is confirmed by the succinctness of the painting's title. We are enjoined to confront history on a first-name basis and deal with its unfolding through the experiences of (and *as*) an individual (recall the mythic *Jason*). By providing no further narrative indications in the title or the scene the artist left open whether Regulus is departing for, or from, Rome, or is returning to Carthage. Being told which moment we witness would allow us to fasten onto the externals of the event *as* an event. In not specifying, Turner conflated all the possibilities and thus throws us into a dilemma about where we are (or should be) that recapitulates Regulus' choice whether to remain safe in Rome or return to his enemies.[53]

Other aspects of the setting contribute to its potent, unsettling effect. The overall atmosphere appears stifling. What at first sight appears to be a festive architectural display, on longer contemplation becomes a towering and impenetrable monument to authority. The row of flag-bedecked ships to the left across the bay takes on a more sinister quality too, when coopers are discovered in the foreground at work on a barrel. One of Turner's critics pointed out that he had rendered a normally bewitching Claudean harbor perverse throughout: "instead of repose of beauty—the soft severity and mellow light of an Italian scene—here all is glare, turbulence, and uneasiness."[54] The stillness of the crowd in the right foreground furthers that uneasiness, particularly the spectre-like child at the water's edge just right of center who acknowledges our presence.

The exercise of looking for Regulus (which Turner's contemporaries engaged in as well) is a necessary explora-

tion that uncovers the unusual narrative development of the episode—if also providing its own lesson in futility.[55] The artist must have been amused by viewers like the critic quoted above, who felt that the "only way to be reconciled to the picture is to look at it from as great a distance as the width of the gallery will allow of" so that "you see nothing but a burst of sunlight."[56] Characterizing the work as "scene-painting," he missed the clues that could have alerted him to the power and significance of Turner's transformation of traditional didactic modes of representation (Rosa's and Wilson's) into the language of landscape painting. Ironically, the punishing burst of sunlight proclaims landscape to be a most effective (and affecting) vehicle for understanding the human condition.

Turner continued to probe the lessons of history in *Ancient Italy—Ovid Banished from Rome* (paired with *Modern Italy—The Pifferari*; figs. 52 and 53), making it clear that ancient Rome, perfidious to Carthage, was no less perfidious to its own citizens. The poet's distress is conveyed through the intense yellow coloration and the insubstantiality of the architectural setting that threatens to disappear before our eyes (and Ovid's too). In this case the protagonist is in evidence: on the left, Ovid is being led away by his captors.[57] Turner's narrative explicitness derives from two considerations. First, banishment would be difficult to characterize in some way other than as an overt act of physical removal. No natural effect or landscape form readily equates with the idea of enforced absence. Second, there was little in the way of an established visual or literary tradition for the story against which Turner might have worked, unlike *Regulus.*

Popular accounts of Ovid's life tended to treat his exile as an ignominious footnote. An 1824 publication on the lives of celebrated Romans dismissed him with the abrupt comment that "Exile seems to have deadened the poet's powers."[58] The entry for Ovid in Lemprière's classical dictionary carped that the poet had invited banishment through his romantic intrigues, and once outcast, "betrayed his pusillanimity" by flattering his enemies, thereby disgracing his reputation and exposing himself "more to ridicule than to pity."[59] Turner engaged in no such condemnation, nor did he investigate causes. Like Delacroix in his 1847 and 1859 versions of the already exiled *Ovid Among the Scythians* (fig. 54), he saw the poet as an unfortunate victim.[60] Turner's setting, a reconfigured Rome (note the Arch of Constantine just left of center), looms like a great phantasm, its dwarfing scale emphasizing Ovid's isolation and helplessness. Despite the indication of a crowd in the middle ground behind the captive, the city has an eerie, deserted quality that adds to the poignant emotional tone of the scene. Ovid's possessions, or at any rate a collection of goods including works of art and a large book opened with a golden marker, lie abandoned in the foreground, attesting to the waste of creative talent. A still more foreboding note comes from the tomb in the lower left inscribed, prematurely, "OVID NASOS." The sun hanging low in the sky over a distant arched bridge calls to mind *The Decline of the Carthaginian Empire*, its pervasive yellow light here illuminating the exiled's misfortune.

The following year, 1839, Turner exhibited a group of images that trace a progression from nature's mythological origins (Proserpine's rape), through ancient history (Agrippina in Rome, Cicero at his villa), to the modern Roman Forum in ruins and a counterpart British scene, the ghost of the Temeraire tugged to her last berth. Each painting in some way reflects on change—in seasons, expectations, empires. In each case something has also been lost: the world is robbed of spring; a man his hopes for peaceful retirement; nations their old glory. *Ancient Rome; Agrippina Landing with the Ashes of Germanicus. The Triumphal*

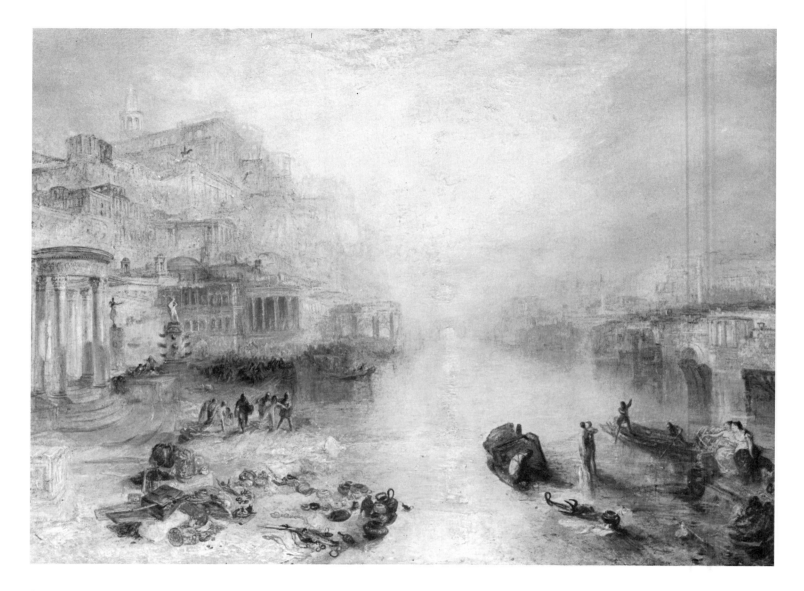

Figure 52. J.M.W. Turner, *Ancient Italy—Ovid Banished from Rome*, 1838. Oil on canvas, $37\frac{1}{4} \times 49\frac{1}{4}$ inches (94.6 × 125 cm), Private Collection, Katonah, New York (BJ 375).

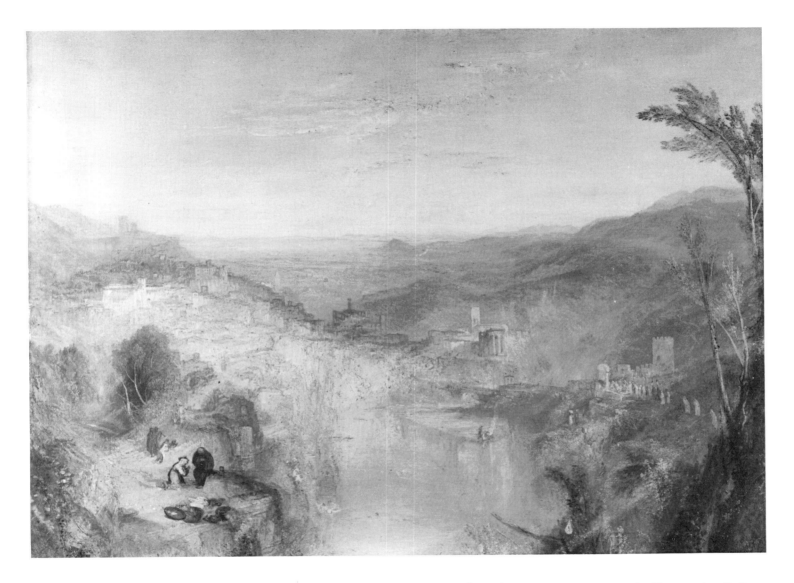

Figure 53. J.M.W. Turner, *Modern Italy—the Pifferari*, 1838. Oil on canvas, $36\frac{1}{2} \times 48\frac{1}{2}$ inches (92.7×123.2 cm), Glasgow Art Gallery & Museum (BJ 374).

Figure 54. Eugene Delacroix, *Ovid Among the Scythians*, 1859. Oil on canvas, $34\frac{1}{2} \times 51\frac{1}{4}$ inches (87.6×130.2 cm), Reproduced by Courtesy of the Trustees, The National Gallery, London.

Bridge and Palace of the Caesars Restored (fig. 55) and its pendant *Modern Rome—Campo Vaccino* (fig. 56) come closest to a traditional demonstration of the effects of time's passage, Turner juxtaposing a resplendent vision of Imperial Rome with a present-day view of its crumbled remains. However, instead of seeing that relationship in conventional eighteenth-century terms, as contrasting states of former glory and present decline, he found a critical rapport between old and new. His adjustments to the historical event narrated in *Ancient Rome; Agrippina Landing with the Ashes of Germanicus. The Triumphal Bridge and Palace of the Caesars Restored* signal his thinking.

The contrast between Benjamin West's famed *exemplum virtutis*, *Agrippina Landing at Brundisium with the Ashes of Germanicus* (1768; fig. 20), and the open-ended imagery of Turner's revised episode could not be more sharp. West's sculptural figures eternally frozen in meaningful poses epitomize ancient devotion to purpose while paying homage to the glory of ancient art. Turner embedded his version of Agrippina's story in a lavish cityscape, the grandeur and audacity of which distracts us from seeking the heroine herself. In terms of composition, it also bears the least resemblance to Turner's favorite artistic model for his classical landscapes of the 1830s: Claude. *Ancient Rome; Agrippina Landing with the Ashes of Germanicus. The Triumphal Bridge and Palace of the Caesars Restored* is thus the most resolutely modern of his ancient settings.

Replacing West's episode of Agrippina's arrival at Brundisium with a reference to her subsequent entry into Rome altered the story's emphasis. According to Goldsmith, once Agrippina had returned to Italy suspicions grew that her husband had not died of natural causes but had been unjustly murdered by his rival. Initially the Romans met her return with shock and stunned silence, though later they broke into loud lamentations against the end of the commonwealth.[61] Turner depicted the figures in his scene as silent to the point of being oblivious. They go about their daily business with no hint of the extraordinary event supposedly taking place. In Turner's reconstruction of the event, Agrippina's valor, and, by extension, the sacrifice of Germanicus, would seem to pass unnoticed.

Although the outward manifestation of power and ambition—the triumphal architecture of the Caesars—rises majestically in the background, it does so, the title reminds us, only through an act of restoration. An etching by Joseph Anton Koch c. 1810 shows the sorry state of the Palatine early in the nineteenth century (fig. 57). Byron had described the decay in vivid language, exclaiming at the close of *Childe Harold's Pilgrimage*, "'tis thus the mighty falls" (Canto IV, cvii). Turner evidently enjoyed the task of rebuilding the site, rivalling the fabrications of Joseph Gandy with his majestic, multi-tiered design.[62] But on close inspection the monuments prove to be flagrantly lacking in solidity, the structures nearest the top looming like an apparition.

The one thing that does endure in Turner's review of the past is nature itself, here benign, but still adding a critical dimension or perspective to our understanding of history. All the missing fanfare appropriate to the historical event invoked in *Ancient Rome; Agrippina Landing with the Ashes of Germanicus* is replaced by the reassuring presence of the natural landscape. Dominating the scene is neither Agrippina and her followers, nor even the architectural display, but the broad, flat, ever-flowing river delicately painted to catch all the nuances of reflected light. The painting's accompanying verse succinctly underscores that emphasis:

———————————————The clear stream,
Aye,—the yellow Tiber glimmers to her beam,
Even while the sun is setting.

Figure 55. J.M.W. Turner, *Ancient Rome; Agrippina Landing with the Ashes of Germanicus. The Triumphal Bridge and Palace of the Caesars Restored*, 1839. Oil on canvas, 36 × 48 inches (91.5 × 122 cm), Turner Collection, Tate Gallery (BJ 378).

Figure 56. J.M.W. Turner, *Modern Rome—Campo Vaccino*, 1839. Oil on canvas, $35\frac{1}{2} \times 48$ inches (90.2×122 cm), Collection of the Earl of Rosebery (BJ 379).

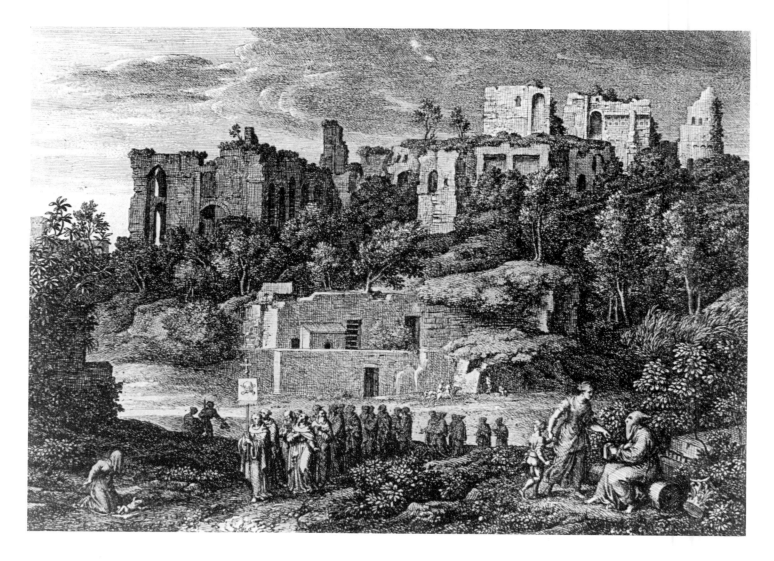

Figure 57. Joseph Anton Koch, *Ruins of the Palace of the Caesars in Rome*, c. 1810. Etching, $6\frac{3}{4} \times 8\frac{7}{8}$ inches (17.1 × 22.5 cm), Library of the American Academy in Rome.

The state may come to its end, foretold by a sinking sun, as it had been in *The Decline of the Carthaginian Empire*, and by the restoration required for the man-made fabric of the city, but the natural landscape prevails. As a reminder, a little boy in the shadows on the lower right reaches out and points to the river.

Turner's larger lesson concerns the way that attentiveness to nature—through the agency of landscape painting—can revise the longstanding cliché about the downward progress of civilization. The respective companion pieces to *Ancient Rome; Agrippina Landing with the Ashes of Germanicus* and *Ancient Italy—Ovid Banished from Rome*, develop Turner's reconfiguration of the past/present comparison.[63] To mark the temporal difference between the two ages the artist employed contrasting compositional formats. The ancient views offer entry into the scene near ground level to encourage the viewer's involvement in the ostensible story being told. The modern views are instead presented from a height that permits us to survey the surroundings and observe various aspects of daily life. From that perspective one sees that nothing is amiss; a felicitous harmony reigns. Turner thus refuted both sides of the eighteenth-century presentation of past versus present. He not only refrained from glorifying ancient heroics (except, perhaps, architectural ones), but also refused to disparage the present day, or even to infuse it with melancholy for what had been lost. In *Modern Rome—Campo Vaccino*, nature has begun a gentle reclamation process on the hillside, while down below, a soft mist cloaks the Forum and seemingly heals its decay. The ancient remains knit harmoniously into one fabric with the later Renaissance, Baroque, and modern buildings, all part of an historical progression.

A more conventional modernization of the eighteenth-century paradigm can be seen in a pair of Roman views painted by Samuel Palmer during his honeymoon there in 1838. Palmer depicted the classical remains *as* remains, showing them deserted in the present day, while the "modern" city, represented by a view of the Piazza del Popolo, appears bustling and festive (figs. 58 and 59).[64] By contrast, when Turner compared two discrete time periods he did so to point up an essential continuity maintained through the agency of nature. That principle was articulated in two lines of verse appended to *Modern Rome—Campo Vaccino*:

> The Moon is up, and yet it is not night,
> The Sun as yet divides the day with her.

They imply that the sun which set on Agrippina's city still sheds its light on present-day Rome, even in its ruined state.[65] Sun and moon also share the sky in *The Fighting Temeraire, tugged to her Last Berth to be broken up, 1838*, where two ages, sail and steam, are in the process of supersession. Turner promoted nature as an order wholly different from the order of history. Where Palmer's scenes convey a positive notion of human progress, Turner's refuse to privilege that perspective. Instead, the artist insisted that we keep in mind the fuller dimension of past and present mediated by, and responsive to, the enduring natural landscape.

Underwriting Turner's approach in *Modern Rome—Campo Vaccino* and *Modern Italy—The Pifferari* was his irrepressible affection for the Italian countryside and fascination with the physical remains of ancient civilization. For all the dismay he may have felt in recalling lessons of human history, he could always be refreshed by the timeless beauty of the Mediterranean region. Though the artist gave the bucolic scenes of *Palestrina—Composition* (c. 1828) and *Caligula's Palace and Bridge* (exhibited in 1831) historical resonance through excerpts from the "Fallacies of Hope," the physical charms of the contemporary landscape resist

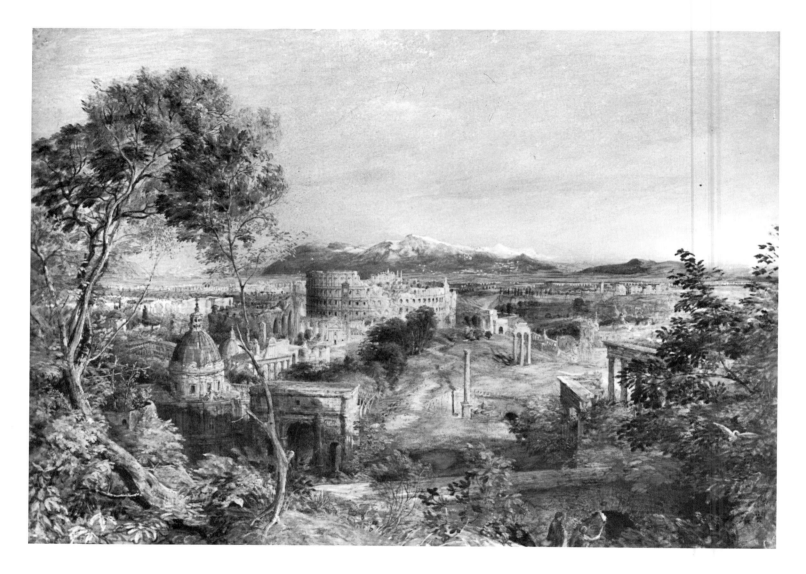

Figure 58. Samuel Palmer, *Ancient Rome*, 1838. Watercolor over pencil, $15\frac{1}{4} \times 22\frac{1}{4}$ inches (38.7×56.5 cm), Birmingham Museums and Art Gallery, Birmingham, England.

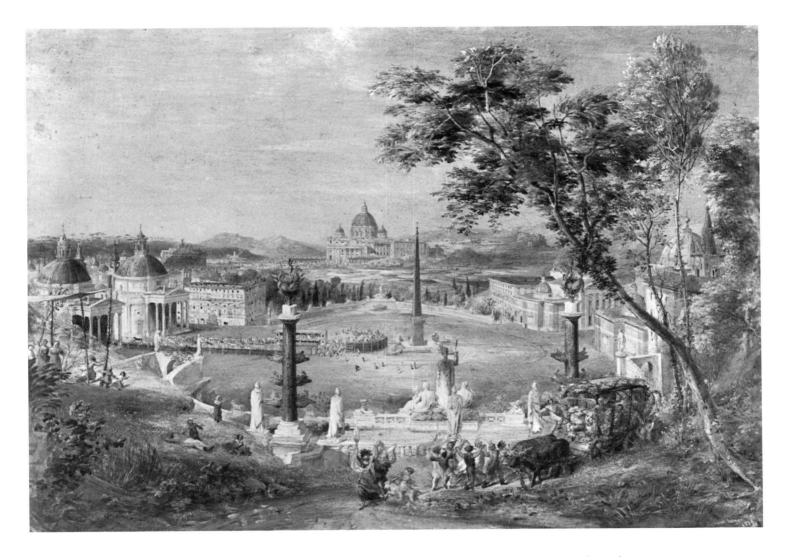

Figure 59. Samuel Palmer, *Modern Rome*, 1838. Watercolor and body color over pencil, $15\frac{1}{4} \times 22\frac{1}{4}$ inches (38.7×56.5 cm), Birmingham Museums and Art Gallery, Birmingham, England.

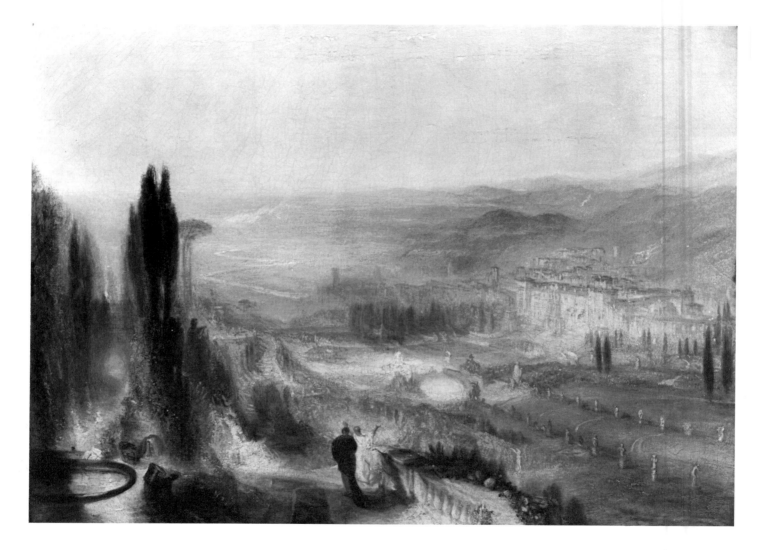

Figure 60. J.M.W. Turner, *Cicero at His Villa*, 1839. Oil on canvas, $36\frac{1}{2} \times 48\frac{1}{2}$ inches (92.7×123.2 cm), Collection of Evelyn de Rothschild, Esq. (BJ 381).

the verses' pessimism.[66] His two modern pendants come close to illustrating Byron's argument that "States fall, arts fade—But Nature doth not die" (*Childe Harold's Pilgrimage*, Canto IV, stanza iii). Ever ready to promote the claims of his calling, Turner argued for some amendment to the middle proposition.

The artist responded to Byron's idea that "arts fade" in *Modern Italy—The Pifferari* (fig. 53). In its particulars the painting's imagery would seem to refer to James Thomson's charge in "Liberty" that the impoverishment of the arts in modern Italy was owed to the stultifying effect of "superstition." Turner's scene of Tivoli, dotted with vignettes of religious devotion, indeed may add up to an indictment of Catholicism.[67] But if the fine arts no longer seem to flourish, from whatever cause (recall that in pagan times, too, poets were denied their voice), simpler pleasures do endure, in the form of music piped by the shepherds of the title. References to music and dance occur in a number of Turner's modern views of ancient sites; by contrast, on the eve of Carthage's decline, musical instruments had been cast aside.[68] It seems unlikely that he would think an art form to be any less valuable for being humble. And in any case, modern times have produced works of art like the landscape before our eyes.

The remaining classical subject from 1839, a scene of Cicero surveying his domain, integrates the thematic concerns of the other ancient history paintings into one dream-like image (fig. 60). History, here construed in terms of cultural progression, is thoroughly embedded within the landscape—Italy as a literal "garden of the world," to quote Byron. Fittingly, the history of Turner's own artistic development figures in the painting as well. Richard Wilson's depiction of the orator at his villa (fig. 11) had impressed him deeply enough to elicit a rare interpretive comment, delivered as part of the "Backgrounds"

lecture.[69] Lamenting Wilson's earlier lack of recognition, Turner praised the way the painting captured the "sigh for the hope, the pleasures of peaceful retirement, or the dignified simplicity of thought and grandeur, the more than solemn solitude that told his feelings." Immediately Turner added the touching observation that "In acute anguish he retired, and as he lived he died neglected."[70]

The ambiguity of the last sentence was economical: is it Cicero's anguish Turner meant, or Wilson's, or both? Painter and orator alike were cheated of a peaceful end. Wilson died in poverty and disrepute; Cicero was forced at the age of sixty-three to flee his villa when his political fortunes changed, only to be caught and murdered (the artist himself was sixty-four in 1839, and had suffered his share of disappointments). Yet the painting's imagery refrains from allusions to the misfortunes to come, offering instead a splendid, undisturbed view of an elegant, welcoming landscape. Seen from behind, the orator in his exclamatory gesture even recalls the staffage figures in eighteenth-century Italian views (compare William Pars' scene of Lake Nemi; fig. 13), but his identity as Cicero signals the anachronistic character of the scene before him. In imagining Cicero's retreat, Turner mixed references to, and monuments from, classical, Renaissance, and contemporary Italy, joining past to present in one continuous flow encompassed by nature.[71] Formal gardens richly decorated with statuary spread out from a post-classical mansion of immense proportions, the abundance of sculpture perhaps another attempt at archaeological restoration.[72] Silhouetted in the shade of the trees in the left foreground, a statue of Apollo with his lyre graces the scene, a reminder that the god of art reigns in such a landscape. *Cicero at His Villa* chronicles several histories at once: the account of the orator's retirement, the expectations and habits of eighteenth- and nineteenth-century English travellers on

the Grand Tour (among whom Turner could count himself), and the progress of art.

If Turner identified with his historical figures, feeling that he shared their aspirations and possibly faced the same sad neglect, he allowed no cynicism or self-pity to impede his own progress. Never knighted, never elected President of his beloved Royal Academy, never free from misunderstanding and sharp criticism, he nonetheless continued to believe in his work, and in nature as its generative source. Given his historical acumen, he must have realized that his art would have an instructive role to play in the future, informing us about the multiple perspectives that shape what we consider to be the meaning of history.

Ancient Greece

Turner painted relatively few works concerned with ancient Greece, one oil early in his career, the other late, and both distinct from each other and from his accounts of ancient Rome or Carthage. He paired the first painting, *The Temple of Jupiter Panellenius, Restored* (1816; fig. 61), which documents ancient architecture and ancient custom rather than treating a specific historical event, with a modern view of the same temple in its current state of ruin, the *View of the Temple of Jupiter Panellenius, in the Island of Aegina, with the Greek National Dance of the Romaika: the Acropolis of Athens in the Distance. Painted from a sketch taken by H. Gally Knight, Esq. in 1810* (fig. 62). The two were an early rehearsal of the before/after or ancient/modern parallels of the 1830s, but conducted with emphasis on Turner's skill at factual, archaeologically correct rendition. Sandwiched between the "high art" accounts of the rise and fall of ancient Carthage, these pendants addressed in a much more documentary manner an immediate political situation both within the realm of art and in contemporary life. The one late painting

concerned with ancient Greece, *Phryne Going to the Public Baths as Venus—Demosthenes Taunted by Aeschines* (1838) (color plate 4) takes delight in openly (one might say brazenly) violating historical truth in order to stage a grand debate between art and philosophy, the senses and reason.[73]

Turner never visited Greece, but he numbered among his friends at least two avid travellers, Henry Gally Knight and C. R. Cockerell, who shared the fruits of their peregrinations with him.[74] The two Temple of Jupiter Panellenius paintings were based on Cockerell's archaeological investigations and, as Turner acknowledged in the second title of the work, Knight's first-hand observation. The temple at Aegina had recently been the object of considerable attention. Inspired by Lord Elgin's success with the Parthenon marbles, Knight, in 1810, tried to purchase the Aegina sculptures for England, only to be routed by the King of Bavaria under suspicious circumstances: the location of the sale had been changed without the British buyer's knowledge.[75]

The two paintings call attention to the need to protect ancient art, by juxtaposing the pristine state of the temple in the past (complete with Turner's reconstruction of the pediment sculptures done in advance of Cockerell's scholarly efforts[76]) with its distressed condition in modern times. In this one instance Turner subscribed to the traditional characterization of the before/after paradigm—but only insofar as it concerned architecture. The similarity of the two compositions calls attention to the temple's loss of roof and pediment, tacitly arguing for the propriety of measures like those taken by Lord Elgin to save the Parthenon sculpture. Turner had been among those voicing support for Lord Elgin's campaign to secure a permanent home for the marbles (subsequently alluding to their neglect in *The Decline of the Carthaginian Empire*). It seems likely he would have supported Knight's efforts as well.[77]

An equally timely issue—Greece's domination by the

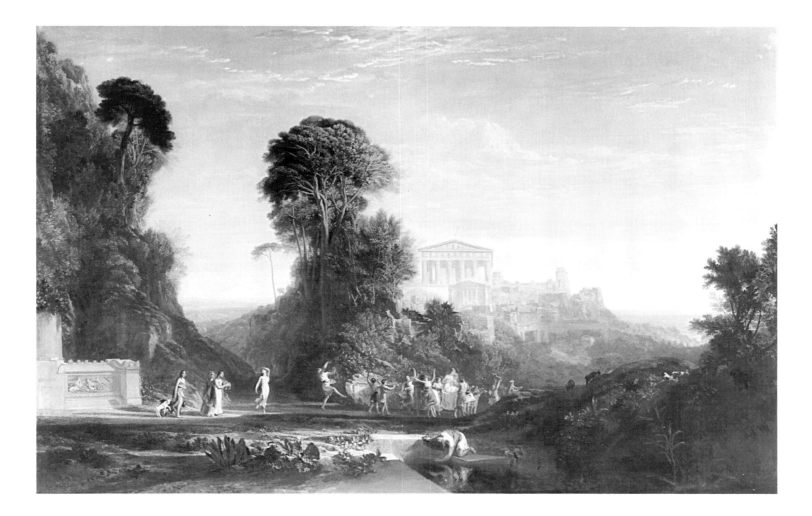

Figure 61. J.M.W. Turner, *The Temple of Jupiter Panellenius, Restored*, 1816. Oil on canvas, 46 × 70 inches (116.8 × 177.8 cm), Private Collection, Katonah, New York (BJ 133).

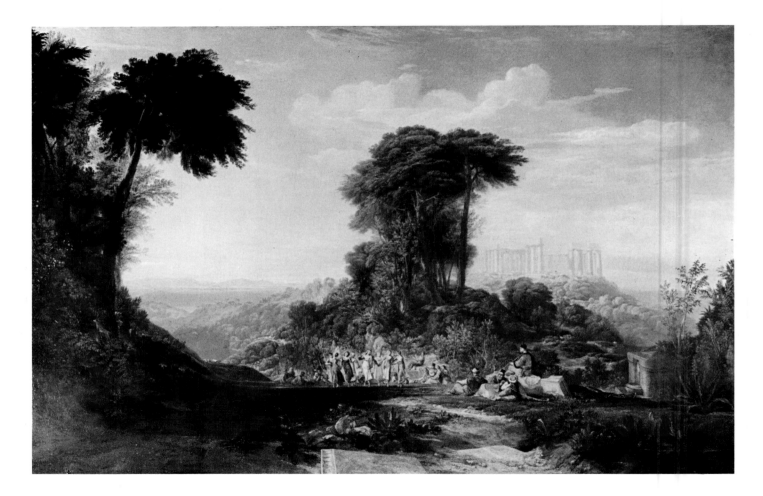

Figure 62. J.M.W. Turner, *View of the Temple of Jupiter Panellenius, in the Island of Aegina, with the Greek National Dance of the Romaika: the Acropolis of Athens in the Distance. Painted from a sketch taken by H. Gally Knight, Esq. in 1810,* 1816. Oil on canvas, $46\frac{1}{4} \times 70$ inches (117.5 × 177.8 cm), the Duke of Northumberland, K.G. (BJ 134).

Turks—underlay the problem of safeguarding ancient art. The topic of Greek independence had been on Turner's mind from as early as c. 1810, when he searched deep into history to find the theme of "Attalus declaring the Greek States to be Free," one of two possible subjects he noted on a sketch of a well-ornamented classical landscape (TB CXX, Miscellaneous:. Black and White, Z). The choice of episode is unusual in Turner's classical oeuvre for its obscurity. Lemprière's classical dictionary identified Attalus as the King of Pergamus who expelled the Gauls from his territory, for which deed the Athenians amply rewarded him.[78] Even Turner's alternative title for the sketch, "Homer reciting to the Greeks his Hymn to Apollo," conjures up a time of peace and unity.

The imagery of the two paintings calls attention to the loss of liberty in modern Greece, but in a typically covert way. Following an 1813 text which cited the Romaika as one example of the survival of older customs like ancient marriage celebrations, Turner supplanted the joyful wedding procession taking place in *The Temple of Jupiter Panellenius, Restored* with a vignette of citizens in the modern age joined together in the country's national dance, the Romaika—one example of unity informing on another more public variety.[79] Thus even as Turner contrasted present ruin with past splendor architecturally, he alluded to a continuity, here cultural, that substantiates a national fortitude noticeably lacking in the case of Carthage. Behind the figures in both paintings the Temple of Jupiter Panellenius (god of *all* the Greeks)—as the Temple of Aphaia was then known—functions as a monument to national unity in the ancient scene, and as the symbol of the Turks' destruction of the Greek State in the modern one.[80]

A different emphasis is supplied by the verses Turner quoted for the ancient view in the Royal Academy catalogue. Taken from Southey's *Roderick, the Last of Goths* (1814) the lines describe a radiant sunrise in the forest:

'Twas now the earliest morning; soon the sun,
Rising above *Aegina*, poured his light
Amid the forest, and, with ray aslant
Entering its depth, illumed the branking pines,
Brightened their bark, tinged with a redder hue
Its rusty stains, and cast along the ground
Long lines of shadow, where they rose erect
Like pillars of the temple.[81]

The poem depoliticizes the pair by marking the temporal beginning of the day and encouraging appreciation of the harmonious integration of nature and civilization in ancient Greece, Turner perhaps using Southey's simile about column-like trees to allude to the origins of architecture in nature. The knowledgeable viewer also might recall that Southey's poem dealt with another instance of oppression, the Moorish conquest of Spain.[82] Thus even in Turner's most archaeological record of history complimentary meanings impart resonance. We can take the two paintings as a celebration of ancient art and architecture (signalled in the titles), as a demonstration of the natural beauty that prevails from one age to the next (argued by the sentiment of the poem), or as the touchstone to an awareness of the Greeks' plight (conveyed by the specifics of the imagery and the original context of the verse).

Phryne Going to the Public Baths as Venus—Demosthenes Taunted by Aeschines also considered the broad topic of the role of art in society, but in a wholly different tone (color plate 4). Exhibited with *Ancient Italy—Ovid Banished from Rome* and *Modern Italy—The Pifferari* in 1838, it offers a quasi-historical episode of Turner's own imagining in which an incident involving ancient philosophers is juxtaposed with one drawn from the annals of ancient art. The painting presents a wholly contrived world that tempers the seriousness of his other ancient historical works with a playfulness characteristic of the late Ovidian subjects. The raking sunlight and steep downward tilt of the foreground toward

the lavish cityscape with its circular "center" immediately draw the eye into the strange proceedings taking place there. The title announces that two narratives operate simultaneously, but the imagery does not readily explain why. Though the scene shares a number of features with *The Parting of Hero and Leander—from the Greek of Musaeus*, exhibited the previous year (color plate 6)—the disorienting light, faint remnants of "paintings" traced in the area of the foreground, and the motif of a bubble—the story does not unfold in the same sequential way, imparting a logic to its multiple parts. Indeed, it presents a puzzle that gave pause to as astute an interrogator of Turner's subject matter as Ruskin. Though he readily offered an interpretation of the theme ("an expression of the triumph of Guilt"), Ruskin included an apology for the artist as well: "There is something very strange and sorrowful in the way Turner used to hint only at these under meanings of his; leaving us to find them out, helplessly; and if we did *not* find them out, no word more ever came from."[83] The painting definitely provides an object lesson for interpreters who expect meaning to be readily accessible.

Turner was aided in his rewriting of history in generous measure by the source material itself. The historical Phryne, an Athenian courtesan of the fourth century BC, was something of a composite character.[84] A celebrated beauty, she supposedly served as the model for Apelles' legendary painting of Venus Anadyomene, as well as inspired Praxiteles, whose mistress she was.[85] Another story recounts how she used her exquisite physical perfection to advantage: on trial for impiety, and aware that condemnation was at hand, she disrobed before the judges, who could only acquit such loveliness. A third exploit reflects on the morals of the Greeks, as much as on Phryne's vanity. So prosperous a prostitute was she that she offered to reconstruct Thebes, providing an inscription be placed on the city walls proclaiming that what Alexander had destroyed, Phryne had rebuilt (a proposition the city fathers decided to refuse).[86] Thus she represented a canon for artists, an ideal of human beauty, and an embodiment of sensual corruption. By casting her in the role of Venus on her way to the public baths instead of to the artist's studio, Turner conflated her various roles, taking care to signal her shifting identity in the title of the painting.

As a counterpart to Phryne's prowess, the story announced in the second half of the title, "Demosthenes Taunted by Aeschines," introduces the themes of philosophy and oratorical skill, and by extension, personal striving, exile, and the shame of harlotry. Historical contemporaries of Phryne, Demosthenes and Aeschines—each of whom also carried multiple associations—maintained a notorious rivalry that descended to personal insult. Where Aeschines boasted of his noble lineage, Demosthenes, a self-made man, accused his competitor of being the son of a courtesan.[87] Eventually Demosthenes vanquished Aeschines in debate and the latter was banished. Both Phryne and Demosthenes were the subjects of paintings in the late eighteenth and early nineteenth centuries, but artists treated their stories individually, in separate episodes.[88] The closest precedent for Turner's curious match perhaps would have been Salvator Rosa's *Phryne Tempting Xenocrates* (in the collection of the Earl of Bessborough) which similarly opposed the sensual with the intellectual, though in a more straightforward confrontation between the two characters seated in three-quarter length against a plain background. Rosa had confounded Phryne with Laïs, another celebrated courtesan, who boasted in vain that she could overcome the strict continence of the philosopher Xenocrates. According to Lemprière, even Demosthenes had sought her pleasures, but when informed that "admittance to her bed was to be bought at the enormous sum of about *300* £ English money, the orator departed, and observed that he would not buy repentance at so dear a price."[89]

Phryne and the two philosophers were in fact "linked" in at least two publications that Turner might have known. The general similarity of the arguments in studies as diverse as Reverend Bromley's tomes on the history of art (see Chapter I), and an article on Grecian women in the *Quarterly Review* in 1819—1820, suggests the currency or familiarity of the connection. Bromley had extolled the ameliorating effects of art demonstrated by the refinement, decorum, and circumspection of life in ancient Greece. He admitted that corruption and excess could still occur, offering as examples the "personal asperities . . . which were thrown upon one another by the Greek orators in their harangues; and particularly by Aeschines and Demosthenes," and, a few pages later, the vanity of Phryne's offer to rebuild Thebes. Bromley explained that in fact "Greece was more corrupt in the sensual passions when the fine arts were at the highest than at any other period."[90]

The author of the *Quarterly Review* essay had been bothered by a related issue, set in a wider context. He wondered how the ancient Greeks, given their love of democracy and high aesthetic ideals, could have ever condoned slavery and encouraged prostitution. He attributed one defense of the latter vice to Demosthenes: courtesans promoted the enjoyment of life by singing, dancing, and, in particular, by enlivening feasts.[91] The author charged that orators, philosophers, and politicians deliberately chose prostitutes as their companions, citing Phryne's extravagance towards Thebes as an indication of prostitution's popularity and prosperity.[92] Greek religion was to blame, for it deified the passions—mythology transforming such corrupting ideas into concrete imagery.

In Turner's painting, Aeschines, the gadfly, gestures (reproachfully?) toward the exotic procession (the prelude to a feast?), perhaps taunting his rival for endorsing such gratification of the senses. It is tempting to see the artist indulging in a bit of playful self-reference here, identifying with Demosthenes harangued by aspersive critics like Aeschines for promoting wantonness. Behind the orators a figure holds up a mirror into which no one looks—a subversion of the *vanitas* motif (like the bubble in the foreground) that may embody Turner's opinion that critics were vainly self-serving.[93] To the left of the two philosophers a stack of paintings rests against the trunk of a tree. Always mindful of the instructive role of nature, the artist depicted the tree bifurcating into barrenness and lushness, a paraphrase of what takes place beneath it. There, his Phryne, as Venus, with her joyous retinue, turns art into the ultimate strumpet, but only in the opinion of peevish old men like Aeschines—or reviewers like one who took Turner to task in 1838 for

showering upon his canvas splendid masses of architecture for distant backgrounds, and figures whereby the commandment is assuredly not broken—and presenting all these objects through such a medium of yellow, and scarlet, and orange, and azure-blue, as only lives in his own fancy and the toleration of his admirers, who have followed his genius till they have passed, unknowingly, the bounds between magnificence and tawdriness. His first landscape is Phryne going to the Public Bath as Venus, in which the wanton lady is positively lost among a crowd of flame-coloured followers—and these, again, show tame beneath such a golden tree as never grew save in the garden of the Hesperides. . . . We would fain escape intolerance and narrowness, but even the imagination of all these gorgeous monstrosities has lost its marvel and its charm for us. We have seen so much of the sorcerer, as to cease to be startled by the "shadows of power" he raises, and to dwell with impatience upon the conjuration (not to call it trick) which produces results so supernatural, but withal so monstrous—. It is grievous to us to think of talent, so mighty and so poetical, running riot into such frenzies; the more grievous, as we fear, it is now past recall.[94]

The painting is its own defense, conveying its moral in terms of the very sensuality at issue. The disorienting pitch

of the foreground, the seducing light that plays havoc with its contours and planes, the uneasy shifts in scale, and the strange, sinuous figures are a dazzling display of stylistic wantonness. Ideal formal beauty has been wonderfully "tarted up"—to keep the language within the spirit of the painting's theme—but all in the service of a flourishing artform: landscape painting.[95]

In *Phryne Going to the Public Baths as Venus—Demosthenes Taunted by Aeschines* Turner rewrote history in order to develop an argument that revises our understanding of the past. In some respects it is his most inclusive historical account, not only because it brings together contrasting realms of inquiry, artistic and philosophical, sensual and intellectual, that perpetually play off each other in a landscape of commanding visual effects, but also because Turner now defined history as something into which art, and by analogy, he himself as artist, must be inscribed. He thwarted our attempt to order the past into a reliable sequence of events by creating an episode that did not exist before its appearance in a work of art, as in *The Goddess of Discord*. But now that "event" concerns the production of a work of art—Phryne *as* Venus—and the circumstances of its reception by critics, Aeschines' taunting. Such a painting, with all its formal and thematic gamesmanship (emblematized in the motif of the frisky dogs with their bubble) in effect becomes its own moral—the only sure one Turner ever really allows us to take away from our study of history as he presented it.

Chapter IV: Notes

1. Typical in its format is "Retrospect of the Fine Arts," *La Belle Assemblee* 2 (1810), pp. 340—41.

2. British Institution Minute Book, 2, p. 134, Meeting of the Directors, May 29, 1810. A month later, they resolved that new subscriptions would be dedicated to furnishing prizes in both history and landscape painting, "looking chiefly to the more elevated branches of Historical and Poetical Composition" (p. 140), but a specific prize for best landscape of the year does not seem to have been awarded until 1814 (see below pp. 227—31). The Institution had sponsored student competitions in landscape prior to that date.

3. *The Diary of Joseph Farington*, 11, p. 3847, entry for January 8, 1811. Something of Turner's concern can also be seen in the provision in his will for a Professorship of Landscape Painting in the Royal Academy, and his proposed old age home for "decayed English artists (Landscape Painters only)," later deleted; see Finberg, *Life of J.M.W. Turner, R.A.*, p. 329.

4. The fullest discussion of Turner's rubrics is in *Notes and Memoranda Respecting the Liber Studiorum of J.M.W. Tuner, R.A. Written and Collected by the Late John Pye*, ed. John Lewis Roget (London, 1879).

5. Royal Academy Catalogue, 1797, p. 9. West did a second version of the *Cicero* in 1804 (Yale University Art Gallery). During the first decade of the century he also explored the conjunction of landscape with classical legend and myth in *Telemachus and Calypso* (1801; Corcoran Gallery) and *Narcissus* (1806).

6. *La Belle Assemblée* 2 (1811), p. 341.

7. The painting is of impressive dimensions: 64 × 101 inches (162.5 × 257 cm). West may have been inspired by Turner's Biblical landscapes dating from the first part of the decade, according to von Erffa and Staley, *The Paintings of Benjamin West*, p. 311.

8. V & A Press Cuttings, 3, p. 891.

9. Martin's appointment came about through a chance reversal in Leopold's fortunes. They had been neighbors before the latter's move to Court; William Feaver, *The Art of John Martin* (Oxford: Clarendon Press, 1975), p. 24.

10. *Annals of the Fine Arts* 1 (1816), p. 434; 2 (1817), p. 580; 3 (1818), p. 665; 4 (1819), p. 254.

11. "An Account of the Public Proceedings and Distribution of the Grand Prizes at the Royal Academy of the Fine Arts of the Royal Institute of France on Saturday, the 4th of October, 1817," *Annals of the Fine Arts* 2 (1817), p. 428.

12. The judges explained that Michallon had excelled first in rendering "le genre et caractère du Site," and then by portraying the figures in a more historical style than the other competitors. The description of the subject issued to the contestants provides an interesting insight into the rather active, extended narrative conceits distilled into figural vignettes in historical landscape:

> Démocrite s'etoit retiré près d'Abdere (ville maritime de la Thrace) dans une solitude agreste ou il se livroit a des études anatomiques dans l'espoir de decouvrir le Siege de l'intelligence humaine. Les Abderitains crurent qu'il etoit devenu fou et inviterent Hippocrate a venir retablir la raison de celui qu'ils croyoient malade. Hippocrate conduit par quelques Abderitains arrive et surprend son ami livré aux études qu'on vient de citer. C'est le moment du sujet qui doit entrer dans le paysage. l'Heure du paysage doit etre le matin; le paysage doit representer un site agreste sans habitation. La ville d'Abdere est dans le lointain.

[Democritus had withdrawn in rustic solitude near Abdera (a coastal city in Thrace), where he pursued his anatomical studies in the hope of discovering the seat of human intelligence. The Abderans thought he had gone mad and invited Hippocrates to restore reason to the apparently sick man. Hippocrates, led by a group of Abderans, arrives and surprises his friend, absorbed in the aforementioned studies. This is the moment that must be included in the landscape. It must be morning, and the landscape must represent a rustic locale without dwellings. The town of Abdera is in the distance.] The documentation for the competition is collected in Phillipe Grunchec, *Le Grand Prix de Peinture* (Paris: Ecole nationale supérieure des Beaux-Arts, 1983), pp. 164 and 339, note 32.

13. Karl Kroeber, in "Experience as History: Shelley's Venice, Turner's Carthage," *English Literary History* 41 (1974), pp. 321−339, established the extent to which equivocation and a considered historical perspective mark the Romantic mind. Study of the idiosyncrasies of Turner's classical iconography led me independently to many of the same conclusions Kroeber articulated. For an opposing point of view see Gage, "Turner and Stourhead," p. 76, who, in discussing many of the same paintings treated here, posited that Turner "expected his imagery to carry a complex yet unambiguous idea." I would argue that in accepting the complexity of events or issues, the artist recognized that he neither could nor should reduce his thinking to finite, unassailable conclusions.

14. The quotation is one of Turner's annotations to his copy of John Opie's *Lectures on Painting*, 1809, transcribed and discussed by Barry Venning, "Turner's Annotated Books: Opie's 'Lectures on Painting' and Shee's 'Elements of Art' (III)," *Turner Studies* 3, no. 1 (1983), p. 35.

15. Ziff, " 'Backgrounds,' " p. 139.

16. Fuseli, *Lectures on Painting*, p. 123.

17. Ibid., p. 143. The distinction he made here also recalls the Reverend Bromley's definition of historical versus poetic painting discussed above, pp. 26−29.

18. Landseer, "British Institution," p. 81. Benjamin West exhibited his *Death of Lord Nelson, or the Naval Victory off Trafalgar* at the Royal Academy in 1811 with a long

descriptive note in the catalogue explaining that "Mr. West, conceiving that such an event demanded a composition every way appropriate to its dignity and high importance, formed it into an Epic Composition. This enabled him to give it that character and interest which the subject demanded."

19. When Turner undertook a commission from George IV in 1822 for a second picture depicting the battle of Trafalgar, he had to deal repeatedly with "advice" from naval experts, to no one's satisfaction. An 1826 review of the painting charged that it was "full of glaring falsehoods and palpable inconsistencies"; quoted in Butlin and Joll, *The Paintings*, 1, p. 157.

20. Ruskin, *Works*, 3, p. 241.

21. The discussion of Turner's 1828 *Boccaccio Relating the Tale of the Birdcage* in Butlin and Joll, *The Paintings*, 1, pp. 151–52, offers a telling instance of the intepretive dilemma that the artist's works can provoke. Acknowledging that he chose his title "for general effect," since Boccaccio's writings include no tale of a birdcage, the authors proceeded to review Jerrold Ziff's proposals for the subject's sources—a "confused recollection" of Samuel Rogers' *Italy* and an "equally confused memory" of a reference to songbirds from a travel guide (p. 151). They concluded, with due hesitation, that if "these influences are correct they illustrate the amazingly unsystematic workings of Turner's mind." The whole discussion tends to deny the artist any poetic license and implies he should have been more literal (and systematic) even when invoking a work of creative fiction (Boccaccio's) as his primary "source." Obviously no similar requirement is placed upon him that he be *topographically* correct when he painted pure landscape. John Gage subsequently pointed out that the painting bears a close resemblance to Thomas Stothard's *Sans Souci* (c. 1817) and other subjects that Stothard based on the *Decameron*—some of which were owned by Samuel Rogers; *J.M.W. Turner, 'A Wonderful Range of Mind,'* (New Haven and London: Yale University Press, 1987), p. 147.

22. The original 1769 edition, which Turner owned, is titled *The Roman History*. I have used a two volume set, the *History of Rome*, 2 vols. (London, 1812), 1, p. 233.

23. The suggestion of Radcliffe as a source was mentioned in Butlin and Joll, *The Paintings*, 1, p. 89.

24. Ann Radcliffe, *The Mysteries of Udolpho*, ed. Bonamy Dobree (London: Oxford University Press, 1966), p. 166. Goldsmith duly included an account of the attack, characterizing it as more of an impediment to the troops than the cold, ice, or altitude, but did not give it prominence or special attention; *History of Rome*, 1, p. 235.

25. The story was recounted by Thornbury, *The Life of J.M.W. Turner, R.A.*, p. 239. Turner had been visiting with his friends the Fawkeses. When the storm came up, he sketched it, and upon displaying his drawing (an unusual gesture for the notoriously secretive artist), he informed his host's son, Hawkesworth Fawkes, that "in two years you will see this again and call it Hannibal crossing the Alps."

26. A full account of the commotion he raised over its display is given in Butlin and Joll, *The Paintings*, 1, pp. 89–90.

27. For a detailed reading of the poem's images see Nicholson, "Turner, Poetry, and the Transformation of History Painting," pp. 94–96. A subsequent study of the poem reaching similar conclusions about Turner's treatment of temporality can be found in Gage, *J.M.W. Turner, 'A Wonderful Range of Mind,'* pp. 192–93.

28. See Fr. D.E. Schleiermacher, "The Hermeneutics: Outline of the 1819 Lectures," translated by Jan Wojcik and Roland Haas, *New Literary History* 10 (1978), pp. 1–16.

29. An example of Turner's interpretive strategy dealing with a topic other than ancient history was discussed by Charles Stuckey in "Turner, Masaniello and the Angel," *Jahrbuch*

der Berliner Museen 18 (1976), pp. 155–75; and Gerald Finley, "Turner, the Apocalypse and History: 'The Angel' and 'Undine,'" *Burlington Magazine* 121 (1979), pp. 685–96.

30. Reynolds, *Discourses on Art*, pp. 145–46, Discourse Eight, delivered December 10, 1778.

31. Compare Caspar David Friedrich's nature symbolism. In his 1806 *Eagle Over Fog-Shrouded Sea*, painted in response to the crushing defeat of the Prussians by Napoleon, he made the eagle a symbol of the German spirit, rising above the storm cloud of the enemy. Lest anyone mistake it for pure landscape, he provided a verbal explanation of the imagery, thus explaining away ambiguities. See Victor Miesel, "Philipp Otto Runge, Caspar David Friedrich, and Romantic Nationalism," *Yale University Art Gallery Bulletin* 33 (1972), pp. 44–45.

32. Paintings concerned with the beginnings of the empire include *Dido and Aeneas* (1814); *Dido Building Carthage; or the Rise of the Carthaginian Empire* (1815); and *Dido Directing the Equipment of the Fleet, or The Morning of the Carthaginian Empire* (1828). *Regulus* (1828, reworked 1837) is related to the First Punic War, c. 250 BC; *Snowstorm: Hannibal and His Army Crossing the Alps* (1812) refers to the Second Punic War, c. 218 BC, while *The Decline of the Carthaginian Empire* concerns the Third Punic War and the empire's historical end, c. 146 BC. The four works exhibited at the Royal Academy in 1850 dealt with the death of the epic Dido.

33. The subjects include, in the order written, "Hannibal Crossing the Alps," "his [Aeneas'?] departure from Carthage and the decline of that Empire," and "Regulus returning." They were preceded by "Cleopatra sailing down the Cyndus," and followed by "Pompey's arrival at [harbor?] after the battle."

34. The paintings' mutual affiliation with Claudean classical landscape may have been foremost in Turner's mind at the time. He stipulated that they be hung with Claude's *Seaport*

with the Embarkation of the Queen of Sheba (fig. 114) and *The Mill*, now identified as *Landscape with the Marriage of Isaac and Rebekah*. In 1831 he amended the bequest, substituting *Sun Rising Through Vapor* for *The Decline of the Carthaginian Empire*; Finberg, *Life of J.M.W. Turner, R.A.*, pp. 330–31.

35. Turner's revision of the past/present conceit bears comparison with eighteenth-century practice, wherein the larger disintegration of society was necessarily equated with physical decay. For example, when Claude's *Seacoast with the Landing of Aeneas in Latium* (LV122), and its companion, *Pastoral Landscape with the Arch of Titus*, (LV182), a pleasantly decorative scene with ruins, were engraved in 1772, they were rechristened the "Allegorical Morning of the Roman Empire," and the "Fall of the Roman Empire" respectively; Roethlisberger, *Claude Lorrain: The Paintings*, 1, pp. 233 and 301. My argument about Turner's understanding of the past/present paradigm and, more generally, the rationale for his fascination with antiquity and Italy was formulated initially in "J.M.W. Turner's Vision of Antiquity: Classical Narrative and Classical Landscape," Ph.D. diss., University of Pennsylvania, 1977. Citing much the same evidence and in some instances using identical comparative examples, Cecilia Powell reached similar conclusions in *Turner in the South* (New Haven and London: Yale University Press, 1987), pp. 166–89. Her focus on the details of the artist's travels in Italy substantiates an understanding of Turner's sources and motives in dealing with antiquity. That emphasis also predicates rather different, and in some cases diametrically opposed, readings of individual paintings than those presented here. The most significant instances of divergence will be noted below.

36. Goldsmith, *History of Rome*, 1, pp. 279–82.

37. The story was reiterated in works as diverse as Dryden's poetry, or Prince Hoare's 1792 opera, *Dido, Queen of Carthage*. On Dryden, see Gage, "Turner and Stourhead," p. 76. William Powell Frith recollected an address to the Royal Academy in which Turner encouraged his fellow Academicians to follow the example of the ancient Romans and work

towards a common purpose; reprinted in Gage, *J.M.W. Turner, 'A Wonderful Range of Mind,'* p. 129.

38. Anon, "Review of Eustace's Tour Through Italy," *Quarterly Review* 10 (October, 1813), p. 228.

39. In an 1816 review of a book on the Congress of Vienna, an Englishman spoke of "the fate of Carthage, too, so often predicted of ourselves from the other side of the water," Anon, "Review of Du Congrès de Vienne, par M. de Pradt," *Quarterly Review* 14 (January 1816), p. 486. One French author explained that the world would one day be too small to accommodate both England and France, and since one of them must fall, it would surely be England because she was already behaving like a latter-day Carthage. He further related that Lord Chatham, foolishly expecting to ruin France, had "instilled into his son William, as Hamilcar had done unto Hannibal, an implacable hatred of the French," the lesson of history obviously having been lost on him, Anon, "Works on England," *Quarterly Review* 15 (July 1816), p. 549.

40. Goldsmith, *History of Rome*, 1, p. 213. An English reviewer noted with dismay that an 1815 French treatise on modern-day Great Britain could not begin without such a comparison: "Carthage," the author says "was a golden Colossus with feet of clay, which the sword of the Romans overthrew, 'et Londres est peut-être chancelante sur ses monceaux de guinées,'" Anon, "Works on England," p. 548.

41. Thornbury, *The Life of J.M.W. Turner, R.A.*, p. 433. John Gage, *J.M.W. Turner, 'A Wonderful Range of Mind,'* pp. 211–12, suggested that Turner found support for this reading of the "as Carthage, so Britain" warning in the thinking of his friends Granville Penn and Lord Carysfort.

42. Goldsmith, *History of Rome*, 1, pp. 245–55; 275.

43. See also an 1832 watercolor vignette, *Napoleon Leaving Fountainbleau*, from the collection of Kurt Pantzer. The 1815 *Battle of Fort Rock, Val d'Aosta, Piedmont, 1796* marked Napoleon's downfall by commemorating an earlier French triumph. Its verse, also from the "Fallacies of Hope," paid the foreign invaders (who, in 1796, did not actually include Napoleon) no small compliment by equating their force with that of nature:

> The snow-capt mountain, and huge towers of ice,
> Thrust forth their dreary barriers in vain;
> Onward the van progressive forc'd its way,
> Propell'd, as the wild Reuss, by native Glaciers fed,
> Rolls on impetuous, with ev'ry check gains force
> By the constraints uprais'd; till, to its gathering powers
> All yielding, down the pass wide devastation pours
> Her own destructive course. Thus rapine stalk'd
> Triumphant; and plundering hordes, exulting, strew'd,
> Fair Italy, thy plains with woe.

Turner could afford to be generous where fate had not.

44. TB CXL, "Richmond Hill. Hastings to Margate," 1815–1816, 4, 7a, 8, 11, 11a, 12. Unfortunately, Turner's handwriting tends toward illegibility there. John Gage, *J.M.W. Turner, 'A Wonderful Range of Mind,'* p. 212, pointed out the similarity between the imagery and moral of *The Decline of the Carthaginian Empire* and Lord Carysfort's intepretation of the episode in his play "The Fall of Carthage," citing Carysfort's lines:

> Ye cities! and thou, Carthage! Chief, where lull'd
> By soul-corrupting wealth, thy *dastard* sons
> Upon the altar of luxurious ease
> Have bound their country's glory! [*my italics*]

The mood of Turner's verse and the complexity of his characterization of the incident would seem to contrast markedly with the clichéd sentiment of Carysfort, however.

45. James Thomson, *Liberty*, Part III, "Rome," lines 373–82; *The Complete Poetical Works of James Thomson* (London: Oxford University Press, 1908), pp. 350–51. Turner's interest in

ancient appreciation for the arts was discussed by Jerrold Ziff in "Turner, the Ancients, and the Dignity of the Art," *Turner Studies* 1, no. 1 (1981), pp. 45–52.

46. The tradition of the arts as the "children" of Mercury had its origin in Renaissance astrology. The god is often depicted in the form of a statue, for example in one of Hendrick Goltzius' drawings for a series on the planets dating from 1596, or in Chardin's *Attributes of the Arts*, 1766. The theme was discussed by Anne-Marie Lecoq in *La peinture dans la peinture*, ex. cat., Musée des Beaux-Arts de Dijon (1982–1983), pp. 30–33.

47. TB CXIV, Windmill and Lock Sketchbook, 1810–1811, 2a–3. The roll continues for an additional fourteen lines, each more illegible than the last. A few names and some telling words that can be deciphered are "Bentivoglio," "Vauglauo[?] lost [or left] his wife for his debts," "Penrose steals [?] as war and fears / a Bailiffs . . . died / Poor chap." A variant reading of the title could be "The Tale of Men."

48. TB CXXIII, Devonshire Coast No. 1, 1811. This is one of the many poems, or fragments of poems, interleaved in Turner's copy of *The British Itinerary* (London, n.d.). No single thought is sustained for more than a dozen lines, and there is a great deal of mental meandering. Wilton, *Turner and the Sublime*, p. 143, suggested that his ultimate source was an Horatian ode, but the artist's verses seem to me more like an original meditation on Wilson's *Departure of Regulus*.

49. No commentary exists on the state of the painting or on the emphasis of its imagery in 1828 when it was exhibited in Rome. Butlin and Joll, *The Paintings*, 1, p. 173, included an account of its repainting at the British Institution in 1837.

50. Lady Sydney Morgan, *The Life and Times of Salvator Rosa*, 2 vols. (London, 1824), 1, pp. 352–53.

51. John Gage provided a sensitive analysis of the painting's tragic theme and the role Turner assigned to the viewer in *Color in Turner*, p. 143, to which my discussion is indebted. In contrast, Andrew Wilton found such a role for the viewer in *Regulus* "so unorthodox indeed that Turner himself may not have intended it"; *Turner and the Sublime*, p. 142. Offering a very different conclusion, Cecilia Powell characterized *Regulus* as "an optimistic and positive painting, a celebration of light and the visible beauties of the world," based on the work's "intrinsic beauty," the dual context of its initial Roman audience and its Claudean inspiration, and Powell's belief that "it would have been very uncharacteristic of Turner to make human physical suffering or torture the central theme and raison d'être of a painting"; *Turner in the South*, pp. 148–51. Her response would seem to fit the *circumstances* of 1828, rather than the version of the painting produced in 1837. The tone of *Ancient Italy—Ovid Banished from Rome* (1838) suggests the artist was entirely capable of conveying sorrow and pessimism.

52. James Thomson, *Liberty*, Part I, "Ancient and Modern Italy Compared," line 104 (*The Complete Poetical Works*, p. 315).

53. Scholars have been taunted by the problem of just where the scene is set, and whether Regulus is coming or going. Gage, *Color in Turner*, p. 147, went to the length of retitling the painting *Departure for Carthage*, to make the moment more precise, an interpretation with which Wilton concurred in *Turner and the Sublime*, pp. 142–43. When Turner wrote his list of subjects on the inside cover of his copy of Goldsmith, he noted only "Regulus returning." The 1840 engraving by D. Wilson after the painting is titled *Ancient Carthage—the Embarcation of Regulus*. To have Regulus leaving Rome imparts a sense of anticipation for the coming horror. However, if Regulus is returning to Carthage—to fill in the blank in Turner's own equivocal notation—then the mood and sense of danger is more acute, and details like the barrel more threatening.

54. *The Spectator*, 11 February, 1837, quoted in Butlin and Joll, *The Paintings*, 1, p . 173.

55. Wilton would like to recognize *Regulus* as one of the tiny figures on the terrace at the far right, near the ships in middle distance; *Turner and the Sublime*, p. 143. In the 1840 engraving after the painting, one figure in that area does stand out as taller and whiter than the rest, but it is still so miniscule as to convey no information at all about Regulus. Powell insisted that Regulus is the figure in the lower left "with both arms raised, in a posture suggesting defeat and in the garments of a slave or captive"; *Turner in the South*, p. 148. The figure appears to be holding a mallet, very like the coopers in Rosa's *Death of Regulus*, and more likely is one of the workmen in that group. Since Turner painted *Regulus* at the same time as the *Vision of Medea* (color plate 8), with its prominent main figure, surely he understood that the narrative effect of a scene without an obvious protagonist, as in *Regulus*, would be quite different.

56. Butlin and Joll, *The Paintings*, 1, p. 173.

57. John Gage, in "Picture Notes," *Turner Studies*, 3, no. 1 (1983), pp. 58−60, suggested that the figure being led away is "too young and informally dressed" to be the poet. He proposed that Ovid is in a boat in the middle distance, left of center. But as Butlin and Joll noted, an identification of the more prominent figure in the foreground must then be offered; Butlin and Joll, *The Paintings*, 1, p. 227.

58. Reverend William Bingley, *Biography of Celebrated Roman Characters* (London, 1824), p. 325.

59. Lemprière, *Bibliotheca Classica*, "Ovid," p. 422.

60. Delacroix commiserated with Ovid's plight in his work for the library of the Palais Bourbon, 1847, and in the small oil reproduced here, commissioned from him in 1856, and now in the National Gallery, London. When Baudelaire reviewed the painting in the Salon of 1859, he found its "sad voluptuousness" worthy of praise:

> just as exile gave the brilliant and elegant poet the sadness he lacked, so melancholy has brought its magical patina to the lush landscape of the painter. It is impossible for me to say that such and such a painting by Delacroix is the best of his pictures, because they are always wine from the same barrel, heady, exquisite, *sui generis*, but it can be said that *Ovid Among the Scythians* is one of those astonishing works such as Delacroix alone knows how to conceive and to paint.

Translated in Maurice Serullaz, *Eugene Delacroix*, (New York: Abrahms, n.d.), p. 156.

61. Goldsmith, *History of Rome*, 2, pp. 122−23.

62. John Gage listed a number of eighteenth- and early nineteenth-century attempts at reconstructing the Palatine to which Turner might have been indebted in *J.M.W. Turner*, ex. cat., Grand Palais (Paris, 1983−84), p. 132.

63. Luke Herrmann, *Turner* (Boston: New York Graphic Society, 1975), p. 45, suggested the pairs were designed to capitalize on the growing market for large scale prints after paintings. While pecuniary interests were probably never far from Turner's mind, he nevertheless selected images that presented a challenge thematically and formally. The visual effects that he used to enhance his narratives were not easily rendered by engraved line, to judge by the instructions he issued; see *Collected Correspondence of J.M.W. Turner*, pp. 184−85.

64. Powell explained that Palmer was following the practice of nineteenth-century guidebooks in separating the modern-day city into its different historical fabrics; *Turner in the South*, pp. 183−84.

65. Lindsay, *Sunset Ship*, p. 50, proposed that the two light sources symbolize the two ages represented in the painting. Turner's verse tag is a close paraphrase of lines from Canto IV, xxvii, of *Childe Harold's Pilgrimage*. They immediately follow the section of Byron's poem that Turner appended to his 1832 painting entitled *Childe Harold's Pilgrimage—Italy*:

> '—and now, fair Italy!
> Thou art the garden of the world.

> Even in thy desert what is like to thee?
> Thy very weeds are beautiful, thy waste
> More rich than other climes' fertility:
> Thy wreck a glory, and thy ruin graced
> With an immaculate charm which cannot be defaced.'

In this case Turner had boldly juxtaposed his visual imagery with the work of a contemporary poet. One critic praised the painting as "the poetry of art and of nature combined, [bearing] the same relation to the real scene as does Byron's description." Fellow artist Richard Westmacott went so far as to call the painting "the most magnificent piece of landscape poetry that was ever conceived"; Butlin and Joll, *The Paintings*, 1, p. 194.

66. See below, pp. 249 and 252 for the respective poems. The lines for *Palestrina* call to mind Hannibal and his futile ambitions once again, while the verse for *Caligula's Palace and Bridge* addresses the Roman emperor about the outcome of his folly.

67. The topic of modern religion was discussed in a number of sources with which Turner was familiar. In the Reverend John James Blunt's *Vestiges of Ancient Manners and Customs Discoverable in Modern Italy and Sicily* (London, 1823), a copy of which Turner owned, the author drew parallels between pagan worship and contemporary Catholic practice as part of a generally derogatory discussion on the modern faith. He also made reference to the Pifferari, shepherds who played pipes on religious holidays. John Gage suggested that Turner used the Ancient Italy/Modern Italy pendants to demonstrate Blunt's point, since the Reverend had also cited Ovid as a source for ancient customs; Gage's thesis was summarized in Butlin and Joll, *The Paintings*, 1, p. 226. Another influence on the painting may have been David Wilkie's 1829 oil, *The Pifferari (Playing Hymns to the Madonna)*, shown at the Royal Academy and subsequently purchased by George IV; Herrmann, *Turner*, p. 45. Turner followed Wilkie's keynote, but diffused the religious theme throughout his own scene. He even included, in the lower right middle ground, two women with the same curious headresses that Wilkie depicted.

68. Greek youths dance the Romaika in the *View of the Temple of Jupiter Panellenius, in the Island of Aegina, with the Greek National Dance of the Romaika* (1816); the woman in the foreground of *Forum Romanum* (1826) has a lute beside her; in the foreground of *Palestrina—Composition* (1828) a man plays a flute; and in *Childe Harold's Pilgrimage—Italy* (1832) a man dances with glee.

69. There were also a number of literary sources for the theme, including Samuel Rogers' *Pleasures of Memory*, the appropriate lines of which Turner checked off in his copy of the collected *Poems* (London, 1827), with the intention of illustrating:

> So Tully paused, amid the wreck of Time,
> On the rude stone to trace the truth sublime;
> When at his feet, in honored dust disclosed,
> The immortal sage of Syracuse reposed.
> And as he long in sweet delusion hung,
> Where once a Plato taught, a Pindar sung;
> Who now but meets him musing, when he roves
> His ruined Tusculum's romantic groves?
> In Rome's great forum, who but hears him roll
> His moral thunders o'er the subject soul?

In Thomson's *Liberty*, pt. 1, Tusculum is mentioned as being changed beyond recognition (line 274). Neither poem matches Turner's mood. The artist's copy of Rogers' *Poems* is catalogued as TB CCCLXVI.

70. Ziff, "'Backgrounds,'" p. 147.

71. For an identification of the monuments and aspects of the scenery, see William Chubb, "Turner's *Cicero at his Villa*," pp. 417–21, who connected some on-the-spot sketches of the villas near Frascati done during Turner's 1819 tour with the artist's interest in Wilson's painting. Powell, *Turner in the South*, pp. 170 and 175, recognized references to Tivoli and the Barberini and Farnese gardens. Her assessment that Turner painted *Cicero at His Villa* "in deliberate rivalry" with

Wilson misses the point of his emphasis on artistic heritage, a history in which he was himself inscribed.

72. Byron's note to Canto IV, clxxiv, of *Childe Harold's Pilgrimage* described the villa at Tusculum, adding that "many rich remains have been found there, besides seventy-two statues of different merit and preservation, and seven busts."

73. In the interim Turner continued to deal with the topic of Greece in the series of illustrations he was commissioned to make for Byron's poems. He produced a total of twenty-six designs for three different editions of Byron's work published between 1825 and 1834; see Mordechai Omer, *Turner and the Poets* (London: Greater London Council, 1975), n.pag.

74. For a detailed survey of Turner's association with Greece, see John Gage, "Turner and the Greek Spirit," *Turner Studies* 1, no. 2 (1981) pp. 14–25.

75. Recounted by C.R. Cockerell in *The Temples of Aegina and Bassae* (London, 1860), pp. ix–x.

76. Gage, "Turner and the Greek Spirit," p. 18, proposed that architect Thomas Allason acted as an intermediary, communicating Cockerell's ideas before they were published in 1818 and 1819. Turner also anticipated working up watercolors from Cockerell's excavation drawings in the early 1820s, but only one example came of their collaboration, a watercolor of the temple and the excavation site, which Cockerell included, in engraved form, in *The Temples of Aegina and Bassae*.

77. Byron had expressed a contrasting sentiment in the "Curse of Minerva," 1811, charging that England had participated in the rape of Greece by stealing her treasures. Turner had been among the first to congratulate Lord Elgin for rescuing the Parthenon marbles. In his enthusiastic letter to Lord Elgin he stated that the sculpture represented "the most brilliant period of human nature" and even included a quote from Horace's *Ars Poetica*, in Greek; *Collected Correspondence of J.M.W. Turner*, p. 31.

78. Lemprière, *Bibliotheca Classica*, "Attalus," p. 93. Gage suggested that Turner found the subject in his copy of Plutarch's *Lives*, where Attalos I Soter, King of Pergamon speaks out against Philip of Macedon's invasion of Thebes; "Turner and the Greek Spirit," p. 24, note 17.

79. Gage identified F.S.N. Douglas' *Essay on Certain Points of Resemblance between the Ancient and Modern Greeks* as Turner's source for the Romaika; "Turner and the Greek Spirit," p. 18.

80. Jack Lindsay argued that Turner was here calling for the renewed freedom of the beleaguered modern Greeks, in *J.M.W. Turner* (New York: Harper and Row, 1966), p. 141. Gage, in "Turner and the Greek Spirit," pp. 16 and 18, attributed the source of the political message to H. Gally Knight's 1817 poem, *Phrosyne: A Grecian Tale* (itself modeled on Byron's indictment of the Turks in *Childe Harold's Pilgrimage*) which includes the following lines:

> "And, join'd in troops, the children sport around—
> Smiles all the scene, and gives to Fancy's eye,
> One glimpse of ancient Greece and Liberty.
> —(Canto 1, 11, 193–95)

Gage would have the continuity serve as a lesson for England.

81. Butlin and Joll, *The Paintings*, 1, pp. 97–98, printed a variant of the poem, with "Abardos" replacing "Aegina." Both names appeared in different printings of the Academy catalogues.

82. Though Turner did not identify Southey as the poem's author, critics like William Hazlitt recognized the source. Hazlitt commented on the artist's translation of the poet's "natural description," but did not discuss the implications of the poem's theme; Butlin and Joll, *The Paintings*, 1, p. 99. Since Turner's conception of the two views of the temple strikes a close parallel with Byron's description of Greece's enduring natural beauty in *Childe Harold's Pilgrimage* (Canto II, lxxxv–lxxxvii), published in 1812, perhaps the artist cited

verses by Southey to downplay any immediate identification with Byron's poems.

83. Ruskin, *Works*, 13, pp. 107—109; 151—58. He formulated his reading by comparing *Phryne going to the Public Baths as Venus* to the 1805 *Shipwreck*, in which he felt Turner was expressing "his sympathy with the mystery of human pain."

84. For a detailed examination of the painting's iconography and its sources, see Nicholson, "J.M.W. Turner's Vision of Antiquity," pp. 236—43, or, more recently, Thomas Coolsen, "Phryne and the Orators: Decadence and Art in Ancient Greece and Modern Britain," *Turner Studies* 7, no. 1 (1987), pp. 2—10.

85. Ziff, "Turner, the Ancients, and the Dignity of Art," p. 48 and note 26, suggested that the artist might have been inspired to paint Phryne by her inclusion in three separate places in Franciscus Junius, *Painting of the Ancients* (1639), which Turner both read and annotated. Junius only refers to her role as model for Apelles and Praxiteles. However, the third reference explains that she may have served for a sculpture of a rejoicing whore: "It is thought that it is Phryne, and many doe perceive in her the love shee bore the Artificer [Praxiteles], and a reward withall in the countenance of the whore" (p. 298).

86. Lemprière, *Bibliotheca Classica*, entry for "Phryne," p. 473, identified the source of the first and third anecdotes as Pliny, *Natural History*, 34. For the first, see also the entry for "Praxiteles," p. 503. Phryne was frequently confused with two other Greek beauties, Laïs and Campaspe. For the second anecdote Lemprière cited Quintilian, II, Ch. 15.

87. Lemprière, *Bibliotheca Classica*, "Demosthenes," pp. 107—109, and "Aeschines," p. 18.

88. Examples include Henry Tresham's 1789 *Phryne at the Possidonian Feasts*, which Finberg proposed as the inspiration for Turner's subject, *Life of J.M.W. Turner, R.A.*, p. 370; John Martin's *Demosthenes Haranguing the Waves* (c. 1837);

and Delacroix's *Demosthenes by the Seashore*, now in the National Gallery of Ireland. The latter two works celebrate Demosthenes' oratorical skills. Marcel Roethlisberger noted a renewed interest in the orator in the nineteenth century, following publication of editions of his speeches. He cited as an example the nineteenth-century rechristening of Claude's *Ezekiel Deploring the Fall of Tytus* as *Demosthenes*; "The Subjects of Claude Lorraine's Paintings," *Gazette des Beaux-Arts* 55 (1960), p. 210.

89. Lemprière *Bibliotheca Classica*, "Laïs," p. 309.

90. Bromley, *A Philosophical and Critical History of the Fine Arts*, 1, pp. 92—97.

91. Anon, "State of Female Society in Greece," *Quarterly Review* 22 (1819—1820), pp. 191—92.

92. Ibid, p. 200.

93. In his annotations to Martin Archer Shee's *Rhymes on Art*, Turner remarked, "It is not the love of art that tempts the critic, but vanity"; see Barry Venning, "Turner's Annotated Books: Opie's 'Lectures on Painting' and Shee's 'Elements of Art' (II)," *Turner Studies* 2, no. 2 (1983), p. 42. When the topic of vanity appeared in Turner's sources on ancient art, the artist was equally ready to comment upon it; Ziff, "Turner, the Ancients, and the Dignity of Art," p. 46.

94. The comments appeared in Anon, "Royal Academy," *Athenaeum*, May 12, 1838, p. 347 and were reprinted, in part, in Butlin and Joll, *The Paintings*, 1, p. 224.

95. Thomas Coolsen felt the moral pertained as much to societal decadence as to "proper" artistic demeanor; "Phryne and the Orators: Decadence and Art in Ancient Greece and Modern Britain," p. 7—9. The detail of paintings stacked on the ground behind and to the left of the two philosophers seems to me the keynote to the painting's primary thematic emphasis.

V *A Grammar of Conventions: Turner's Reading of Ovid*

The sadness that pervades *Ancient Italy—Ovid Banished from Rome* reflects Turner's sympathy for a kindred spirit (fig. 52). He had entered the world of Ovid's *Metamorphoses* with abandon, exploring its passions and intrigues in a remarkable group of early sketches (c. 1805), in a set of drawings and etchings for his *Liber Studiorum* project (1806–1819), and in a series of paintings dating from the first decade of the century to the early 1840s. The poem brought out the best of Turner's interpretive instincts. He had no need for intermediaries such as the famous *Ovide Moralisé* or the many eighteenth-century treatises on mythic symbolism to understand the poem's deeper meaning.[1] Instead, he engaged the narratives directly, realizing through his sensitive appraisal of the *Metamorphoses* the extent to which Ovid's landscape settings served as more than just background for the poet's episodes.

Indeed, the poem's subject matter presented Turner with a ready-made context for telling a story with the elements of nature. He neither had to revise the material of the *Metamorphoses* nor in any way contrive his scenes for the sake of the landscape "setting." This advantage encouraged the artist to experiment formally, first by integrating observed naturalistic detail into the narratives—vindicating Wilson's perceived fault in *The Destruction of Niobe's Children* —and later, by effecting his own transformation of natural elements into pure painted effect. In his Ovidian works Turner's interest in narration and meaning meshed perfectly with his equally intense study of the means of expression at his command.

Underwriting this cogent formal investigation was his appreciation of the long tradition of Ovidian painting into which he willingly inscribed himself. Contrary to his practice with historical subjects, Turner used time-honored narrative conventions for stories from the *Metamorphoses* without changing or embellishing them precisely to empha-size his *stylistic* departure. In the Ovidian paintings from the 1830s and 1840s, his conspicuously direct "borrowings" constituted a significant gesture in his professional self-definition—coming at the very moment when his work was under attack for its modernity. The fact that from time to time he resorted to open parody of his sources and even of his own work is a revealing indication of the painter's willingness to address the nature of his artistic endeavor.

This is not to say that the content of the stories, or the intricacies of their telling ceased to interest Turner. Indeed, his reading of the *Metamorphoses* was informed by its preoccupation with a single theme: love and its pitfalls. Among the amatory tales he favored those with a decidedly erotic character that could be translated through landscape equivalents. That Turner may have found an outlet for his own guarded emotions in treating these stories about the myth of love suggests that the Ovidian works should be accorded a privileged place in his oeuvre.

Early nineteenth-century painters and poets alike were rediscovering the charms of the *Metamorphoses* both as a source of inspiration and as a model for direct emulation. Keats' *Endymion* or Shelley's "Song of Apollo" and "Song of Pan," among a host of others, contributed to a noticeable revival of the mythic in literature.[2] One commentator in 1822 remarked on the phenomenon, explaining that the modern poets had "breathed a new life into the dry bones of old mythology; and even Mr. Wordsworth, notwithstanding his avowed preference for the merely and familiarly natural, has not only done ample justice, in one of the finest passages of the 'Excursion,' to the creating spirit of ancient fable, but has shown a fondness of late, for classical tales and images." The writer went on to note a significant change in the character of the moderns' myth, however. He felt contemporary poets had abandoned something of the "strength and manliness" of the ancients in favor of

"an exquisite tenderness; a soft and melting radiance; a close and affectionate affinity to the gentler parts of nature"— precisely the qualities that the Romantics enjoyed in stories from the *Metamorphoses*.[3]

In the visual arts Ovidian subject matter had been a significant aspect of the Old Master legacy passed on by eighteenth-century landscape painters like Wilson, Thomas Jones, or Jacob More. Recognizing its value to their own endeavor, the new generation of artists, in particular Turner, John Martin, and Joshua Cristall, gave Ovidian themes a new prominence and focus. For example, George Arnald (1763—1841), a specialist in moonlit scenes, took advantage of Ovid's suggestive descriptions of ambience and moment to produce his own equivalent of "tenderness" and "melting radiance." In *Pyramus and Thisbe*, exhibited at the Royal Academy in 1810 (fig. 63), Arnald communicated the poignancy of the lovers' misfortune by emphasizing the poet's indications of a moonlit sky, quiet pool, and shadowy tree (*Metamorphoses*, 4, 55—169). To enhance the hushed atmosphere of the setting and appeal to his modern viewers' tastes, Arnald added a ruin at the right, overgrown with lush vegetation. It was the kind of subject that Turner also anticipated painting.[4] Artists' enthusiasm for the *Metamorphoses* and related ancient love stories indeed may have won over their colleagues in the literary arts, since much of the poetry inspired by Ovid postdates the corresponding painting by upwards of a decade.

Turner's admiration for the sentiment and phrasing of the *Metamorphoses* can be registered in his lengthy, unadulterated citation from the poem to accompany *Narcissus and Echo*, his first purely Ovidian oil painting, in 1804. Neither then nor later did he feel the need to rearrange Ovid's verse to accommodate his interpretation of an episode. He used an edition of the poem first published in 1717 and popular throughout the eighteenth and early nineteenth century—a collaborative effort by a group of poets that included

Addison, Dryden, and Gay. The compiler, Dr. Samuel Garth, acknowledged in his preface that the contributors had followed a liberal process of adaptation, while striving to present the poet's wit, elegance of description, and his "peculiar Delicacy in touching every circumstance relating to the Passions and Affection."[5] Turner seems to have had no difficulty going beyond what the Augustans perceived to be a delicacy of expression to discover the strong emotional undercurrents that animate the poem.[6]

The artist's own visual "edition" of the *Metamorphoses* nonetheless had its idiosyncracies. Surprisingly, Turner showed no interest in the act of metamorphosis per se, a fact which set him apart from the majority of mythological painters and Ovidian illustrators since the Baroque era. Rather than take up the challenge of depicting Ovid's clever transformations, he left the magical part of the poetry to the viewer's imagination and concentrated instead on moments when the entire ambience of a scene was charged with drama. Occasionally he allowed for some violence, as well as an element of tragedy, but his usual instinct was to select instances heavy with a sense of anticipation, thereby enhancing the feelings of captivation or longing recounted in the stories. For the works prior to 1814, Turner tended to choose tales set deep in forest glades, often by pools or rivers. These locales readily allowed for the introduction of naturalistic landscape elements. For the oils of the 1830s and 1840s, the artist preferred episodes requiring more breadth, light, and openness in their landscape settings, equally consistent with his formal concerns at the time.

The Early Sketches

Ovidian subjects first appeared in the "Studies for Pictures. Isleworth" sketchbook (TB XC) along with a variety of other classical and Biblical themes. Though the work here was tentative—in some cases Turner simply writing down

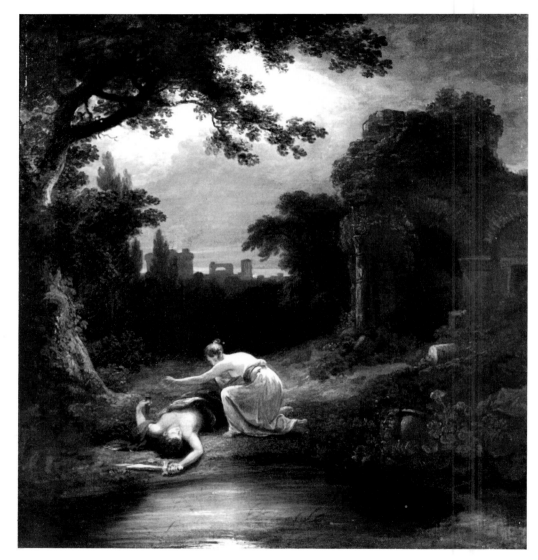

Figure 63. George Arnald, *Pyramus and Thisbe*, 1810. Oil on canvas, $35\frac{1}{2} \times 32\frac{1}{2}$ inches (90.2×82.5 cm), Private Collection.

the titles of prospective episodes—still it represented an inventive search for narrative material that contrasts with his study of ancient history. The artist was reading the poem freshly, rather than merely collecting familiar themes treated by other artists as he would later, if for the purpose of exploiting that familiarity. The stories that caught his attention included the account of Mercury duping Argus, the only one that he sketched out to any degree (plate 11), and also the most frequently treated episode, artistically speaking, of the group; and, on the next page, the tale of Phaeton's sisters lamenting their foolhardy brother's death, indicated in a very brief drawing of three figures labeled with a title in the lower right corner (plate 12). He subsequently wrote down in a list three intriguing titles: "Latona and the Herdsmen," "Pan and Syrinx," and "Salamacis and Hermaphroditus" (along with a second notation of "Phaeton's Sisters"; plate 13).[7] These episodes provide broad contrasts of emotion ranging from rude comedy to excessive grief to unfulfilled desire. Had each been executed, they would have offered a fair test of the artist's skill in dealing with narrative. Their distinctive plots did not allow for interchangeable compositions or stock figures, as in the Dido/Nausicaa or Pompey/Brutus/Cleopatra parallels, nor did they elaborate a single theme. Rather, Turner's choice of stories represented an engaging preliminary response to the poem.

The artist's attentiveness to his literary source can be gauged by even so seemingly generic a composition as the one labeled 'Mercury and Argus.' In the drawings which precede it in the sketchbook, the artist had been immersed in the problem of visualizing an idealized classical harbor as well as an ancient cityscape suitable for the stories of Dido or Nausicaa (plates 8 and 9). On the intervening page (plate 10) an idyllic view of Isleworth explored the pastoral harmony to be found in observable nature. When he then turned to imagining a suitable environment for the trickster god, Mercury, Turner did not simply sketch out a generic Claudean staging, but instead created a wooded retreat that in its screening and density signaled for him the enchanted world of the *Metamorphoses*. Its features would be remembered and repeated elsewhere for the Ovidian tales of Dryope and the birth of Adonis (compare figs. 71 and 72). As a setting for Mercury's duping of Argus it included some specific indications from Ovid's description: through the center of the composition flows the stream at which the heifer Io drinks (beneath the large, leaning tree on the left bank) while directly across on the right bank, reclining on a gentle, shaded rise, Argus guards her at Zeus' behest. Even though the schematic figures barely can be identified without careful scrutiny and the help of the annotation in the lower right corner, the story nonetheless unfolds in its own particular landscape. Those characteristic aspects of the setting would be given their due prominence in the 1836 painting of the same subject (fig. 89).

The remaining four tales to which he referred in the "Studies for Pictures. Isleworth" (TB XC) sketchbook indicate how adventuresome Turner had been at the outset —confronting the text rather than capitulating to the tradition of Ovidian painting. The episodes concerning Phaeton's sisters and Latona for example bear some relationship to the example of Richard Wilson, but measurable in the degree of departure, not similarity. Wilson's painting of Phaeton petitioning Apollo to be allowed to drive his chariot (illustrated here in engraved form), which had been on the market in 1801, depicts what some commentators held to be the most significant story in the poem (fig. 64).[8] A textual note in one early nineteenth-century edition of the Garth translation explained that the episode was told "with a greater air of majesty and grandeur than any other in all Ovid. It is indeed the most important subject [the

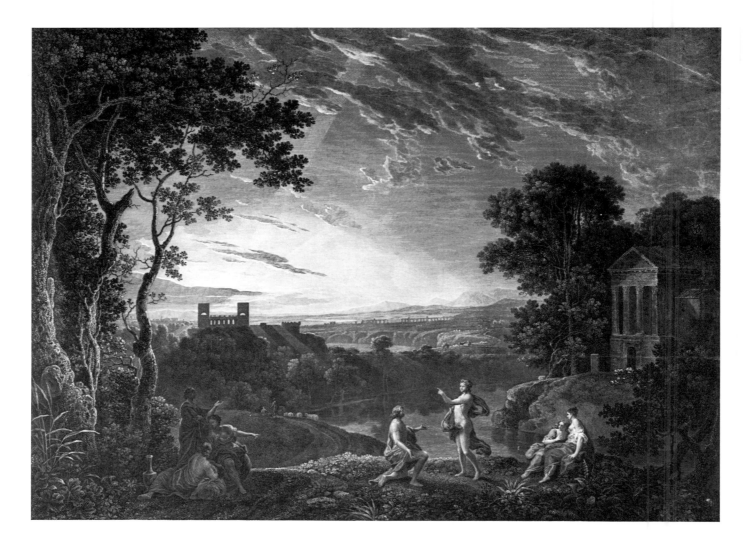

Figure 64. Richard Wilson, *A Large Landskip with Phaeton's Petition to Apollo*, 1763, engraved by William Woollett. $19\frac{1}{8} \times 24\frac{1}{4}$ inches (48.6 × 61.6 cm), Courtesy of the Trustees of the British Museum, London.

poet] treats of, except the deluge."[9] Turner instead fixed on its much less well-known sequel, in which the young man's sisters gathered to mourn his fatal plunge from the sky. Ovid made their wild grief into yet another lesson about excess, but the artist, pursuing the "exquisite tenderness" that Romantics sought in myth, would seem to have been aiming for a mood of quiet commemoration in his thumbnail sketch of three graceful figures before a tomb.[10] The total absence of any landscape background is a telling indication of his fascination with the story per se.

Latona's story would have presented a complete contrast in mood. It involves country boors who would not let her drink at a forest pool. When they added insult to injury by jumping about and muddying the water, she had them changed into frogs whose ugliness Ovid delighted in describing (6, 311—82). Something of Turner's wit can be seen in his preferring this account of gross behavior to the story which immediately precedes it in the text—Latona's punishment of the hubristic Niobe. He steered wide of Wilson's precedent in that instance. Although there is no way of knowing how Turner might have envisioned the scene, when he did deal with a similar instance of loutish behavior in his 1814 oil *Appulia in Search of Appulus*, he chose to exploit the basic humor of the situation and maintain a light didactic tone. An indication of the artist's immersion in the stories themselves can be educed from his verbal summaries of them. In contemporary editions of the *Metamorphoses* both the printed heading in the text and the listing in the index refer to Latona's story as "The Peasants of Lycia Transformed into Frogs."[11] The artist dropped the geographical indication in his sketchbook notation while specifying that the mortals with Latona were "herdsmen." Though elsewhere he might occasionally misspell or misname a character (in one notation transforming Aesacus and Hesperie to "Eacus and Hippolita"), he nonetheless

had a thorough grasp of the plot in question when he visualized it.[12]

The remaining two subjects on Turner's list, Pan and Syrinx and Salmacis and Hermaphroditus introduce the theme of yearning and desire experienced from the male character's point of view in the one tale, and from the female's in the other. Both stories of unwelcome infatuation and pursuit resolve in clever metamorphoses that account for specific natural phenomena and pose interesting problems in terms of their representation. The episode of Pan and Syrinx is recited in the *Metamorphoses* as a matter-of-fact explanation of the origin of Pan's famed musical instrument: to escape Pan's ardor, Syrinx was changed into a reed ("Now while the lustful god, with speedy pace / Just thought to strain her in a strict embrace, / He fill'd his arms with reeds, new rising on the place." 1, 974—75). When Turner eventually developed the story a few years later in a composition intended for the *Liber Studiorum*, he vividly conveyed the passion and heat of the chase rather than dwelling on its picturesque consequences (fig. 77).

It is a pity that Turner never worked up the matching episode. If his more lascivious sketches are any indication, he had the necessary disposition for visualizing its wanton characters, its physically explicit action, and its sensual setting. Salmacis' lust for the beautiful but chaste son of Venus culminated at a crystalline pool in a graphic rape that fused their sexes forever (4, 284—387). Very few artists in the early modern era experimented with the story, and when they did, they chose not to exploit its curious outcome. An example of decorous neoclassical flirtation with the episode can be seen in Anton Raphael Mengs' elaborate drawing of the couple (c. 1760; fig. 65). The implications of the meeting are tactfully restricted to the couple's nudity, the orientation of Salmacis's gesture, and the apprehensive look on the young man's face. When, in 1814, John Martin

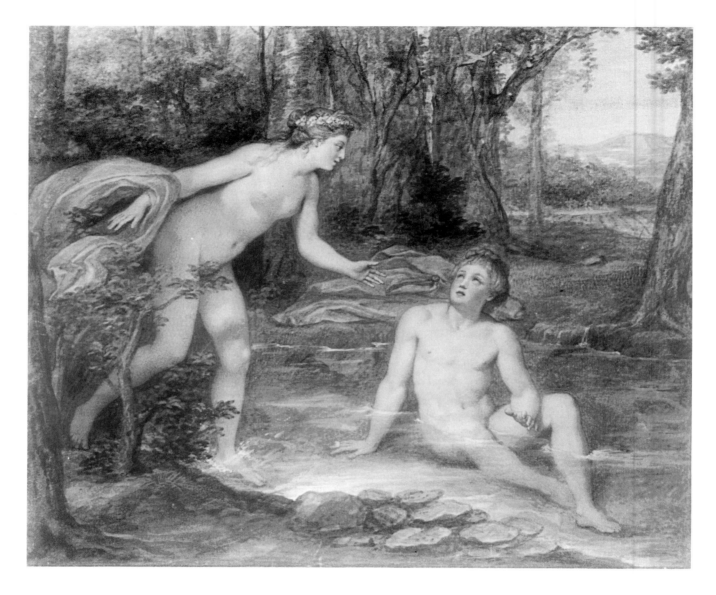

Figure 65. Anton Raphael Mengs, *Salmacis and Hermaphroditus*, c. 1760. Grey gouache, heightened with white, over black chalk, $9\frac{1}{4} \times 11$ inches (23.5 × 27.9 cm), Museum Boymans-van Beuningen, Rotterdam.

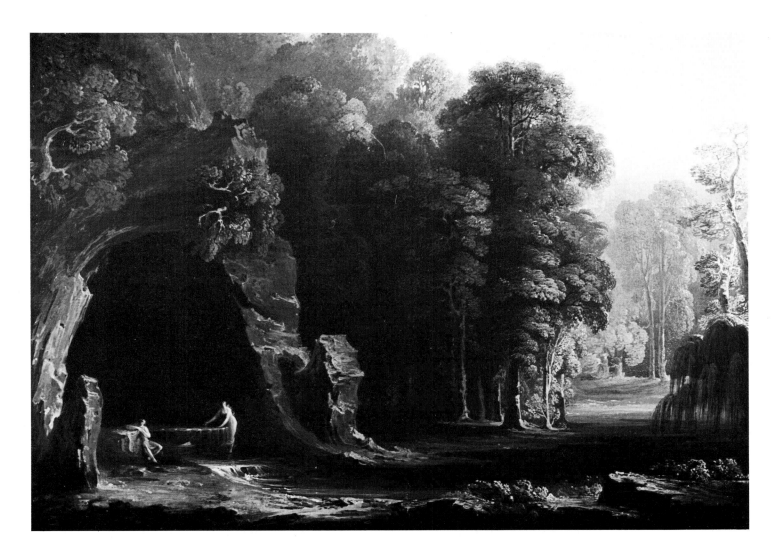

Figure 66. John Martin, *Salmacis and Hermaphroditus*, c. 1814. Oil on canvas, $17 \times 23\frac{1}{2}$ inches (43.2×59.7 cm), Mead Art Museum, Amherst College, Amherst, Massachusetts.

painted a version of the episode, he dodged the issue of androgyny (and sex in general) by keeping his figures tiny and separate, though perhaps touching upon the story's indictment of woman's corruption of man through the unconscious symbolism of the wide, dark cave opening at the left of the fanciful landscape (fig. 66).

Turner was particularly attuned to the sexual currents running through the *Metamorphoses*. By paying close attention to Ovid's highly charged descriptions of nature, the artist discovered the underlying eroticism of the poem and realized the extent to which the poet had symbolized human passions with the elements of landscape.[13] Taking his inspiration from the poem's lush natural imagery, Turner elaborated his own rather pessimistic view of the complexities and pitfalls of male/female relationships. It was a topic that lay at the heart of his fascination with myth and antiquity, even in its most sober manifestations (the course of the Carthaginian empire, for example). The concentration of Ovidian themes that Turner treated or considered in the decade between 1804 and 1814 suggests that their insistent rehearsal of the antagonism between the sexes held a personal relevance for the artist, providing an oblique way to assess or confront his own otherwise guarded emotional life. A longstanding relationship with Sarah Danby, a recent widow when they began their alliance in 1798, produced two daughters but never resulted in marriage. Though he included all three as beneficiaries in his first will, he revoked their legacies a decade later. A niece of Sarah's, Hannah Danby, entered Turner's household about 1809, and remained with him until his death and was trusted enough to be named legal custodian of his paintings in a codicil the artist added to his will in 1839. Hannah subsequently shared that responsibility with Sophia Booth, another companion of his later years.

The seemingly less than conventional nature of Turner's personal life might (or might not) have been conditioned by the difficult circumstances of his mother's mental distress—she entered Bethlehem Hospital in 1800 after years of instability in their family home, only to die there within four years.[14] If an anecdote can be trusted, Turner may have shifted allegiance from the women in his life to his art and the institution that promoted it. Hearing news of Benjamin Robert Haydon's suicide, he is reported to have muttered "He stabbed his mother, he stabbed his mother," meaning Haydon's defamation of the Royal Academy.[15] In any case, unlike contemporaries who chose to deal with romantic anguish publicly, and in the present—for example Francis Danby and his portrayal of heartbreak in *Disappointed Love* (fig. 67)—it would seem that Turner maintained a safe distance by examining such topics only in mythology, history, or literature. His most powerful diatribes against the cheat of love are thus cast in the ancient guise of *The Parting of Hero and Leander—from the Greek of Musaeus* or *Glaucus and Scylla—from Ovid's Metamorphosis*.

Always exercising his keen curiosity about narrative, visual imagery, and the nature of meaning, the artist also sought to understand *how* myth had acquired its symbolic force. In the Finance Sketchbook (TB CXXII, 1807?–1814), he transcribed long passages about Hindu, Greek, and Roman religion taken from an impressive range of sources.[16] At the same time Turner included a telling reference to an essay by Richard Payne Knight on priapean symbolism, which presented a thorough and graphic account of the sexual origins of ancient rites. Knight's attempts to decode the symbolical language of ancient art in terms of natural equivalents would have substantiated Turner's own intuitions about the allegorical nature of myth. However, the connoisseur and the painter differed strongly in their response to Ovid. Knight felt the *Metamorphoses* to be an unreliable source, the stories being too "wild

Figure 67. Francis Danby, *Disappointed Love*, 1821. Oil on panel, $24\frac{3}{4} \times 32$ inches (62.8×81.3), By Courtesy of the Board of Trustees of the Victoria & Albert Museum, London.

and capricious" for his scholarly purposes.[17] Turner, having informed himself about current anthropological beliefs, eschewed "scientific" intellectualizing and concentrated instead on the poem's impassioned account of ill-fated lovers. Indeed, he gave himself over wholeheartedly to their emotionally charged intrigues.

A series of five Ovidian subjects dealing with the consequences of lust, rape, and incest treated in another early sketchbook are a case in point (TB XCIV, Hesperides (2), 1805–1807, 13–17). Turner seems to have done the sequential sketches, which are in pen, ink, and wash, in one sitting, and with a vigor and intensity that match their subject matter (figs. 68–72). The way the episodes are clustered implies that he worked directly from the poem, or at least from a fair recall of it. Thoroughly involved in the stories, he abbreviated his handling, noting the essential conflict and then compensating for the lack of detail by titling each drawing in the lower right corner. In the quality of line as well as in the gestures and placement of the figures, one can observe Turner in the very process of searching out each tale's significance to the story as a whole.

The first three, the 'Death of Achelous,' the 'Death of Nessus,' and the 'Death of Lycus' (Turner's spelling of Lichas), form a running narrative about Hercules that follows the order of the extended account in the *Metamorphoses* (9, 1–280). Typical of his sensitive appraisal of heroics, when the artist studied the legend of one of the greatest figures in antiquity, he focused not on his greatest triumphs, but on the sequence of events leading to his ultimate defeat through the ways of the heart. By contrast, Géricault (who shared many of Turner's tastes in classical subject matter) chose to emphasize the hero's prowess: when in one session he sketched out the compositions portraying Hercules' wrestling match with Antaeus and the episode of the Nemean lion, he celebrated the hero's physical strength in bold, Rubensian terms (fig. 73).

In Turner's rendering, even a moment of clear victory—Hercules vanquishing Achelous, fellow suitor for the hand of Dejanira—seems to lack flourish (fig. 68). The small scale and almost contemplative calm of the figures isolated at the center stage confound the notion of superhuman prowess. Perhaps the artist had been moved to downplay Hercules' heroic valor by the sombre tone of the story—told from the point of view of the loser. The challenger, Achelous, who had the power to change his form first into a snake and then a bull, recounts his own demise in the poem, aware that his one defense, transformation, cannot save him:

> Straight on the left his nervous arms were thrown
> Upon my brindled neck, and tugged it down;
> Then deep he struck my horn into the sand,
> And fell'd my bulk along the dusty land.
> —(9, 97–100)

In effect Turner transferred the physicality and turbulence proper to their encounter from the figure of Hercules, static and contained as he kneels beside the bulk of the downed bull, to the landscape setting. The crisp, sharp marks of the pen, the spattering, and the messy, agitated blotching on the right convey the force and energy proper to Hercules, but withheld from him in the sketch. Notice, also, that Turner's terse captions for each of the episodes commemorate the vanquished as much as record the hero's deed.[18]

The second sketch, the 'Death of Nessus' begins to suggest the sense of futility underlying Hercules' love for Dejanira (fig. 69). It deals with the hero's duping by, and subsequent punishment of, Nessus, his bride's guardian-turned-ravisher. Since antiquity, artists had interpreted the story either as a scene of passion and theft as the centaur carries off Dejanira (fig. 21); as a tale of valiant revenge (when the hero takes aim with his bow and kills the deceitful Nessus); or as a foreboding of Hercules' death (through the

Figure 68. J.M.W. Turner, 'Death of Achelous,' TB XCIV, Hesperides (2) Sketchbook, 13, 1805–1807. Pen and ink and wash, $5\frac{3}{4} \times 9$ inches (14.6 × 22.8 cm), Turner Collection, Tate Gallery.

Figure 69. J.M.W. Turner, 'Death of Nessus,' TB XCIV, Hesperides (2) Sketchbook, 14, 1805–1807. Pen and ink, $5\frac{3}{4}\times 9$ inches (14.6×22.8 cm), Turner Collection, Tate Gallery.

Figure 70. J.M.W. Turner, 'Death of Lycus,' TB XCIV, Hesperides (2) Sketchbook, 15, 1805–1807. Pen and ink, $5\frac{3}{4} \times 9$ inches (14.6 × 22.8 cm), Turner Collection, Tate Gallery.

Figure 71. J.M.W. Turner, 'Dryope,' TB XCIV, Hesperides (2) Sketchbook, 16, 1805—1807. Pen and ink, $5\frac{3}{4} \times 9$ inches (14.6 × 22.8 cm), Turner Collection, Tate Gallery.

Figure 72. J.M.W. Turner, 'Birth of Adonis,' TB XCIV, Hesperides (2) Sketchbook, 17, 1805–1807. Pen and ink, $5\frac{3}{4} \times 9$ inches (14.6 × 22.8 cm), Turner Collection, Tate Gallery.

Figure 73. Theodore Géricault, *Hercules and the Lion*, n.d.. Pencil drawing, 3 × 2 inches (7.6 × 5.4 cm), Musée Bonnat, Bayonne.

agency of Nessus' poisoned cloak which the dying centaur gave to Dejanira). Antonio del Pollaiuolo's fifteenth-century depiction of Hercules' vengeance is one of the more memorable and vivid examples of the central moment of the story (fig. 74). Turner also chose that part of the episode, perhaps because it both resumes and foretells the rest. However, he showed Hercules from behind, as he did his other heroes, taking aim with a faintly delineated bow. The figure's half-kneeling stance is more impacted than that of Pollaiuolo's boldly planted Hercules, while the restriction of the action to the left side of the composition results in a narratively inactivated expanse of landscape on the right that accentuates the hero's loss. The eye tracks away from him, toward the receding pair on the opposite shore, experiencing the separation of husband and wife from Hercules' viewpoint. The smudges of wash in the area of the trees emphasize that movement as well as graphically suggest his (and the painter's?) fury at the deception.

The last of the Hercules drawings relates an event infrequently depicted by painters: the senseless slaying of Lichas, an innocent servant (fig. 70). Fearing her husband was unfaithful, Dejanira thought to entice him back with a gift: she commanded Lichas to bring Hercules Nessus' cloak, unaware that it was poisoned. Through her unfounded jealousy, Hercules met an agonizing end described by Ovid in vivid detail. In his torment, the hero seized poor Lichas and hurled him into the air, whence he changed into a stone that fell to sea. Canova, in a sculptural group from 1810, treated the subject as an opportunity to display rippling flesh, showing the muscular hero poised to throw the young man slung over his back. Turner's choice of moment instead suggests the senselessness of the act. Hercules, positioned with his back to us, looks at the destruction he has just wrought, but the broken body of Lichas seems no trophy. Once again; the painfulness of the story's implications seems to have been given outlet in the swiftness or curtness of the pen strokes and in the broad, hasty treatment of the tree to the left. In all three drawings one can observe Turner responding to the differing tempos of the episodes, literally narrating them through his handling and the quality of his mark-making.

The remaining two sketches in the group deal with women who fell victim to love, one against her will, one in defiance of nature's rules. Both episodes require rather elaborate landscape settings since their lessons depend upon symbolic as well as literal meanings of specific natural elements. The story of Dryope, fourth in Turner's sequence (fig. 71), follows shortly after the account of Hercules in the text (9, 331−93). It is a complicated tale of lost innocence in which the theme of sexual violence is embodied in the metaphor of flower picking. Having herself been violated by Apollo, Dryope unwittingly despoiled the purity of metamorphosed nymphs more chaste than she: she plucked a blossom for her son unaware it was the nymph Lotis, transformed into a flower while resisting assault by Priapus. When Poussin sketched the episode in his own group of Ovidian drawings, he avoided altogether the injustice of Dryope's fate so poignantly lamented by her sister in the poem (fig. 75). Instead he made the tale a cautionary lesson for young boys/putti about transgressing against nymphs, offering Dryope's punishment, transformation into a tree, as the prime exhibit in an admonitory lecture.[19] Turner remained captivated by the loaded gesture of flower gathering itself. He set the episode in a shaggier, more schematic version of the wooded landscape envisioned for 'Mercury and Argus,' adding a small pool at the lower right. The heaviness and density of the surrounding vegetation respond to the tale's underlying carnality while the figures of mother and son call up its sad ironies.

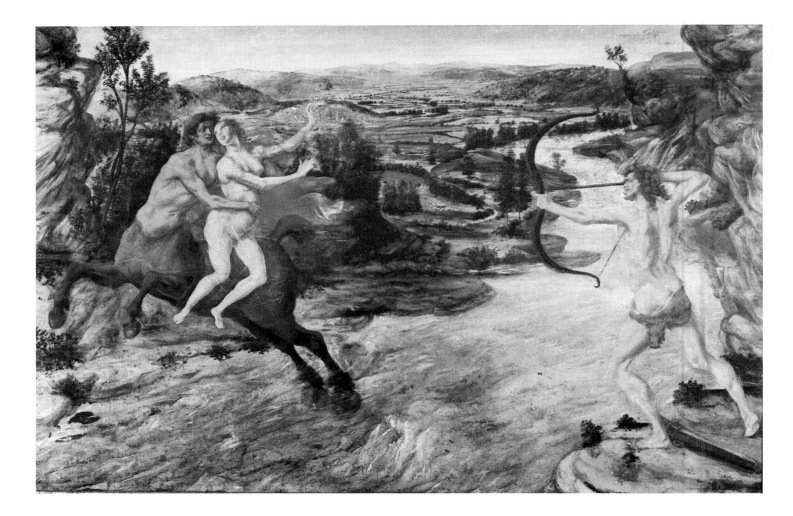

Figure 74. Antonio del Pollaiuolo, *Hercules and Dejanira*, c. 1470. Egg tempera and oil (?), now on canvas, transferred from panel, $21\frac{1}{2} \times 31\frac{3}{16}$ inches (54.6 × 79.2 cm), Yale University Art Gallery, New Haven, purchase from James Jackson Jarves.

Figure 75. Nicolas Poussin, *Dryope*, c. 1620–1623. Pen and bistre with grey wash, $6\frac{3}{16} \times 13\frac{1}{8}$ inches (15.7 × 33.3 cm), The Royal Library, Windsor Castle.

The last of Turner's sketches, the "Birth of Adonis" (10, 437–518), forms the conclusion to the dark tale of Myrrha's unremitting love for her father (fig. 72). It also completed Turner's consideration of Adonis' story, ending up where the artist might otherwise have begun. In this one instance the artist flirted with the process of transformation, although he stopped short of detailing its oddity. As punishment for her incestuous behavior, the pregnant Myrrha, like Dryope, was changed into a tree, the bark of which parted to give birth. Poussin, in another of his Ovidian drawings, showed Myrrha with arm and head bursting into leaf, while Gaspard Dughet depicted the transformation as complete and the delivery in progress in one of the paintings decorating the Palazzo Borghese in Rome. Turner preserved Myrrha in human form, aligning her against the trunk of a tree in yet another version of his mythic woodland setting. Observing her body, one recalls the nature of her crime, rather than simply marvelling at the extraordinary entry

Figure 76. J.M.W. Turner, TB XCIII, Hesperides (1) Sketchbook, 32a, c. 1805−1807. Pen and ink, $6\frac{3}{4} \times 10\frac{3}{8}$ inches (17.1 × 26.4 cm), Turner Collection, Tate Gallery.

of her ill-fated son. The real world with its cities and buildings lies beyond the screen of what are soon to be fabulous trees.

The most overtly violent of Turner's Ovidian drawings was contemporary with the above group, but occurred in the sketchbook that contained preparatory work for *The Goddess of Discord Choosing the Apple of Contention in the Garden of the Hesperides* and *Dido and Aeneas* (TB XCIII, Hesperides (1) Sketchbook, c. 1805–1807). A quick notation of a stag being torn apart by hounds, with a commanding figure standing further back, depicts the death of Actaeon (fig. 76).[20] Diana's swift, cruel reaction to the young hunter's invasion of her privacy fixed itself in Turner's mind and years later (c. 1835–1840) he reworked the scene in an unfinished oil sketch. Perhaps the savagery of Actaeon's punishment remained too extreme for him to bring to finished form.[21]

The Liber Studiorum: Ovid Naturalized

Where, in the private world of his sketches, Turner could entertain the idea of exotic passions, in work intended for public consummation he tactfully selected subject matter free from nuance or controversy. For the *Liber Studiorum*, his compendium of landscape compositions, the artist chose themes long popular with painters. Moreover, each had a well-established iconography from which he essentially did not stray. All of the stories concern ill-fated couples suffering in one form or another from love's excesses, Turner's roster of episodes deriving from nearly every book of the poem. Had each episode been worked up for publication, the series would have represented his own illustrated Ovid, as it were. Among the published plates he treated the tales of Cephalus and Procris, Aesacus and Hesperie,

and a scene of the abduction of Europa, incorporated into the frontispiece. Unpublished subjects, in the form of drawings or etchings, included Glaucus and Scylla, Pan and Syrinx, and Narcissus and Echo, the latter based on the 1804 painting.[22] And in what may have been a list of potential *Liber Studiorum* subjects, Turner noted the episode of Pyramus and Thisbe, along with references to two other couples, Dido and Aeneas, and Hero and Leander.[23] The particular invention in these images comes from Turner's introduction of naturalistic features of landscape that deftly animate the stories and rediscover their significance. The artist simplified plots, limiting himself to the main characters acting out their roles with broad, clear gestures in the most unambiguous parts of the story. He had no need for the "chorus" of onlookers that Poussin provided in his Ovidian drawings.[24] True to the spirit of Ovid, Turner suppressed any sense of moralizing in favor of a vivid characterization of love's defects—mistrust, excessive desire, rejection—all the more primal for being shown in their natural settings.

The didactic aims of the *Liber Studiorum* project would have argued against too idiosyncratic an interpretation in any case. By assigning the Ovidian subjects to the "Historical" category (see above, p. 89) the artist made them part of his demonstration of how to "set" a subject from serious literature or the Bible. The lesson one learns is that landscape should never be construed merely as "background," that it must participate in the narration. By contrast, the "E P" compositions are gracious, non-narrative Claudean landscape scenes which are complete as such. In not explaining the designation "E P," it was as if Turner hesitated to assign just one adjective to the essentially ineffable beauty of idealized nature.

Having separated his Ovidian cast of characters from their traditional haunts in classical landscape (in the eight-

Figure 77. J.M.W. Turner, *Pan and Syrinx*, n.d.. Pen and sepia and wash, $8\frac{3}{8} \times 10\frac{7}{8}$ inches (21.3×27.6 cm), Courtesy of the Trustees of the British Museum, London.

eenth century they would have been placed in "E P"-type compositions), Turner responded to the specific verbal suggestions in the poem with attention and directness. Each of the Ovidian subjects in the *Liber Studiorum* required a distinctive locale: a marsh, a secluded spring, the seashore, a deep wood (figs. 77–80). The artist imbued these imagined settings with the immediacy and informality of his Thames/Wey oil sketches, done out-of-doors in 1806–1807. *Pan and Syrinx*, for example, is filled with lush vegetation reminiscent of that recorded in *Willows beside a Stream* (fig. 81).[25] In effect Turner improved upon Ovid's inventive descriptions of nature by grounding his own in intense study of the real world. That the artist chose to elevate such relatively unrefined natural scenery to the level of "Historical" landscape in the *Liber Studiorum* is not without significance. In so doing, he brought a fresh perspective about nature into the "Higher Departments" of his art, proving after all the wisdom of Wilson's instincts in *The Destruction of Niobe's Children*.[26]

The test of this proposition is that in none of the Ovidian four works created specifically for the project can the landscape really stand without its figural complement. Remove what might at first appear to be conventional eighteenth-century staffage and the compositions lose their integrity to a greater degree than would a landscape by Claude, though not because they are merely "pure naturalism only thinly disguised by its subject."[27] Following Ovid's example, Turner depicted nature as a co-conspirator in the emotional intrigues of its inhabitants to such a degree that setting and characters fuse into one inseparable narrative entity.

This integration is aided by the small scale of the figures, by varied textural effects, and by effects of light that combine to convey a sense of intimacy and sensuality. The dense, springy vegetation in *Pan and Syrinx* reiterates the enervated pursuit and anguished resistance taking place within it (or vice versa). Its exuberant growth closes in on the scene just as Pan does on his quarry. The beam of light illuminates and further vitalizes the "human" drama, amplifying Pan's ardor in the process. Similar elements are treated in a rather different manner in *Aesacus and Hesperie* (fig. 78), which bears the caption "Vide Ovid Met[s] Book XI." Here, as in the case of *Jason*, Turner embroidered upon Ovid's account, if in keeping with the poet's style elsewhere. The lines he would have us search out in the *Metamorphoses* are matter-of-fact in telling how Priam's son

> Had long the nymph Hesperie woo'd
> oft through the thicket or the mead pursu'd:
> Her haply on her father's bank he spy'd,
> While fearless she her silver tresses dry'd;
>
> —(11, 770–72)

Calamity and heartbreak follow, but Turner did not so much as hint at the outcome. Instead, he concentrated on a charged moment of desire before the chase begins, translating its intensity through the density and lushness of Hesperie's sheltered glade. Her retreat is invaded not only by the young man peering from behind the diagonally thrusting tree, but also by the streaming sunlight that penetrates its cool recesses. Few painters had responded to the episode, perhaps because the poet left so much to be supplied. Yet it is precisely this latitude for imagination that Turner exploited, and which he incorporated into his own image. Both the viewer and Aesacus enjoy a privileged viewpoint, and both become voyeurs, savouring the scene and fantasizing over the story's denouement.

The story of Glaucus and Scylla presented still another kind of challenge in terms of mood and locale (fig. 79). To underscore the unrequited love between the seagod and the nymph, the painter isolated them on an empty beach that emphasizes the impossibility of their union. Each "inhabits"

Figure 78. J.M.W. Turner, *Aesacus and Hesperie*, published January 1, 1819. Etching and mezzotint, $7 \times 10\frac{1}{4}$ inches (17.8×26 cm), Courtesy of the Trustees of the British Museum, London.

Figure 79. J.M.W. Turner, *Glaucus and Scylla*, TB CXVIII, P, Liber Studiorum Drawings, c. 1813. Pen and sepia, $8\frac{7}{8} \times 11\frac{1}{16}$ inches (22.5 × 28.3 cm), Turner Collection, Tate Gallery.

Figure 80. J.M.W. Turner, *Cephalus and Procris*, published February 14, 1812. Etching and mezzotint, engraved by George Clint, $7 \times 10\frac{1}{4}$ inches (17.8 × 26 cm), Courtesy of the Trustees of the British Museum, London.

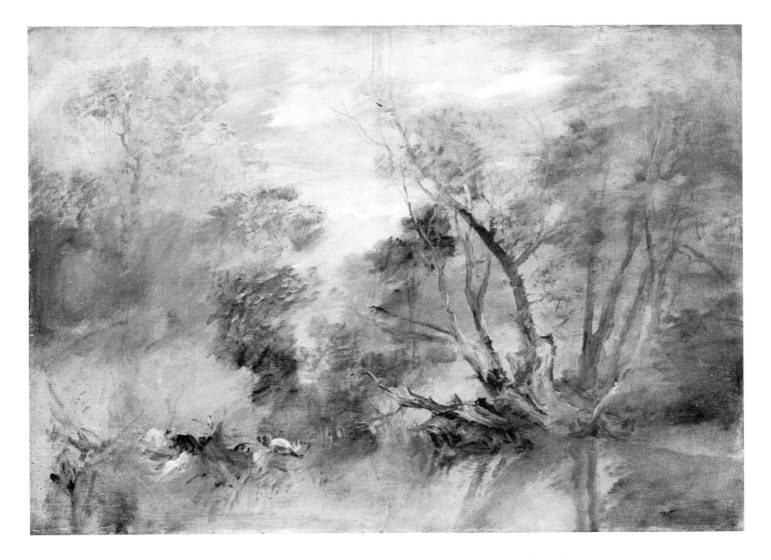

Figure 81. J.M.W. Turner, *Willows Beside a Stream*, c. 1806—1807. Oil on canvas, $33\frac{7}{8} \times 45\frac{3}{4}$ inches (86×116.2 cm), Turner Collection, Tate Gallery (BJ 172).

his or her own element: Glaucus, the water, Scylla, the sheltered cove in which she sought refuge. Behind them, an arched rock formation seals off their little bay—and their emotional encounter—from the rest of the world. This element of the landscape graphically describes their opposed desires, both joining *and* separating them through its arch and void.[28] The minimal development of the figures obscures some of the story's motivation—it was Glaucus' notorious ugliness that repelled Scylla—but insures that the basic emotional charge of the episode is not overwhelmed by curious detail like that included in the later oil of the same theme. Instead, the story is recounted through the simple expressiveness of its setting.

For *Cephalus and Procris* Turner let light and shadow intensify a tragedy caused by a failure of trust (fig. 80). Procris could not see that her fears about her husband's virtue were unfounded; Cephalus could not see that the "game" rustling in the brush was his spying wife, and so accidentally shot her. The artist brought them out of the darkness into the open and the light, literally and meta-phorically, for their tender last embrace. The contrast between the shadowy woods and the isolated clearing echoes the play of deception with truth that marks their story. Verdant trees on the left and dying ones on the right echo the tale's outcome. Turner must have been thinking of Claude's *Liber Veritatis* drawing of the same subject, but orchestrated its basic features for a different effect (fig. 82). Claude had selected the moment of surprised discovery, indicating it through gesture but then dissipating its impact in the overall nervousness of the composition and the evenness of the fawn brown tones. Turner's scene is one of highly charged stillness in which a forceful contrast of light to dark emphasizes the story's sad denouement.

As a group, the *Liber Studiorum* subjects vividly mine the sentiment of the *Metamorphoses'* amatory tales. With these works Turner "illustrated" Ovid in a most complimentary fashion—visualizing the episodes not as curious literary fictions, but as events ripe with a sense of the present moment. While something of that immediacy would be imparted to his late mythological works, the mood and bearing of the Ovidian oil paintings that are contemporary with the *Liber Studiorum* works by contrast exhibited a basic conservatism, formally speaking. They are major canvases in which Turner reverted to an idealized, classically ordained approach to landscape painting. The stories told in *Mercury and Herse*, 1811, and *Appulia in Search of Appulus, vide Ovid*, 1814 (exhibited, respectively, at the Royal Academy and the British Institution) take place in full public view, as it were: the intimacy and sensuality of the *Liber Studiorum* scenes is replaced by pageantry in the one work and light comedy in the other.[29] *Mercury and Herse* offers a comprehensive vision of antiquity, in which the world of the gods and goddesses comes alive through a beguiling interplay of figures, architecture, and arcadian landscape reminiscent of Claude. *Appulia in Search of Appulus, vide Ovid* by contrast parodies too much dependence on artistic models, and amuses itself with Ovid as a literary source. In effect, the two paintings rehearsed the issues of emulation and manipulation of artistic conventions that would occupy Turner twenty years later in the Ovidian oils of the 1830s and early 1840s, but with none of their stylistic panache.

Mercury and Herse (fig. 83) recounts the beginning of a tale from Book 2 that is otherwise concerned with jealousy and extortion on the part of Herse's sister Aglauros. Characteristically, Turner chose the one segment that occurs out-of-doors. The opening lines tell of Mercury's infatuation with the lovely Herse, whom he spied in a procession of virgins honoring the feast of Minerva. The festive scene described in the poem was particularly popular among seventeenth-century painters. A version by

Figure 82. Claude Lorrain, *Landscape with the Death of Procris, Liber Veritatis* 100, c. 1646–1647. Ink and wash, $7\frac{3}{4} \times 10\frac{1}{4}$ inches (19.6 × 26 cm), Courtesy of the Trustees of the British Museum, London.

Figure 83. J.M.W. Turner, *Mercury and Herse*, 1811. Oil on canvas, 75×63 inches (190.5×160 cm), Private Collection, England (BJ 114).

Figure 84. Francisque Millé, *Mercury and Herse*. Oil on canvas, National Gallery of Scotland, Edinburgh.

Figure 85. J.M.W. Turner, TB CXXIX, Woodcock Shooting Sketchbook, 36, 1810−1812. Pen and ink, $7\frac{1}{8} \times 4\frac{5}{16}$ inches (18.1 × 11 cm), Turner Collection, Tate Gallery.

Figure 86. J.M.W. Turner, TB CXXIX, Woodcock Shooting Sketchbook, 38, 1810−1812. Pen and ink, $7\frac{1}{8} \times 4\frac{5}{16}$ inches (18.1 × 11 cm), Turner Collection, Tate Gallery.

Figure 87. J.M.W. Turner, TB CXXIX, Woodcock Shooting Sketchbook, 39, 1810–1812. Pen and ink, $7\frac{1}{8} \times 4\frac{5}{16}$ inches (18.1 × 11 cm), Turner Collection, Tate Gallery.

Francisque Millé (1642–1679/80), formerly in the collection at Bridgewater House, is entirely representative of the tradition: the order and formality of the landscape setting, the central place given to the procession of statuesque women, and the airborne, hovering figure of Mercury are all familiar features of the episode's representation in the fine arts (fig. 84).

Even if Turner had been aware of a precedent like that of Millé, he still chose to begin with a reading of the poem, lines from which he quoted in the Royal Academy catalogue. As with the tale of Aesacus and Hesperie, Ovid indicated very little about the setting, remarking simply that the story took place somewhere in the "vast regions" near Athens and "wide Munichia" (2, 708–10).[30] In two different sketchbooks, Turner worked at bringing to form a suitably idealized locale, orienting the composition vertically and improvising with Claudean motifs. The Woodcock Shooting Sketchbook (TB CXXIX, 1810–1812) contains twenty-one nearly consecutive sketches executed in the same quick, bold style that explore the classical landscape format and its familiar elements with remarkable zeal (figs. 85–87). They prove just how engrossed the artist could become in re-creating a mythic realm.[31] Since the immediate theme concerns a display of ideal beauty, Turner concentrated on describing the landscape in an appropriately elegant manner. We enjoy a commanding view over a finely graduated distance. The vertical orientation, the tall framing trees, and the rich harmonies of blue, green, and brown impart an elegance that transports the viewer far from his/her everyday existence.

Allusions in the painting to the tale's conclusion are tactfully unobtrusive. The ruins of a bridge in the middle distance might be taken as a touch of imperfection in otherwise unblemished surroundings, while the dour young woman and her chiding companion seated at the left may relate to Aglauros being stung by Envy over Mercury's interest in Herse, although nothing insists upon that identi-

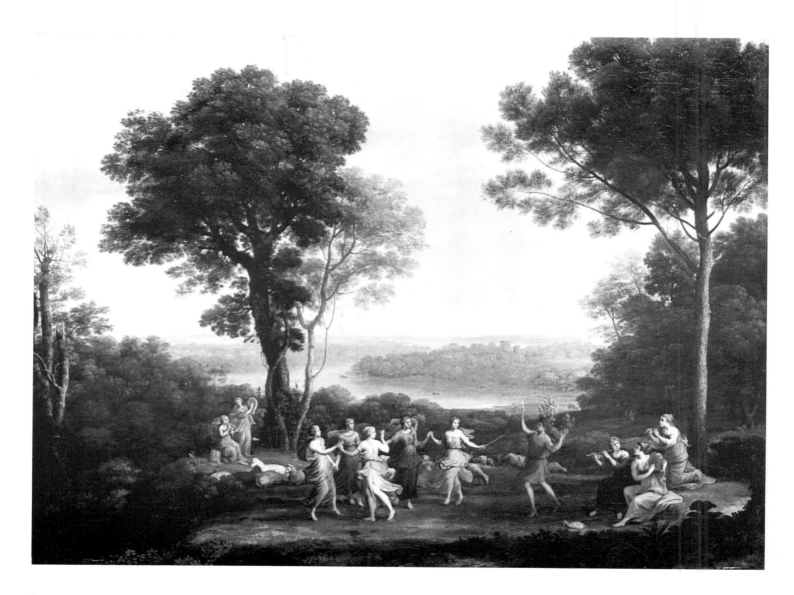

Figure 88. Claude Lorrain, *Landscape with the Metamorphosis of the Apulian Shepherd* (LV 142), 1657. Oil on canvas, $39\frac{1}{2} \times 52$ inches (100.3 × 132 cm), National Gallery of Scotland, Edinburgh.

fication. In his "Backgrounds" lecture Turner had analyzed how Veronese, in his painting of *Mercury, Herse and Aglauros* (1585), combined various elements of a richly appointed interior to enhance the actions of the main characters and thus the meaning of the story.[32] By adjusting the features of Claudean classical landscape—recession into distance, atmosphere, light—Turner paralleled the Venetian painter's narrative accomplishment, but entirely in his own idiom. His landscape exerts a captivating pull that paraphrases in natural terms the attraction Herse holds for Mercury. Aptly, the god stands to the right, observing the scene much as we do.

Because *Appulia in Search of Appulus, vide Ovid* (1814; fig. 116) so pointedly addresses the issue of stylistic affiliation with Claude, it will be treated in detail in a separate discussion about Turner's relationship to his predecessor (Chapter VI). However, the artist's witty elaboration of the act of metamorphosis needs mention here since it attests to his keen appreciation of the spirit of the poem. Turner's subject had its origins in Book 14 (516—27), where Ovid briefly recounted a tale about a country boor who insulted nymphs by parodying their dance. As punishment, the peasant was transformed into a wild olive tree, the bitter berries of which are a reminder of the young man's offensive language. Claude's 1657 *Landscape with the Metamorphosis of the Apulian Shepherd* (fig. 88), the only known representation of the episode in painting, demonstrated in almost textbook fashion how the doctrine of *ut pictura poesis* should operate. Following Ovid point for point, the painter depicted the shepherd's transgression and its outcome, showing the transformation in progress in an idyllic re-creation of the Italian countryside.

Turner extended the story with a curious denouement of his own devising. To challenge the aesthetic biases of critics who valued Old Masters more than modern art, he provided the shepherd with a similarly named mate who seeks his whereabouts. Turner teasingly left the references to the poetic text literally as text within his scene, writing Appulus' name on the tree the shepherd has become in his version (at the left side of the painting), and inscribing the full title, "Appulia in Search of Appulus hears from the Swains the cause of his Metamorphoses," in yellow paint in the lower left corner. The mimicking behavior in this case, as Turner's contemporaries were all too aware, involved the artist's unabashed appropriation of Claude's well-known *Landscape with Jacob, Laban and His Daughters* as a thematically revised composition of his own (fig. 117). In the painting, Appulia "hears" the reason for one metamorphosis while we see the fruits of a grander transformation before our very eyes, in the likeness (*and* dissimilarities) of Turner's painting to his predecessor's. The painting's playful address of the dangers inherent in blind emulation, as well as its open dialogue with the tradition of Ovidian art, set the tone of his later approach to the Old Masters as a source for artistic guidance.

The Late Ovidian Oils

Between 1836 and 1841 Turner embarked on a concentrated excursion into the world of the *Metamorphoses* that resulted in a delightful group of paintings thoroughly stamped with his interests.[33] Forming the mythic complement to his ancient histories and their modern pendants, these works offer summary statements on the key issues informing his Ovidian study: the manipulation of style and the role of formal play (Turner in effect thematizing artistic metamorphosis); the transformation of mythic narrative into the idiom of landscape; and the disappointment of love. Although the paintings treat these topics with varying degrees of emphasis, as well as wit or sarcasm, all exhibit

the same high level of imaginative projection and narrative attentiveness in reinterpreting Ovid and the *Metamorphoses*.

Style as Meaning

For the paintings that interrogate the role of artistic tradition in visualizing literary narrative or that rethink traditional imagery in terms of landscape, Turner selected episodes that were both entirely familiar and symbolically uncomplicated: Mercury duping Argus, the pursuits of Bacchus and Ariadne, Apollo and Daphne, Pluto and Proserpine, and, like a grand finale, the abduction of Europa (the unexhibited canvas dates from the last ten years of Turner's life). Given their overall comprehensibility, it may be that the artist saw them in the same didactic light as the *Liber Studiorum* (several reprised tales included in, or intended for, that project), perhaps designing them in direct response to the increasingly negative, and sometimes cruel, criticism leveled against modern art by writers like the Reverend John Eagles in *Blackwood's Magazine* beginning in the mid-1830s. In 1833, Eagles, one of Turner's *bêtes noires*, had published an essay encouraging painters to develop their poetical instincts by seeking inspiration from the likes of Ovid:

> I have often thought a sketcher would do well to read some delightful tale, say in Ovid's *Metamorphoses* or Spenser, and then, with the character of the picture vivid in his mind, go forth to the rocks, the woods, and wilds, and sketch and paint in, on the spot, objects, tones, and colours, as may be most applicable; and with the poetry in his heart he will not be afraid to heighten a little, for Nature will often give him but a glimpse, where he must imagine a great deal. . . . Ovid's *Metamorphoses* is a delightful book for the landscape painter. It takes him back to the fabulous—it endows his pencil with the license to create—to divest the earth of its every-day common look, and cover it with beauty of a golden antiquity[34]

That would seem to describe Turner's vision of the classical realm perfectly. However, to Eagles' mind, the artist had already shed too much light, literally speaking, on the arcadian dream, and he proceeded to inveigh against Turnerian excess. His remarks have a familiar ring, strongly recalling Reynolds' pronouncements about landscape and Wilson's failure therewith, now updated to include formal concerns like color. The relevant passages are quoted at length so that the full flavor of Eagles' invective comes through:

> If you can see no poetry in nature beyond what is on the retina of your eye, you want the mind's eye to constitute the painter; you must be the poet, or discard the whole concern; you must have a convertible power, and have enjoyed visions of Fairy Land; and you must people your pastoral, or your romantic, or your poetical, with beings that are not on the poor's books. . . . The scene should be a poetical shelter from the world, and if in any thing partaking of it, it should be only so much so as would shew it to be a part and parcel of the "debateable land" that lies between Fairy Land and the cold Utilitarian world. As it is to be a shelter, remember repose, and let not the glorious sun himself act the impertinent intruder, and stare you ever in the face like a Polyphemus, stationed in mid heaven, hid with a cerulean curtain, all but his eye.
>
> There are modern pictures that would make you long for a parasol, and put you in fear of the yellow fever, and into a suspicion of the jaundice; scenes pretending too to be Fairy Land that are hot as capsicum, terribly tropical, "*sub curru nimium propinqui solis*," where an Undine would be dried and withered, and you would long more for an icicle than Lalange, and would cry out for the shades of Erebus to hide you in. Horace says, "place me under the chariot of the too near sun, in a land unblest of houses." Yet do artists in defiance build their structures under the blaze of the sweltering orb, and then perhaps give you a river, where even a Niobe could not squeeze out the moisture of a tear . . . and where is the divine Poesy

of Painting all this while? She has withdrawn, and refused to be dragged on the excursions into Chaos, and hides herself in abhorrence of conflagration. The old masters of landscape never painted extraordinary effects; they aimed more at permanent and general nature, than accidental and evanescent beauties.[35]

The author then cited Claude, and especially Gaspard Dughet, as models still worthy of being followed.

Nothing Eagles had to say against Turner's increasingly fluid handling and heightened sense of color would have been new to the artist. As he assured the young Ruskin a few years later, he paid no attention to such negative comments "for they are of no import save mischief and the meal tub."[36] Yet the barrage of criticism also coincided with Turner's series of painted challenges to artists as diverse as Watteau, Titian, and Canaletto. His propensity to quote from and parody these masters served as an alternate way to look with a critical eye at his own artistic gesture from within the history or context of his discipline. The resulting works are among the most perplexing images in Turner's oeuvre—not as strong visually as Manet's or Picasso's Old Master paraphrases, but just as informed. They artfully recycle the conventions of past art—the styles, compositional formats, and narrative ploys—as part of a spirited exploration of the way meaningful visual imagery is constituted.

By quoting from a panoply of other painters and paintings as he did, Turner pointed out how a vocabulary of visual forms acquires meaning, and how that meaning can be transformed when conventions of representation are consciously adjusted or distorted. He poked and prodded at his models to show that such conventions are there to be changed, and that new and equally valuable meanings can emerge in the process. As a corollary to his exploration of the way that style affects the sense or import of imagery, Turner confronted the issue of what constitutes style *per se*. Precisely by invoking a rapport between his work and art of the past—the best example being his "dependence" on Titian for his own version of *Bacchus and Ariadne*—he provided a clear context in which to recognize the nature and importance of the new formal contributions involving color, brushwork, and the rendering of light that his own style introduced.

Mercury and Argus (1836), the earliest of the Ovidian group, and *Bacchus and Ariadne* (1840) among the last, present two very different approaches to formulating imagery (figs. 89 and 90). The first artfully knits together motifs and ideas from various sources to create a scene respectfully reminiscent of a tradition of representation. The latter openly paraphrases a single, readily identifiable precedent as a way of informing on the talents (and/or perceived limitations) of both artists. The tale of Mercury duping Argus, which had seduced Turner thirty years earlier, requires a snowy heifer grazing, her guardian resting beside the bank of a river, the god playing his pipes —components that add up to a charming pastoral scene, free from troubling implications and providing ample excuse for a painter to dwell on the features of the landscape itself. Many artists had found the theme congenial, the examples closest to Turner's version including Salvator Rosa's, for the placing and poses of the main figures, and Claude's *Landscape with Argus Guarding Io*, which shares the same basic disposition of major elements (fig. 91).[37] Though Turner's composition is upright and Claude's horizontal, both used the centralized stream to separate the left and right masses. Turner coyly alluded to Claude by including, at the top of the mountainous rise on the right, a section of the circular temple that appears in full lower down in Claude's composition. Like Mercury, he engaged

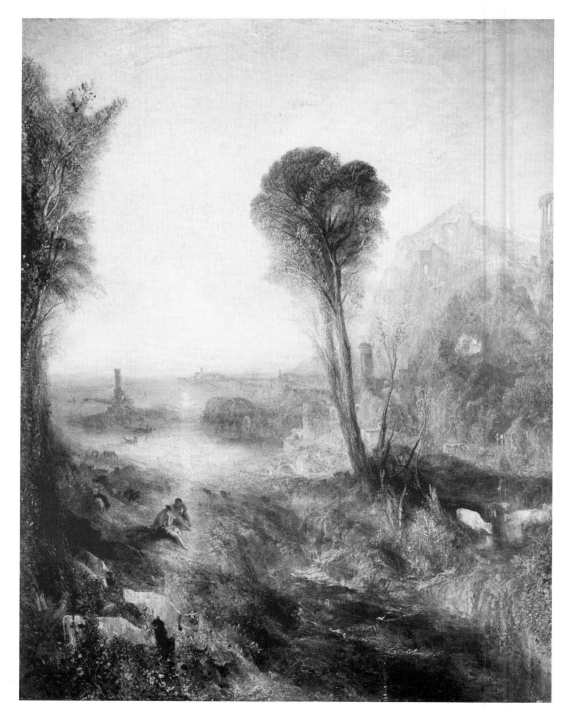

Figure 89. J.M.W. Turner, *Mercury and Argus*, 1836. Oil on canvas, 59 × 43 inches (149.8 × 109.2 cm), National Gallery of Canada, Ottawa (BJ 367).

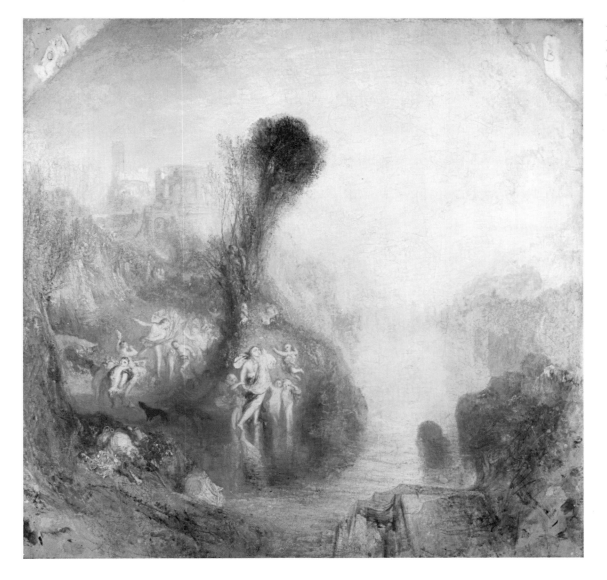

Figure 90. J.M.W. Turner, *Bacchus and Ariadne*, 1840. Oil on canvas, 31 × 31 inches (79 × 79 cm), Turner Collection, Tate Gallery (BJ 382).

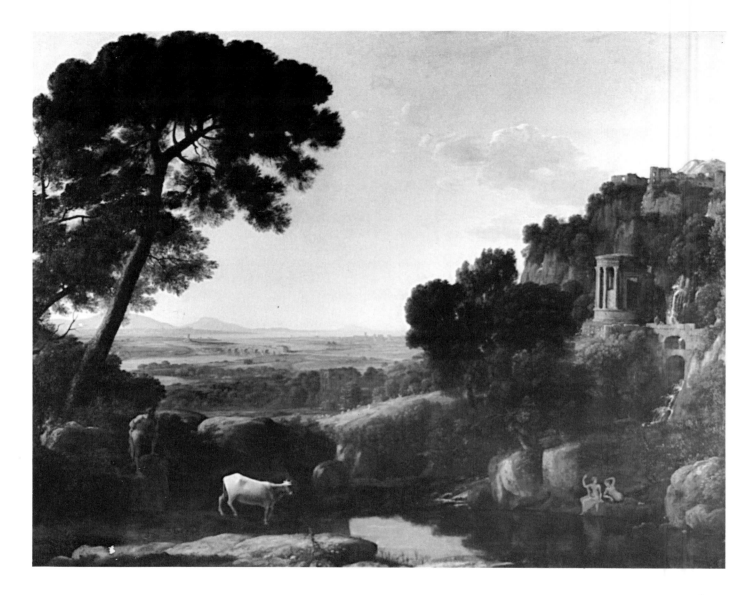

Figure 91. Claude Lorrain, *Landscape with Argus Guarding Io* (LV 86), 1644−1645. Oil on canvas, 40 × 50 inches (102 × 127 cm), Collection of Viscount Coke and the Trustees of Holkham Estate.

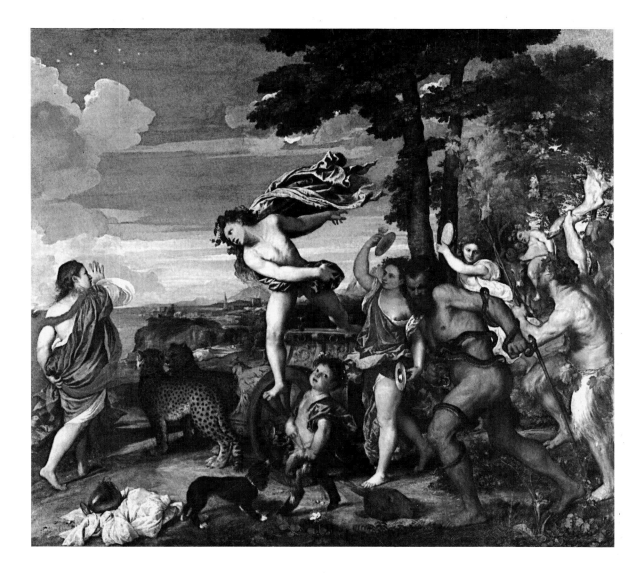

Figure 92. Titian, *Bacchus and Ariadne*, 1523. Oil on canvas, 69 × 75 inches (175.2 × 109.5 cm), Reproduced by Courtesy of the Trustees, The National Gallery, London.

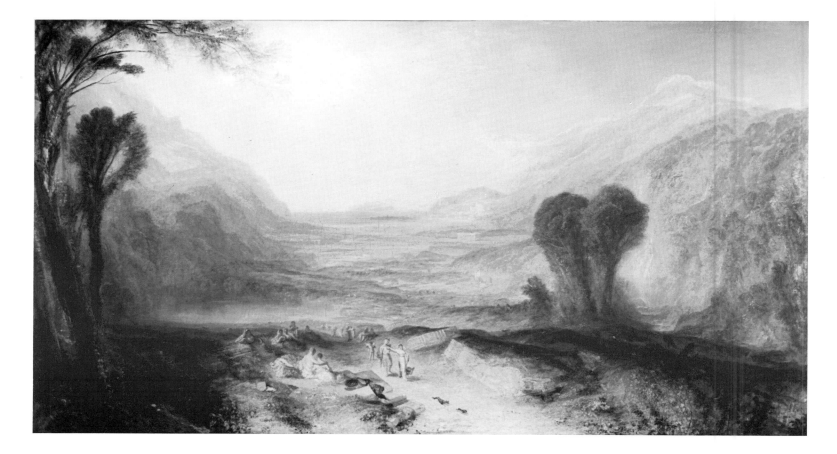

Figure 93. J.M.W. Turner, *The Story of Apollo and Daphne—Ovid's Metamorphoses*, 1837. Oil on canvas, $43\frac{1}{4} \times 78\frac{1}{4}$ inches (109.8 × 199 cm), Turner Collection, Tate Gallery (BJ 369).

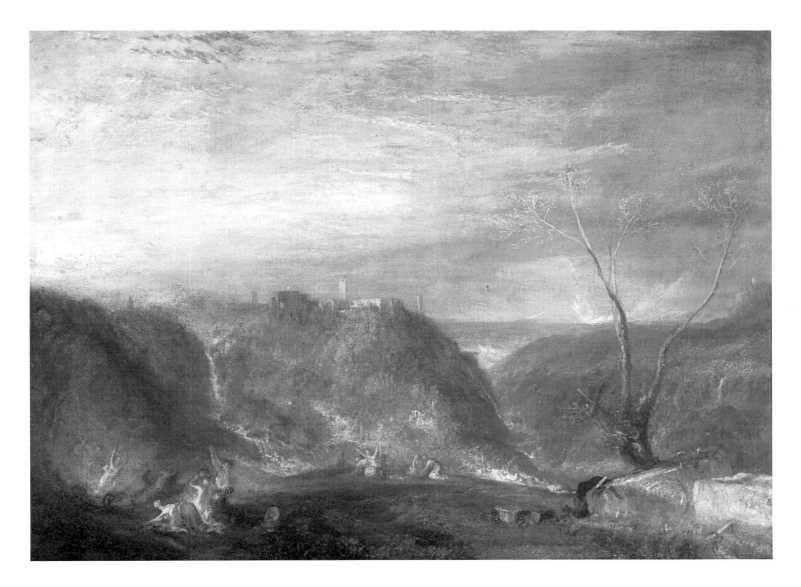

Figure 94. J.M.W. Turner, *Pluto Carrying off Proserpine—Ovid's Metam.*, 1839. Oil on canvas, $36\frac{3}{8} \times 48\frac{5}{8}$ inches (92.4 × 123.6 cm), National Gallery of Art, Washington D.C., Gift of Mrs. Watson B. Dickerman (BJ 380).

in a gentle deception, presenting something that is not entirely what it appears to be at first sight. Where Claude's landscape is classical throughout—temples dotting the background—Turner's was apparently based on contemporary Scottish scenery. According to H.A.J. Munro of Novar, the setting had been drawn from the coastal area of Ross-shire, an area Turner visited in 1831.[38] By "modernizing" classical landscape in this manner (a maneuver first tried in *Thomson's Aeolian Harp*, 1809, and *Crossing the Brook*, 1815; figs. 115 and 120), the painter found a way to represent Eagles' "debatable land," a place somewhere between fantasy and observable nature.

Bacchus and Ariadne, on the other hand, at first sight appears to be nothing short of sacriligious, the work of a "distorted imagination," as one critic unkindly put it.[39] The magnificent Titian on which it was based had sparked a lively controversy in 1826 when the government purchased it for the fledgling National Gallery (fig. 92). Opponents claimed that the price paid had been far too high for a work considered to be damaged and poorly repainted. One critic even asserted that the figures were weak![40] Turner certainly showed Titian's efforts to advantage with his caricature-like copies of Bacchus, Ariadne, and their retinue, scaled down to fit a dream-like, mellifluous landscape. Since his respect for, and understanding of, Titian's art ran deep, the pastiche can only have been entirely affectionate—and perhaps even self-deprecating.[41] In their redesigned composition the figures inscribe a perpetual circuit of pursuit around a miniaturized isle of Naxos. By reversing the positions of Titian's main characters, Turner redirected the nymph's somewhat shocked gaze back toward the viewer, soliciting our reaction to this virtuoso metamorphosis of one painter's presentation into the idiom of another.[42] We quickly realize the power an artist wields over our imagination in comparing the idea

we form of love amongst the gods from Titian's handsome portrayal with the one provoked by Turner's version.

At the same time the Romantic artist provided his own winning demonstration of the allure of mythological landscape. The hard clarity of Titian's sky and the intensity of his colors, particularly the keynote sapphire blues and emerald greens, accentuate the vigor and drama of the foreground scene. Turner instead employed muted tones and warm harmonies, creating a golden atmosphere that softens all the forms within it and that joins river and sky into one continuous glowing substance. In effect the handling recalls Titian's late style in all its evocative sensuality, but Turner's emphasis is on the transformation of landscape into pure light, a metamorphosis entirely in keeping with the poetic imagery of Ovid's story. To honor Ariadne, Bacchus created a new constellation from the crown she wore (visible in the upper left corner of Titian's painting). As it made its ways into the heavens, its jewels changed into gleaming lights whose radiance would seem to have been diffused across Turner's sky. Eventually his version of the legend joined the national collection too, but free of charge.

The process by which mythical accounts can be transformed into natural display totally in keeping with their fabulous character is made manifest in a sequence of three paintings: *The Story of Apollo and Daphne—Ovid's Metamorphoses* (1837; fig. 93), *Pluto Carrying off Proserpine—Ovid's Metam.* (1839; fig. 94), and *Europa and the Bull* (c. 1840–1850; color plate 5). One can observe Turner economizing his means of expression, increasingly letting the quality of the brushwork, the sensuality of color, and the shimmering atmosphere and light tell the stories of pursuit and kidnap. If the figures eventually become simple markers of the action, it is because their episodes relate primal moments in the mythology of nature painted by Turner as if the

original act of creation or transformation were very much in progress.

The Story of Apollo and Daphne—Ovid's Metamorphoses involves perhaps the most famous scene of pursuit and transformation in classical mythology. However, Turner chose not to dwell on Daphne changing into a laurel, the paradigmatic instance of myth explaining nature explaining myth. Instead he opted for the tale's less animated beginning when, boastful about having slain Python, Apollo foolishly derided Cupid's tiny bow. In Turner's scene, the god of love takes his revenge. Apollo, the shining deity of Turner's earlier works, is diminished to an ordinary man who tags along after his capricious lady, while behind them Cupid aims the arrows of hopeless infatuation. Leading the entourage, a greyhound bears down on a hare, a visualization of Ovid's simile for Daphne's ensuing flight and Apollo's chase. Turner quoted the corresponding lines from the *Metamorphoses* in the Academy catalogue:

> "Sure is my bow, unerring is my dart;
> But ah! more deadly his who pierced my heart.
> *　*　*　*　*　*　*　*
> As when th'impatient greyhound, slipt from far,
> Bounds o'er the glebe to course the fearful hare,
> She, in her speed, does all her safety lay;
> And he, with double speed, pursues the prey."

In so doing he pointedly contrasted approaches to representation in the painting and poem for the viewer's pleasure and edification. One can start with Ovid's figure of speech in the verse—"As when th'impatient greyhound, slipt from far"—then see the simile literalized in the painted image of the hound and hare.[43] That little vignette both temporalizes the moment and robs the principal figures of their mythical prowess by transposing their attributes so concretely to the hare and greyhound. Turner's stylized figures of Apollo and Daphne may defuse the tale's tragic element (one cannot but think of Bernini's frightened nymph), but here, too, the artist more than compensated by mythifying the panorama of nature itself. The painting's extreme breadth (it measures 43¼ × 78¼ inches; 109.8 × 199 cm) enhances the deep, inviting recession created by the undulating folds of the hills and valley. The sheer expanse, relative to the small scale of the figures, encourages the viewer to spend a long time perusing the vista, imagining Daphne's flight through its flowing spaces. Its overall coloration—greens and blues that softly shift from one into another, and the soothing insubstantiality of the landscape elements, evoke the natural/mythical dualilty of Daphne's coming transformation. The whole scene is enchanted. This dreamworld is perhaps the most critical topography through which Turner travelled in creating his art.[44]

Pluto Carrying off Proserpine—Ovid's Metam., exhibited at the Royal Academy in 1839, combines an element of parody, as in *Bacchus and Ariadne*, with a direct translation of narrative into the language of landscape. In this instance Turner designed his figures to poke fun at fellow artist William Etty, who had exhibited his own version of the theme that same year (fig. 95). Although he had been an admirer of Turner, Etty became one of the few painters to break ranks and criticize his colleague's late works as "fiery abominations."[45] Perhaps in his own quiet way Turner was returning the insult when he substituted the scattering of figures aptly described by one commentator as "sulphureous tadpoles" for the similarly posed fulsome nudes that had earned Etty a dubious celebrity.[46] Their ineptness seems to mock Etty's pretensions toward the Grand Manner, but the overall tone of the painting is not reproving. Turner's larger concern was to reinvest the story with its initial import as an account about the origins of the seasons.

Figure 95. William Etty, *Pluto Carrying Off Proserpine*, 1839. Oil on canvas, 51 × 77 inches (129.5 × 195.6 cm), location unknown.

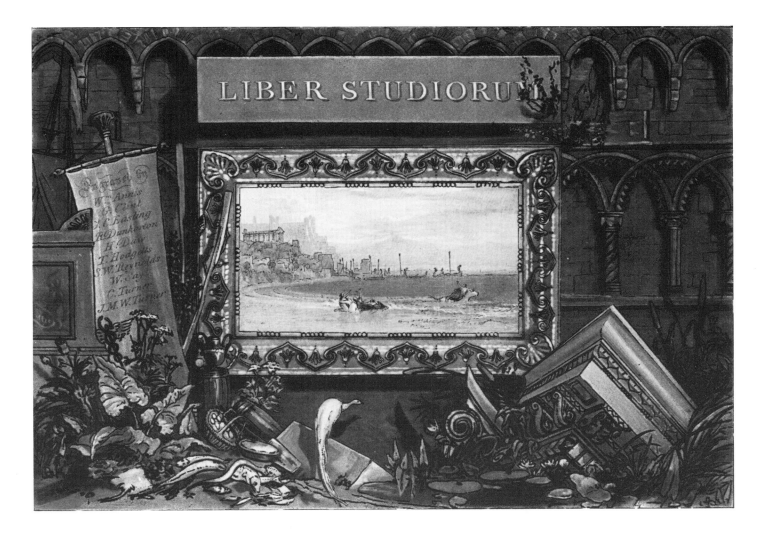

Figure 96. J.M.W. Turner, Frontispiece to the *Liber Studiorum*, published May 23, 1812. Etching and mezzotint, $7 \times 10\frac{1}{4}$ inches (17.8 × 26 cm), Courtesy of the Trustees of the British Museum, London.

The small scale and insubstantiality of the figures—the kidnapping itself is relegated to the lower left corner—keeps attention fixed on the less than abiding character of this particular landscape. Ovid had set the tale in a delightful, flower-filled place, but Turner rendered it stark, as if a preview of the consequences of Proserpine's abduction. The very brushwork lacks its characteristic lushness. The dryly painted, sparsely leafed tree on the right reminds us that this theft threatened to rob the world of eternal spring. The barrenness of the landscape is all the more confounding when one recognizes the locale to be the usually idyllic Italian Campagna.[47] By setting the scene in Tivoli (Ovid had stipulated the "Fair fields of Enna" in Sicily), Turner deftly played with the Grand Tour penchant for associating legend with place: the classic story of seasonal regeneration is transposed to one of the most revered and perennial landscapes of Italy, as if to underscore the potency or universality of the mythic in nature.

The most complete, inspired metamorphosis of mythology into landscape, and of landscape into formal effect, can be seen in *Europa and the Bull* (c. 1840–1850) in which brushwork and color are given free reign and all but carry the weight of the narrative (color plate 5). The subject first appeared as the lavishly framed "painting" in the center of the *Liber Studiorum* frontispiece, 1812, etched by Turner himself (fig. 96). Placed against Gothic panelling and surrounded by architectural fragments and an assortment of plants and objects, the little painting of Europa being carried off by Jupiter disguised as a bull elegantly announced the *Liber Studiorum* project by symbolizing the origins of Western civilization and confirming the artist's allegiance to the traditions of European art.[48] The late oil painting is one of the unfinished, or at least unexhibited, *Liber Studiorum* revisions in which the solidity of the original forms and compositions are dissolved into Turner's fabled veils of tinted steam. In *Europa and the Bull* the effect is particularly felicitous. Its mythical aura augments as the natural elements mingle into one elemental substance that wondrously shifts from hot to cool across the canvas.

It has been proposed that Turner found his inspiration in Titian's version of the subject (now in the Isabella Stewart Gardner Museum, Boston).[49] If so, he would have paid the Venetian painter a fitting last homage by basing his own late painting on a magnificent example of Titian's old-age style. Indeed, the characterization of the abduction as one involving some struggle must have derived from Titian and/or artistic tradition since in the poem Europa is artfully seduced. While sharing his special affinity for Ovid's sensuality, Turner asserted his own artistic identity by emphatically supplanting Titian's ample young woman, flailing on the bull's back, with a landscape of glowing color that surpasses even the Venetian's and that uses inchoate forms in the process of taking shape to invoke the mythical birth of Western culture.

One of his fellow artists described the initial stages of Turner's later paintings as being "without form and void," like chaos before creation. He, too, went on to characterize the artist as a "magician, performing his incantations in public" (cf. p. 133 above).[50] Any chaos one might choose to see in a late painting like *Europa and the Bull* is the chaos of creation in progress: paint and brushwork becoming a story about powers of transformation and generation. The actual handling is not so much gestural as charged with narrative significance. Turner needed only a few calligraphic strokes of white paint to suggest Europa, Jupiter, and the idea of their metamorphosis, but these whispy "figures," in the context of the scene as a whole, are no less a presence, in their own idiom, than those of Titian.

The Meaning of Love

The artist's advancing years did little to alter his thinking on the dilemma of male/female relationships. Apparently nothing in his life experiences had persuaded him to abandon his pessimistic view of love's entrapment. Two late paintings pointedly address that perception, adding a disgruntled note to Turner's otherwise spirited public excursion into the world of myth: *The Parting of Hero and Leander—from the Greek of Musaeus* (color plate 6) and *Glaucus and Scylla—from Ovid's Metamorphoses* (fig. 105). As the citation to the ancient author Musaeus in the first title announces, the tale of the mortals Hero and Leander is something of an interloper in a chapter on Ovid and the *Metamorphoses*. However, an indulgence seems warranted on a number of counts. The story concerns one of the most famous couples from antiquity, classic enough to have been included in the company of the letter-writing lovers in Ovid's *Heroides* and to have inspired numerous Romantic painters and poets, even to the point of foolhardy emulation. Turner's nuancing of their tragic affair is both rich and lucid, making the painting an unparalleled demonstration of his thoughtful manipulation of meaning, generally speaking, as well as serving as a key to the complexities of the more densely packed meditation on love in *Glaucus and Scylla—from Ovid's Metamorphoses* in particular. Finally, it represents perhaps his most ambitious amalgamation of sources and conventions, each retailored to suit Turner's purpose in telling the story anew. The painting caps his study of how one reworks the traditions of representation—a leitmotif in his Ovidian imagery as a whole.

The Parting of Hero and Leander—from the Greek of Musaeus was exhibited in 1837 with *The Story of Apollo and Daphne—Ovid's Metamorphoses*, and while the paintings were not pendants, they complement each other well: both are large canvasses that match landscape with seascape, calm with storm, and light with dark in the tradition of Claude or Poussin.[51] As an added dimension, their episodes relate opposed desires: Daphne rejected Apollo and ran from him while Hero and Leander could not bear parting.[52] Of the two, *The Parting of Hero and Leander—from the Greek of Musaeus* is the more complex in its storytelling. Here Turner combined different levels of reality, portrayed time sequentially, and integrated figures with landscape so that the intrigue and melodrama in Musaeus' vivid account of tragic young lovers invades every inch of the painting.[53] The artist further enriched his imagery by references to, and revisions of, versions of Hero and Leander's infatuation derived from both the visual arts and literature. Their story had enjoyed a long popularity. In the fine arts examples date from antiquity through the early modern period. Among the Old Masters, Mola, Rubens, Rembrandt, and Poussin all painted notable works that for the most part concentrated on Leander's drowning. A highly finished drawing by de Loutherbourg proves how well the story lent itself to fashionable late eighteenth-century tastes for crashing seas, castles, and stormy nights (fig. 97). In English literature, the theme was familiar from at least the sixteenth century, appearing in forms ranging from poems and ballads to Byron's 1810 swim across the strait that separated the lovers.[54] It came to hold special fascination for the writers of Turner's generation, literary interest in the subject postdating his first study of the ill-fated couple.[55]

The artist had pondered the lovers' misfortunes over a period of nearly three decades, during which time he made at least four preparatory sketches that changed surprisingly little in conception from first to last. In the initial drawing, recorded in the Calais Pier Sketchbook (TB LXXXI, 57),

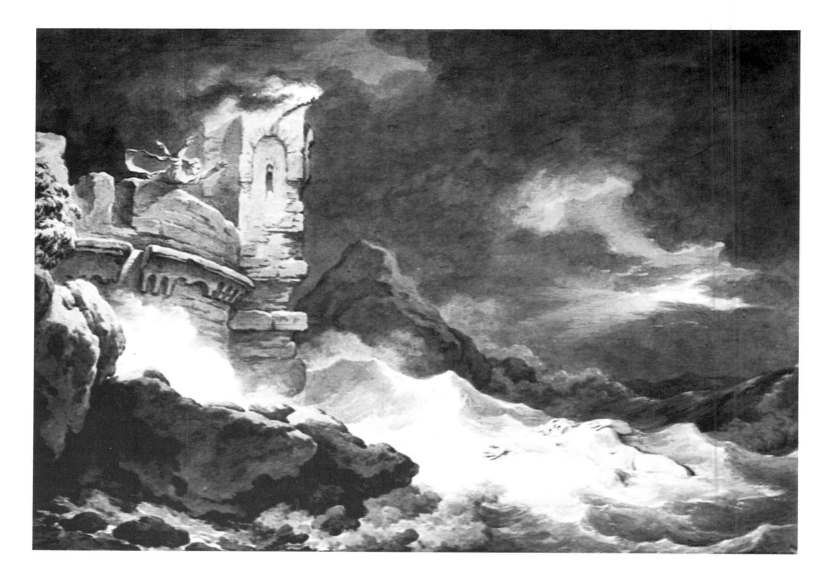

Figure 97. Philip James de Loutherbourg, *A Sea Storm—Hero and Leander*, c. 1772. Pen and bistre, $9\frac{3}{4} \times 14\frac{3}{8}$ inches (25 × 36.5 cm), Plymouth City Museums and Art Gallery, Plymouth, England: Cottonian Collection.

Figure 98. J.M.W. Turner, TB LXXXI, Calais Pier Sketchbook, 57, c. 1799–1805. Black and white chalk on rough grey paper, $10\frac{3}{4} \times 17\frac{1}{8}$ inches (27.3 × 43.5 cm), Turner Collection, Tate Gallery.

Figure 99. J.M.W. Turner, TB CXLIV, "Yorkshire 1," 103a, 1813–1816. Pencil, $3\frac{3}{4} \times 6\frac{1}{16}$ inches (9.5 × 15.4 cm), Turner Collection, Tate Gallery.

he took up the challenge of a nocturnal setting, using grey paper to advantage in visualizing a fantastic cityscape and dark sea (fig. 98). Sometime between 1813 and 1816 he revised the scene in a second sketch (TB CXLIV, "Yorkshire 1," 103a; fig. 99), refining its basic idea well enough that he needed to make only minor adjustments in subsequent drawings.[56] The lovers' parting held such significance for him that he refused to rush his version of the story before the public eye, even when he began to be preempted by fellow artists.

In the exhibited oil, Turner brought together a wealth of borrowed ideas which he exploited with panache in addressing the devastating effects of love. His method recalls that of *The Goddess of Discord Choosing the Apple of Contention in the Garden of the Hesperides*, where a new meaning was wrought from preexisting parts. Turner first subverted the order of events recounted by Musaeus. The ancient author had the young man die while trying to swim across the Hellespont *to* Hero one wintry evening. As Turner reconstructed the story in both the painting and the verse he wrote to accompany it, Leander met his end *after* the lovers' clandestine evening encounter, on his way home.[57] The poem, printed in the Royal Academy catalogue, establishes the sequence of events as the artist construed them:

> The morning came too soon, with crimsoned blush
> Chiding the tardy night and Cynthia's warning beam;
> But Love yet lingers on the terraced steep,
> Upheld young Hymen's torch and failing lamp,
> The token of departure never to return.
> Wild dashed the Hellespont its straited surge,
> And on the raised spray appeared Leander's fall.

To narrate the story in the painting, Turner depicted each of its stages simultaneously, with characters reappearing as the event progresses in a left to right reading of its separate moments. As with *Snowstorm: Hannibal and His Army Crossing the Alps*, the verse plays an essential role as guide to the complicated visual imagery.

The main action signalled in the title, the lovers' parting, occurs at the center of the composition, but is presented only as a small-scale vignette in the middle ground. That treatment both diminished the possibility for a display of tender sentimentality and, in a rehearsal of his parodied "quotations" in *Pluto Carrying off Proserpine—Ovid's Metam.*, put fellow artist William Etty in his place, as it were. In 1827 Etty had exhibited his own version of *The Parting of Hero and Leander* at the Royal Academy (fig. 100), the figures of which, in their poses, coincidentally recall Turner's earliest depiction of the lovers.[58] Perhaps as a retort Turner, in turn, modeled the final version of his embracing couple on his colleague's imagery. Painted in a flat, unmodulated tan, the unflatteringly clumsy figures are upstaged by the area around them, sea and sky commanding much more attention through their varied colors and rich textures, the artist using both impasto and thin, streaky paint to dazzling effect.

At the left a captivating vision of Sestos, Hero's home, extends out toward the viewer (fig. 101). Reality seems to evaporate before our eyes as veils of color and light obscure the floor planes and dematerialize the architectural elements. Paintings within the painting—one at the foot of the grand stair, another, a Claudean port turned sideways in the foreground paving—literally and figuratively force us to shift our perspective in order to come to terms with what we see. Attention finally rests, though, on the incredible group of figures and/or sculptures that line the balustrade, bidding Leander farewell (fig. 102). Furthest back is a statue (?) of a seated, entwined couple, painted in a monochrome tan quite unlike the flesh color of the "real" figures to the right and forward of them. The sculpted lovers visually and thematically balance the scene

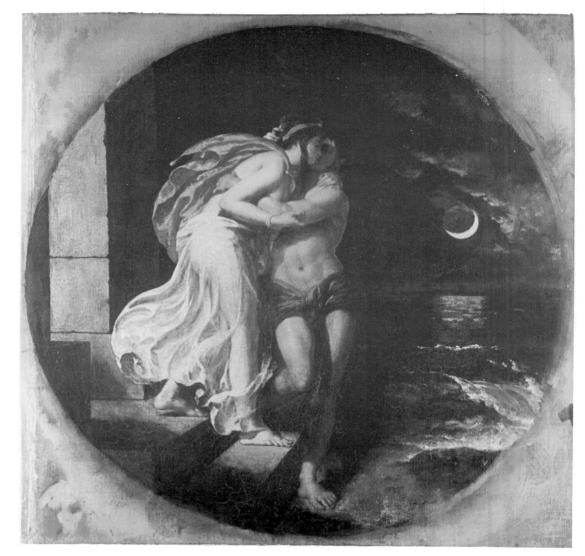

Figure 100. William Etty, *The Parting of Hero and Leander*, 1827. Oil on canvas, $31\frac{1}{2}$ × 33 inches (80 × 83.8 cm), Tate Gallery.

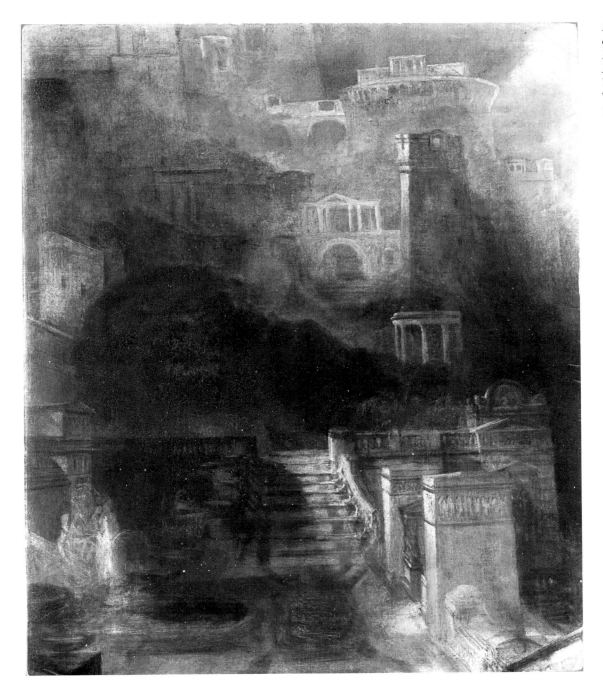

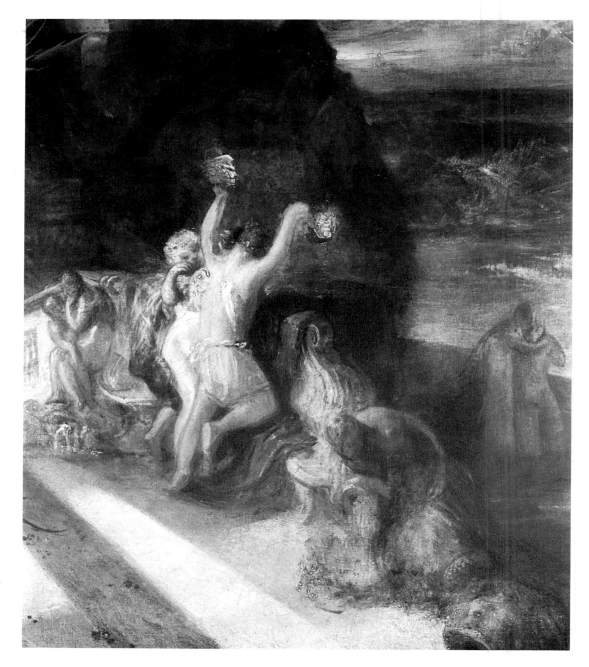

Figure 102. J.M.W. Turner, detail, *The Parting of Hero and Leander—from the Greek of Musaeus*, 1837, Reproduced by Courtesy of the Trustees, The National Gallery, London.

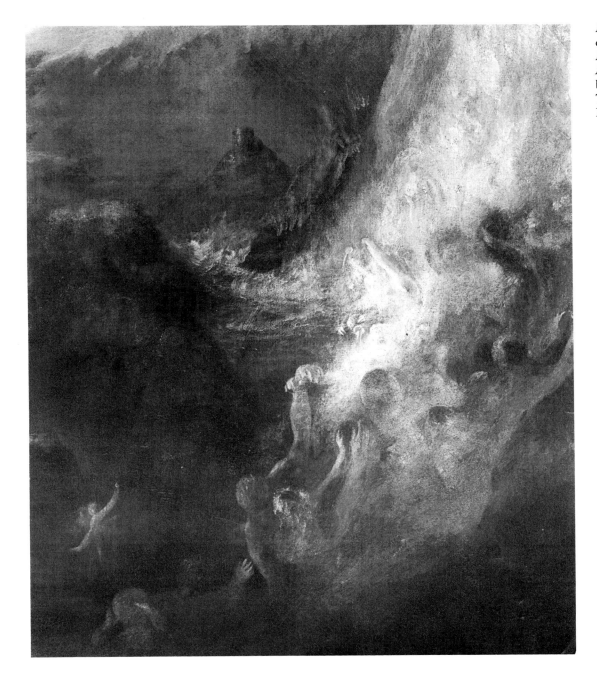

of Hero and Leander at the water's edge, recalling through their embrace the earlier happiness of the star-crossed pair. The more prominent pair along the railing consists of an androgynous "young Hymen" pressed up against a mature Cupid. The former's curly head, garlanded with flowers, identifies him as the god who, with his burning torch, normally presides over marriages. Here, however, his light is held aloft by the winged "Love," whose bow has been set aside on the ground. In his other hand Cupid elevates the "failing lamp," the beacon with which Hero had guided Leander's nightly passage to her, and one of the identifying features of the episode. As Turner's poem explained, the lamp has now become the symbol of the young man's doom, "the token of departure never to return."

There is no small irony in Hymen's presence and Cupid's gesture. Musaeus had specified that the secretive nature of the lovers' marriage denied them the necessary blessings:

No youth with measur'd dance the nuptial crown'd
No tuneful Hymen's congratulating found.
. . .
No nuptial torch its golden lustre shed
Bright torch of love to grace the bridal bed.
— (395–96; 399–400)

In the painting, then, the two lights held up by the figure of Love "illuminate" an equation of marriage with death, a dire fate borne out elsewhere in the painting. A somber note is struck by the nearby sculpted (?) figure, enigmatic and withdrawn, pouring a blue fluid from a vase. It suggests that an offering or libation is already being made to the dead. Finally, at the very front lies a brown sea monster with a curling tail from whose gaping mouth spills a fish, a harbinger of Leander's briny end.

The contrasting states of being—real, unreal, mythic— that Turner depicted along the balustrade and throughout the scene, parallel his display of modes of representation in *The Story of Apollo and Daphne—Ovid's Metamorphoses* but in a more powerfully instructive way. We become aware of our *inability* to readily decipher what we see. The artist works his magic on our powers of reason, and in the process, coerces us to examine our expectations about representation per se, and to recognize that even minor shifts in the *way* a figure is painted produce a consequent change in its status or meaning. One of the real pleasures of *The Parting of Hero and Leander—from the Greek of Musaeus* is the sheer variety of its brushwork, ranging from filmy patches to dense, opaque areas. As in *Europa and the Bull*, the handling of the paint begins to narrate the tragedy.

Turner revealed the consequence of the lovers' union at the far right (fig. 103). A stormy wave crashing against the cliffs breaks into a foam of ghostly figures, some gray, transparent, and weightless, others more solid and flesh-colored, but all love's flotsam now. Their entangled bodies blur together, one limb seeming at first to belong to one figure, then another. As if striving to break free, they gesture upward, but with no sense of energy. Some seem to be holding onto, or trying to grasp, giant spheres or bubbles. This nightmarish vision surely had its precedent in Rubens' violent depiction of Leander's drowning, wherein Neptune's daughters claim their quarry in a great sweeping wave, while an ominous sea monster, father to the one on Turner's balcony, waits his turn in the bottom left corner (fig. 104).[59]

In some respects Turner's *The Parting of Hero and Leander—from the Greek of Musaeus* was a gesture of reconciliation toward Rubens. From the time of his first study in the Louvre he had stubbornly excluded the Flemish master from his list of preferred models. In his notes he had criticized Rubens for distorting nature, chiefly through illogical light effects and the misplaced fall of shadows.

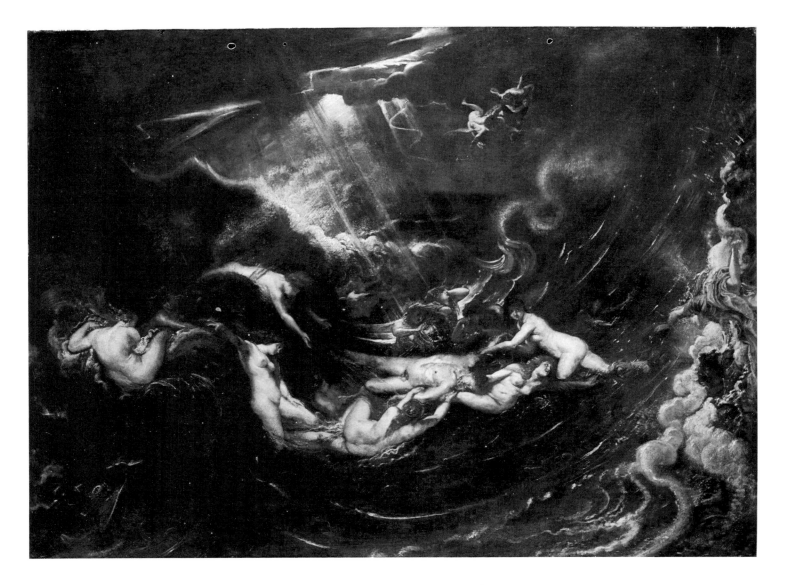

Figure 104. Peter Paul Rubens, *Hero and Leander*, c. 1606. Oil on canvas, $38\frac{5}{8} \times 52$ inches (98 × 132 cm), Yale University Art Gallery, New Haven.

Later, in the "Backgrounds" lecture he charged him with destroying the simplicity, truth, and beauty of pastoral nature, an opinion from which he would not be shaken.[60] In the image of Sestos, however, Turner indulged in a fantastic display of light and shade that outdid Rubens on his own terms. At the other side of the canvas he seems to have countered his predecessor's sensuous corporeality and celebration of human passion with his own thin spectres.

The overall tone of his narrative is correspondingly muted. Various details reinforce the message about the perils of marriage, but they must be sought out. A tiny Hymen-like figure, torch in hand, hovers just at the edge of an ominously dark arch piercing the rock formation behind the tide of bodies. In the right foreground where the handling is loose and the paint opaque, as if concealing something, the wraiths glide over what appears to be a sarcophagus. Against its face two fragile but exceedingly distinct little bubbles float upward as well. A poem Turner had written much earlier (c. 1800)—at about the time he first sketched his idea for the painting, and not long after his alliance with Sarah Danby—informs at least this section of the work, if not the whole scene and the rest of the Ovidian love subjects as well:

> Love is like the raging Ocean
> Winds that sway its troubled motion
> Woman's temper will supply
>
> Man the easy bark which sailing
> On the unblest treacherous sea
> Where cares like waves in fell succession
> Frown destruction oer his days
> Oerwhelming crews in traitrous ways.
>
> Thus thro life we circling tread
> Recreant poor or vainly wise
> Unheeding grasp the bubble Pleasure
> Which bursts his grasp or flies[61]

The themes of antagonism between the sexes and the treachery of women against men underlie interpretations of the Hero and Leander story other than Turner's, of course. Only Musaeus, it seems, placed the blame for uncontrolled desire equally: Hero should have resisted her passion and not signalled Leander on a stormy night, but he too should have recognized the dangers and stayed at home. No such equanimity colors the account in Ovid's *Heroides*, where Hero's whimpering sends Leander to his death against his better judgment. Keats' 1816 sonnet "On a Leander Gem" blamed womanhood itself for the destruction of the young man, though with more teasing good will than rancor:

> Come hither all sweet maidens soberly,
> Down-looking aye, and with a chasten'd light,
> Hid in the fringes of your eyelids white,
> And meekly let your fair hands joined be,
> As if so gentle that ye could not see,
> Untouch'd, a victim of your beauty bright—
> Sinking away to his young spirit's night;
> Sinking bewilder'd mid the dreary sea:
> 'Tis young Leander toiling to his death.
> Nigh swooning, he doth purse his weary lips
> For Hero's cheek, and smiles against her smile.
> O horrid dream! see how his body dips
> Dead-heavy; arms and shoulders gleam awhile:
> He's gone: up bubbles all his amorous breath![62]

While Turner's indictment against women and their entrapments of love and marriage is more serious, its didacticism is tempered by the phantasmagoric fascination of the scene as a whole. The close values and sombre coloring convey a hint of sorrow, while the unsettling and nervous brushwork in the areas of sky and sea evoke the emotional chaos of love, the streaky dawn literally chiding the night sky and wan moon so that the celestial spheres

are in conflict too. Overall, the presentation is as unstable, visually, as the relationships and emotions of those who love.

Glaucus and Scylla—from Ovid's Metamorphoses (fig. 105), with its contrastingly hot coloration and complicated imagery, amplifies that message by calling up the full range of emotional turmoil associated with love: longing, rejection, jealousy, rage, heartbreak. In this case, Turner conflated a narrative sequence in the *Metamorphoses*, telling (or alluding to) the stories of several different would-be relationships intertwined around the episode of the sea god Glaucus and his desire for the nereid Scylla. In the poem their story is preceded by the tale of Acis' ill-fated love for Galatea (13, 740—897).[63] Galatea narrates by explaining to Scylla how she refused the advances of the cyclops Polyphemus, causing him to lash out in fury and crush her beloved Acis with a stone. Seeing his blood flowing from beneath the rock, she transformed her lover into a stream (and hence into a river god).

In the painting, a figure whose prominent horns identify him as the hapless Acis rises out of the water at Scylla's feet. The contrasting patch of blue water in an otherwise ruddy sea, just below his head, may signal his subsequent transformation. Turner thus has him join Glaucus in supplicating a nymph no longer as demure as she had been in Ovid's text or in his own earlier *Liber Studiorum* drawing. In Salvator Rosa's version (fig. 106), a painting as dear to English admirers as his *Regulus*, any coquettishness on Scylla's part in raising her skirts is offset by the groping physicality of her would-be lover, Glaucus. John Martin showed the nymph in desperate flight, the affront to her virtue heightened by the chasteness of the surrounding landscape (fig. 107).[64] In Turner's version, amorini tug at Scylla's drapery as if to reveal pleasures that only lead to torment for unlucky suitors. The prominence of her scantily clad figure also calls to mind the nereid's subsequent fate: her nether parts were transformed into dogs.

That punishment was visited upon Scylla through the jealousy of the temptress Circe. Spurned by the nereid, Glaucus sought help in his quest from Circe, unaware that she desired him for herself. Indeed, her passion and anger would literally seem to have colored the scene Turner painted. When the sea god rudely rejected her

> Straight Circe reddens with a guilty Shame,
> And vows Revenge for her rejected Flame.
> Fierce liking oft a spite as fierce creates;
> For love refus'd, without aversion, hates.
> To hurt her hapless rival she proceeds;
> And by the fall of Scylla, Glaucus bleeds.
>
> —(14, 39—44)

Sea, sky, and land coalesce into one fiery red-orange substance that communicates those driving emotions and that alludes to the actual and figurative fates of Acis and Glaucus. By substituting a lurid evening sunset for the intense noon-day heat of the poem, Turner further exaggerated the treacherous landscape of jagged edges and sharp peaks that Ovid had described in telling the story of Glaucus and Scylla (13, 899—916). The artist may have developed his multireferential story about the temptations and pitfalls of love with the idea of making *Glaucus and Scylla—from Ovid's Metamorphoses* a pendant to the *Dawn of Christianity*, also exhibited in 1841. The two paintings offer a contrast in both formal terms (warm versus cool tonalities) and thematic: the corporeal as opposed to the spiritual. At that stage in his life, however, the artist seems to have felt that religion held no better promise or hope than had love.[65]

The combined lessons of Turner's Ovidian inquiry into how conventions of representation work; how they can be transformed or manipulated; how, through stylistic metamorphosis, an artist can discover and convey the animating spirit of a poet as inventive as Ovid; how human passions (but precisely *not* empassioned sensations) can be led astray

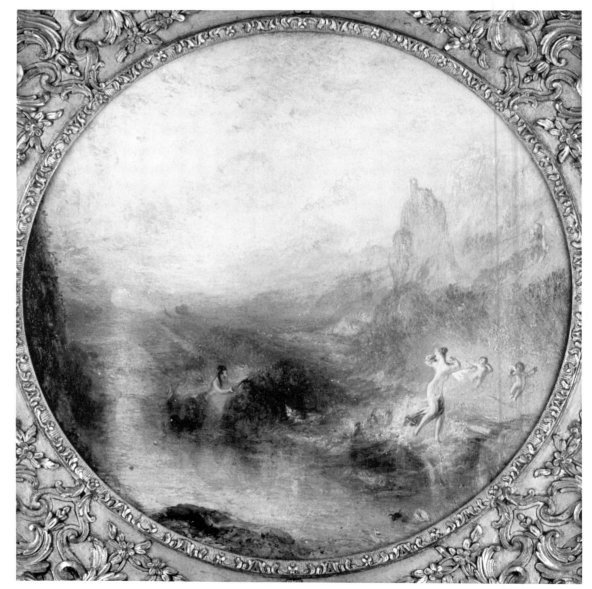

Figure 105. J.M.W. Turner, *Glaucus and Scylla—from Ovid's Metamorphoses*, 1841. Oil on panel, 31 × 30½ inches (79 × 77.5 cm), Kimbell Art Museum, Fort Worth, Texas (BJ 395).

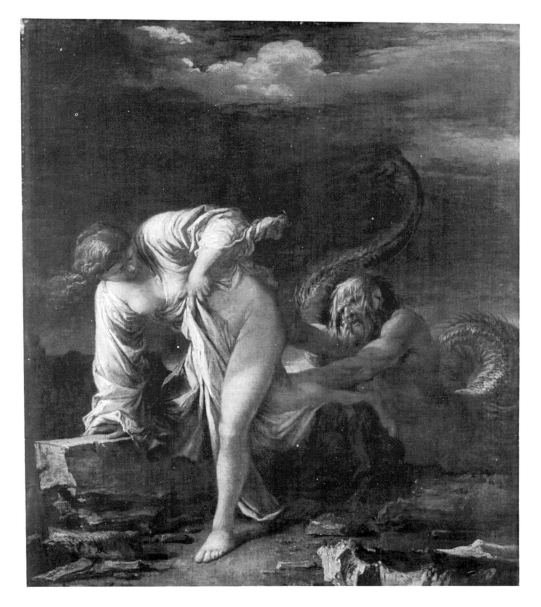

Figure 106. Salvator Rosa, *Glaucus and Scylla*, 1663. Oil on canvas, $33\frac{1}{2} \times 27\frac{1}{2}$ inches (85×70 cm), Musées Royaux des Beaux-Arts, Brussels.

Figure 107. John Martin, *Glaucus and Scylla*, c. 1820. Watercolor and pencil, $8\frac{5}{8} \times 11\frac{1}{4}$ inches (22×28.5 cm), Collection, Vassar College Art Gallery, Poughkeepsie, New York.

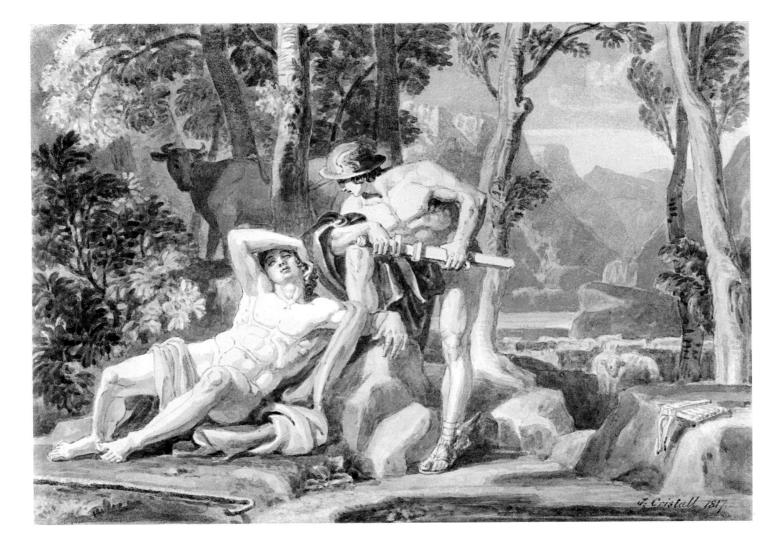

Figure 108. Joshua Cristall, *Mercury and Argus*, 1817. Watercolor, $8\frac{5}{8} \times 12\frac{1}{8}$ inches (22 × 30.8 cm), The Henry E. Huntington Library and Art Gallery, San Marino, California.

Figure 109. Samuel Coleman, *David Dancing before the Ark of the Covenant*, c. 1830. Oil on canvas, 35 × 47 inches (88.9 × 119.4 cm), City of Bristol Art Gallery and Museum, Bristol, England.

Figure 110. Francis Danby, *Enchanted Castle, Sunset*, 1841. Oil on canvas, 33 × 46 inches (83.8 × 116.8 cm), By Courtesy of the Board of Trustees of the Victoria & Albert Museum, London.

take on an added intensity in the context of his contemporaries in landscape painting. When Joshua Cristall depicted the episode of Mercury and Argus in a watercolor dating from 1817 (fig. 108), he came much closer to illustrating Ovid in the traditional sense of the word, however nobly, than Turner ever let himself do. In *Salmacis and Hermaphroditus* or *Glaucus and Scylla* John Martin shared Turner's emphasis on the landscape, but in the vein of Cristall, his images do not tease, cajole, or confound us in the way that Turner's best Ovidian works can.[66] In the latter, we savor the essential character of myth itself. At the same time, his art persuades us to learn to recognize when and how innovation occurs, so that we may appreciate it for what it is.

An equally revealing comparison can be drawn with the endeavors of the Bristol School artists—Francis Danby, Samuel Coleman, or Samuel Jackson. Earnestly seeking to re-create the fairyland that the Reverend Eagles had lauded, they embarked on total flights of imaginative fancy.[67] Works like Coleman's *David Dancing before the Ark of the Covenant*, c. 1830, or Danby's *Enchanted Castle, Sunset*, 1841 (figs. 109 and 110), delight through their elaborate depiction of exotic forms, but undertake no inquiry into the structures of meaning that enhance or inform that exoticism. Turner, instead, grounded his visions in the mood and spirit of Ovid's poetry, in the traditions of the Old Masters, and in the reality of nature and the act of painting, a sweeping gesture that imparts significance where there might otherwise only be whimsy. His Ovidian landscapes were essays both in mythologized nature and in the topography of Ovidian myth.

Chapter V: Notes

1. *Ovide Moralisé*, attributed to Phillipe de Vitry, provided Christian interpretations, casting Apollo as Christ and Phaeton as the anti-Christ, for example, The Abbé Banier's *La Mythologie et les Fables Expliquées par l'Histoire* (Paris, 1738—1740) was one of the better known eighteenth-century etiological commentaries. He explained Hercules as a symbol for dike building, or Achelous as a river that constantly flooded. Translations of his commentary on Ovid appeared as early as 1732 in Garth's translation of the *Metamorphoses*. Other sources included Lemprière's *Bibliotheca Classica* and John Bell's *New Pantheon* both of which could be quite equivocal about the possible meanings of myth. For example, the entry in Bell's work for Hermaphroditus commented simply that "Some represent this fable of the poets as a figurative description of marriage," p. 395.

2. The classic study of the influence of Ovid and other ancient writers is Douglas Bush's *Mythology and the Romantic Tradition* (New York: W.W. Norton Company, 1963).

3. Anon, "On the Poetical Use of the Heathen Mythology," *The London Magazine* 5, no. 26 (1822), p. 113.

4. Turner included the subject in a list of prospective *Liber Studiorum* titles discussed here on p. 147. Butlin and Joll noted an unfinished small painting, c. 1798—1799 (BJ 34a) that includes figures possibly representing Pyramus and Thisbe, *The Paintings*, 1, p. 25.

5. This preface was included in the 1732 edition, Ovid, *Metamorphoses*, ed. Garth et al. (Amsterdam), reprinted Garland Publishing, Inc. (New York, 1976), n.pag. New editions of the Garth translation appeared in London in 1758, 1794, 1807, 1812, and 1826. For additional commentary I have used the two editions closest, chronologically, to Turner's initial interest in the poem, that from 1794 and the volume of translations added to Anderson as vol. 14 of *A Complete Edition*, in 1807.

6. An introductory essay on the life and writings of Ovid in the 1794 edition of the Garth translation of the *Metamorphoses* substantiates Turner's modern perception of the poem: it

cites the poet's "chief excellence" as a "luxuriant and sportive imagination," and his weak point as "a looseness of expression, too often bordering on immorality; his thoughts are sometimes as obscene, as his language is elegant"; 1, p. iii. In a perceptive assessment of Turner's response to Ovid, Cosmo Monkhouse proposed that the artist had so far surpassed the flavor of the Garth translation that he must instead have known (or should have known[!]) Golding's much more colorful sixteenth-century translation, "Ovid, Turner, and Golding," *Art Journal* 32 (1880), pp. 320—32.

7. The first two derive from Book 1, the rest from Books 2, 6, and 4 respectively. Turner seemed to have been in a list-making frame of mind. On 56a he wrote out several Biblical titles: "Jacob and Esau," "Jacob and Rachel," and "Laban Searching for his Images," as well as "Pope's Pastoral or Garth's," also including a line of poetry. See, also, the drawings with alternate titles: plates 1, 10, 11, and 13.

8. The Duke of Bridgewater sold the painting in 1801; Constable, *Richard Wilson*, p. 163.

9. The comment was included in Anderson, *A Complete Edition*, 14, p. 343.

10. Claude preceded Turner in experimenting with a slightly different aspect of the sequel in a lost oil, *Landscape with the Three Heliads Searching for the Dead Phaeton* (LV 143). Claude had in fact sketched the sisters mourning wildly at Phaeton's tomb, but it seems unlikely Turner could have seen or known of this drawing, which was in the Pallavicini collection in Rome. Roethlisberger noted that in all other known versions of the sisters' episode, artists concentrated on their subsequent transformation into poplars that shed tears of amber; *Claude Lorrain: The Paintings*, 1, p. 340. Members of the post-Girtin Sketching Society had chosen "Phaeton asks of Phoebus Apollo the Chariot of the Sun" as one evening's subject some time after 1812; Hamilton, *The Sketching Society*, p. 13.

11. Ovid, *Metamorphoses* (1794), 2, p. 61; Anderson, *A Complete Edition*, 14, p. 388.

12. TB CXLIII, Liber Notes (2) Sketchbook, 1815—1816, inside end cover. Elsewhere he got it right: in TB CLIVa, Liber Notes (2) Sketchbook, 1816—1818, 31 he noted it as "Esacus and Hesperie." In text headings, the story is titled "Aesacus transformed into a cormorant" over his love for the nymph Hesperia.

13. For a discussion of Ovid's symbolism see Charles Paul Segal, *Landscape in Ovid's Metamorphoses: A Study in the Transformation of a Literary Symbol*, Hermes: zeitschrift für klassische philologie, Einselschriften, Heft 23 (Wiesbaden: F. Steiner Verlag, 1969) pp. 12—13.

14. Finberg, *Life of J.M.W. Turner, R.A.*, pp. 68—69.

15. The story was first recounted in Thornbury's biography, there attributed to Daniel Maclise, but was given its fullest airing and analysis in Lindsay, *J.M.W. Turner*, pp. 92—96.

16. Chubb, in "Minerva Medica and the Tall Tree," pp. 34—35, transcribed the notes, which were copied from Alexander Dow, *History of Hindostan*, 1768, and Sir William Jones, "On the Chronology of the Hindus" and "On the Gods of Greece, Italy, and India," collected in Jones' *The Works of Sir W.J.* (London, 1799).

17. Richard Payne Knight, "A Discourse on the Worship of Priapus," (1786), reprinted in *Sexual Symbolism* (New York: Bell Publishing Co., 1957), p. 91. Knight's description of the Greeks' "great Creator" would, however, have offered a heady metaphor for an artist's power: the deity, operating upon "inert matter" in a perpetual act of creation and generation, claimed light as "his necessary and primary attribute, co-eternal with himself, and with him brought forth from inert matter by necessity"; pp. 31—35.

18. The index entries and text headings for the three episodes in the 1794 edition of the poem are more varied: the first is given matter-of-factly as "The Story of Achelous and Hercules," the second concurs with Turner's annotation, being "The Death of Nessus the Centaur," while the third is explanatory—"The Transformation of Lichas into a Rock"; Ovid, *Metamorphoses*, 3, pp 5, 9, and 14 and index. Turner skipped over the intervening story labeled "The Death of Hercules" (p. 11).

19. For Poussin's illustrations to Ovid, see Jane Costello, "Poussin's Drawings for Marino and the New Classicism: I. Ovid's *Metamorphoses*," *Journal of the Warburg and Courtauld Institutes* 18 (1955), pp. 296–317.

20. The sketch is the second in a group of three (31a–33a), all of which include similarly gesturing figures.

21. Butlin and Joll listed the oil sketch as *Mountain Glen, perhaps with Diana and Actaeon* (BJ 439). They suggested that its composition may have been distantly inspired by two Titians of the same subject that first arrived in England in 1798; *The Paintings*, 1, pp. 277–78.

22. *Cephalus and Procris*, issued February 1812, was engraved by George Clint; *Aesacus and Hesperie*, issued January 1819, was engraved by Turner himself. *Jason* was also included among the published plates; it appeared in June 1807. Among the unpublished subjects *Glaucus and Scylla*, c. 1813, was etched by Turner and engraved by William Say. *Pan and Syrinx* exists as a drawing, now in the British Museum, along with two impressions of an etching, probably by George Dawe. *Narcissus and Echo* was etched in soft ground by Turner.

23. The list of subjects is in TB CIII, Tabley Sketchbook No. 1, 1808, on the inside cover. There are seven titles, beginning with "5 Plague/10 Plague/Deluge/Narcissus and Echo," as Turner gave them. He included versions of the first three in the *Liber Studiorum*. In one of his Academy lectures, Turner remarked on the two precedents for his themes, noting that both Poussin's *Pyramus and Thisbe* and Gaspard Dughet's *Dido and Aeneas* contained atmospheric effects more northern than southern; from BM Add. MS 46151 CC, reprinted in Gage, *Color in Turner*, pp. 213–14.

24. Anthony Blunt, *Nicholas Poussin* 2 vols. (New York: Pantheon Books, 1967), 1, p. 45.

25. The similarity was noted by Butlin and Joll, *The Paintings*, 1, pp. 117–18, who suggested that the left foreground may contain a scene of dogs attacking a stag, "a reminiscence of one of Rubens' boar hunts." Since the oil sketch also bears some relation to the depiction of Diana and Acteon in TB XCIII, Hesperides (1) Sketchbook, c. 1805–1807, 32a, perhaps the commotion refers to Acteon's fate. It would seem that even as Turner painted out-of-doors along the Thames his thoughts drifted to the mythological realm.

26. Turner commented on his "naturalizing" adjustments to the classical landscape tradition in *Appulia in Search of Appulus*; see below, p. 231. Despite its revised Ovidian plot, he planned to include the work in the E P category of the *Liber Studiorum*, no doubt because of its strong Claudean affiliations. According to Finberg *Narcissus and Echo* may have been destined for the same category, perhaps for similar reasons; *The History of the Turner's Liber Studiorum* (London: Ernest Benn Ltd., 1924), pp. xxxix, xliii. *Appulia in Search of Appulus* was engraved by William Say, but remained among the *Liber Studiorum's* unpublished plates.

27. Eric Adams, *Francis Danby* (New Haven: Yale University Press, 1973) p. 19.

28. That particular geologic formation fascinated Turner. It appears in *Chryses*, 1811 (fig. 143) and the c. 1830 oil sketch *Rocky Bay with Figures* (BJ 434).

29. *Apollo and Python*, also exhibited in 1811, might be considered an Ovidian subject as well, since the episode is recounted as part of the Giant's War in Book 1. Turner's printed poem and his sketchbook drafts to some degree echo the phrasing and diction of Dryden's translation (for example, lines like "So monstrous was his bulk, so dire a sight" or "Th'expiring serpent wallow'd in his gore" (1, 589 and 595). In the introductory essay on Ovid in the 1794 edition of the Garth translations, the author explained that the poet's allegories "whether physical, moral, or historical, always contain some instructive precept, wrapped up with much art and developed with particular sagacity." Three subjects (cited as examples) were treated by Turner in one form or another: the story of Apollo and Python, as an instance of physical allegory; the story of Actaeon torn to pieces by his hounds (and the story of Erisicthon starved by hunger) as moral allegory—the two episodes being "figurative illustrations which plainly indicate that extravagance and luxury constantly end in want"; and as historical allegory, the rape of Europa, "who was carried away by the Candians in a galley, the stern of which was adorned with a bull"; Ovid, *Metamorphoses*, 1, pp. viii–ix.

30. In his verse tag for the Royal Academy catalogue, Turner corrupted Ovid's lines slightly, eliminating the reference to Athens:

> Close by the sacred walls in wide Munichia's plain
> The God well pleased beheld the Virgin train.

31. Butlin and Joll, *The Paintings*, 1, p. 81, identified only leaf 20 of the Woodcock Shooting Sketchbook (TB CXXIX) group with the painting. I propose that the entire suite of sketches be considered as one sustained imaginative endeavor. Similar vertical compositions occur in TB XC, "Studies for Pictures, Isleworth." The first is leaf 52a (plate 11). Leaf 57 is definitely associated with the painting, while 57a through 60 are variations on that scene (plates 13 and 14). Interestingly, in both sketchbooks the drawing most

identifiable as preparatory to the painting initiates the "improvisation," as it were, rather than culminates it.

32. John Gage connected Turner's orchestration of the painting's color with the artist's lecture on Veronese's work; *Color in Turner*, p. 89–90.

33. Intervening between the Ovidian works from the early years of the century and these later canvases are several paintings that do not conform to the stylistic or narrative features of either group, but whose stories are recounted in Ovid (as well as other literary sources). They include the *Bay of Baiae: Apollo and the Sibyl*, 1823 (from 14, 134–41); the *Vision of Medea*, the ancient source for which might also be Seneca's tragedy, *Medea*; and *The Golden Bough*, 1834, which could have been based on a reading of the *Aeneid*.

34. Reverend John Eagles, "The Sketcher No. IV," *Blackwood's Edinburgh Magazine* 34 (1833), p. 529.

35. Eagles, "The Sketcher, No. 1," *Blackwood's Edinburgh Magazine* 33 (1833), pp. 684–85.

36. Finberg, *Life of J.M.W. Turner, R.A.*, p. 364. It was one of Eagles' salvos in 1836 that provoked Ruskin to begin his defense of Turner culminating in the five volumes of *Modern Painters*.

37. Compare either Rosa's *Argus, Io, and Mercury*, Nelson-Atkins Gallery, Kansas City, or *Romantic Landscape with Mercury and Argus*, National Gallery of Victoria, Melbourne. One version was exhibited at the British Institution in 1838; Algernon Graves, *A Century of Loan Exhibitions*, 5 vols. (1914; reprinted New York: Burt Franklin, 1966), 3, p. 1137. Turner reversed the positions of the figures, but conformed to their poses. The Claude had been in England since 1746. Michael Kitson, "Turner and Claude," *Turner Studies* 2, no. 2 (1983),

proposes that the painting's source was instead Claude's *Landscape with the Rest on the Flight into Egypt*, LV 88.

38. Finberg, *Life of J.M.W. Turner, R.A.*, p. 359.

39. The remark appeared in *Blackwood's Magazine*, September 1840, quoted by Butlin and Joll, *The Paintings*, 1, p. 213.

40. The painting had belonged to Thomas Hamlet, who made it available for frequent exhibition and copying by Royal Academy students. He offered it along with a Poussin and an Annibale Caracci for the total sum of £9,000. In letters to the *Times* and various other newspaper reports critics argued that the Titian—choicest of the three—should be valued at no more than £4,000; W.T. Whitley, *Art in England 1821–37*, (Cambridge: Cambridge University Press, 1930), pp. 103–104.

41. Turner in fact owned a copy of the Titian, noted in *Turner 1775–1851*, ex. cat. London: Tate Gallery, 1974, p. 145. Charles Stuckey, "Temporal Imagery in the Early Romantic Landscape," Ph.D. diss., University of Pennsylvania, 1972, p. 182, suggested that Turner painted his version in response to Charles Lamb's ideas about the representation of time in Titian's painting.

42. Marcia Briggs Wallace, "J.M.W. Turner's Circular, Octagonal, and Square Paintings, 1840–46," *Arts Magazine* 53 (1979), p. 117, note 19, read the outward glance as an indication of Turner's awareness of Lamb as co-respondent. I prefer to see it as an acknowledgment of the viewer more generally. Powell interpreted the painting rather more seriously, casting Ariadne as a tragic heroine in a scene that she felt replaced the "joyous mood" of Titian with "chaos and fear"; *Turner and the South*, p. 193. The handling of the figures and the overall quality of the landscape argues for a less dramatic, more chimerical presentation.

43. Turner's contemporaries noticed his ploy but did not necessarily approve. *Blackwood's Magazine* (1837) found the method "odd": "He makes [the simile] precede, and thrusts it into the very foreground before his figures, and there we have such a hare and hound!"; quoted in Butlin and Joll, *The Paintings*, 1, p. 221.

44. Two contemporary responses to the painting communicate its effect well. The *Literary Gazette* found it "One of those gorgeous effects of prismatic colours in all their original and distinct vividness, which under any other management than that of Mr. Turner would be offensive; but which he renders absolutely magical." Samuel Palmer wrote that "Turner's corruscation of tints and blooms in the middle distance of his Apollo and Daphne, is nearly, tho' not quite so much a mystery as ever," both quoted in Butlin and Joll, *The Paintings*, 1, p. 221.

45. Alexander Gilchrist, *The Life of William Etty*, 2 vols. (London, 1855), 2, p. 216.

46. The remark about Turner's figures appeared in *Blackwood's Magazine*, as quoted by Butlin and Joll, *The Paintings*, 1, p. 233. The imploring and swooning pair of nymphs to the right of center in Etty's composition reappear reversed and rotated in the lower left of Turner's scene; the kneeling nymph at the extreme right of Etty's middle ground finds a new place closer to the center in Turner's.

47. C.F. Bell, *A List of the Works Contributed to Public Exhibitions by J.M.W. Turner, R.A.* (London: George Bell and Sons, 1901), p. 137, annotated copy, Victoria & Albert Museum, first identified the scenery and Tivoli.

48. In the Calais Pier Sketchbook (TB LXXXI, 159) there is a pen drawing of a wildly gesturing figure on a bull, seen from the rear, which definitely relates to the frontispiece, but has not previously been associated with it. Ruskin felt

the scene of Europa and the Bull summed up the *Liber Studiorum* by functioning as a symbol of "the decay of Europe by that of Tyre, its beauty passing away into terror and judgment," quoted in Charles Eliot Norton, *Catalogue of the Liber Studiorum* (Cambridge, 1874), p. 13. That explanation of the kidnapping inverts the meaning of the story: from Asia a new continent was created. The Reverend Stopford Brooke, in *Notes on the Liber Studiorum of J.M.W. Turner, R.A.* (London, 1885), pp. 1–2, suggested that the "painting" stood for the Historical plates, just as bits and pieces of the still life represented the Architectural, Marine, and Pastoral ones.

49. Butlin and Joll, *The Paintings*, 1, p. 303.

50. E.V. Rippingille, the source of the phrase, was describing Turner at work in the British Institution on the Philadephia version of the *Burning of the House of Lords and Commons, 16th October, 1834*; cited in Butlin and Joll, *The Paintings*, 1, p. 209.

51. A question exists about the dating of the painting. Finberg stated that it had been done at perhaps the same time as *Regulus*, c. 1828; *Life of J.M.W. Turner, R.A.*, p. 367. Butlin and Joll, *The Paintings*, 1, p. 221, pointed out that while in coloring it is similar to the work Turner did in Rome in 1828, its canvas is much finer than the kind he used then. Nor is there any evidence of later reworking, as in the case of *Regulus*. Hence the more likely possibility that Turner completed the painting c. 1837, the year it was exhibited.

52. Ralph Wornum, in his *Turner Gallery*, p. 70, compared the "rational and beautiful" light in *The Story of Apollo and Daphne* with its "divided and impossible" counterpart in *The Parting of Hero and Leander*. Herrmann, *Turner*, p. 44, also treated them as opposites.

53. Musaeus' text was translated by Francis Fawkes, and was included in Anderson's *A Complete Edition*, 13, pp. 235–40.

54. For a list, see Douglas Bush, "Musaeus in English Verse," *Modern Language Notes*, 43 (1928), pp. 101–104.

55. Helen Law, *Bibliography of Greek Myth in English Poetry*, revised ed. (Folcroft, Pennsylvania: The Folcroft Press, 1955), p. 20, listed six examples of the subject: Byron's "Written after Swimming from Sestos to Abydos," 1810; Keats' "Sonnet on an Engraved Gem of Leander," 1819; Leigh Hunt's "Hero and Leander," 1819; T. Hood's "Hero and Leander," 1827; Tennyson's "Hero to Leander," 1830; and Thomas Moore's "Hero to Leander," 1840.

56. The later sketches are in TB CCCXLIV, Miscellaneous Drawings, c. 1825–1841 (427, which is on an undated letter addressed to Walter Fawkes, who died in 1825) and TB CCLXXVIII, Mouth of the Thames Sketchbook, 1832 (1a–2).

57. Thomas Hood's 1827 poem also begins with the lovers' parting at dawn, after which Leander drowns through the agency of the nymph Scylla.

58. Etty provided a short synopsis of the story for the Royal Academy catalogue: "Hero was a beautiful woman of Sestos in Thrace, and priestess of Venus, whom Leander of Abydos loved so tenderly that he swam over the Hellespont every night to see her," p. 23. In 1829, he exhibited a pendant, *Hero Having Thrown Herself from the Tower at the Sight of Leander Drowned, Dies with His Body*.

59. The version illustrated here had been in England, for part of the time in the collection of Sir Peter Lely. Its provenance was discussed by Michael Jaffe, "Rubens in Italy: Rediscovered Works," *Burlington Magazine*, 100 (1958), p. 420.

60. Ziff, " 'Backgrounds,' " pp. 130 analyzed Turner's attitude toward Rubens, and quoted the following letter, written by Wilkie from Rome in 1829:

I dined with Turner yesterday, at Mr. S. Rogers, full of banter as usual, but with great good humour. He broke out, to the annoyance of all, against the landscapes of Rubens. There was no arguing with him. His violence was just inverse to the weakness of his position, which however, he seemed to take the keenest interest in defending. We impressed upon him our regret that such a man as he could not feel the beauties of such an observer as Rubens.

61. TB XLIX, Salisbury Sketchbook, 1799—1800, end cover. This rather cleaned-up transcription is taken from Lindsay, *J.M.W. Turner*, p. 73. Finberg, *Inventory*, 1, p. 125, printed a slightly different reading, though the general sense is the same. Interestingly, subsequent drawings in the sketchbook are of sailing ships.

62. John Keats, *Poetical Works of John Keats*, 2nd ed., ed. H.W. Garrod (Oxford: Oxford University Press, 1958), p. 535. The sonnet, written 1816, was published in *The Gem* in 1829 (p. 108). Further on in the same issue, punning stanzas on the lovers written by Thomas Hood were printed opposite an engraving of Hero and Leander by Henry Howard (p. 145).

63. The doubling of stories was noted by John Russell Sale, "Turner's Apocalyptic Visions," Master's paper, University of Pennsylvania, 1969.

64. On the popularity of the Rosa, see Thomas Bodkin, "A Note on Salvator Rosa," *Burlington Magazine* 58 (1931), pp. 91—92.

65. Wallace, "J.M.W. Turner's Circular, Octagonal, and Square Paintings," p. 112, examined the iconography of the *Dawn of Christianity* and concluded that Turner did not posit religion as a saving alternative there. Butlin and Joll, *The Paintings*, 1, pp. 243—44, left open the possibility that the pendant of the *Dawn of Christianity* was *Bacchus and Ariadne*, not *Glaucus and Scylla—from Ovid's Metamorphoses*.

66. Cristall, a founding member of the Old Water Colour Society, counted among his favorite classical sources Virgil and Theocritis, along with Ovid. Basil Taylor, *Joshua Cristall* (London: Her Majesty's Stationery Office, 1975), pp. 104—109, listed the following mythological and ancient history subjects in his oeuvre, all in watercolor: *Arcadian Shepherds; Io Metamorphosized into a Heifer; Theseus and the Minotaur, with Ariadne; Perseus and Andromeda; Hylas and the Nymphs; Diana in Her Chariot; Apollo Tending the Flocks of Admetus*; and studies of Narcissus and Echo, Phaeton driving the chariot of the sun, Hercules and Nessus, and Hercules with Cerberus at the mouth of hell.

67. Ironically, they were very much influenced by Turner's classical works according to Francis Greenacre, *The Bristol School of Artists*, City Art Gallery, Bristol, September—November, 1973, p. 21. The Reverend Eagles had been a pupil of William Bird, the founding father of the Bristol School.

VI *Claude and the Classical Dream*

Of all the traditions or conventions that Turner confronted in his artistic career, Claudean classical landscape stood forth as preeminent. He never took for granted Sir Joshua Reynolds' advice about the transcendent powers of the French painter's work. In painting after painting and sketch after sketch, the artist explored the seductive pull of Claude Lorrain's idealization for himself, and came to understand in a profound way that it constituted the very *art* of landscape. Elsewhere Turner might exalt nature's destructive force or celebrate its regenerative power, but in classical landscape he savored the intricate play of human values and sentiments shaping a refined, intellectualized vision of the natural world. Where thematic exploration of the legends of antiquity provided insight into origins and their narration in landscape painting, Claude's art offered the means to understand the formal gestures that bring that world into being visually. Turner's task in re-creating an enchanted realm for his nineteenth-century audience was to maintain a delicate balance between homage and revision, between landscape as a tradition and landscape as a modern form of expression.

The artist acknowledged the significance of the Claudean mode of representation in his 1820 painting *Rome, from the Vatican* (fig. 111). One of the works of art prominently displayed in the left foreground—a luminous arcadian landscape in a carved and gilded frame—stands next to a painting of the Expulsion in a way that should leave Adam and Eve with little to fear. It is as if the Biblical couple were about to be driven from one paradise into another: a verdant and pleasantly pastoral scene that offers the viewer, too, a welcome retreat from the treeless, urban, modern Rome stretching out beyond the loggia. Mediating between the city and the idyllic little world of the painting within a painting is a sculpted river god who in his mythic

embodiment would inhabit arcadian ground, but in the real world exists only as an artifact, a stone relic of a lost era. The Claudean landscape, by contrast, does more than simply depict "fairy land," to recall Reynolds' description; with its glowing light, it beckons one to enter the realm of the ideal. Turner went so far as to title the little scene "Casa di Raffaello," identifying it as the perfect environment for a painter of genius—Raphael, or, by extension, himself.[1]

The artist openly addressed his debt to Claude's conception of the "classical dream" (as Charles Eastlake once wistfully called idealized landscape[2]) when he willed in 1829 that *Dido Building Carthage* and *The Decline of the Carthaginian Empire* be hung in perpetuity with the master's *Seaport with the Embarkation of the Queen of Sheba* (fig. 114) and *Landscape with the Marriage of Issac and Rebekah* (which he called *The Mill*)—provided his own works were "deemed worthy" of the honor.[3] As Turner had explained in his "Backgrounds" lecture, there was no better place than England in which to appreciate Claude's merits, since so many of his best works were in British collections.[4] By providing an opportunity for comparison through his bequest, he encouraged study of Claude's qualities while fostering recognition of the ways he had revised them.

Underwriting Turner's project was an awareness of the basic affinity that existed between him and his predecessor. Who but Claude had rivalled Turner's rendering of effects like the "golden orient or the amber-coloured ether, the midday ethereal vault and fleecy skies, resplendent valleys, campagnas rich with all the cheerful blush of fertilization, trees possessing every hue and tone of summer's evident heat, rich, harmonious, true and clear, replete with all the aeriel qualities of distance, aeriel lights, and aeriel colour"— and who but Turner could have comprehended and encom-

Figure 111. J.M.W. Turner, *Rome from the Vatican; Raffaelle, accompanied by La Fornarina, preparing his Pictures for the Decoration of the Loggia*, 1820. Oil on canvas, $69\frac{3}{4} \times 132$ inches (177×335.5 cm), Turner Collection, Tate Gallery (BJ 228).

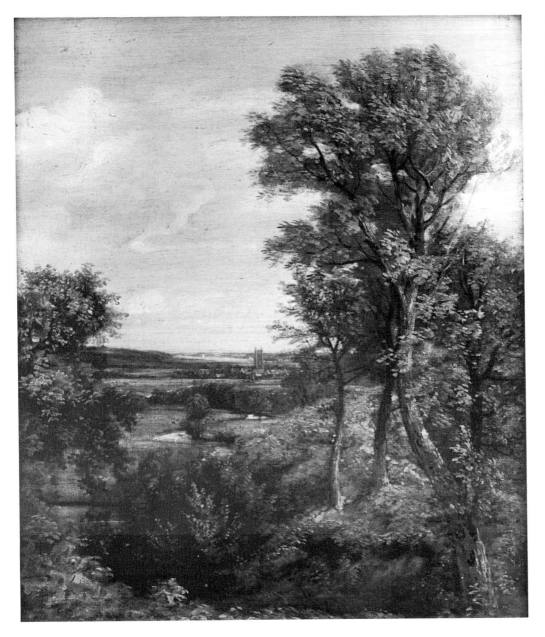

Figure 112. John Constable, *Dedham Vale*, 1802. Oil on canvas, $17\frac{1}{8} \times 13\frac{1}{2}$ inches (43.5 × 34.3 cm), By Courtesy of the Board of Trustees of the Victoria & Albert Museum, London.

passed so many of Claude's qualities in one rushing sentence.[5] He clearly understood the extent to which Claude's art had grown out of close, continual study of nature, part by part, a realization that informed his own process of idealization.[6] At the same time, Turner recognized that his predecessor's projection of antiquity was itself emotionally convincing and thematically intriguing. His jesting request to be buried with *Dido Building Carthage* as his shroud must have stemmed from a desire to both rest with the tragic queen whose account Claude, too, had followed, and be enfolded in the warm Claudean light shining on Carthage's port.[7]

While Turner might show the proper respect for Poussin and his "powerful specimens of . . . Historical Landscape," deserving of admiration and respect "for their purity of conception uncharg'd with colour or of strained effect"—his very language taking on an appropriately sombre tone—his heart went out to Claude.[8] He shared in the sentimentality of his contemporaries, who thoroughly enjoyed the visual pleasures and mental release afforded by Claude's art. The critic William Hazlitt best expressed how his generation understood the Claudean ideal.[9] Admiring Claude's *Morning* and *Evening of the Roman Empire* (now *Seacoast with the Landing of Aeneas in Latinum*, LV 122; and *Pastoral Landscape with the Arch of Titus*, LV 82), Hazlitt wrote of feelings of immortality and the yearnings of passion. Such scenes, and the objects in them, he argued, should induce the mind "to mould them into a permanent reality, to bind them fondly on the heart, or lock them in the imagination as in a sacred recess, safe from the envious canker of time." He went on to explain that "No one ever felt a longing, a sickness of heart, to see a Dutch landscape twice; but those of Claude, after an absence of years, have this effect, and produce a kind of calenture."[10] If only the Reverend Eagles and Turner's other critics in the 1830s and 1840s

had similarly appreciated the voluptuousness of the tropical fever and delirium to which Hazlitt referred. Eagles certainly claimed to have seen evidence enough of that kind of "disease" in his way of painting.

Constable's letters communicate a response to Claude very much like Hazlitt's even in its suggestion of physicality. Bliss, for him, was to be alone in a room at Coleorton hung with Claude's works, as he unabashedly enthused to his wife. In response to her concern, he offered precious little reassurance about his loyalties: "I do not wonder at your being jealous of Claude. If anything could come between our love, it is him . . . the Claudes, the Claudes are all, all, I can think of here."[11] To Constable, Claude represented a model of perfection from whom he could learn mastery of his craft. Each encounter with his predecessor's art must have given him something new, hence his undiminished enjoyment of direct copying in oil. Of course, he thoroughly assimilated the lessons, leaving little evidence of tutelage. Having studied the structure of Claude's *Landscape with Hagar and the Angel* (1646/47; in the collection of Sir George Beaumont), Constable "naturalized" a scene like the 1802 *Dedham Vale* (fig. 112), varying the foliage and filling the composition with nature's debris.[12] If, subsequently, he turned to Claude for inspiration in aspects ranging from the design of river views to proper finish, he did so unobtrusively. With Constable, the issue of influence remains complex but nonetheless subordinate to his pursuit of naturalism.

Turner, by contrast, forced the question of artistic heritage by retaining Claudean classical landscape intact and by making it a fundamental component of his oeuvre. He distilled Claude's work into two essential compositional formats, a seaport and an inland setting, which he likewise personalized and updated—but in so doing left no doubt about their source. The little painting in *Rome from the Vatican*

represents the latter type in its simplest form, its design pleasingly ordered and familiar. For Turner, the Claudean typos served less as a source for invention than as an emblem with which to invoke the idea of passage—from the present to the golden past, from the ordinary to the enchanted, and from the prosaic in landscape to the inspired. The "air of composition" that he marked in Claude's work functioned in his own like a metaphor for all the creative effort needed to protect landscape painting from the charge of being mere "mapwork."[13]

At the beginning of his career, the young artist had had a moment's hesitation about how to respond to Claude. In 1799 Farington recorded how, standing before one of Claude's recognized masterpieces, Turner "was both pleased and unhappy while He viewed it,—it seemed to be beyond the power of imitation."[14] No wonder then, that he availed himself of Poussin's order and rationality for the ambitious 1800 and 1802 Plague pictures, for Poussin must have seemed a model of comprehensibility by comparison. Visiting France—and possibly seeing a number of Claudes in the Louvre—somehow brought the master's style within his grasp, as Turner amply proved in the glowing *Festival Upon the Opening of the Vintage at Macon*, 1803.[15] Thereafter, the lesson of Claude's graceful formalizing even appeared in some of Turner's English views. He may have discovered touches of his predecessor in the Thames scenery that he studied so intently from 1804 on, or imported Claudean motifs into his views of the area near Windsor or Richmond (fig. 113). The practice substantiated the artist's belief in the possibility of "a northern line of demarcation of genius" in landscape, the hints of Claude in the Thames paintings for example lending an air of eternal beauty to counterbalance the changeable effects of English weather that critics like Winckelmann had denigrated.[16]

The quality of Turner's idealization derives from precisely that kind of exchange between the natural and the imaginary. His projection of a harmoniously arranged natural environment never subject to the ravages of time imparted an elegance and breadth to his observation of the real world. In the same way, Turner's acute perception of the ongoing drama of actual nature imparted a seriousness to his conception of the ideal and led him to question the significance of the golden age by means of classical narrative. The process can best be seen in Turner's sketchbooks. Looking through "Studies for Pictures. Isleworth" (TB XC) (plates 1—16), is like embarking on a journey that wends its way between the delightfully imagined and the sensually experienced.[17]

Appropriately enough, the book's first page depicts an ornate little ship with rowers ready for departure (plate 1).[18] There follows a series of riverside sketches that track the Thames, some exploring the environs of Windsor Castle, others relating to the c. 1807—1810 oil *Thames at Weybridge*. On leaf 11a, Turner began to elaborate on his vision of a classical seaport (plate 2). It is a remarkable little drawing, cognizant of Claude's embarkation settings, but already manipulating its model to different ends. Where Claude, in a painting like *Seaport with the Embarkation of the Queen of Sheba*, beckons one to sail away, to be elsewhere, lost in time (fig. 114), Turner from the outset constructed a dream world that is more enclosed and more *present* to us. Denser in its architectural massing and more active through its multiplication and distribution of ships, his scene suggests that we are there to witness an event.

Further along in the sketchbook, on leaf 21, the artist shifted inland to a view of the outskirts of what was to become Carthage in the 1814 oil, *Dido and Aeneas* (plate 3). Worked up in watercolor, the scene combines ornate pageantry with immediacy of light and textural effect,

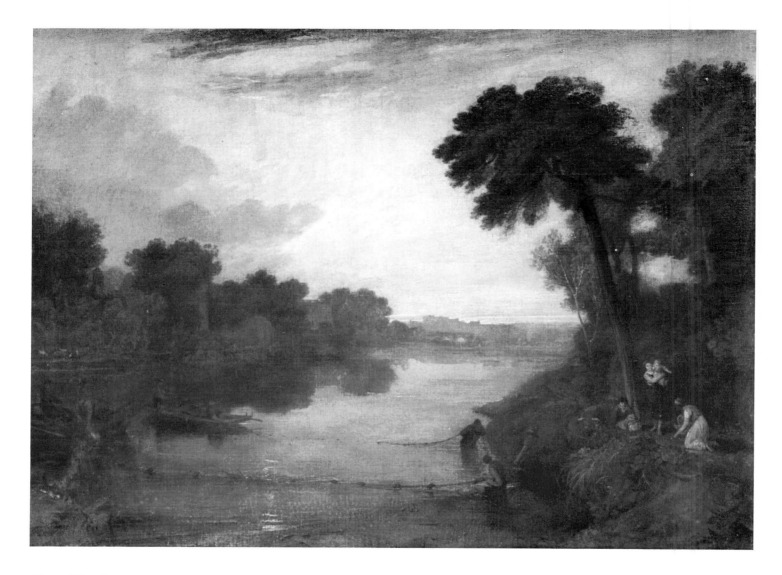

Figure 113. J.M.W. Turner, *The Thames Near Windsor*, c. 1807. Oil on canvas, 35 × 47 inches (88.9 × 119.4 cm), Tate Gallery and the National Trust (Lord Egremont Collection), Petworth House (BJ 64).

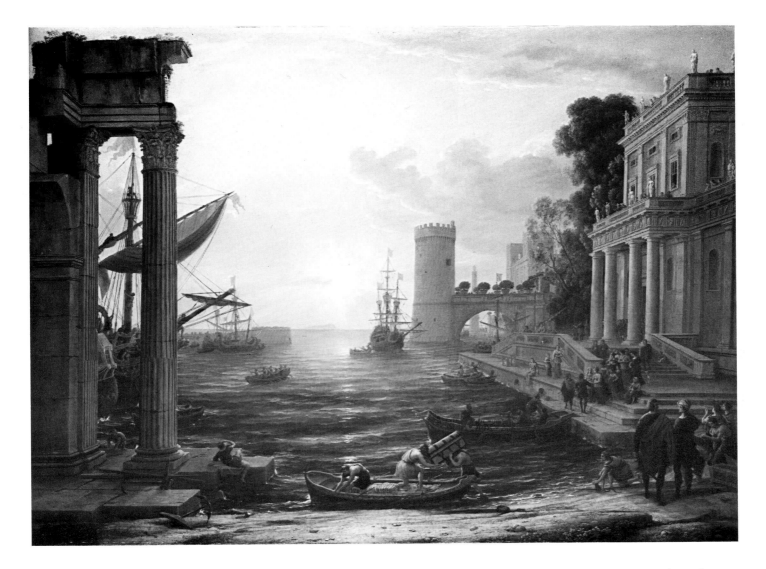

Figure 114. Claude Lorrain, *Seaport with the Embarkation of the Queen of Sheba* (LV 114), 1648. Oil on canvas, $58\frac{1}{2} \times 76\frac{1}{4}$ inches (148.5 × 194 cm), Reproduced by Courtesy of the Trustees, The National Gallery, London.

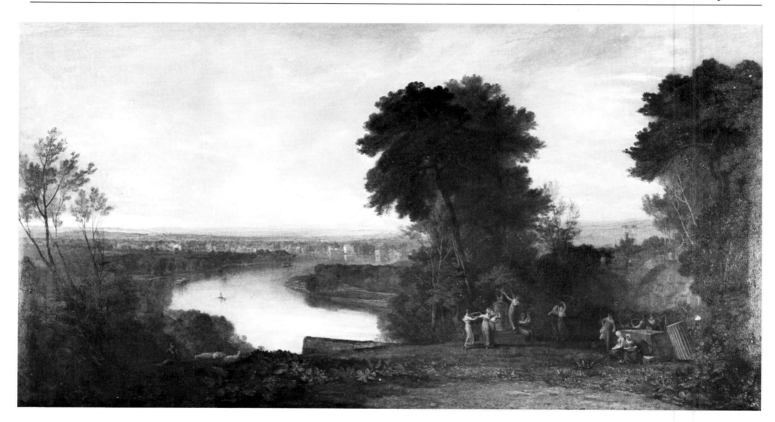

Figure 115. J.M.W. Turner, *Thomson's Aeolian Harp*, 1809. Oil on canvas, $65\frac{5}{8} \times 120\frac{1}{2}$ inches (166.7 × 306 cm), Manchester City Art Galleries, Manchester, England (BJ 86).

conjecture with observation. The process of comparison and mutual reinforcement that led to such a synthesis can be observed in sequences elsewhere in the sketchbook, where classical *capriccios* (some resembling Isleworth) alternate with direct renderings of scenery along the Thames (plates 4 and 5), eventually yielding a grand classical seaport worked up in watercolor (plate 8). Whether the terrain Turner drew was actual or imagined, he explored it with a sustained fascination, moving close, pulling away, shifting his view left or right. In the classical settings, one can see him

coaxing a world into being, as he had for Mercury and Herse (cf. figs. 85–87) less from a given prototype, by rote, than through his appreciation of the act of idealization and his fascination with the ancient lore that animated classical ground.

Before Turner put his Claudean study to work in a painting with a specifically classical theme, he provided a handsome demonstration of the rapport between the ideal and the real in *Thomson's Aeolian Harp*, exhibited in 1809 (fig. 115). It commemorates the poet whose verse Turner had so freely borrowed a decade earlier while simultaneously showing off the evocative powers of poetic painting. Here Turner responded to lines from the *Seasons* and other poems in depicting the scene, then added his own lengthy verses in the Royal Academy catalogue to complete his imagery.[19] His poem informs us that the women dancing before the monument right of center are personifications of the Seasons, the figure of Spring "breathing balmy kisses to the Lyre." We assess them as idealized beings against the context of the real-world rustics gathered around the tomb further right. And where the landscape through its overall design, light, and atmosphere recalls the example of Claude as an expressive constant, Turner at the same time tied it to the present through the view of Richmond that stretches off in the left distance.[20]

With *Mercury and Herse*, exhibited in 1811, the artist finally reached Reynolds' "fairy land," where myth fully inhabits the landscape (fig. 83). He had worked patiently toward such a consonance of classical form and classical content, having begun with the most characteristic Claudean visual qualities (the centered sun in works from 1799), and proceeding through compositional paraphrase (in *Festival Upon the Opening of the Vintage at Macon*), to the allegorical nuancing of *Thomson's Aeolian Harp*. In *Mercury and Herse* both story and landscape seem enchanted. The painting

is a realization of the various concerns that Turner had expressed for landscape in his "Backgrounds" lecture. It more than fulfills his initial observation that "To select, combine, and concentrate that which is beautiful in nature and admirable in art is as much the business of the landscape painter in his line as in the other departments of art."[21] Turner's working method was exemplary: he took his inspiration for the scene's overall demeanor and handling from Claude, then proceeded to match the Old Master quality for quality from the list of formal virtues he had recited. Claude's "midday etherial vault ... resplendent valleys ... aeriel qualities of distance ... and aeriel colour" reappear with a new delicacy and subtlety of touch. Turner's work shines forth as a manifest achievement in landscape, and indeed won admiration and praise from a wide audience that included the Prince Regent.[22]

Rather than simply capitalize on that success, Turner proceeded by calling into question the process of emulation that inspired it. With *Appulia in Search of Appulus, vide Ovid* (1814; fig. 116), he once again confronted the dichotomy between tradition in landscape painting and the impetus of modern art. Where his first essay with *The Goddess of Discord* and the *Fall of the Rhine at Schaffhausen* was quietly didactic, this time he pointedly answered detractors who accused him of fostering neither. He met these insinuations with cleverness and wit by drawing a direct comparison between his work and Claude's—a comparison that at one and the same time proved his affiliation with the past and championed his own present-day accomplishment.

To make his point, the artist entered *Appulia in Search of Appulus* in a competition for which he was thoroughly overqualified—the annual contest for young, aspiring artists run by the British Institution.[23] His quarrel was with the British Institution itself, and all that it was doing to retard the progress of contemporary art. Chief among the organi-

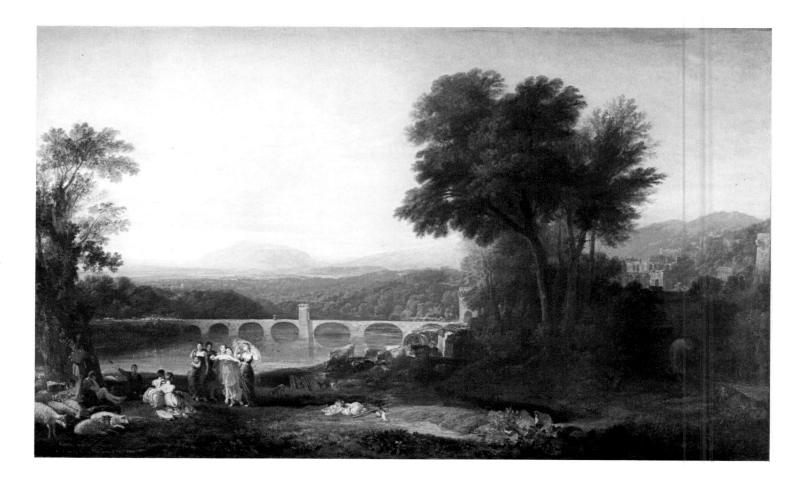

Figure 116. J.M.W. Turner, *Appulia in Search of Appulus, vide Ovid*, 1814. Oil on canvas, $57\frac{1}{2} \times 93\frac{7}{8}$ (146×238.5), Turner Collection, Tate Gallery (BJ 128).

zation's sins was its persistent encouragement of a healthy market in Old Masters—benefitting the connoisseurs and collectors who constituted its membership, not contemporary artists desperately in need of vigorous public support for their livelihood. That basic conflict of interests surfaced in the Institution's decision to schedule their retrospective exhibitions concurrently with the Academy's annual modern shows. Adding insult to injury, they planned to inaugurate their programme in 1813 by featuring none other than the Royal Academy's first president. When they approached the Academy Council about a loan of works from their collection, members "Smirke, Turner, & Calcott were not inclined to grant the pictures, and thought the plan of exhibiting a Collection of pictures by Sir J. Reynolds at the British Institution during the Exhibition of the Royal Academy invidious towards the Artists of the present day."[24]

A more fundamental disagreement about the proper basis for artistic creation affected Turner personally. The Institution, and particularly founder-member Sir George Beaumont, espoused the principle of imitation, understood as literally as possible. For example, when the Institution commenced its annual competitions in 1807, it stipulated that that year's entries be "proper in point of Subject and Manner to be a companion" to a select list of Old Masters made available for study.[25] In the days before a permanent national collection students needed access to exemplary works of art for their edification, but the policies of the Institution turned a sound learning process into an inhibiting religion. Even Constable, who understood the value of copying, bitterly protested their excesses. He wrote, in 1822:

> *The art will go out*; there will be no genuine painting in England in thirty years. This will be owing to pictures driven into the empty heads of the junior artists by their owners, the directors

of the British Institution, etc. In the early ages of the fine arts, the productions were more affecting and sublime, for the artists, being without human exemplars, were forced to have recourse to nature; in the latter ages, of Raphael and Claude, the productions were more perfect, less uncouth, because the artists could then avail themselves of the experience of those who were before them, but they did not take them at their word, or as the chief objects of imitation. Could you but see the folly and ruin exhibited at the British Gallery, you would go mad. Vander Velde, and Gaspar Poussin, and Titian, are made to spawn multitudes of abortions: and for what are the great masters brought into this disgrace? only to serve the purpose of sale.[26]

Earlier, Turner had come in for an especially heavy dose of criticism from Beaumont, the voice of the Institution, precisely because his "seducing skill"—the one merit his chief detractor allowed the painter—caused other artists to imitate him, Turner, and not the Old Masters.[27] The connoisseur also accused the artist of willfully subverting the example of Beaumont's beloved Claude by imparting to oil the lightness and transparency of watercolor. Rather than seeing that technique as an improvement upon the Old Master's delicate atmospheric effects, Beaumont charged that Turner was diminishing the "force" of oil—or more properly the authoritative tones of aged varnish. At one point in 1813 Turner declared he had had enough and would cease to exhibit, but on reconsideration decided "not to give way,— before Sir George's remarks."[28]

Sending *Appulia in Search of Appulus* to the British Institution competition was one way for him to counter his critics. In the minds of the enemy camp, however, his motives were more base. Turner's affront was publicly "revealed" in an angry letter to *The Examiner* from a highly suspect "Amateur," printed on February 13, 1814, six weeks before the competition jury met.[29] Not only was it "degrading,"

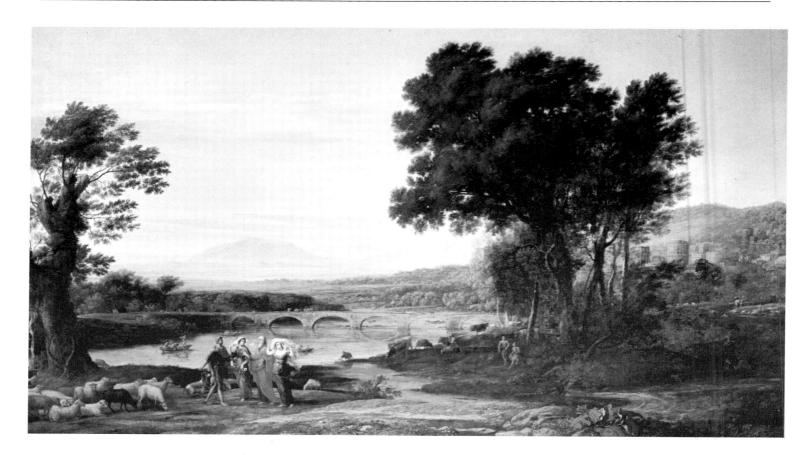

Figure 117. Claude Lorrain, *Landscape with Jacob, Laban and His Daughters* (LV 134), 1654. Oil on canvas, $56\frac{1}{2} \times 99$ inches (143.5 × 251.5 cm), The British Treasury, on indefinite loan to the National Trust, Petworth House.

for "a man decidedly at the head of his profession" to have considered competing against novices, the author charged, but he had withheld his entry until he could survey the strengths of the competition. Moreover, the Royal Academician had submitted a work that was not even original! Turner had indeed disregarded the deadline for

the competition, but more to irk the judges and invite the disqualification with which his entry subsequently met than to gain advantage over fellow contestants. His delaying tactic spared the British Institution officials, one of whom was his patron, Lord Egremont, from having to pronounce on the merits of a most extraordinary "copy"—though not before causing them considerable discomfort and embarrassment. For *Appulia in Search of Appulus* resembles its model, Claude's *Landscape with Jacob, Laban and His Daughters*, closely enough in composition, major elements, and size to warrant the "Amateur's" claim that Turner had been lacking in invention, at least at first view (fig. 117).

While the painting looks very like the Claude in question (one of the treasures of Lord Egremont's famed collection at Petworth House) it is emphatically Turner's in its handling, luminosity, and overall development. The perceptive viewer can see in it precisely how his art grew out of Claude's, and in what ways it represented a departure. Turner first adjusted his composition to enhance the eye's passage into the infinite Claudean distance. He countered the strong horizontal emphasis of his model by marking the major line of recession with a tower added to the bridge and by opening a second path into the distance with another river at the far right. To smooth the transition from foreground to background Turner eliminated many of the secondary figures and details with which Claude had decorated the intervening space. Instead, he let a subtle play of light and shadow enliven the newly unified area.

More impressive, though, are the changes Turner made to the foundations of Claude's reputation—his glowing light and "softening hue." Where Claude's background is finely radiant, Turner's is still more shimmering and his atmospheric effects more delicate. Light shines through Turner's foliage, not on it. Constable had found the *Landscape with Jacob, Laban and His Daughters* "grand and solemn, but cold,

dull, and heavy, a picture of Claude's old age."[30] If this was an opinion with any wider currency, then Turner had selected a particularly apt candidate for renovation. However, the superb quality of the resulting painting shows the high respect he had for its model.

And therein would have been the dilemma for the British Institution judges: they could neither award the overly Claudean *Appulia in Search of Appulus* a prize, nor pass it over in favor of something less proficient but more original without exposing their values to serious scrutiny. Though Turner rescued them from having to make such a judgment by his tardiness, he did not hesitate to comment on the whole proceeding by means of the new subject matter that he had superimposed on the Petworth Claude. As discussed above (p. 179), he played with the moral of the Ovidian tale that Claude had included in his 1657 *Landscape with the Metamorphosis of the Apulian Shepherd* (owned by the Marquess of Stafford, also a British Institution worthy), by drawing a parallel between the boorish shepherd's mimicry of divine beings and his own actions in paraphrasing Claude's picture and taunting the British Institution to react. Just as Appulus intruded upon an idyllic (i.e., Claudean) landscape, spoiling it for its genteel inhabitants by aping their pastimes, so the artist commented on the connoisseur's trust in imitation with a copy about copying.

If the shepherd's fate—being turned into an olive tree—provides a caution about such practices, the painting as a whole demonstrates where the essence of fruitful emulation resides: in an understanding of the original that leads to innovation and independent creativity. Unfortunately the British Institution failed to heed the lesson.[31] They awarded first prize to a painting which may have avoided reference to Claude altogether, but was nonetheless derivative. The winning landscape, T. C. Hofland's *Storm off the Coast of Scarborough*, was, according to one review, a night

Figure 118. J.M.W. Turner, *Dido and Aeneas*, 1814. Oil on canvas, $57\frac{1}{2} \times 93\frac{3}{8}$ inches (146×237 cm), Turner Collection, Tate Gallery (BJ 129).

Figure 119. Claude Lorrain, *View of Carthage, with Dido, Aeneas, and their Suite Leaving for the Hunt* (LV 186), 1676. Oil on canvas, $47\frac{1}{4} \times 58\frac{3}{4}$ inches (120×149.5 cm), Hamburger Kunsthalle, Hamburg.

scene, violently stormy and black throughout, but a little too much like Vernet.[32]

Turner had a final rejoinder ready in any case. Just two months later, he exhibited *Dido and Aeneas* at the Royal Academy, and on time moreover (fig. 118). It complemented the humorous ploy of *Appulia in Search of Appulus* with an earnest and loving translation of the Claudean ideal into modern usage. Accordingly, the painting is not about Claude *per se*, nor does it model itself on any particular example of his work; rather, it acknowledges the eloquent beauty of the French master's art while pursuing its own exploration of the imaginative reaches of antiquity and idealized nature. For an historical account like that of Hannibal, where the form of the landscape contributes to the tale's outcome, Turner had boldly shaped the look of an observed mountain storm to suit his interpretive ends. To convey the bright promise and happy beginning of legendary Dido's ill-fated empire, he deferred to the Claudean vision of antiquity, realizing that its delicately stylized, orderly presentation of nature perfectly captured the spirit of Virgil's verse. By nuancing the story line in his own way, Turner avoided mere stylistic pastiche and transformed the features of seventeenth-century landscape into a thoroughly Romantic reverie about antiquity.

When Claude took up the subject of Dido and Aeneas in a late painting known in the nineteenth century as *Dido Showing Aeneas the Port of Carthage*, he devised a composite episode referring to a sequence of events (now called *View of Carthage, with Dido and Aeneas, and their Suite Leaving for the Hunt*, 1676; LV 186; fig. 119). His scene suggests both the earlier tour of the city Dido made with Aeneas (IV, 98–100), as well as Aeneas' final departure by sea (IV, 668ff.).[33] The succinctness of Dido's gesture, pointing out the thriving port and its ships, keeps the full scope of the narrative prominently in the viewer's mind. By contrast,

Turner chose to portray a much less expository moment in the story. The episode of the morning of the hunt presented in *Dido and Aeneas* (IV, 182–87) is something of an interlude, providing the opportunity for enchanting detail. William Hazlitt, in trying to resist the painting's effect, could only see its strange modernity: "This picture, powerful and wonderful as it is, has all the characteristic splendour and confusion of an Eastern composition. It is not natural nor classical."[34] His criticism refers to Turner's shift from the decorum and narrative clarity of a painting like Claude's to the glittering opulence of his imagined procession, and to the spun-sugar confection of turrets, temples, arches, and aqueducts that form its backdrop.

Indeed, the pageantry is such a source of delight that it distracts us, as it did Queen Dido, from reading the signs which indicate that Aeneas' presence bodes ill. In the foreground, just to the left of the royal couple, is an incomplete pier across which a vase-like object casts a long shadow, a harbinger of the subsequent halt to Dido's building campaign. In the middle distance, remains of a bridge are overgrown with vegetation and enshrouded in mist. So unobtrusive are these ruins that their incongruity in a place with no previous settlement draws on one only gradually.[35] As if to reawaken us to our responsibility as observers, Turner interposed a collection of elegant spectators who serve to distinguish our reality from Dido's fiction, where chimerical hopes and dreams momentarily hold sway. That prod toward our self-awareness, with its melancholy reminder of the ultimate impossibility of closing the gap between the real and the imagined, finally tied Turner to the early nineteenth century, no matter how much he flirted with the sensibilities of his predecessors.

His dialogue with Claude continued at the same level of intensity the following year, when he exhibited *Dido Building Carthage* and *Crossing the Brook* (figs. 47 and 120).[36]

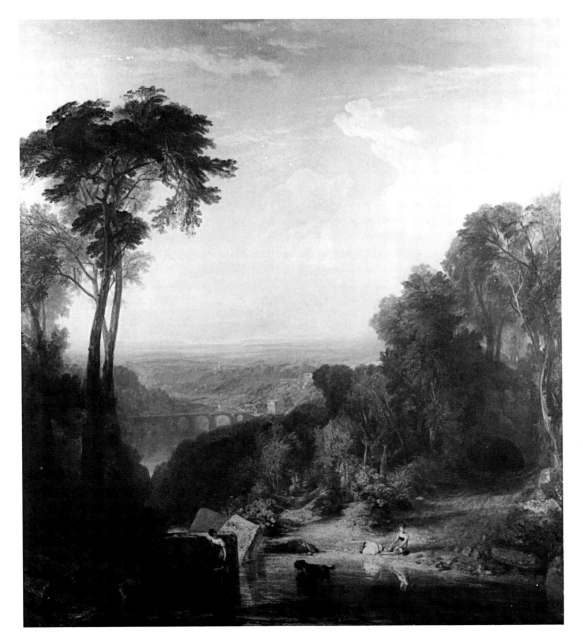

Figure 120. J.M.W. Turner, *Crossing the Brook*, 1815. Oil on canvas, 76 × 65 inches (193 × 165 cm), Turner Collection, Tate Gallery (BJ 130).

Figure 121. Claude Lorrain, *Landscape with Ascanius Shooting the Stag of Silvia*, 1682. Oil on canvas, $47\frac{1}{4} \times 59$ inches (120×149.8 cm), Ashmolean Museum, Oxford, England.

The two paintings treat complementary kinds of idealized landscape, much as Claude's harbor scene *View of Carthage, with Dido and Aeneas, and their Suite Leaving for the Hunt* matched its pendant, a contrasting wooded composition, *Landscape with Ascanius Shooting the Stag of Silvia* (fig. 121). In *Dido Building Carthage* Turner finally realized the enchanted seaport vision imagined in his sketchbooks; with *Crossing the Brook* he summarized his study of Devonshire, which, like the Thames scenery in "Studies for Pictures. Isleworth" (TB XC), he had observed in all its particularity. Both paintings powerfully synthesized their respective preliminary drawings, and both incorporated Claudean principles with real inspiration.

Dido Building Carthage turned a seaport like that in Claude's *Seaport with the Embarkation of the Queen of Sheba*, with all its disparate indications of coming and going, into a place where one is encouraged to stay in order to ponder the story's implications. With what temerity Turner concentrated the whole theme of departure in the launching of a toy boat. The literal and figurative shift in scale quietly underscores our obligation to search out the story's clues. From the motif of the children playing, the eye follows the river and the path of the sun into the heart of Carthage— and all that Dido had hoped it to be. By closing off the city at the back with a bridge, Turner deftly unified his scene to the greater enhancement of both the architectural display and the tale he wanted to tell about dedication to purpose. Opinions that year, save that of Beaumont, were glowing— and agreed that Turner had surpassed Claude. As one judicious writer put it, "Turner may be allowed to remind us of Claude as long as he will flatter our national feeling by producing such . . . a work which, in grandeur and ideal beauty is such as that distinguished Frenchman never even caught a glimpse of."[37]

Crossing the Brook was perhaps the more daring of the two Claudean essays, for it masterfully proved what Turner had advised his students—that one should not be blind to the "abundant advantages which nature has given" to northern landscape artists.[38] The painting demonstrates that native ground needed very little idealization to match the paragon of Italy and seventeenth-century classical landscape.[39] Turner's depiction of the deep bends in the river Tamar and undulating hills of the Devonshire countryside impart a sensuality and life force to the Claudean conception of nature and landscape. The ordering structures of seventeenth-century composition are there in the exaggeratedly graceful repoussoir trees and the infinite recession (cf. one of Claude's vertical compositions such as *Landscape with Hagar and the Angel*), but they have been co-opted into a modern pastoral idea. The leftward diagonal pull of the river literally offsets and thus enlivens the Old Master prototype. The easy integration of the local mining works visible in the distance, and the two contemporary young women (perhaps Turner's daughters) with their shaggy dog situate the moment and scene as being poised somewhere between the present and the eternal.

Just such a demonstration of the virtues of a modern reworking may have been timely, given various contemporary homages to Claude being paid both at home and abroad. The previous year, while Turner was engaged in his own competition with the French master, John Glover (1767−1849), the "British Claude," had set himself up conspicuously in the Louvre among the Claudes and Poussins. According to an eyewitness, he was there with "an immense canvas on which he gave out that he was painting a picture which would unite the beauties of the masterpieces around him."[40] When Glover later exhibited the resulting *Landscape, Composition* at the Oil and Water

Figure 122. John Glover, *Apollo Tending Goats*, after 1812. Oil on canvas, $21\frac{3}{8} \times 27\frac{3}{8}$ inches (54.4×69.5 cm), Private Collection

Figure 123. George Barret Jr., *Landscape Composition*, n.d.. Oil on canvas, 59 × 90 inches (149.8 × 228.6 cm), By Courtesy of the Board of Trustees of the Victoria & Albert Museum, London.

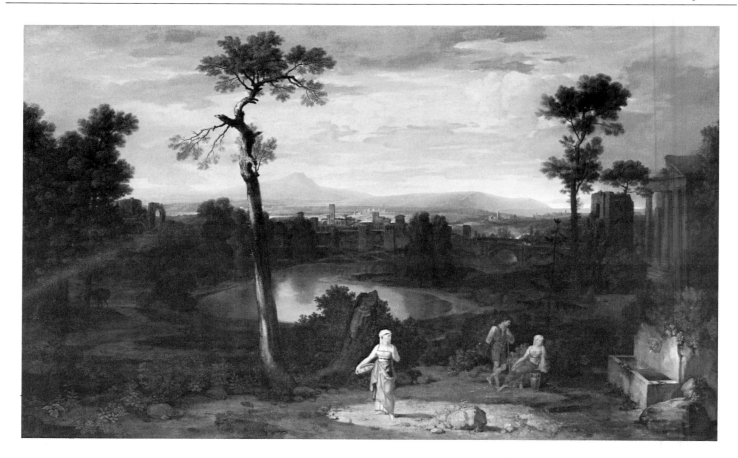

Figure 124. Washington Allston, *Italian Landscape*, 1814. Oil on canvas, 44 × 72 inches (111.8 × 183 cm), The Toledo Museum of Art, Toledo, Ohio, gift of Florence Scott Libbey.

Colour Society, he boasted in a remark printed in the catalogue that the painting had won a gold medal from the King of France in the 1814 Salon. The work has since disappeared, but an idea of his degree of assimilation can be gained from a more modest canvas, *Apollo Tending Goats*, painted sometime after 1812 (fig. 122).[41]

Glover's scene is the quintessence of classical repose achieved through artful massing and balance. His composi-

tion exploits a basic symmetry that, however tactfully disguised by nature's profusion and seeming irregularity, is still tied to the idea of classical landscape as a set type. The river receding into the center of the scene (and marked by the distant bridge) establishes a soothing spatial flow. All is calm, quiet, and timeless; even the goats seem perennially at rest. In *Crossing the Brook*, Turner animated the landscape—brought it to life as it were—by countering the expected recession into the distance with the competing interest of the sandy road on the right leading down to the water. The dog positioned in the center foreground becomes a refreshingly informal pivotal point for the eye's journey through the landscape. In 1820 Glover opened his own gallery, interspersing Claudes, a Wilson, and a copy of Gaspard Dughet among his own works for comparison. He apparently invited Turner to join him in the enterprise, but Turner declined the offer.[42]

Another contender for the title of "English Claude," George Barret Jr. (1767—1842), had a more limited repertory than Glover. One of his favorite compositions (fig. 123) employed a foreground that dips near the center framed by clumped repoussoir trees, with the ubiquitous curving, reflective body of water beyond, frequently punctuated at its bend by a bluff or protruding hill. Sometimes figures dressed in helmets and togas would be added to impart a classical air to the scene, but they never enact any specific narrative. Barret also perfected a credible etherealizing glow in which to bathe his settings; they are tinged with the sentiment of arcadian reverie, but only just.

Still more conservative in their depictions of idealized nature were works like Washington Allston's *Italian Landscape*, exhibited at the Royal Academy in 1814 (fig. 124). The painting is a composite of classical landscape ideas, resuming in its earnest American way the progress of eighteenth-century European painters in their dialogue with both an artistic tradition and the nostalgic conception of Italy and antiquity. Allston's only innovation in this scene of a placid, centralized body of water leading to an Italianate town in the distance, with foreground adorned with ruins, fountains, and classically posed peasants, was to give prominence of place to one of the spare, weathered trees he so preferred. The chaste propriety of his landscape was precisely the sort to satisfy Sir George Beaumont. The connoisseur may even have educated Allston to the refinements of Claude. The latter's influence in *Italian Landscape*, however distant it might seem, had tempered the artist's earlier taste for the more "heroic" and Poussinesque style practiced while Allston was in Rome (1804—1808) by Joseph Anton Koch (cf. fig. 19).[43] Allston's stylistic shift toward Claude was a profitable one, moreover, since it subsequently brought him Beaumont's patronage.

On the continent, and particularly in Rome during the first decade of the century, German and French landscape painters alike paid homage to Claude in occasional paintings, but for the most part preferred Nicolas Poussin and Gaspard Dughet as models for their formulation of a neoclassical counterpart to history painting.[44] Koch, Gottlieb Schick, Pierre-Henri de Valenciennes, or Jean-Victor Bertin in their various ways sought to impose order and rationality on both Italianate landscape and the classical heritage. The Germans remained the more resolute in seeking out the geometry of nature, their solid forms heightened by the hard, clear light in which they were bathed. Koch's late work, *Landscape with Apollo amongst the Shepherds* (1834; fig. 125) recalls Poussin's *Landscape with Polyphemus* but with even more rigorous parallel planes or stages to the landscape, each marked by its own herd or flock of animals and shepherds. Gottlieb Schick's *Heroic Landscape with Hagar and Ishmael* (c. 1803—1804; fig. 126) structures the scene with the stark simplicity of a straight, centrally positioned route back to a composition of ancient buildings designed and arranged with infinite care.

Figure 125. Joseph Anton Koch, *Landscape with Apollo amongst the Shepherds*, 1834. Oil on canvas, $30\frac{1}{2} \times 44$ inches (77.5×111.8 cm), Collection of Georg Schäfer, Schweinfurt, West Germany.

Figure 126. Gottleib Schick, *Heroic Landscape with Hagar and Ishmael*, c. 1803–1804. Oil on canvas, $34\frac{1}{2} \times 45\frac{7}{8}$ inches (87.6 × 116.5 cm), Thorvaldsens Museum, Copenhagen

Figure 127. Pierre-Henri de Valenciennes, *Historical Landscape representing Mithridates*, 1819. Oil on canvas, Musée des Augustins, Toulouse.

French artists opted for a larger dose of nature's sensuality, relatively speaking. Their landscapes are more verdant, and the path through them more relaxed and

winding, rather in the manner of Gaspard Dughet. Valenciennes's *Historical Landscape representing Mithridates* (1819; fig. 127) adds a dramatic sky for further effect

without seriously altering the basic conception seen earlier in the work of Bertin (cf. fig. 43). Only toward 1830 did French landscape painters renew their acquaintance with Claude, finding his work instructive at a time of growing interest in naturalistic effects.[45]

The one foreign painter who had kept the Claudean faith, Nicolas-Didier Boguet (1755–1839), not surprisingly had many patrons who were British.[46] Perhaps it was to Boguet that Beaumont referred, if disparagingly, when he confirmed his dislike of Turner's *Dido Building Carthage* to Farington. He felt that it was "painted in a false taste, not true to nature; the coloring discordant, out of harmony, resembling those French Painters who attempted imitations of *Claude*, but substituted for His purity and just harmony, violent mannered oppositions of Brown and hot colours to Cold tints, blues and greys"[47] Given Beaumont's inability to see Turner's qualities, it comes as no surprise that he might not appreciate even a less radical palette like that of Boguet. But he should have had no quarrel with the French painter's composition and attention to detail in works like *Triumph of Bacchus*, 1803 (fig. 128). Boguet's scene has all the dignity and repose of Claude's later works, coming as close to being a copy as seems possible without actually becoming one.

Turner's relationship to Claude differed from the above-mentioned artists in a number of ways. First, whatever he took from Claude, whether the effects of a setting sun, the pleasing contours of a receding bay, or the indications of an historical narrative, Turner repaid by investing that light, topography, or subject matter with new significance. He did not simply avail himself of Claude's style because it was handsome or easy to reproduce. He demonstrated through the blinding rays of *Regulus* or the splendid ephemerality of *Caligula's Palace and Bridge* (fig. 131) a perceptive understanding of Claude's aspirations for the affective power of nature—including those narrative goals the older artist may have left unfulfilled. He did not so much "outdo" his predecessor as maximize Claude's initiatives in the name of high achievement in the art of landscape. Second, and perhaps more important, Claudean idealization was in itself a *form* of meaning for Turner. It stood for the transcendent powers of the imagination at the same time that it was an active demonstration of those powers.

No wonder, then, that he took Claude, and Wilson too, along as travelling companions, as it were, on his first trip to Italy in 1819. For all the considerable enthusiasm Turner showed for the sights before him, recorded with such obvious delight in the twenty-odd sketchbooks he filled, he took care to note the "First bit of Claude," when he spied it, looking across to the town of Osimo.[48] He was seeing nature through art, being instinctively or consciously wary of the "tame delineation of a given spot"; well into the 1820s fellow artists like Fuseli cautioned that a topographical approach resulted in the lowest, most uninteresting species of landscape painting.[49] Turner also discovered the colors of both Claude and Wilson in the hills and vales, puzzled over the latter's viewpoint at Tusculum, and was twice specifically reminded of "L[or]d Egremont's Claude" as he toured.[50]

The outcome, in grand style, was *The Bay of Baiae, with Apollo and the Sibyl*, 1823 (fig. 129), a glowing, mellifluous scene that summarizes a northerner's enchantment with the classical beauty of the Mediterranean, much as *Rome from the Vatican, Forum Romanum*, and an unfinished, but equally monumental Venetian view (BJ 245), recapitulated other aspects of Turner's voyage of discovery. To celebrate the balmy pleasures of the Italian coast he adopted the classical landscape idiom, but immediately introduced changes that enhance the seductive pull of the essentially Claudean vista. To begin with, Turner altered Claude's normal proportions by extending the landscape laterally while also leaving the scene less "framed" at the sides.[51]

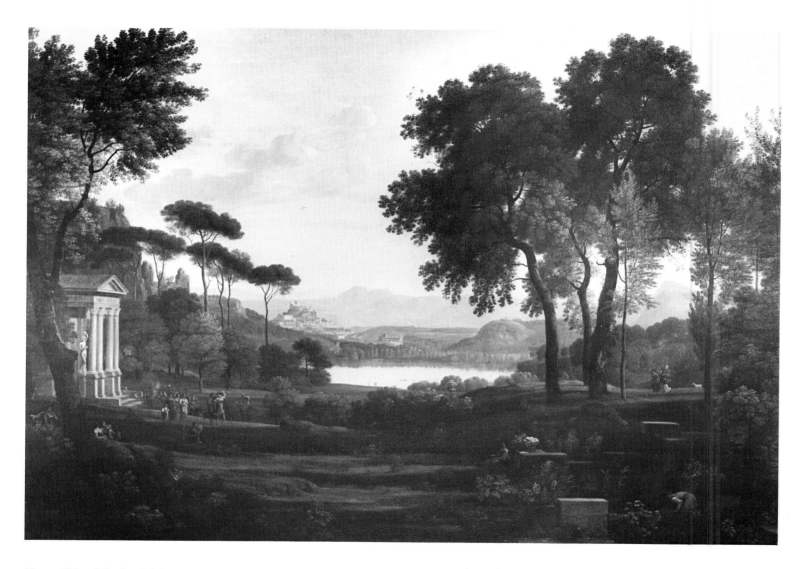

Figure 128. Nicolas-Didier Boguet, *Triumph of Bacchus*, 1803. Oil on canvas, $49\frac{1}{2} \times 69\frac{1}{4}$ inches (126×176 cm), Museo e Gallerie Nazionali di Capodimonte, Naples.

Figure 129. J.M.W. Turner, *The Bay of Baiae, with Apollo and the Sibyl*, 1823. Oil on canvas, $57\frac{1}{4} \times 94$ inches (145.5×239 cm), Turner Collection, Tate Gallery (BJ 230).

Figure 130. J.M.W. Turner, *Palestrina—Composition*, 1828. Oil on canvas, $55\frac{1}{4} \times 98$ inches (140.5 × 249 cm), Turner Collection, Tate Gallery (BJ 295).

A graceful inward curve is then inscribed by the tree that leans toward the right, by its long shadow, and by the path at the left. To establish the recession to the distant bay, the artist deftly used puddles of light and shade, rather than with wedges of land or water, imparting a floating, undulating quality to the transit back.

For his choice of mythological subject, Turner drew upon Wilson's example by connecting the scenery of Baiae with its legendary heritage. The Sibyl had petitioned Apollo for longevity equal to the number of grains of sand she held in her hand. By failing to ask for eternal youth as well, she condemned herself to age away into nothingness (*Metamorphoses* 14, 134–41)—rather like the fate of ancient civilizations, the ruined remnants of which are scattered thoughout Turner's setting. But the moral of the Sibyl's tale is readily offset by the larger demonstration of nature's enduring beauty. The sunlight playing over the fragments prevents too much melancholy about time's ravages and the cheery inscription from Horace, "Liquidae placuere Baiae" in the left foreground, and the wishful thinking in Turner's motto, "Waft me to Sunny Baiae's shore," printed in the exhibition catalogue, similarly forestall any brooding in face of such an enchanting panorama.[52]

Even as Turner planned his second trip to Italy, in 1828, he thought ahead to Claude. So eager was he, that he wanted unusually large canvases waiting, in order that "the very first brush in Rome" be applied to a companion piece to Lord Egremont's celebrated Claude.[53] Once in the city, he settled into a period of intense, concentrated work, impressing the young Charles Eastlake with his stamina and provoking his Roman audience by the exhibition of *The Vision of Medea, Regulus* and *View of Orvieto*. The latter two works masterfully updated his favorite paradigms of Claudean composition. The seaport scene, *Regulus*, became the epitome of Turner's narrative transformation of his predecessor's art; the inland view of Orvieto, through its topographical inspiration and its vignette of washerwomen, tested his rapprochement of the real and the ideal. The artist had probably also at least begun to work on his labor of love, the "companion piece" which has long been identified with *Palestrina—Composition* (fig. 130).

Exhibited in 1830 at the Royal Academy, the painting is a grandiose and entirely worthy modern complement to the Petworth *Landscape with Jacob, Laban and His Daughters*, so intimately studied by Turner in/for *Appulia in Search of Appulus*. With infinite sophistication, *Palestrina—Composition* acknowledges Claude's graces while counterpointing them with its own surprises. Rather than holding our attention at the middle of the scene, Turner's composition cuts back deeply into space both on the left, following the arched bridge which is now boldly perpendicular to the picture plane, and on the right, down the long allée. At the center, where in Claude's painting a river flows serenely, Turner's plunges over an unseen cascade, creating a challenging and unexpected gulf that the eye must bridge. Beyond, the panoramic view is nothing short of intoxicating in its breadth and delicacy. Lest we lose our bearings completely, the artist added what seem to be inappropriately sobering thoughts in the verse printed in the Royal Academy catalogue:

> Or from yon mural rock, high-crowned Praeneste,
> Where, misdeeming of his strength, the Carthaginian stood,
> And marked with eagle-eye, Rome as his victim.

Once again one can only pity Hannibal for his blindness in surveying such a scene and thinking of nothing but the false promise of victory in battle. Indeed his "presence" in the landscape has now been reduced to that of a verbal echo that seems pointedly insignificant relative to the lesson of nature's permanence.

Caligula's Palace and Bridge, 1831, goes even one step further in dreaming the classical dream (fig. 131). If the scenery of Palestrina had been partly a fiction, as the qualification "—Composition" in the title announced, it was still within the realm of the possible. In *Caligula's Palace and Bridge*, Turner concocted a vaporous architectural wonder

Figure 131. J.M.W. Turner, *Caligula's Palace and Bridge*, 1831. Oil on canvas, 54 × 97 inches (137 × 246.5 cm), Turner Collection, Tate Gallery (BJ 337).

to stand for the emperor's well-known engineering folly in certain defiance of both visible reality and historical fact.[54] Bathed in the warm morning light, it seems very much a fragmentary apparition of the building in Claude's *Enchanted Castle*, as his *Landscape with Psyche and the Palace of Amor* was then called (fig. 132). The relationship between the two paintings beautifully characterizes the nature of "influence" for Turner. Once again he was not dependent on Claude

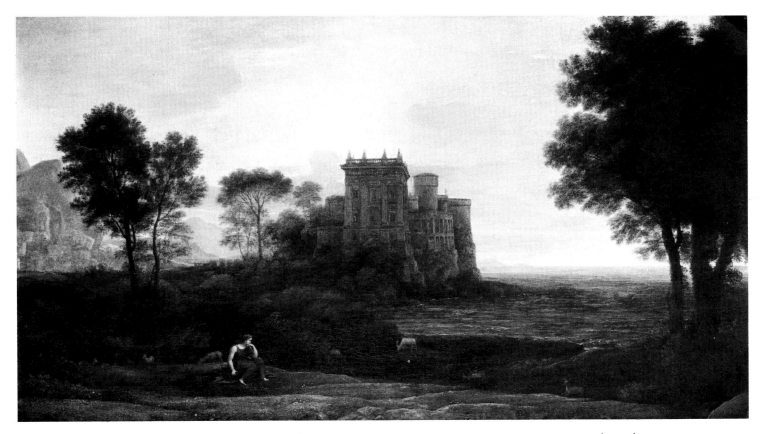

Figure 132. Claude Lorrain, *Landscape with Pysche and the Palace of Amor* (LV 162), 1664. Oil on canvas, $34\frac{1}{4} \times 59\frac{1}{2}$ inches (87 × 151 cm), Reproduced by Courtesy of the Trustees, The National Gallery, London.

for his image, except in the sense of a fully conscious, tender act of recollection. The similar disposition of trees, for example, functions in his painting like an aid to the memory, signalling the return to a vaguely familiar place.

Turner nonetheless recast Claude's magical spell. Golden tones of the new day replace Claude's more sombre, silvery blues, while rustic lovers, united and blissfully unaware of intrigue or deceit, supplant heartbroken princesses. How-

ever gently, the painting reiterates the dialectic of past and present art once again. In this case, though, contemporaries responded wholeheartedly to such modern enchantment. One of the most glowing reviews speaks to the painting's ineffable quality, learned from Claude but translated fully into Turnerian terms:

> In *Caligula's Palace and Bridge*, one of the most magnificent and extraordinary productions of the day, how admirably has the artist embodied the conceptions of the poet—Ay, he has done more than embody the conceptions of the poet; the creation of fancy and of genius, the picture is full of the breathings of poesy—it is poesy itself. The air-tint—the distances—are magical; for brilliancy, and depth, and richness, and power, it can hardly be surpassed.[55]

Even Turner could not wholly resist the seductive charm of his scene. Though he began verse for the painting by chiding Caligula about his ambitions, the artist closed with a redeeming thought about the landscape itself that foreshadows the claims made for nature's resilience and lasting beauty in the paired ancient and modern scenes of Italy and Rome of 1838–1839:

> What now remains of all the mighty bridge
> Which made the Lacrine lake an inner pool,
> Caligula, but massy fragments left,
> As monuments of doubt and ruined hopes
> Yet gleaming in the morning's ray, that tell
> How Baiae's shore was loved in times gone by?

Surely both he and Claude can be counted among those lovers.

Turner expressed his warm feelings for Italy and its landscape in another poem, written at the close of his second stay. It begins

> Farewell a second time the land of all bliss
> that cradled Liberty could wish and hope
> E'er the fell Saxon and Norman band
> Flouted his early[?] terror on thy shore.
> Why go then? No gentler traveller[?]
> Crosses thy path save the ailing[?] star[?] stranger.

A few garbled lines later he invoked "ariel Claude" as one whose works did justice to the country's beauty.[56] In the various oil sketches that Turner made during his second trip, he had responded with equal exuberance to both the countryside and its interpretation by Claude. In one group of seven compositions, originally painted on a single, large canvas, the artist let observed and imagined landscape coexist, just as he had much earlier in the "Studies for Pictures. Isleworth" (TB XC) sketchbook. At Lake Nemi, the artist made a particularly inspired record of place that perpetuates the appreciative delight in being there expressed by eighteenth-century predecessors like William Pars (fig. 133).

In other moments, however, Turner's thoughts were absorbed by classical epic, or strayed to a harbor reminiscent of Carthage (fig. 134). Perhaps in such classical compositions he was setting the stage for Regulus' appearance, though none of the sketches can be called preparatory to the finished oil. In exhibited works like *Regulus* or *Ancient Italy—Ovid Banished from Rome*, or his last four paintings, the theme of embarkation became the occasion of grief or tragedy. As Turner envisioned them, those cities and harbors conspire to induce fear, pain, or sadness in victim and viewer alike. Privately, however, passage from—or to—his urban embodiment of the classical dream must have involved pleasurable escape, for he returned there whenever he had the chance. The image of the ancient cityscape was incredibly tenacious, appearing in sketches and drawings that date from every period in Turner's career. His fascination bordered on the obsessive when he sometimes divided

Figure 133. J.M.W. Turner, *Lake Nemi*, 1828. Oil on canvas, $23\frac{3}{4} \times 39\frac{1}{4}$ inches (60.3 × 99.7 cm), Turner Collection, Tate Gallery (BJ 304).

Figure 134. J.M.W. Turner, *Claudean Harbor Scene*, 1828. Oil on canvas, $23\frac{5}{8} \times 36\frac{7}{8}$ inches (60×93.6 cm), Turner Collection, Tate Gallery (BJ 313).

Figure 135. J.M.W. Turner, TB CCII, Ports of England Sketchbook, 29a, 1822–1823. Pencil, $7 \times 10\frac{1}{8}$ inches (17.8×25.7 cm), Turner Collection, Tate Gallery.

Figure 136. J.M.W. Turner, TB CCIV, "River," 1a, 1823—1824. Pencil, $7\frac{3}{8} \times 4\frac{3}{8}$ inches (18.8 × 11.2 cm), Turner Collection, Tate Gallery.

up a page and filled it with a profusion of little classical compositions (figs. 135 and 136).[57] He drew them everywhere, including on the backs of letters and notices received in the mail (TB CCLXIIIa, Miscellaneous Black and White, 1820—1830, 7 and 8).

Perhaps the most fascinating of all are a group of six ancient scenes, sketched one each on calling cards, some of which had been printed with Turner's name and address (TB CCCXLIV, Miscellaneous Drawings, c. 1830—1841, 432—439). They are like tiny postcards from the far reaches of Turner's imagination, and one cannot help but picture him shuffling through them, recalling his mental excursions to their realms. The finest example, sure in its drawing and intricate in its architectural invention, seems to depict a spot where the artist had stopped to linger (fig. 137). Having learned about the affective power of idealization from Claude, he paid his predecessor the ultimate compliment by using it not just to show the outward appearance of an enchanted place, however exquisite in its perfection. For Turner, the art of classical landscape lay in the creation of an environment, a transcendent world and time into which one can project oneself through the workings of the imagination. Acknowledging the tradition in the open, affectionate way that he did, the artist renewed the classical dream for his own generation.

Figure 137. J.M.W. Turner, TB CCCXLIV, Miscellaneous Drawings, 436, c. 1830–1841. Pen and ink on a visiting card, $1\frac{1}{2} \times 3$ inches (3.8 × 7.6 cm), Turner Collection, Tate Gallery.

Chapter VI: Notes

1. Gage, *Color in Turner*, pp. 92–95, established Turner's autobiographical implications in *Rome from the Vatican*. He also suggested that the landscape is an allusion to Raphael's growing reputation as an exponent of that genre. If so, then the Renaissance painter was nonetheless a Claudean one in Turner's eyes. For a more elaborate interpretation of *Rome from the Vatican* see Mordechai Omer, "Turner and 'The Building of the Ark' from Raphael's Third Vault of the Loggia," *Burlington Magazine* 117 (1975), pp. 691–702.

2. In a letter written in 1821, Eastlake mused that he sometimes regretted his "heathen taste, for I see more to allure me in the beauty and simplicity of a classical dream than in the less plastic and picturesque material of my own faith," Charles Eastlake, *Contributions to the Literature of the Fine Arts* (London, 1870), p. 99. He later yielded to its allure.

3. Turner wanted his works to "hang on the same line same height from the ground" as the Claudes as well; Finberg,

Life of J.M.W. Turner, R.A., p. 330. His 1831 substitution of *Sun Rising Through Vapour* for *The Decline of the Carthaginian Empire* made the comparison a closer one.

4. Ziff, " 'Backgrounds,' " p. 145.

5. Ibid., p. 144.

6. Turner elaborated, with somewhat tortured syntax, that "had [Claude] not so studied, we should have found him sooner pleased with simple subjects of nature, and [would] not [have], as we now have, pictures made up of bits, but pictures of bits," ibid., p. 144.

7. The anecdote is credited to the sculptor Chantrey by Wornum, *Turner Gallery*, p. 34.

8. Ziff, " 'Backgrounds,' " p. 143.

9. For Hazlitt's reading of Claude, see Claire Pace, "Claude the Enchanted: Interpretations of Claude in England in the Earlier Nineteenth Century," *Burlington Magazine* 111 (1969), pp. 738–39.

10. William Hazlitt, *Complete Works*, ed. P.P. Howe, 21 vols. (London and Toronto: J. Dent and Sons Ltd., 1930–1934), 10, p. 57. The discussion comes from *The Principal Picture Galleries in England*, 1824.

11. Leslie, *Memoirs of the Life of John Constable*, p. 111, written during his stay at Coleorton in October and November, 1823. Turner, too, once wrote about getting to work "con amore" on a pendant to Lord Egremont's "beautiful Claude"; see below p. 262, note 53.

12. Turner sketched the same Claude, along with four others, in his Fonthill Sketchbook, TB XLVII, c. 1799–1805,

discussed by Jerrold Ziff, "Copies of Claude's Paintings in the Sketchbooks of J.M.W. Turner," *Gazette des Beaux-Arts* s. 6, 65 (1965), pp. 51−53. For Constable's study of Claude, see Michael Rosenthal, *Constable, the Painter and His Landscapes* (New Haven: Yale University Press, 1983), pp. 34−35.

13. Ziff, " 'Backgrounds,' " p. 144. Turner's discussion of Claude's pictorial design in the "Backgrounds" lecture may initially have included a mild critique of too much idealization. Having just explained how the master studied the parts of landscape, he concluded, "Thus may be traded his mode of composition, namely, all he could bring in that appear'd beautifully dispos'd to suit either the side scene or the large trees in the centre kind of composition. Thus his buildings, though strictly classical and truly drawn from the Campo Vaccino and Tivoli, are so disposed of as to carry with them the air of composition [and too often drags back in spite of all the valuable freshness and beauties the spectator and tempts him to deny that nature never did or could appear so artificially deceitful]." Ziff noted that the section in brackets appeared in two versions of the lecture but was subsequently crossed out. Michael Kitson, "Turner and Claude," pp. 4−5, preferred to read the excised part not as a criticism, but as a compliment to the effect that "Claude's composition is so inventive—in effect, so ideal, that the spectator cannot believe that nature, despite the truthful rendering of the atmosphere, can ever look so attractive" (p. 5).

14. He had gone to see the Altieri Claudes, *Landscape with the Father of Psyche Sacrificing at the Milesian Temple of Apollo* (LV 157), and *Landscape with the Landing of Aeneas in Latium* (LV 185), purchased by William Beckford; *The Diary of Joseph Farington*, 4, p. 1219, entry for May 8, 1799. Ziff proposed that the artist nonetheless felt adequate to the task of making a watercolor copy of the landscape composition—without the figures—of LV 185 (in TB LXIX, "Studies for Pictures"

1800−1802, 122); "Turner et les grands maîtres," *J.M.W. Turner* (Paris, 1983−1984), p. 26.

15. Andrew Wilton, *J.M.W. Turner, His Art and Life*, (New York: Rizzoli International Publications, Inc., 1979), p. 60, considered Turner's watercolors of Caernarvon Castle of 1799 and 1800 (fig. 29) to be Claudean in their approach and treatment of atmosphere. Compositional similarities became more pronounced after the artist's continental trip, however. See the watercolor of *Lake Geneva, with Mont Blanc from the Lake*, c. 1805, in the Yale Center for British Art, for its Claudean balance and repose. Curiously enough, Turner had not copied any of the Claudes in the Louvre. Ziff, "Copies of Claude's Paintings," pp. 52−54, speculated on the reasons why the artist omitted such study.

16. In "A Note on Reflexes and English Landscape," which Turner wrote sometime around 1810, he championed the unpredictable northern climate, "where nature seems to sport in all her dignity," and British landscape painters' ability to make art of it; British Museum Add MS 46151 CC, transcribed and printed in Gage, *Color in Turner*, p. 213.

17. The chronology of the sketching sessions recorded in the book has yet to be firmly established. I do not presume that Turner literally started on the first page and systematically worked his way through. His use of different media and the working up into watercolor of some of the drawings suggest that he took up the sketchbook at different times for a variety of purposes. However, once filled (and then labeled by him for reference), the sketchbook remained a compendium of landscape ideas, the juxtapositions of which are nonetheless informative—perhaps as much for the artist himself as for his subsequent viewers.

18. The transcription of Turner's notation listing the barque's possible passengers is given above, p. 68.

19. John Gage proposed that the scenery derives from a passage in *Summer* (lines 1417—29); Adele Holcomb pointed to William Collins' 1749 *Ode occasion'd by the death of Mr. Thomson* as the source; Thomson himself published *An Ode on Aeolus's Harp* in 1748; see Butlin and Joll, *The Paintings*, 1, pp. 64—65.

20. Kitson, "Turner and Claude," p. 8, suggested that Turner's source of inspiration was Claude's *Landscape with Jacob, Laban and His Daughters* (fig. 117), which he felt the artist used for *Festival Upon the Opening of the Vintage at Macon* as well. The differences between the model and its progeny seem equally significant, however; in particular the way Turner elongated the composition and aligned the river with the land and figures.

21. Ziff, " 'Backgrounds,' " p. 133. For a discussion of the painting's theme, see above pp. 172 and 177.

22. See Butlin and Joll, *The Paintings*, 1, pp. 81—82, for the various comments.

23. For a more detailed account of the competition and Turner's actions in it, reconstructed from the British Institution minutes, see Kathleen Nicholson, "Turner's 'Appulia in Search of Appulus' and the Dialectics of Landscape Tradition," *Burlington Magazine* 122 (1980), pp. 679—86.

24. *The Diary of Joseph Farington*, 12, p. 4272, entry for December 26, 1812. Finberg, *Life of J.M.W. Turner, R.A.*, pp. 207—208, suspected that Turner submitted *Appulia in Search of Appulus* partly on behalf of the Royal Academy, as a semi-official gesture of protest. In 1815, the dispute intensified with the publication of *Catalogue Raisonné*, which attacked the British Institution.

25. This regulation, they explained, was to encourage the students' "attention to original composition"; British Institution Minute Book, Meeting of the Directors, March 2, 1807. It was revoked the next year, at the Annual Meeting of the Governors, May 31, 1808.

26. Leslie, *Memoirs of the Life of John Constable*, p. 95. In a footnote, Leslie excused the Institution's directors of any wrong-doing and commented that Constable "did not sufficiently consider that those who are content to spend much of their time in copying pictures, are not of that class who would advance or even support the art under any circumstances."

27. As related to Farington by A.W. Callcott; *The Diary of Joseph Farington*, 11, p. 3945, entry for June 8, 1811. Farington is the source of most of the accounts of Beaumont's campaign of verbal abuse; see also the entry for October 21, 1812 (ibid., 12, 4223—24).

28. Ibid., p. 4328, entry for April 8, 1813. The source for the anecdote was once again Callcott. As one of Turner's "followers," he suffered much the same treatment. He also informed the diarist that because of Beaumont, Turner "had not sold a picture in the Exhibition for some time past."

29. Letter to the Editor, signed "Amateur," published in *The Examiner, A Weekly Paper on Politics, Domestic Economy, and Theatricals*, ed. John Hunt and Leigh Hunt, February 13, 1814, pp. 107—108.

30. *John Constable's Correspondence*, 3, p. 58.

31. Some of Turner's contemporaries got his point, however. The following year, Robert Smirke, gossiping to Farington about the *Catalogue Raisonné*, "approved the remark in it that there had been a virulence of criticism on pictures painted

by Turner, such as should be reserved for crime, but wholly disproportioned to a subject of painting, however much disapproved. He defended Turner's works and said they ought not to be judged by comparing them with the works of Claude or others; that they were in a style quite his own and consistent"; *The Diary of Joseph Farington*, 13, p. 4635, entry for June 2, 1815.

32. The reviewer was Robert Hunt, in *The Examiner*, April 17, 1814, p. 254. He had dismissed Turner's painting entirely, reciting the same reasons given by the "Amateur." Hofland's painting was purchased from the exhibition by the Marquess of Stafford. Its present whereabouts are not known. Ironically, Hofland (1777–1843) was noted primarily as a copyist. During the 1814 British Institution retrospective of Richard Wilson he produced five or six copies and was rewarded by having them purchased as a lot, with the buyer telling him to name his own price; Constable, *Richard Wilson*, p. 134.

33. For the most recent reading of Claude's treatment of the subject, see H. Diane Russell, *Claude Lorrain* (Washington D.C.: National Gallery of Art, 1982), pp. 190–93.

34. Hazlitt was writing for the *Morning Chronicle*, May 3, 1814; quoted in Butlin and Joll, *The Paintings*, 1, p. 93.

35. Unless one recalls Virgil's description in Book IV, 123–28:

> Meantime the rising towers are at a stand;
> No labours exercise the youthful band,
> Nor use of arts, nor toils of arms they know:
> The mole is left unfinished to the foe;
> The mounds, the works, the wall neglected lie,
> Short of their promised height, that seemed to threat the
> sky.

Compare the positive connotations of intact bridges discussed by Adele Holcomb, "The Bridge in the Middle Distance: Symbolic Elements in Romantic Landscape," *Art Quarterly* 37 (1974), pp. 31–58. Ralph Wornum, who studied Turner's works and their sources closely, was puzzled by the fact that the city already looked old. Confounding the historical Carthage with the legendary one, he proposed that the ruined bridge was perhaps a symbol of "the luxury, the element of decay, which attended [the new empire] at its very birth," *Turner Gallery*, p. 27. Virgil had used the prosperity of Carthage only to intensify the tragedy of Dido's fate. In engravings after the painting, but not visible in the work itself today, a faint volcano smokes, another potential threat to the peace and prosperity. In Claude's *View of Carthage, with Dido, Aeneas, and their Suite Leaving for the Hunt* (fig. 119), the roofline of the royal palace is incomplete and grown over with vegetation, but otherwise the city is in good repair.

36. Turner's exhibition pieces for 1815 are the perfect illustration of his multiple interests. As involved as the two Claudean works were with formal issues, they would have vied for attention with four Swiss watercolors including *The Battle of Fort Rock, Val d'Aosta, Piedmont, 1796*; the spare beauty of *Fishing upon the Blythe-Sand, Tide Setting in*; and the pyrotechnics of *The Eruption of the Souffrier Mountains, in the Island of St. Vincent, at Midnight, on the 30th of April, 1812, from a Sketch taken at the Time by Hugh P. Keane, Esq.*

37. Anonymous review titled "RA No. 1," recorded for May 5, 1815, in the V & A Press Cuttings, 3, p. 922.

38. Ziff, "'Backgrounds,'" p. 128.

39. John Gage cited a comment by Turner that the area around the Maidenhead railway bridge excelled over that of any river in Italy; *Turner: Rain, Steam, and Speed*, p. 26.

40. "Artistic Reminiscences of Thomas Barker of Thirkleby, Thirsk, Yorkshire," Victoria & Albert Museum Manuscript Collection. On another day, Barker thought Glover to be fast asleep in front of his project, but "was assured by the artist that he had only been in deep meditation on this amazing picture." Another account of his challenge piece gave its dimensions as 72 × 48 inches (183 × 122 cm); V & A Press Cuttings, 3, p. 882.

41. Basil S. Long, "John Glover," *Walker's Quarterly* (London: Walker's Galleries, April 1924), no. 15, pp. 16–17, reported that the Louvre painting was last seen, in very poor condition, in 1853 in a Birmingham dealer's shop. He quotes a review from 1817 that provides some description of the work: "a rich autumnal light is shed over the whole scene, cattle are seen browsing at the foot of a mountain knee-deep in mown grass, whose fragrance one almost feels; several human figures are collected in a valley, some loitering about, some reclining in the shade, some amusing themselves with various sports, but every look and every moment seems in unison with the season."

42. Ibid., p. 17. Glover was highly successful financially, having benefited from the market for copies and pastiches. A remark of Constable's on his delight at being in a "room full of Claudes (not Glovers, but real Claudes)" attests to his place in the London art scene; Leslie, *Memoirs of the Life of John Constable*, p. 108. In 1815, Glover sent a large oil (78 × 112 inches; 198.1 × 284.5 cm) entitled *Jacob taking charge of the Flocks and Herds of Laban* to the British Institution. Perhaps he hoped to outdo both the Petworth Claude and *Appulia in Search of Appulus*.

43. William H. Gerdts and Theodore E. Stebbins, Jr., "*A Man of Genius,*" *The Art of Washington Allston* (Boston: Museum of Fine Arts, 1979), p. 46.

44. The case for Claude's impact was argued by Marcel Roethlisberger in *Im Licht von Claude Lorrain*, ex. cat., Munich, Haus der Kunst, (Munich: Hirmer Verlag, 1983).

45. Marie-Madeleine Aubrun, *Aspects du paysage néo-classique en France de 1790 à 1855*, ex. cat., Paris, Galérie du Fleuve, 1974, p. 6. She attributed the shift partly to the influence of J-B. Deperthes' *Thèorie du paysage*, published in 1818.

46. Marie-Madeleine Aubrun, "Nicolas-Didier Boguet, 'Un Emule du Lorrain,'" *Gazette des Beaux-Arts*, 83 (1974), pp. 317–20. Boguet lived out his adult life in Rome, catering to an international clientele. Among his patrons were Lord Bristol and his daughter Elizabeth. Stendhal wrote of Boguet, "c'est un élève de Claude Lorrain et le meilleur."

47. *The Diary of Joseph Farington*, 13, p. 4637–39, entry for June 5, 1815.

48. TB CLXXVII, "Ancona to Rome," 1819, 6. For a thorough study of Turner's trip and his sketches see Powell, *Turner in the South*, pp. 20–35.

49. Fuseli, *Lectures on Painting Part II* (London, 1820), p. 27. Turner knew the terrain of Italy well, even before he actually set foot on it, and so was fully prepared to enjoy its features once there. See, for example, the drawings he had worked up beforehand for James Hakewill's *A Picturesque Tour of Italy*, 1818, and his own sketches of the same sites subsequently made *in situ*.

50. He made his color notations inside the cover of TB CLXXVII, "Ancona to Rome"; in TB CLXXVI, "Venice to Ancona," 22a, on the sketch of a calf, which was 'Dun Brown. Claude'; and in TB CLXXXII, "Albano, Nemi, Roma," 28a–29, where in the middle distance he saw

"Wilson—Brown Campagna." In TB CLXXIX, Tivoli and Rome Sketchbook, 41—41a, he labeled a sketch 'Grey Castle. Claude.' He first recalled the Petworth Claude when he encountered, or expected to encounter scenery "Very like" it, recorded in TB CLXXI, "Route to Rome," 26a. It came to mind again when he was occupied with Tusculum, in TB CLXXXII, "Albano, Nemi, Roma," 27a—28.

51. The Petworth *Landscape with Jacob, Laban and His Daughters* is itself one of only a few of Claude's canvases especially elongated in format.

52. John Gage would have it that Turner was symbolically alluding to the luxury and lasciviousness that was Baiae's downfall through the details of the rabbit (an attribute of Venus) and the snake (the symbol of evil) in the far right foreground; "Turner and Stourhead," pp. 80—81. Perhaps implicit in Turner's wish to be carried back to Baiae was a desire to partake of its ancient vice! Reviewing the theme of time's passage in contemporary literary sources, Powell drew a parallel between Shelley and Turner in particular. On the basis of the autumnal coloring of the *Bay of Baiae, with Apollo and the Sibyl*, she felt Turner emphasized "the vicissitudes of human affairs while using the landscape itself to point the same moral"; *Turner in the South*, pp. 117—21.

53. Turner had written from Paris to Charles Eastlake, in Rome, sometime around August 23, 1828, the date of the postmark. The relevant part of the letter reads: "However it may be I must trouble you with farther requests viz . . . that the best of all possible grounds and canvass size 8 feet $2\frac{1}{2}$ by 4 feet $11\frac{1}{4}$ inches to be if possible ready for me, 2 canvasses if possible, for it would give me the greatest pleasure independant of other feelings which which [sic] modern art and of course artists and I among their number owe to Lord

Egremont that the my [sic] first brush in Rome on my part should be to begin for him con amore a companion to his beautiful *Claude*." Reprinted in *Collected Correspondence of J.M.W. Turner*, p. 118.

54. According to Goldsmith, *History of Rome*, 2, p. 154, the bridge was made up of ships tied together across three-and-a-half miles of sea. Timbers were placed over the decks and buildings erected over them. As Gage pointed out, both Richard Colt Hoare and Eustace were aware of its temporary nature. He suggested that in creating his imagery, Turner followed the popular belief that the remains of the mole of Puteoli were in fact those of Caligulas's bridge; "Turner and Stourhead," p. 82.

55. Anon, "The Fine Arts," *La Belle Assemblée* 13 (June, 1831), p. 288.

56. The poem is in TB CCXXXVII, Roman and French Notebook, 1828, 8a—9. It continues:

> The yellow trimmed Tiber so refulgent[?]
> But his lost greatness of Imperial Rome.
> Where are the sturdy oaks and Beech
> That cloath thy native soil?
>
>
>
> and should be duly paid
> a Debt which to quit had become a duty
> Not to be shewn by words but works
> as that [loss] of long
> ariel Claude whose study[?] all
> Thy beauty Italy and give to thee
> What Britain boasts[?] of thy trees and parks.

The transcription is by John Gage, from "Turner's

Academic Friendships: C.L. Eastlake," *Burlington Magazine* 110 (1968) p. 682. The poem contains some twenty-six lines in all, many of which are illegible. Gage's efforts after the first five lines were heroic, given Turner's handwriting there.

57. Similar drawings in TB CCII, Ports of England Sketchbook, 1822—1823 include 30a and 31a. For an earlier series, see TB CXXXIX, Hastings Sketchbook, 1815—1816, leaves 3—6, where the sketches are one to a page, and fairly elaborate in their description; later examples are in TB CCLXXVIII, Mouth of the Thames Sketchbook, 1832, inside front cover and leaves 1a and 2, the latter two perhaps related to *Hero and Leander*. Among the drawings catalogued as TB CCCXLIV, Miscellaneous Drawings, 1825—1841, number 372 is an extensive classical port.

VII *Epic Journeys: Turner's Heroes and Heroines*

Stories drawn from ancient epic poetry held a privileged position in Turner's classical oeuvre. He began his excursion into antiquity thinking about an episode from the *Aeneid*, and he ended it, and his artistic career, similarly engaged. At critical moments in between, he used epic subject matter to underline statements of principle about art and about life. Never was it merely the pretext for a display of the "epic" style that the artist had formulated in the first decade of the nineteenth century. The colorful warfare recounted in ancient poetry would have been well suited to such an encompassing, decentered narrative approach, but the sweeping heroics of epic narrative did not capture the artist's imagination. In the sketches and paintings based on the *Iliad*, the *Odyssey*, the *Argonautica*, and the *Aeneid*, he chose instead to conduct a sensitive, extended study of individuals caught in the web of destiny.

Working virtually simultaneously from all four major epics, Turner discovered and explored the critical incidents animating each. It is telling that some of his preferred themes were without precedent in the history of painting. Where models did exist, the artist either was unaware of them or chose to ignore them. Nor did neoclassical taste in epic subject matter interest him, in contrast to his choice of subjects from ancient history. His selection of episodes constitutes a genuinely perceptive reading of the poems, on a par with his study of Ovid, but broader by virtue of the source material itself.

The stories in question inhabited the artist's mind in a fundamental and touching way. He maintained a constant dialogue with them, relating the episodes to his own life as he reviewed them over time. When he was young and full of his own daring, he could enjoy the adventurous quests of Aeneas or Jason. As he became older, he was drawn to quieter and more complicated moments of personal crisis.

He also shifted his attention to those persons affected directly, and often adversely, by the heroes' exploits. Turner's innermost feelings seem to have emerged when he considered the dilemmas faced by Dido or Medea. He had decided from an early age that history held only disappointment in store for mortals, but he was reluctant to let that truth apply to the heroes and heroines of classical epic.

His initial study of epic themes is concentrated in two sketchbooks, "Studies for Pictures. Isleworth" (TB XC, 1804–1806), and "Wey, Guil[d]ford" (TB XCVIII, 1807). In the former, where stories from all four ancient sources appear, the artist was particularly attentive to similarities in plot, annotating several scenes with alternative suggestions for their thematic development (plates 8, 9, 14). The rapport he found between or among the episodes amplified the significance each held in the larger account of its hero's progress. Given their overall elaboration it seems clear he was thinking ahead to major paintings (plates 2, 6, 7, 14 and 15). In the "Wey, Guil[d]ford" (TB XCVIII) sketchbook, he restricted himself to episodes from the *Iliad*, *Odyssey*, and *Aeneid*, dealing with them more or less sequentially, and without drawing comparisons. Even so, this suite of sketches has an impressive narrative coherency (figs. 138–142). Each distills from its respective source a pivotal moment visualized with exceptional sureness and clarity. Turner's powers of concentration are all the more remarkable given the inherent differences in the themes, which range from youthful foolhardiness to blind passion and from piousness on the part of a despairing parent to the humbling of a wily hero, and that same hero's ultimate triumph. Like the Hercules group in Hesperides (2) Sketchbook (TB XCIV) these sketches appear to have been done in a single, inspired sitting. The drawing is fluid throughout

Figure 138. J.M.W. Turner, 'Ascanius,' TB XCVIII, "Wey, Guil[d]ford," 1, 1807. Pencil, $4\frac{9}{16} \times 7\frac{3}{16}$ inches (11.6 × 18.2 cm), Turner Collection, Tate Gallery.

Figure 139. J.M.W. Turner, 'Dido & Eneas,' TB XCVIII, "Wey, Guil[d]ford," 2, 1807. Pen and sepia and wash over pencil, $4\frac{9}{16} \times 7\frac{3}{16}$ inches (11.6 × 18.2 cm), Turner Collection, Tate Gallery.

Figure 140. J.M.W. Turner, 'Ulysses & N,' TB XCVIII, "Wey, Guil[d]ford," 3, 1807. Pen and sepia and wash over pencil, $4\frac{9}{16} \times 7\frac{3}{16}$ inches (11.6 × 18.2 cm), Turner Collection, Tate Gallery.

and the touches of wash added to the latter four economically add "detail." Though the figures are schematic enough to make necessary the titles Turner added in the lower right corner of each (especially for "Ascanius," the first drawing in the series and the only one in pencil, rather than worked over in pen, or in pen alone), once identified, the scenes seem not to need any additional narrative embellishment.

The extent of Turner's acquaintance with the epics and the acuity of his response to that material becomes most apparent when all of the sketches and related paintings concerning each epic are examined together, rather than in the order or place in which the works were made. Nonetheless, the intensity and scope revealed in the "Wey, Guil[d]ford" (TB XCVIII) sketches should stand as a reminder of the comprehensiveness of his thematic inquiry.

Homer's **Iliad** *and* **Odyssey**

Of the four major ancient epics, the *Iliad*, with its extended accounts of battle, offered the least material for Turner's discourse on antiquity. The open violence and brutality of ancient warfare that so vividly animates the poem had no more appeal for him than did the cruelty of some of the Ovidian tales. Characteristically, he isolated the one episode that dealt with the innocent victims of war, told through the plight of Chryses, whose daughter had been taken as booty by the Greeks. The story occurs in Book I, and serves to introduce the antagonisms that propel the rest of the action: the rivalry between Achilles and Agamemnon, and the disharmony between the Greeks and their gods. Achilles' wrath might have held more dramatic possibilities as a subject, but Chryses' anguish, and the resolution of his circumscribed dilemma, provided a poignant example of helplessness in face of unreasonable forces. Equally impor-

tant, the ancient priest's story also directly incorporated elements of the natural landscape as a significant aspect of the narrative.

In "Studies for Pictures. Isleworth" (TB XC), Turner first envisioned the pageantry attendant on a happy ending to the tale. A draft labeled "Chryseis returning to C[?]" (in the lower right) makes use of the classical harbor on which he had been working as the setting for the reunion of father and daughter (plate 6). A second sketch worked up the scene in watercolor. It is labeled in the upper left with references to both the Chryses episode ("Ulysses . . . at Crusa[?]"), and a parallel theme of rejoicing, "Jason's arrival at Colchis" with the Golden Fleece, from the *Argonautica* (plate 8). On the adjacent page, Turner began to bring the scene to life in his own mind by identifying some of the figures and specifying their activity. Jason's story seems to have become the more intriguing for the artist as he envisioned

> Females dancing and crowning the rope[?] with flowers, or the Foreground Figures rejoicing. The left—the Priest attenting [?] to receive the Fleece. Jason and the Argonauts on Board, bearing the Fleece. Ulysses with [Chryseis] offering her to her Father.

The introduction of Ulysses signals Turner's attentiveness to the narrative development of the tale in several senses. In the *Iliad* Ulysses appears in the Chryses episode merely as an emissary in the negotiations. At one and the same time Turner was being faithful to the poem, to the pomp he envisioned in his harbor scene (Ulysses providing added status as a counterpart to Jason), and to Claude's choice of episode in *Seaport with Ulysses Restituting Chryseis* (1644).[1]

The artist subsequently concentrated on the father's despair, rather than on a public celebration. Sketches in "Wey, Guil[d]ford" (TB XCVIII) shift the moment back to the charged description of Chryses' final measure to win Chryseis' return (fig. 141). After trying every means to

Figure 141. J.M.W. Turner, 'Chryses,' TB XCVIII, "Wey, Guil[d]ford," 4, 1807. Pen and sepia and wash, $4\frac{9}{16} \times 7\frac{3}{16}$ inches (11.6 × 18.2 cm), Turner Collection, Tate Gallery.

Figure 142. J.M.W. Turner, 'Ulysses Poly,' TB XCVIII, "Wey, Guil[d]ford," 5, 1807. Pen and sepia and wash, $4\frac{9}{16} \times 7\frac{3}{16}$ inches (11.6 × 18.2 cm), Turner Collection, Tate Gallery.

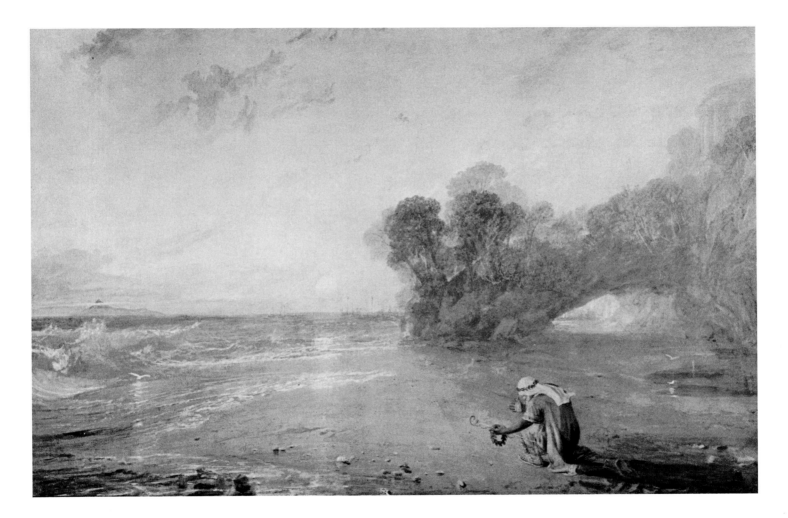

Figure 143. J.M.W. Turner, *Chryses*, 1811. Watercolor, $26 \times 39\frac{1}{2}$ inches (66×100.3 cm), Private Collection.

placate the Greeks, Chryses, priest of Apollo, implored the god to unleash his powers in aid of his cause. The moment required little elaboration, and Turner wisely responded with tactful restraint, both in the initial drawing, and later, in the finished watercolor which he exhibited in 1811 (fig. 143). Along a lonely seashore, the grieving father kneels in an act of supplication, petitioning his deity to punish the Greeks with perpetual darkness. The citation from the *Iliad* that the artist included in the Royal Academy catalogue deftly connected supernatural with natural, describing Apollo as "The God who darts around the world his rays."[2] The orb of the sun hanging low in the sky masterfully renders the metaphor in nature's terms. All of Turner's claims for the power of landscape painting seem to be substantiated in this simple, quiet scene.[3]

The *Odyssey* inspired images that were equally potent— and far happier in mood. Two incidents held the artist's attention: Ulysses' meeting with the young maiden Nausicaa (Book VI) and his flight from Polyphemus (Book IX). The subjects counterpoint each other perfectly, revealing the extremes of the Greek hero's character. In the one instance, stripped of his glory and reputation, Ulysses gracefully humbled himself; in the other, perhaps his finest moment, he controlled his destiny with pride and defiance. Drawings for each episode bracket those dealing with Chryses in the "Wey, Guil[d]ford" (TB XCVIII) sketchbook (figs. 140 and 142). In "Studies for Pictures. Isleworth" (TB XC), Turner imagined Nausicaa and her friends engaged in the young girl's premature preparations for marriage (plate 9). Inspired by Athena, she had persuaded her indulging parents to let her wash her wedding garments at the pool where Ulysses would soon find her. Homer had described her procession in lavish terms, to which Turner readily responded, linking the scene with Dido and Aeneas' wedding day in his notations on the sketch.

The "Wey, Guil[d]ford" (TB XCVIII) drawing con-

tinues the story with attention to its charming details. Once at the pond, the young maidens forgot about laundry in favor of their childish games. Turner showed them playing in a group on the far right, while Nausicaa, chasing a stray ball, encounters the disheveled and embarrassed Ulysses at the center. The episode relates Ulysses' final test to win his passage home: having been shipwrecked on Nausicaa's island, the hero had no choice but to throw himself on the young girl's mercy. Her parents' prosperous city, to him a welcome sight, is visible through the trees in the background of the sketch. Their encounter represents a brief interlude in his saga, when beauty, naïveté, and kindness prevail over cunning and wile. Moreover, Nausicaa's youthful hopes and dreams contrast with Ulysses' worldliness in both the poem and Turner's two drawings. Nausicaa thinks she may have found a husband and Ulysses believes his trials may be over. Both are mistaken, but the consequences were not dire for either. The artist translated the delicacy of the moment through the gently animated drawing style. The graceful looping lines of the shrubs and tree tops, the almost decorative elaboration of detail, and even the elegant proportions of the figures convey well the genteel nature of the encounter.[4]

Turner imagined the second theme, Ulysses deriding the cyclops Polyphemus, with a bravado and economy of line that match the actions of its hero. The artist was so sure in his conception of the scene recorded in the "Wey, Guil[d]ford" (TB XCVIII) sketchbook that neither an oil sketch nor the finished version done some twenty years later differs significantly from it. In the drawing, Polyphemus occupies his seat on the crest of the mountain, already a part of its contour, while below him an ancient barque is under sail, the squiggles at its prow perhaps corresponding to the sublime nereids who surround the vessel in the exhibited oil painting. The early date of the sketch, relative to the final version, substantiates how deeply and steadfastly

an idea or image could impress itself in Turner's mind, while the bold liveliness of the pen and ink drawing (with no preliminary pencil) conveys the artist's absorption in the narrative moment as he was crystallizing it.

Turner's studies of these two aspects of Ulysses' will to survive would have made a splendid pair had both been realized in finished oils, even offering a contrast between a woodland setting and a seascape in good Claudean fashion. By itself, *Ulysses Deriding Polyphemus—Homer's Odyssey* (1829) is an extraordinary image, deserving John Ruskin's claim that it was "the central picture in Turner's career" (color plate 7).[5] It is also the one entirely bright spot in his otherwise guarded view of antiquity's heroes. Ulysses alone withstood Turner's process of reevaluation, perhaps because he had succeeded on his own terms, and without seriously damaging anyone blameless along the way. Even when Calypso offered the hero a way to cheat time by a promise of immortality, he rejected it in favor of accomplishing his appointed goal (Book V). Nor was Ulysses ever deluded by false expectations. Accordingly, *Ulysses Deriding Polyphemus—Homer's Odyssey* was one of the few major classical paintings that Turner did not burden with verse from the "Fallacies of Hope."

The artist once reportedly made light of the painting's subject, in what Thornbury referred to as his "joyous spirit of mystification," but in fact the imagery is as open and accessible as it can be.[6] Turner followed the indications of the epic poem closely, choosing the crucial moment in Ulysses' adventure for his subject. While imprisoned in the cyclop's cave, the hero had cunningly denied his identity (in both senses) to escape his tormentor's wrath: when Polyphemus repeatedly asked his name, he would only answer "Noman." Once free, however, Ulysses proudly exclaimed to all the world just who and what he really was.[7] Turner's scene glows with that self-confident revelation, the breaking light of dawn answers back to the smoky gloom of the cyclop's realm. As verbal emphasis, Ulysses' name, in Greek, decorates a banner waving from his ship's mast. Beneath it, another flag commemorates a previous triumph, the plot with the Trojan horse that had led to the sack of Troy.

The painting's celebration of prowess and fortitude led Ruskin to construe it as a quasi-autobiographical statement. That Turner might identify with Ulysses' defiance seems very much in keeping with his ability to enter into the animating spirit of the legends he interpreted. Ruskin's explanation, one of his most delightful, argued that the artist

had been himself shut up by one-eyed people in a cave 'darkened with laurels' (getting no good, but only evil, from all the fame of the great of long ago)—he had seen his companions eaten in the cave by the one-eyed people—(many a painter of good promise had fallen by Turner's side in those early toils of his); at last, when his own time had like to have come, he thrust the rugged pine-trunk, all ablaze—(rough nature, and the light of it)—into the faces of the one-eyed people, left them tearing their hair in the cloud-banks—got out of the cave in a humble way, under a sheep's belly—(helped by the lowliness and gentleness of nature, as well as by her ruggedness and flame)—and got away to open sea as the dawn broke over the Enchanted Islands.[8]

In fact Turner projected himself into the painting in a number of ways, his identities as landscape painter and mythographer merging completely as he brought his imagery into being. Given the artist's awareness of modern natural science he may have drawn upon a longstanding association of Polyphemus with volcanic activity in his conflation of mountain, monster, and smoke, updated to conform to current scientific theories. Similarly, Turner may have introduced the fantastic nereids that surround the prow on the basis of recent observations about phos-

phorescence.[9] But it is also the case that the artist need have gone no further than his ancient sources to find such imagery, as well as examples of the symbolic use of color and light. For example, the nereids may also serve to foreshadow the future destruction of Ulysses' fleet, if Turner remembered their presence and meaning in the *Aeneid* (Book X, 221−27). Just as Aeneas was preparing for an ill-fated battle, he is forewarned when

> A choir of nereids meet him on the flood.
> Once his own galleys, hewn from Ida's wood:
> But now, as many nymphs, the sea they sweep
> As rode, before, tall vessels of the deep.
> They know him from afar; and in a ring
> Inclose the ship that bore the Trojan king.

Turner obviously wanted his imagery to work on several levels at once. As a demonstration of how to read nature allegorically he superimposed Apollo's team of horses on the rising sun in an outline drawing of red paint.[10] The role of myth in explaining natural forces and the ability of landscape to breathe "new life into the dry bones of old mythology" could not have been made more clear. But the artist also inhabited his scene, figuratively speaking, by transposing a legend from antiquity into the domain of modern art. The painting is a virtuoso display of effects, from the fragile transparency of the nereids to the soft opacity of the smoky sky. Some passages, the mist rising around the rocks at the left background, for example, are so entrancing that one's thoughts about Ulysses can be easily (if temporarily) displaced by the sheer visual experience of color or atmospheric effect. The overall play of blues and lavenders against yellows and reds creates an equivalent poetry, not in service to Homeric epic, but in a heartfelt response to it. Turner's partisans frequently complimented him on just that accomplishment. One favorable reviewer remarked of *Ulysses Deriding Polyphemus—Homer's Odyssey* that " . . . the poetical feeling which pervades the whole composition, the ease and boldness with which the effects are produced, the hardihood which dared to make the attempt,—extort our wonder and applause."[11] One need not stand in front of the painting for very long before those observations are confirmed.

The Argonautica

The positive culmination of Turner's thinking about Ulysses and the *Odyssey* contrasts sharply with his ultimate response to Jason and the Argonauts, and, later, Aeneas and Dido. Where in the first decade of the century he had been attracted by Jason's quest for the Golden Fleece, dramatizing it in the 1802 oil and celebrating its successful completion in the "Studies for Pictures. Isleworth" (TB XC) sketch, he subsequently abandoned the motif and the young man altogether. At no point had there been so much as a mention of his companion Medea. As if to compensate for that earlier slight, she became the focus of the only other oil painting related to the legend of the *Argonautica*, the *Vision of Medea* (1828; color plate 8). Moreover, she dominates her scene, presenting an angry rebuttal to her lover's claim for glory.

The lines written for the painting and identified in the Royal Academy catalogue as coming from the "Fallacies of Hope" recount her story and, following Turner's usual practice—if with somewhat more urgency—inform the visual imagery:

> Or Medea, who in the full tide of witchery
> Had lured the dragon, gained her Jason's love,
> Had filled the spell-bound bowl with Aeson's life,
> Yet dashed it to the ground, and raised the poisonous snake
> High in the jaundiced sky to writhe its murderous coil,
> Infuriate in the wreck of hope, withdrew
> And in the fired palace her twin offspring threw.[12]

At last Turner credited her for her past service in disarming the dragon and insuring Jason's success. However, it is the third line of the verse that calls attention to the central action in the painting. We see Medea at the mid-point of her story, engaged in an incantation that becomes a far more critical test of her convictions. As the poem explains, she is working her magic to restore Jason's father's youthfulness. The poem continues by expressing her outrage at the sorry outcome of her saga with the full force of Turner's poetic language.

The painting's imagery similarly conflates references to her past, present, and future. Turner based his conception of the story on a number of sources including Ovid's *Metamorphoses* (7, 181−251), Seneca's tragedy *Medea*, and possibly even a contemporary opera, *Medea in Corinto*, by J. S. Mayr.[13] In the *Metamorphoses*, Jason coerces Medea to restore his father Aeson's youth by tampering with the laws of nature very much against her better judgment. Taking to the woods, she begins her incantations over a boiling cauldron of herbs and ingredients that she had gathered; these appear, as enumerated in the poem, in the left foreground still life. Turner's setting recalls the happy bower he had designed for *Venus and Adonis*, but it has now become a place of sorcery and dark deeds, serpents tumbling with putti amidst the tree tops. On the ground at the far right an enormous, curling dragon's tail appears, recalling the episode of the Golden Fleece and Turner's 1802 painting. Further back in the gloom, a tiny torch-bearing figure may represent the fury Megaera, guiding the brother that Medea killed while fleeing with Jason.[14] On the left, in the sky, Medea's two children fall to their deaths from the chariot in which she ultimately fled. To punish Jason for abandoning her in favor of another woman, she subsequently slaughtered their offspring before his eyes. Thus Medea's vision, as she works to rejuvenate Aeson, is a survey of her own life.

But Turner not only conflated episodes (and references to his own past work), he fundamentally altered the story to bring out its ironies, much as he had done in *The Goddess of Discord Choosing the Apple of Contention in the Garden of the Hesperides*. In his poem, Medea *refuses* to continue with her magic. She dashes the "spell-bound bowl" to the ground, and before withdrawing, lashes out against her victimization, raising the "poisonous snake / High in the jaundiced sky." Her gesture of defiance (and acknowledgment of her own identity?) in the painting is in fact similar to that of the tiny figure of Ulysses, standing with arms upraised at the stern of his ship in *Ulysses Deriding Polyphemus*. As a counterpoint to her magic, the three fates cut and measure life spans at the very center of the composition. According to ancient sources, "Triple Hecate" should preside over magical spells and incantations, but Turner chose to supplant the mysterious divinity with the custodians of the duration of human life.[15]

The fates put Medea's life story, as well as her efforts to rejuvenate Aeson, into a larger, and unalterable, perspective. Above them the huge bubbles that rise out of Medea's potion further qualify her powers by making all too clear the ephemerality of love, hope, and life in general. In the lower bubble Turner inscribed what appears to be the outline of Hercules and the Hydra as a reminder that even such strength and valor as the legendary Hercules possessed is fleeting. The artist might also have been aware that the bubbles were an early nineteenth-century colloquialism for cheating, an offense committed by Jason against Medea, and by Medea against nature and the fates.[16]

The painting is both large (68⅜ × 98 inches; 173.5 × 249 cm) and lavish in its color and variety of brushwork. In Rome, where it was first exhibited, and in London, two years later, contemporary viewers found it somewhat baffling. The imagery invites that response, in keeping with the theme of magic powers. It is tempting to imagine that

Turner saw Medea as a kindred spirit. After all, when she appeals to the forces of nature for help in working her sorcery in the *Metamorphoses*, she reminds them that

> Oft by your Aid swift Currents I have led
> Thro' wand'ring Banks, back to their Fountain Head;
> Transform'd the Prospect of the briny Deep,
> Made sleeping Billows rave, and raving Billows sleep;
> Made Clouds, or Sunshine; Tempests rise, or fall,
> And stubborn lawless Winds obey my Call.
> —(7, 196–201)

Rather like a landscape painter, she has the power to manipulate nature and take command over time—though not over fate.

The *Vision of Medea* confronts the issue that Turner had first raised in *Snowstorm: Hannibal and His Army Crossing the Alps*—how to understand one's place in a larger history. In that earlier painting, where the forces of nature literally and figuratively structured Hannibal's story, the general could not see the ironies of his situation, past, present, or future because he was subsumed into the human and natural chaos. By contrast, Medea's life is reconstituted through references to events that she *does* see for what they are: visions or illusions of her own making. Taken as traditional symbols of hope's ephemerality, the bubbles confirm that sad truth. But they would seem to have still another meaning, for as Turner painted them, they are also a demonstration of the nature of art itself, representing representation for the fragile conjuring act that it is.[17] Those transparent spheres, rendered ever so delicately in the three primary colors, prompt our recognition that Medea's sorcery is indeed an art, and conversely, that painting is a form of magic. The striking artificiality of the landscape setting seems to underline the analogy between painting and conjuring. But where the artist might have empathized with Medea's personal disillusionment, he did not, like her, cease to practice his craft.[18]

The Aeneid

Turner culminated his vision of antiquity by treating its dissolution at Carthage, with Dido and Aeneas. To the extent that his classical yearnings initially emerged from his reading of the *Aeneid*, it seems entirely fitting that over time they should also have been realigned, and finally been resolved, through repeated reference to the ancient poem. Only a few episodes in fact appealed to the artist, but he cherished them like old friends. They were of a piece with his other epic subjects in dealing with themes of personal striving, the magnitude of parental love, and the heartbreak attendant on self-sacrifice, but they acquired special distinction in Turner's mind through their association with Claudean classical landscape. He could not resist the chance to retrace at one and the same time dreams about empire and about harmony in nature.

Claude himself had become captivated by the *Aeneid* in the last decade of his life, during which time he completed a series of six paintings that follows the hero's various journeys and encounters.[19] Turner not only shared his interest in the episode of Aeneas' meeting with the Cumaean Sibyl and the interlude with Dido, but also sketched the story of Ascanius, Aeneas' son, in direct response to his predecessor's imagery. The extremely abbreviated figures just left of center that appear to be taking aim with a bow in the first drawing of the "Wey, Guil[d]ford" (TB XCVIII) series recall those in the last oil Claude ever painted, *Landscape with Ascanius Shooting the Stag of Silvia* (fig. 121). In its general features, Turner's composition also

relates to Claude's *Coast of Libya with Aeneas Hunting* (fig. 144). Ascanius' story, which tells of an innocent blunder that becomes the pretext for bloodshed and warfare (*Aeneid*, Book VII, 483—99), provided exactly the kind of irony-laden moment set out-of-doors in a wooded landscape that Turner preferred, but in the end he chose not to pursue it.

His own direct response to the poem emerges in the other *Aeneid* subjects that he considered but similarly left unrealized: Aeneas' sojourn with Evander, and the hero's departure for war with Evander's son Pallas, both from Book VIII. In "Studies for Pictures. Isleworth" (TB XC), he noted them as alternative themes for the same sketch (with a third title, 'Return of the Argo' [plates 14 and 15]). The artist had worked up the fairly complicated setting through several drafts, imagining an elegant architectural display that spreads across two pages. Here he was very much on his own, for Evander's story had not inspired any obvious precedents in painting. By thinking about its possibilities, Turner showed how little the overt heroics of the poem interested him. Evander, King of Arcadia, had been forced to flee his homeland as had Dido, and had resettled in Italy where he built a new city on the Palatine. When Aeneas faced an impending war, the young hero sought aid from the aging, kind-hearted man who in a show of hospitality led him on a tour of his domain, much as the Carthaginian queen had done earlier (VIII, 401—70). Turner's sketch, with its simple indication, 'Eneas and Evander,' could fit that episode perfectly.

The second subject that Turner noted, 'Pallas & Aeneas departing from Evander,' is a far more poignant story, and much more revealing of the artist's sympathetic response to the undercurrents in the poem. In Dryden's translation of the epic, Aeneas plays a secondary role in this instance. Evander being too old to go into battle on the hero's behalf, offered Aeneas the assistance of his beloved son, Pallas. As

the two young men take their leave, the father speaks movingly of the curse of aging and the profound depths of parental love (VIII, 740—71), only to reiterate those sentiments in a different light when he subsequently learns of his son's death. In a double acknowledgment of the pain caused by Aeneas, Pallas' body is returned to him wrapped in vests embroidered by Dido. Had Turner continued with the theme in a finished oil, it might have been one of his most affecting works.

Instead, he gave his attention to the preceding episode in the poem, concerning the Queen of Carthage and her visitor. The preparatory sketches for the 1814 painting of *Dido and Aeneas*, chronologically the first of his Carthage works, substantiate how thoroughly Turner enjoyed translating Virgil's poetry into an elegant visual display. Not only did he set out the composition in "Studies for Pictures. Isleworth" (TB XC) (plate 3), but he repeated it with much the same degree of elaboration in the Hesperides (1) Sketchbook (TB XCIII), 1805—1807 (leaves 5, 6a, 7; fig. 145). His fascination here with the dawn departure for the hunt (IV, 182—87) contrasts with the scene other landscape painters depicted most frequently: the afternoon storm near a woodland cave, with its sublime torrents and flashing fires (IV, 231—46).[20]

The drawing labeled 'Dido and Aeneas' in the "Wey, Guil[d]ford" (TB XCVIII) sketchbook seems to pick up the story at that later point, but with less interest in the extreme effects of weather favored by an earlier artist like Thomas Jones (fig. 139; cf. fig. 18). Turner let the bending trees and billowing drapery suggest the coming tempest without actually detailing it. The similarity of its composition to the one that follows, the sketch of the Ulysses and Nausicaa episode, suggests that the artist continued to be mindful of the rapport between the two themes established in his annotations to the schematic vertical setting in

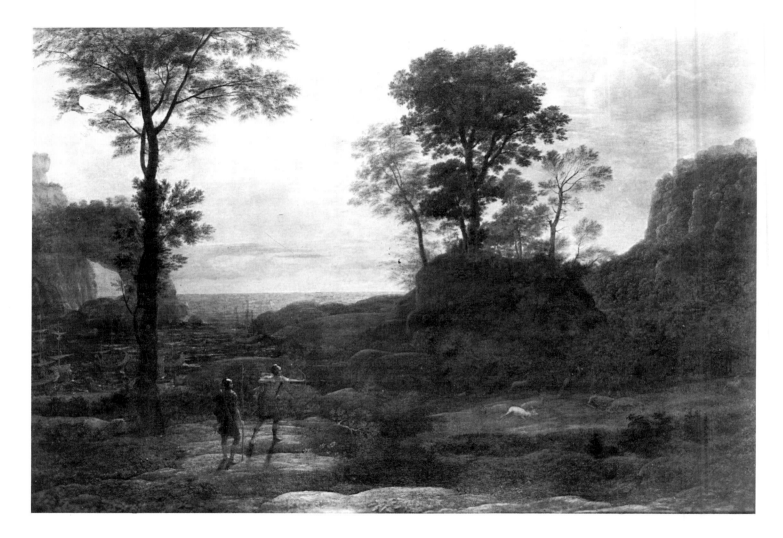

Figure 144. Claude Lorrain, *Coast of Libya with Aeneas Hunting* (LV 180), 1672. Oil on canvas, $43\frac{3}{4} \times 62\frac{1}{4}$ inches (111×158 cm), Musées Royaux des Beaux-Arts, Brussels.

Figure 145. J.M.W. Turner, TB XCIII, Hesperides (1) Sketchbook, 5, 1805–1807. Pen and ink and wash, $6\frac{3}{4} \times 10\frac{3}{8}$ inches (17.1 × 26.4 cm), Turner Collection, Tate Gallery.

Figure 146. J.M.W. Turner, *Dido Directing the Equipment of the Fleet, or The Morning of the Carthaginian Empire*, 1828. Oil on plywood, transferred from canvas, 59 × 89 inches (149.8 × 226 cm), Turner Collection, Tate Gallery (BJ 241).

"Studies for Pictures. Isleworth" (TB XC) (plate 9). Turner's awareness of the rapport between the two stories attests to his sensitive reading of the two poems, for Virgil in fact modeled his description of Aeneas' first sight of Dido on the passage in Homer where Ulysses espies Nausicaa.[21]

In the painting, Turner followed the poet's specific indications (as much Dryden's as Virgil's) about the procession, the costumes, livery, and accoutrements. In some cases the artist set up multiple allusions through such details in order to connect the present moment with aspects of the larger story. For example, the central group of spectators are not only the poem's "more wakeful huntsmen" who accompany the royal pair, but in their feminine grace they recall Venus, who disguised herself in their garb in Book I (461–64). The lines the artist cited in the Royal Academy catalogue, complete with a reference to "4th Book of Dryden's Aeneis," similarly expand upon the immediate scene:

> When next the sun his rising light displays,
> And gilds the world below with purple rays,
> The Queen, Aeneas, and the Tyrian Court,
> Shall to the shady woods for sylvan games resort.

Rather than having appended the "correct" corresponding description of the entourage (IV, 182–87) and thereby flirt with the mere notion of illustration, Turner instead chose an appropriate reference that nonetheless carries its own irony. The speaker of his lines is Juno, proposing the outing to Venus as a means to seal the lovers' bond. As the goddess of love cunningly knew, that bright morning would in fact become the first day of "all succeeding woe" for Dido (IV, 245–46).

Retracing the path that led to that false promise, Turner shifted his attention to Dido's prior accomplishment in *Dido Building Carthage* (1815; fig. 47). His depiction of her involvement with plans for the city speaks to a strength, fortitude, or commitment that runs contrary to the usual portrayal of her as a love-struck hostess or tragic suicide.[22] The contrast between the left side of the scene, where all is in preparation, and the right side, where buildings stand finished and vegetation flourishes, points up how ambitions can be fulfilled—providing one keeps one's promises. Turner maintained his positive assessment of Dido despite his subsequent exploration of historical Carthage's downfall, even strengthening it in the 1828 *Dido Directing the Equipment of the Fleet, or The Morning of the Carthaginian Empire*, with its thriving port now opened up to the outside world at its far end (fig. 146).

The 1828 painting is enigmatic on several counts. Purported to be a commission for a "Mr. Broadhurst," the work never left the artist's possession.[23] Since Turner would not part with *Dido Building Carthage* at any price, perhaps he was willing to produce a second version for the market, only to have misgivings about letting even that painting go. Though it is all but impossible to assess the work's qualities today because of the serious deterioration of its surface, contemporary reviewers found it "extremely beautiful and powerful." The work's poor condition unfortunately also complicates the task of understanding the scene's narrative development. In what may have been a preparatory sketch for the painting (dating from c. 1823–1824), Turner envisioned an arrangement of active figures, including one approaching from right of center who bears some similarity to the figure of Dido in the 1815 oil (fig. 147). The 1828 painting does not follow the sketch's emphasis, but instead seems to concentrate on architectural display and on an essentially scenic view of a grand harbor. If ships are being equipped, that activity takes place far enough in the distance not to demand attention. The morning of the empire is celebrated, rather, by a blaze of

Figure 147. J.M.W. Turner, TB CCIV, "River," 7a, 1823—1824. Pencil, $4\frac{3}{8} \times 7\frac{3}{8}$ inches (11.2 × 18.8 cm), Turner Collection, Tate Gallery.

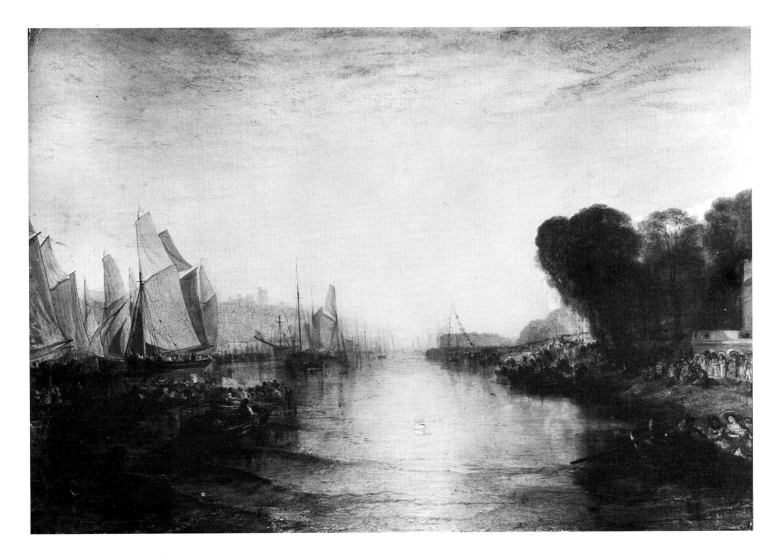

Figure 148. J.M.W. Turner, *East Cowes Castle, The Seat of J. Nash Esq.: the Regatta Starting for Their Moorings*, 1828. Oil on canvas, 36 × 48½ inches (91.5 × 123.2 cm), By Courtesy of the Board of Trustees of the Victoria & Albert Museum, London (BJ 243).

Figure 149. J.M.W. Turner, *Aeneas Relating His Story to Dido*, 1850. Oil on canvas, 36 × 48 inches (91.5 × 122 cm), now lost, formerly Tate Gallery (BJ 430).

sunlight and the seemingly endless stretch of classical facades.

Reconstructing Carthage in such an exuberant way was no small accomplishment. Nineteenth-century commentators frequently marveled that its civilization had disappeared without a trace, one writer in 1816 noting that "The dreadful imprecations of their eternal enemy the Romans, have been strictly fulfilled against this devoted city."[24] Perhaps Turner took up the challenge of fabricating a worthy setting for the Carthaginian queen in *Dido Directing the Equipment of the Fleet or The Morning of the Carthaginian Empire* with one eye on John Martin's still more extravagant flights of fancy. Martin's explanatory note defending the imaginative excesses of his own *Fall of Ninevah* (also of 1828), provides insight into Turner's showy re-creation:

> The mighty cities of Ninevah and Babylon have passed away. The accounts of their greatness and splendour may have been exaggerated. But where strict truth is not essential, the mind is content to find delight in the contemplation of the grand and the marvelous. In the solemn visions of antiquity we look without demanding the clear daylight of truth. Seen through the mist of ages, the great becomes gigantic, the wonderful swells into the sublime.[25]

But where Martin reached for the full heights of the sublime, Turner slipped away into Claudean reverie, refreshed in this case by first-hand experience of the natural beauty of a real place such as Cowes, which he had just then visited.[26] In both *Dido Directing the Equipment of the Fleet or The Morning of the Carthaginian Empire* and *East Cowes Castle, The Seat of J. Nash Esq.; the Regatta Starting for Their Moorings* (1828; fig. 148), the classical composition embodies the alluring appeal of setting out and encourages a yearning for what lies beyond. Turner did not hesitate to distort that ideal configuration when he wanted to express the anguish

of Regulus or Ovid, but he kept it intact for Dido, at least for the time being.

Not until the artist was in his seventies, more than twenty years later, did he decide on one last retelling of the story of legendary Carthage. Perhaps he felt the need to bring it to a conclusion in line with his own experiences, or, finally, to examine the competing obligations that led to Dido's downfall, which at last he could acknowledge. In his series of four paintings dating from 1850 he traced a progression from hopefulness to disappointment to departure and death, summarizing the first four books of the *Aeneid* yet also musing on the motives of the principal characters. The works include *Aeneas Relating His Story to Dido*, now lost, which commenced the lovers' affair, *Mercury Sent to Admonish Aeneas*, which spells its end, *The Visit to the Tomb*, in which Dido finally becomes accountable for her lack of fortitude, and *Departure of the Fleet*, which closes the saga on a sad note for both Dido and the future (figs. 149–152).

Characteristically, Turner manipulated the story to suit his own interpretive ends. Indeed, this final gesture of appropriation and reconstruction (of Virgil's plot and Claude's seaport) was as thorough—if not heroic in its own way—as any of the artist's earlier endeavors. By expanding the narrative over four separate scenes, the artist could determine its emphases to a far greater degree than in a single painting, no matter how iconographically nuanced. This multiplication of images suggests he very much wanted to achieve a wholeness of vision about the mythic world that he knew so well. During the preceding decade he had produced a number of such sequences, ranging from four Venice paintings that followed the times of day (shown in 1845), to the whaling subjects (two in 1845 and two in 1846) that considered aspects of man's struggle against nature. Through reference to each other and to the outside world,

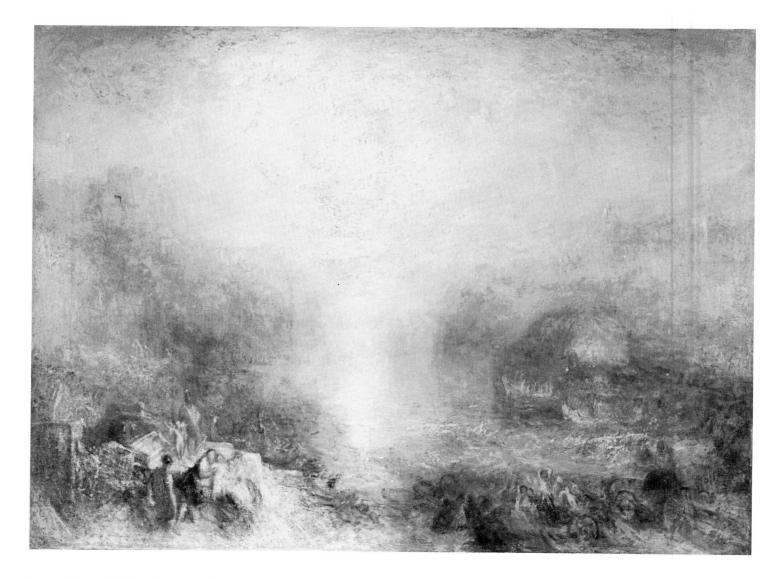

Figure 150. J.M.W. Turner, *Mercury Sent to Admonish Aeneas*, 1850. Oil on canvas, $35\frac{1}{2} \times 47\frac{1}{2}$ inches (90.2 × 121 cm), Turner Collection, Tate Gallery (BJ 429).

the paintings order events according to patterns the artist deemed significant, giving him consummate control over the record(ing) of history. Turner's late style, with its emphasis on translating "immediate sensations" (emotional as well as optical) through color and brushwork, further personalized his re-presentation of the world around him.[27]

In that regard, the *Aeneid* paintings are visions of visions —those of Claude, of eighteenth-century connoisseurs, and of the artist's own earlier revisions of classical landscape and ancient epic. The same entirely familiar composition underlies each of the surviving works; it has been simplified, but is still as evocative of transcendence as ever. The principal figures appear in the foreground of each work as if on a stage. For once they are relatively clear and easy to identify, standing apart, as they do, from the landscapes beyond. As Aeneas' pursuit of destiny and the failure of Dido's dreams are enacted, the classical world begins to dissipate before our eyes, its architectural embodiment dissolving in layers of misty light. In effect, Turner let his re-creation of antiquity revert to its natural—and painterly —elements.

The separate themes and appended verses from the "Fallacies of Hope" explain the reasons for the transforma-tion step by step. The artist arranged the events into a cycle that runs from night to day, then back to night.[28] As with Hannibal's story, Turner underlined the inevitability of disappointment by invoking the revolution of time—in this case a single day in which so much is lost. The first painting prepares the way for Dido's downfall, tracing her seduction to the hero's recounting of his quest. The artist seated the couple under a canopy on the deck of an ornate ship, a scene that paralleled Turner's image of yet another pair of star-crossed lovers, Anthony and Cleopatra, in the "Studies for Pictures. Isleworth" (TB XC) sketch (plate

16).[29] The accompanying poetry explained that 'Fallacious Hope beneath the moon's pale crescent shown, / Dido listened to Troy being lost and won." Since Virgil too sets the incident at night, the blue sky and rainbow, far above in one corner, would have constituted false promise for both the Carthaginian queen and the viewer.

With the second work, *Mercury Sent to Admonish Aeneas*, Turner contested ancient authority still more pointedly.[30] Virgil's messenger god roused the hero with a stirring lecture about his obligations to the future, but the artist let them both linger. As Turner's verse explained, "Beneath the morning mist, / Mercury waited to tell him of his neglected fleet." The focus thus remains on the present moment and the imminent loss, rather than on exploits to come. Perhaps the cloaked (and helmeted?) male figure in the lower left foreground is Mercury, looking on, while Aeneas, with Ascanius in his guise as Cupid, stands immediately above on a platform. To the right, figures merge with the water's edge as the Carthaginian dream begins to give way.

Visit to the Tomb, with its shrill charge that "The Sun went down in wrath at such deceit," is a parallel moment in which Dido too must face her responsibilities. The *Aeneid* contains no such episode; in the poem the enraged Dido thinks only of her abandonment, not of the dead Sychaeus to whom she had dedicated her vows. But Turner remem-bered, and issued a terse comment about deceit that applies to all the parties involved.[31] Not only has Aeneas cheated Dido, but she has cheated herself and her people. She appears in the lower left foreground beside the tomb (?), which is decorated with a madonna-like figure and guarded by a strange gargoyle. Aeneas is behind her, while to the front stands Ascanius/Cupid with blue doves. The figures seem much less firm, and the foreground area less well defined than in the preceding work. Across the water, on

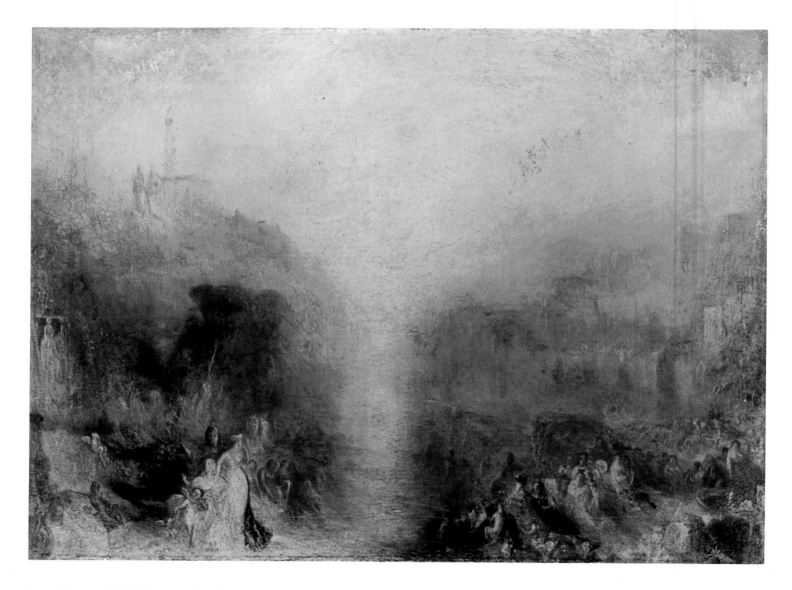

Figure 151. J.M.W. Turner, *The Visit to the Tomb*, 1850. Oil on canvas, 36 × 48 inches (91.5 × 122 cm), Turner Collection, Tate Gallery (BJ 431).

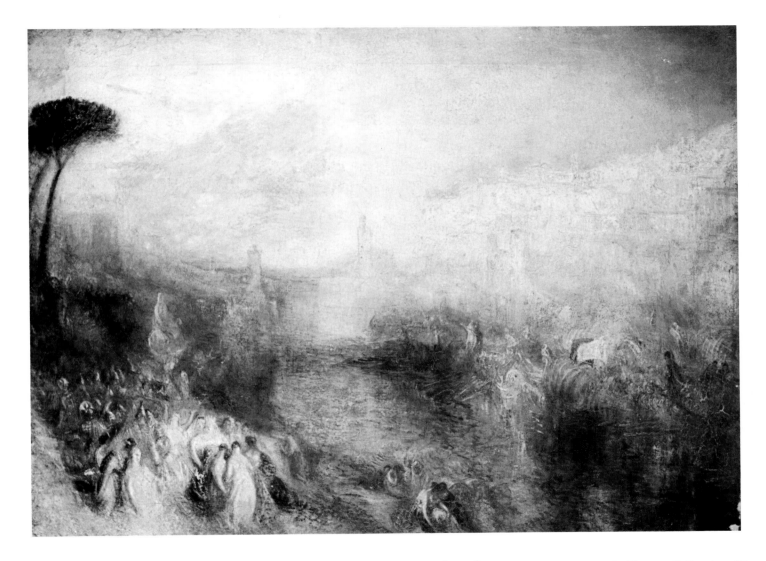

Figure 152. J.M.W. Turner, *Departure of the Fleet*, 1850. Oil on canvas, $35\frac{3}{8} \times 47\frac{3}{8}$ inches (89.5 × 120.5 cm), Turner Collection, Tate Gallery (BJ 432).

the far right, are the ruins of an arched bridge that harken back to the 1814 painting.

Departure of the Fleet expresses the hurt and despair of its story through hot coloration, boneless, almost spectre-like figures, and agitated brushwork on the right-hand side of the composition. It provides the perfect visual equivalent for Dido's angry speech as she prepared for death once her lover had gone (IV, 839–949). Turner's own verse foretells the bleak future succinctly: "The orient moon shone on the departing fleet, / Nemesis invoked, the priest held up the poisoned cup." With the return of night (at least verbally) comes a figurative darkness: a curse (Nemesis invoked) that will ensure enmity between Rome and Carthage for generations to follow, and an allusion to Dido's end ("the poisoned cup"). The artist changed the means of her death, for in the poem she throws herself on a blazing funeral pyre, having already stabbed herself with a knife. In Turner's mind her demise would have to be far quieter and more bitter. In some measure, he, too, was letting go of the hopes and dreams upon which his vision of antiquity had been built, though there is a touching show of resilience in his introduction of the two tall trees at the left of the painting. However vestigially, they reinsert life, and a reminder of the redeeming power of nature, into the scene and the empire that was Carthage.

The sad finality of the narrative should not obscure the achievement of the paintings themselves. By conveying so much so simply and eloquently, they handsomely conclude Turner's lifelong quest to validate landscape's affective and expressive powers. One last time the artist demonstrated how different sources of meaning—an epic poem, a "classical" design which renders a sense of order or harmony, and the expressive capacities of color or brushwork—could become inseparable aspects of a new narrative embodied in his landscapes. Indeed, in the fraught handling of these late works is a final lesson about style itself as meaning. While Dido still entertains her dreams of a future with Aeneas, her world as portrayed in *Mercury Sent to Admonish Aeneas* is bathed in a glowing mist that obscures detail, such as it is. As destiny and reality impinge, and Aeneas' departure ensues, forms clarify once again, relatively speaking. Of the three existing canvases, *Departure of the Fleet*, last in the narrative sequence exhibits the firmest brushwork and spatial ordering. Though the differences in handling among these works of Turner's infirm old age might be rationalized as unevenness, that unevenness corresponds to the nuances of the story as he construed it. Such "narrative" conveys a Romantic's vision of antiquity; it addresses the making of art as a conscious process with its own long history; and it recounts how the self becomes part of the story one tells.

Antiquity, for Turner, represented not so much a standard of perfection, a paragon of virtue and principle as an era when noble aspirations were complicated by the play of emotions and expectations were thwarted by the fallibility of human behavior. This humanization of antiquity makes Turner's classical world, however grandiose its setting or depiction, more "real," or more accessible than the neo-classical version. It is not taken from the frozen marble images of classical sculpture—remote and immutable. Rather, in paintings as disparate as *Snowstorm: Hannibal and His Army Crossing the Alps* and *Ancient Rome; Agrippina Landing with the Ashes of Germanicus*, the artist connected the dreams of antiquity to the hopes of the present, using nature as an ongoing drama that structures as well as witnesses—and then puts into perspective human endeavor.

For Turner the allure of antiquity also equated with the tradition of idealized landscape with which he so identified. The last four works reiterate the artist's understanding that the creative act of painting should incorporate its own

history. In effect, they recapitulate the genre's progress, taking their inspiration from seventeenth-century conceptions of perfection and order; from late eighteenth-century attempts to enlarge visual meaning through poetic association; and from his own era's inspired transcriptions of natural effects. A legacy for the future is there too, in Turner's extraordinary formal invention. Rather than memorializing past achievement, the classical paintings in his oeuvre substantiate the process of change as a vital aspect of art.

By his choice of themes, Turner reconstituted a classical world shaped to reflect his own immediate interests—rather than those of the eighteenth-century or even the seventeenth-century artistic canon. The stories he told about heroes like Regulus, about the gods and nymphs of the *Metamorphoses*, or about ancient civilizations, exalted nature's critical role in the narrative of antiquity. But at the same time, his treatment of those episodes stressed the necessity for artist and viewer alike to discover that role through the act of interpretation. If we are drawn into Turner's landscapes, it is because the stories they tell require an act of deciphering. The straightforward account promised by the paintings' ostensible subjects (and the titles Turner himself crafted) is inevitably complicated and enriched by the development of the imagery. Once lured into the interpretative play between narration and visual imagery, we are committed to experience the painting and *realize* its theme, not just look at it. In the process, we learn something about the very nature of meaning in visual imagery: how symbols and references become nuanced over time; that meaning shifts with the beholder. The Ovidian works, for instance, insist that one become aware that the story being told is, by its nature, only a superficial account of yet other, larger stories—about myth as a system of understanding, about art as a means to give that understanding coherence, about

basic human emotions that foil one's ability to reason.

Finally, the patterns of involvement that Turner's classical subjects and classical landscapes effect in the viewer extend to the relationship of the artist to his work as well. In elaborating his narratives, Turner, too, entered into the stories, giving them twists that accorded with his personal understanding of the world and offered him a way to confront his own aspirations and disappointments. Part of this autobiographical thrust involves the introduction of art and art-making as a concurrent theme. Calling attention to conventions of representation, to the expressive potential of style, and to the power of imaging—witness the *Vision of Medea*—the artist inscribed himself and the genre of landscape into history in its larger sense.

Throughout his career the artist had combatted a persistent myth about his art, summed up in a critic's derisive comment that *Mercury Sent to Admonish Aeneas* was but "another picture from his 'Fallacies of Hope,'—the said fallacy being any hope of understanding what the picture means."[32] Turner's contemporaries all too often resisted his invitation to explore the thematic and narrative richness of his art. But the nature of his achievement did not, for all the resistance it met, go unnoticed. A kind note from his friend George Jones in 1850 underscores what Turner's critics missed: "I saw your picture [in the Royal Academy] this morning for the first time, and more glorious effusions of mind have never appeared—*your* intellect defies time to injure it."[33]

Chapter VII: Notes

1. Claude's painting entered the collection of Louis XIV in the seventeenth century and is now in the Louvre. According

to Roethlisberger, Claude's was the only painted representation of the scene, the choice of subject being that of his patron; *Claude Lorrain: The Paintings* 1, p. 228.

2. The full quotation, taken from Pope's translation of the *Iliad*, reads:

> The trembling priest along the shore return'd,
> And in the anguish of a father mourn'd;
> Disconsolate, not daring to complain,
> Silent he wander'd by the sounding main;
> Till safe at a distance to his God he prays;
> The God who darts around the world his rays.

The lines, which were quoted without change from Book I, 47–52, also reinforce the emotional pitch of the scene.

3. Turner's handling of the equation between light and Apollo in *Chryses* bears comparison with the treatment of the god in *Apollo and Python*, exhibited that same year. In the oil painting, the Sun God, depicted in his human form, has just done battle with a physical embodiment of darkness. The artist also thought to pay homage to the poet's ability to describe the god when he noted "Homer reciting his Hymn to Apollo," as a possible subject for a picture, in TB CXX, *Miscellaneous: Black and White* (2), Z, c. 1810. Among the "Wey, Guil[d]ford" (TB XCVIII) group of sketches *Chryses* is the only subject repeated. On 3a Turner first (?) did a brusque, almost messy drawing of the scene in pencil, the figure of Chryses being somewhat more dramatic than in the neater pen sketch illustrated here. The composition reappears on 5a and 6, the latter of which records only the setting.

4. There is an interesting rapport between Turner's conception of the episode and the depiction of the same subject by Rubens in *Ulysses on the Island of the Phaeacians*, in the Palazzo Pitti in Florence. Turner seemed more interested in the encounter itself, and his setting is the more sylvan.

5. Ruskin, *Works*, 13, p. 136.

6. Thornbury recounted that at a dinner party, Turner bet some of the guests that they did not know the source of *Ulysses Deriding Polyphemus*. When one replied, "from the *Odyssey* of course," the artist laughed and said no, it was from a song by Tom Dibdin: "He ate his mutton, drank his wine, / *And then he poked his eye out*"; *The Life of J.M.W. Turner*, p. 446. Gage, *Color in Turner*, p. 255, identified its source as Dibdin's *Melodrame Mad! or the Siege of Troy*, 1819.

7. For a discussion of both the importance of the episode in the poem, and Turner's understanding of it, see Philipp Fehl, "Turner's Classicism."

8. Ruskin, *Works*, 13, pp. 136–37.

9. John Gage proposed these scientific associations, citing the writings of Joseph Priestly and Erasmus Darwin on the topic of phosphorescence; *Color in Turner*, pp. 129–32.

10. The horses are barely visible in reproduction. Turner modeled them on the Elgin marbles, in particular the horses of Helios from the East Pediment.

11. The comment appeared in the *Athenaeum*, for May 13, 1829, p. 300; reprinted in Butlin and Joll, *The Paintings*, 1, p. 184.

12. This poem, and the lines for *Palestrina*, were the first citations from the "Fallacies of Hope" since the one for the watercolor *The Battle of Fort Rock, Val d'Aosta, Piedmont, 1796*, in 1815. Both begin as if there had been a common antecedent ("Or from yon rock, high-crowned Praeneste"; "Or Medea, who in the full tide of witchery"), and hence imply they both derive from the same text. That suggestion is maintained to a degree in the verse for *Caligula's Palace and Bridge*, wherein the emperor is addressed by name.

13. Charles Stuckey, "Temporal Imagery in Early Romantic Landscape," p. 169, first proposed Seneca's play as Turner's inspiration. Indeed the painting's imagery does conform more closely to Seneca's account than it does even to Ovid's, but Turner's library did not include a text of the play, an omission that would make this potential source exceptional in the artist's classical oeuvre. John Gage included a list of Turner's books in *Color in Turner*, pp. 215–16. Powell made an interesting but problematic case for the influence of Mayr's opera in *Turner in the South*, pp. 151–56. She assumed (following the opera's libretto) that Medea's incantation is to poison a robe for Jason's new bride. I prefer to accept the story line Turner provided in his poem, since it better explains the presence of the other figures in the scene and identifies the cause of Medea's anger as something more complex than jealousy. At the same time it seems entirely likely that the artist could have been impressed by the opera's staging, and used it as yet another source for the overall presentation of the scene.

14. Stuckey, "Temporal Imagery in Early Romantic Landscape," p. 170. The reference to Megaera comes from Seneca's play.

15. In traditional iconography Hecate either has the heads of a dog, boar, and horse, or, if in her human form, has three different heads and bodies, joined at one neck; Lemprière, *Bibliotheca Classica*, pp. 259–60. Turner's figures here are similar to those in a little watercolor drawing of the fates related to the *Golden Bough*; Gage, "Turner and Stourhead," p. 74.

16. See the entries for "The Bubble," and "To Bubble" in *A Dictionary of Buckish Slang, University Wit, and Pickpocket Eloquence* (London, 1811; reprinted Northfield, Illinois: Digest Books, Inc., 1971), n.pag. For example, the *Quarterly Review* 35 (1827), p. 222, published a farcical poem "The Greek Bubble," which was a diatribe against a fraudulent loan scheme offered to Greece by a group of bankers.

17. Asking "But Why 'Medea' in Rome?" Jerrold Ziff, in *Turner Studies* 2, No. 1 (1982), p. 19, suggested that the artist playfully presented his *Vision of Medea*, at short notice and with a temporary rope frame, to draw a parallel between his own "performance" for the art audience in Rome and a story in Pliny about a *Medea* by Timomachus purchased and put on display by Julius Caesar. That Turner could enjoy conjuring up the past in the way Ziff described, while still working his own feat of magic in the painting itself, is entirely characteristic. Compare the circumstances of *Appulia in Search of Appulus*.

18. Recall both Rippingille's 1836 characterization of Turner at work like "a magician, performing incantations in public," and the 1838 review that called him a sorcerer engaged in conjuration, pp. 133 and 192 above.

19. The works include *Coast View of Delos with Aeneas* (LV 179, 1672); *Coast of Libya with Aeneas Hunting* (LV 180, 1672); *Coast View with Aeneas and the Cumaean Sibyl* (fig. 26); *Landscape with the Landing of Aeneas in Latium* (LV 185, 1675); *View of Carthage, with Dido, Aeneas, and their Suite Leaving for the Hunt* (fig. 119); *Landscape with Ascanius Shooting the Stag of Silvia* (fig. 121). Among Claude's finished drawings from the same period are scenes of King Latinus imploring the oracle of his father; Aeneas and Achates meeting Venus as a huntress; Iris and Turnus; and Venus giving arms to Aeneas; Roethlisberger, *Claude Lorrain: The Paintings*, 1, p. 421.

20. Turner referred to one of the better known treatments of the lover's story, Gaspard Dughet's *Storm: The Union of Dido and Aeneas* (National Gallery, London), in a note for an Academy lecture; Gage, *Color in Turner*, pp. 133, 213.

21. Victor Poschl, *The Art of Virgil*, trans. Gerda Seligson (Ann Arbor: University of Michigan Press, 1962), p. 61.

22. An excellent example of the smitten Dido is Giovanni Francesco Romanelli's tapestry cartoon, *Dido Showing Aeneas*

Her Plans for Carthage, c. 1635 (Norton Simon Museum of Art), in which she gazes lovingly at the hero, forgetting the plans she had been reviewing with him. Both Reynolds and Fuseli had painted dramatic scenes of Dido's death in 1781. Fuseli's is in the collection of the British Art Center, Yale University; Reynolds' is in the Royal Collection, Great Britain. Turner's positive assessment of Dido might also be gleaned from references to her in an unfortunately illegible poem in TB CXXIX, Woodcock Shooting Sketchbook, 6a—7. It begins "Twas the [bluest?] Lake / in the Grotto of Pope," and goes on to compare the "Nymph of the Grotto" to Dido.

23. For its history see Butlin and Joll, *The Paintings*, 1, p. 149.

24. Sidney Smith, "The Barbary States," *Quarterly Review* (April, 1816), p. 154.

25. John Martin *Descriptive Catalogue of the Picture of the Fall of Ninevah* (London, 1828).

26. While Turner was visiting at East Cowes Castle, he made a series of sketches in pen and white chalk on blue paper that include a study for *Dido Directing the Equipment of the Fleet*, TB CCXXVII(a), East Cowes Castle, 15; Butlin and Joll, *The Paintings*, 1, p. 149. Other related drawings include TB CCLX, Pencil and Ink on Blue Paper etc., 7 and 8, and TB CCLXIII(a), Miscellaneous Black and White, 7.

27. An astute review of the 1845 *Whalers* published in *The Times*, commended the distinction in the artist's work between observation and expression, noting that "To do justice to Turner, it should always be remembered that he is the painter, not of reflections, but of immediate sensations"; reprinted in Butlin and Joll, *The Paintings*, 1, p. 261.

28. The following discussion of the thematic development of the 1850 paintings is indebted to Jerrold Ziff's explanation in "Turner's Last Four Paintings," *Artforum* 1 (1964), pp. 24—27, reprinted in *Turner Studies* 4, no. 1 (1984), pp. 47—51.

29. The imagery of the lost *Aeneas Relating His Story to Dido* was described by C.F. Bell, in *A List of the Works Contributed to Public Exhibitions by J.M.W. Turner, R.A.*, p. 159, Ziff, "Turner's Last Four Paintings," p. 26, first noted the similarity between the two sets of lovers.

30. Butlin and Joll, *The Paintings*, 1, pp. 274—74 reversed the order of the first two works, but their arrangement does not follow the development of the story in Virgil. Dido bids Aeneas to recount his adventures at the end of Book I. Mercury appears in Book IV to deliver his exhortation.

31. Ziff identified the episode's origin in Ovid's *Heroides*, where Dido in fact reflects on her vows, so hopelessly broken; "Turner's Last Four Paintings," p. 26.

32. Quoted in Butlin and Joll, *The Paintings*, 1, p. 274.

33. Ibid.

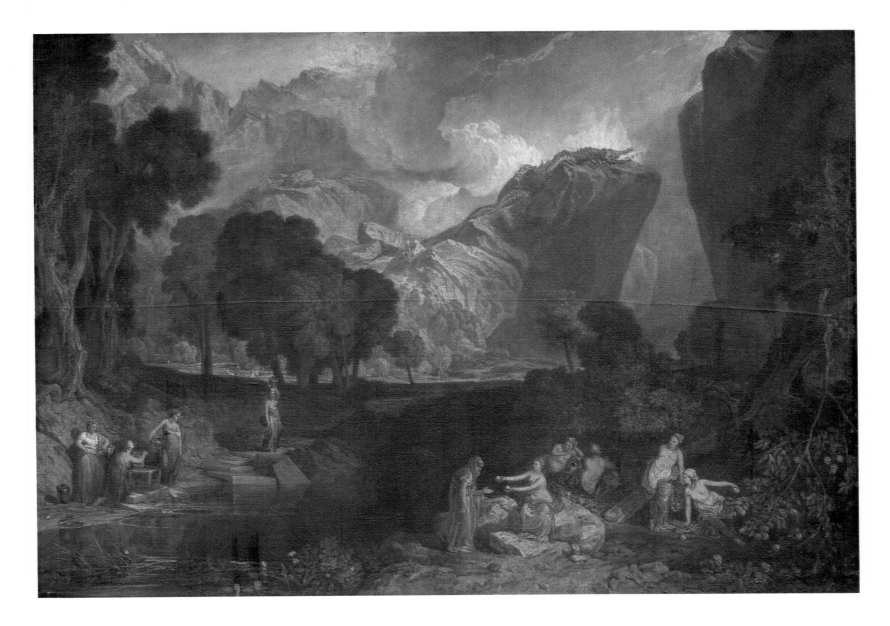

Color Plate 1. J.M.W. Turner, *The Goddess of Discord Choosing the Apple of Contention in the Garden of the Hesperides*, 1806. Oil on canvas, $61\frac{1}{8} \times 86$ inches (155 × 218.5 cm) Turner Collection, Tate Gallery (BJ 57). The seam across the painting is a result of the canvas being folded.

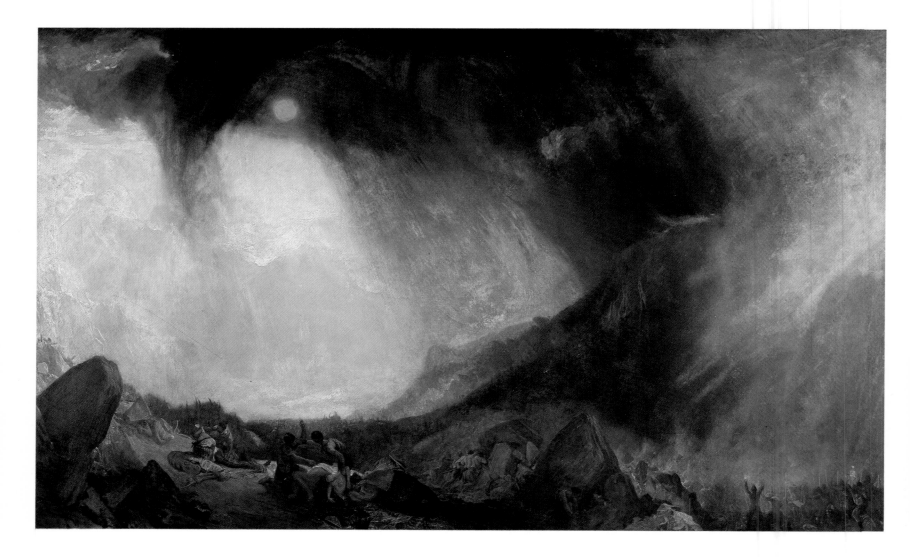

Color Plate 2. J.M.W. Turner, *Snowstorm: Hannibal and His Army Crossing the Alps*, 1812. Oil on canvas, $57\frac{1}{2} \times 93\frac{1}{2}$ inches (146×237.5 cm), Turner Collection, Tate Gallery (BJ 126).

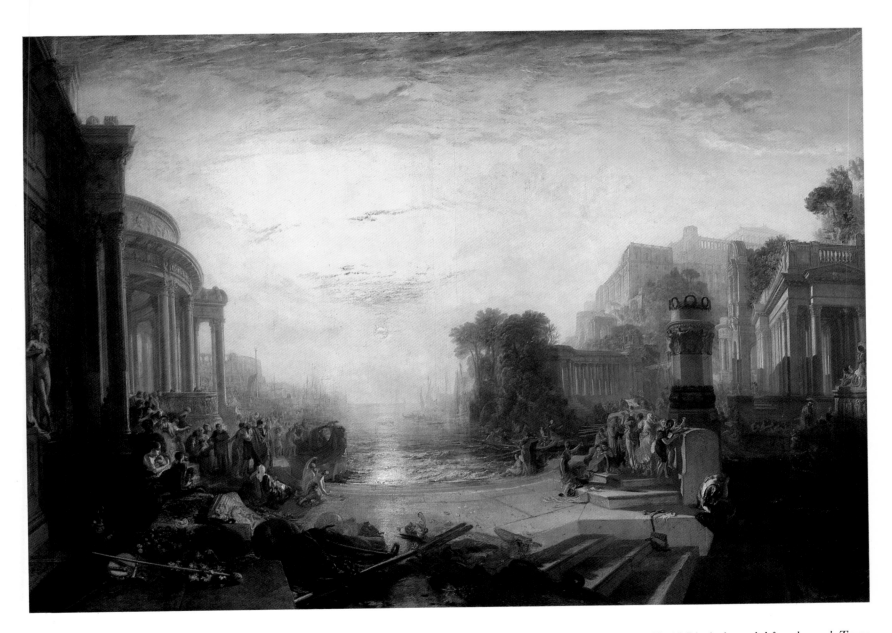

Color Plate 3. J.M.W. Turner, *The Decline of the Carthaginian Empire — Rome being determined on the Overthrow of Her Hated Rival, demanded from her such Terms as might either force her into War, or ruin her by Compliance: the Enervated Carthaginians, in their Anxiety for Peace, consented to give up even their Arms and their Children,* 1817. Oil on canvas, 67 × 94 inches (170 × 239 cm), Turner Collection, Tate Gallery (BJ 135).

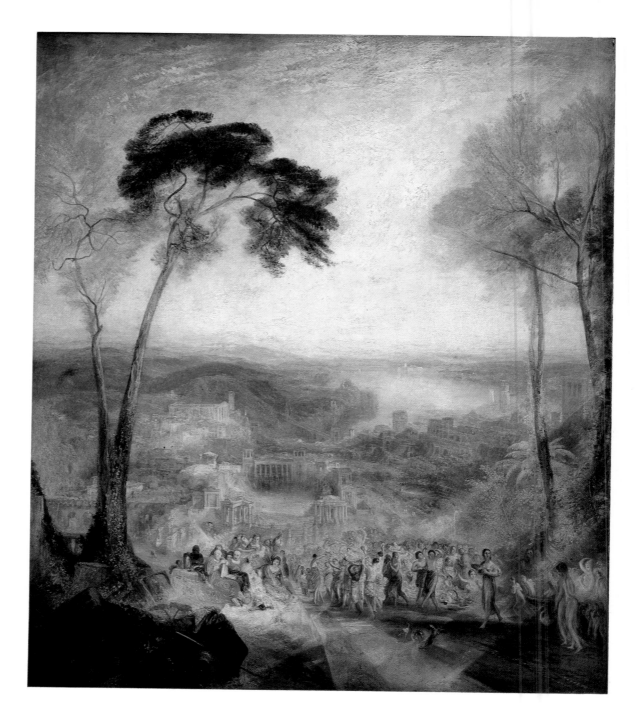

Color Plate 4. J.M.W. Turner, *Phryne Going to the Public Baths as Venus — Demosthenes Taunted by Aeschines*, 1838. Oil on canvas, 76 × 65 inches (193 × 165 cm), Turner Collection, Tate Gallery (BJ 373).

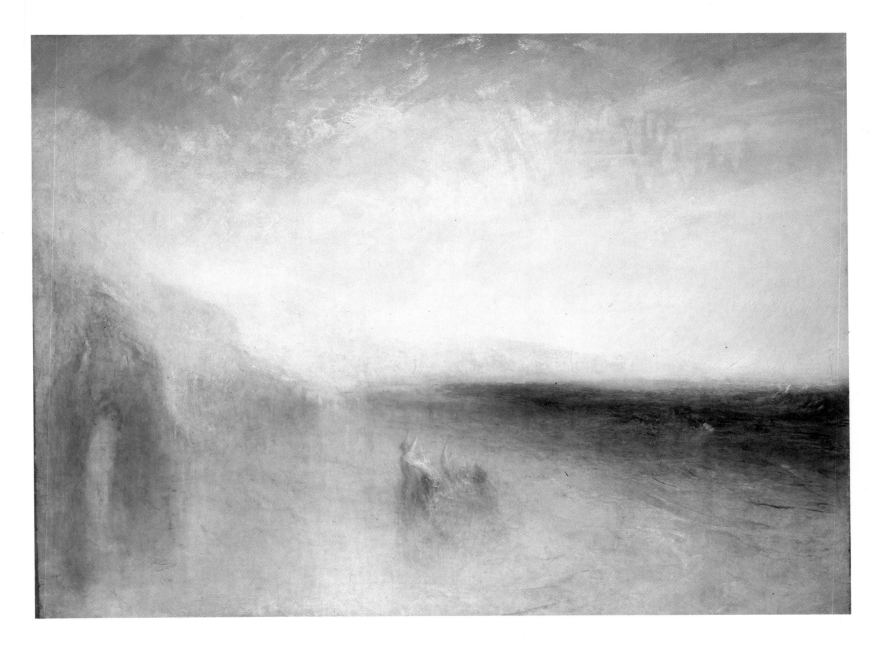

Color Plate 5. J.M.W. Turner, *Europa and the Bull*, c. 1840–1850. Oil on canvas, $35\frac{7}{8} \times 47\frac{7}{8}$ inches (90.8 × 121.6 cm), The Taft Museum, Cincinnati, Ohio, Gift of Mr. and Mrs. Charles Phelps Taft (BJ 514).

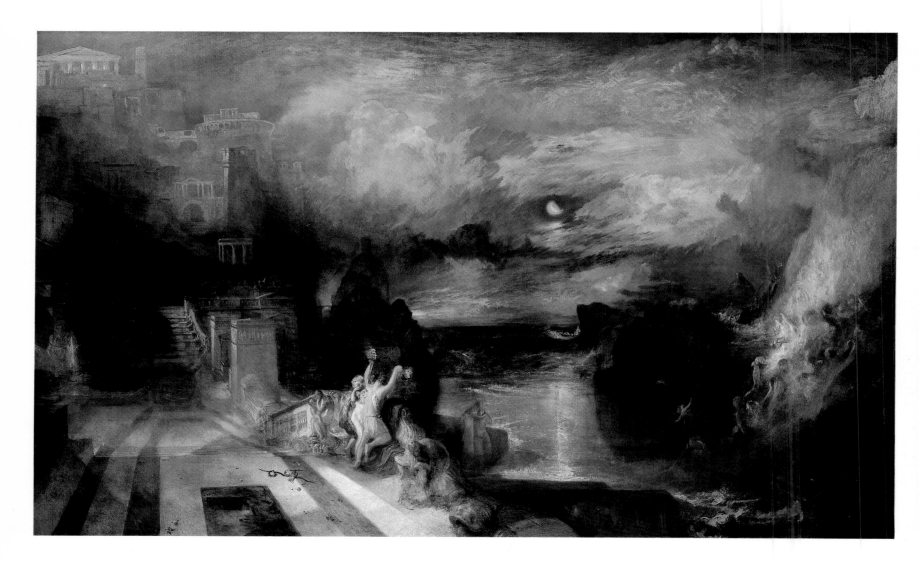

Color Plate 6. J.M.W. Turner, *The Parting of Hero and Leander — from the Greek of Musaeus*, 1837. Oil on canvas, $57\frac{1}{2} \times 93$ inches (146×236 cm), Reproduced by Courtesy of the Trustees, The National Gallery, London (BJ 370).

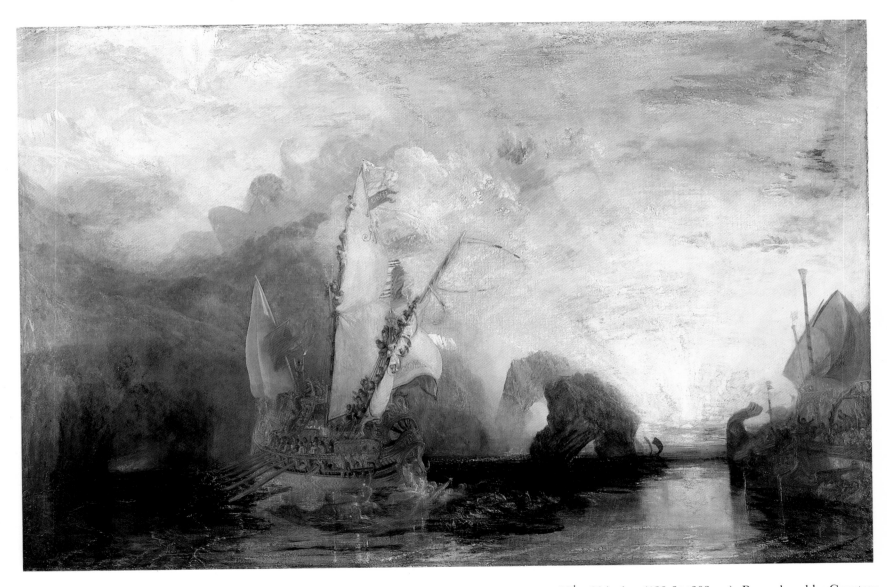

Color Plate 7. J.M.W. Turner, *Ulysses Deriding Polyphemus — Homer's Odyssey*, 1829. Oil on canvas, $52\frac{1}{4} \times 80$ inches (132.5×203 cm), Reproduced by Courtesy of the Trustees, The National Gallery, London (BJ 330).

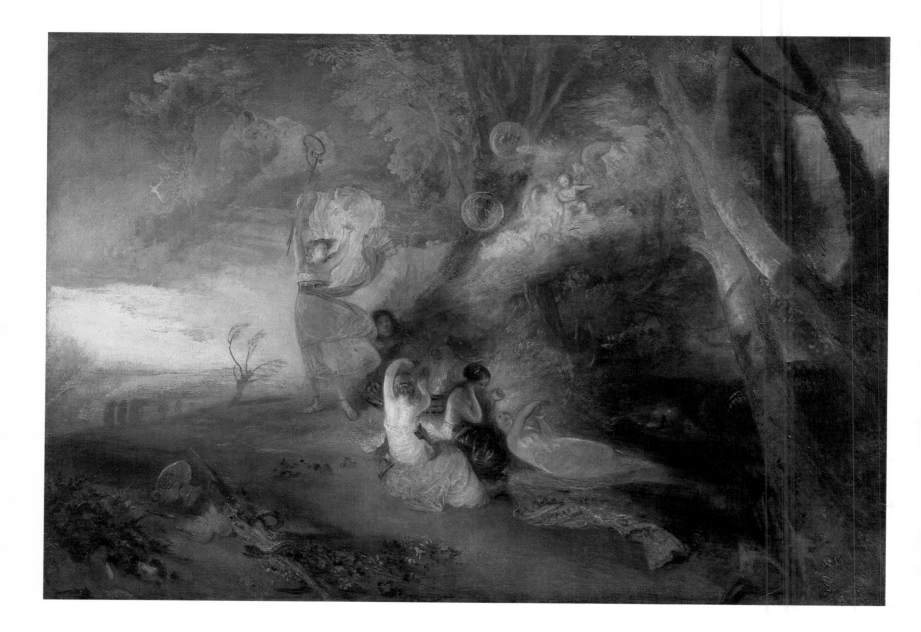

Color Plate 8. J.M.W. Turner, *Vision of Medea*, 1828. Oil on canvas, $68\frac{3}{8} \times 98$ inches (173.5×249 cm), Turner Collection, Tate Gallery (BJ 293).

Plate 1. J.M.W. Turner, TB XC, "Studies for Pictures. Isleworth," 1, 1804–1806. Pen and ink, $5\frac{3}{4} \times 10$ inches (14.6×25.4 cm), Turner Collection, Tate Gallery.

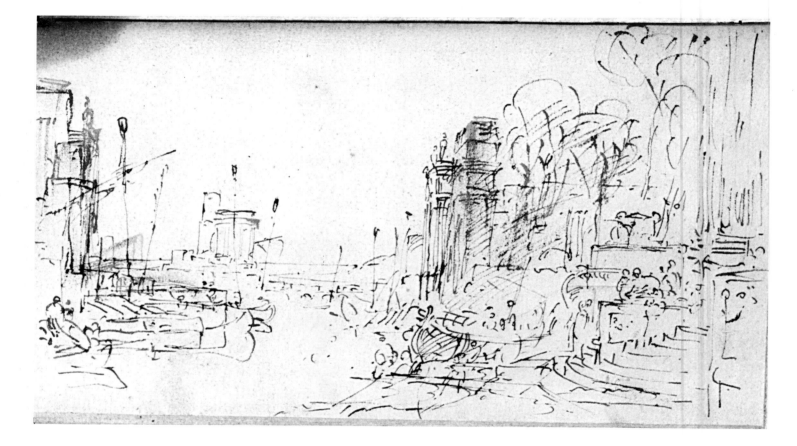

Plate 2. J.M.W. Turner, TB XC, "Studies for Pictures. Isleworth," 11a, 1804–1806. Pen and ink, $5\frac{3}{4} \times 10$ inches (14.6×25.4 cm), Turner Collection, Tate Gallery.

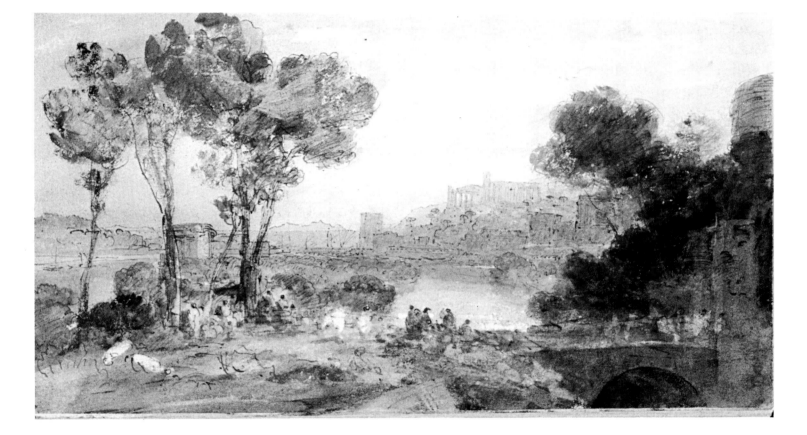

Plate 3. J.M.W. Turner, TB XC, "Studies for Pictures. Isleworth," 21, 1804−1806. Watercolor, $5\frac{3}{4} \times 10$ (14.6 × 25.4 cm), Turner Collection, Tate Gallery.

Plate 4. J.M.W. Turner, TB XC, "Studies for Pictures. Isleworth," 30a, 1804—1806. Pen and ink, $5\frac{3}{4} \times 10$ inches (14.6 × 25.4 cm), Turner Collection, Tate Gallery.

Plate 5. J.M.W. Turner, TB XC, "Studies for Pictures. Isleworth," 31, 1804—1806. Pen and ink, $5\frac{3}{4} \times 10$ inches (14.6 × 25.4 cm), Turner Collection, Tate Gallery.

Plate 6. J.M.W. Turner, TB XC, "Studies for Pictures. Isleworth," 34, 1804–1806. Pencil, pen and ink, white chalk, $5\frac{3}{4} \times 10$ inches (14.6 × 25.4 cm), Turner Collection, Tate Gallery.

Plate 7. J.M.W. Turner, TB XC, "Studies for Pictures. Isleworth," 36a, 1804—1806. Pen and ink, $5\frac{3}{4} \times 10$ inches (14.6×25.4 cm), Turner Collection, Tate Gallery.

Plate 8. J.M.W. Turner, TB XC, "Studies for Pictures. Isleworth," 49a, 1804—1806. Watercolor, $5\frac{3}{4} \times 10$ inches (14.6 × 25.4 cm), Turner Collection, Tate Gallery.

Plate 9. J.M.W. Turner, TB XC, "Studies for Pictures. Isleworth," 52a, 1804–1806. Pen and ink, $5\frac{3}{4} \times 10$ inches (14.6 × 25.4 cm), Turner Collection, Tate Gallery.

Plate 10. J.M.W. Turner, TB XC, "Studies for Pictures. Isleworth," 53, 1804–1806. Pen and ink, $5\frac{3}{4} \times 10$ inches (14.6 × 25.4 cm), Turner Collection, Tate Gallery.

Plate 11. J.M.W. Turner, TB XC, "Studies for Pictures. Isleworth," 54, 1804–1806. Pen and ink, $5\frac{3}{4} \times 10$ inches (14.6×25.4 cm), Turner Collection, Tate Gallery.

Plate 12. J.M.W. Turner, TB XC, "Studies for Pictures. Isleworth," 54a, 1804−1806. Pen and ink, $5\frac{3}{4} \times 10$ inches (14.6×25.4 cm), Turner Collection, Tate Gallery.

Plate 13. J.M.W. Turner, TB XC, "Studies for Pictures. Isleworth," 55a, 1804–1806. Pen and ink, $5\frac{3}{4} \times 10$ inches (14.6 × 25.4 cm), Turner Collection, Tate Gallery.

Plate 14. J.M.W. Turner, TB XC, "Studies for Pictures. Isleworth," 58a, 1804–1806. Pen and ink, $5\frac{3}{4} \times 10$ inches (14.6 × 25.4 cm), Turner Collection, Tate Gallery.

Plate 15. J.M.W. Turner, TB XC, "Studies for Pictures. Isleworth," 59, 1804–1806. Pen and ink, $5\frac{3}{4} \times 10$ inches (14.6 × 25.4 cm), Turner Collection, Tate Gallery.

Plate 16. TB XC, "Studies for Pictures. Isleworth," 84a, 1804−1806. Pen and ink, $5\frac{3}{4} \times 10$ inches (14.6×25.4 cm), Turner Collection, Tate Gallery.

Selected Bibliography

Adams, Eric. *Francis Danby*. New Haven: Yale University Press (1973).

Alison, Archibald. *Essays on the Nature of and Principles of Taste*. Edinburgh (1790).

Anderson, Robert. *A Complete Edition of the Poets of Great Britain*. 14 vols. London (1792—1795; 1807).

Anon. "Retrospect of the Fine Arts," *La Belle Assemblée* 2 (1810), pp. 340—41.

_____ "Review of Eustace's Tour Through Italy," *Quarterly Review* 10 (October 1813), pp. 222—50.

_____ "Review of *Du Congrès de Vienne, par M. de Pradt*," *Quarterly Review* 14 (January 1816), pp. 481—505.

_____ "Works on England," *Quarterly Review* 15 (July 1816), pp. 537—74.

_____ "State of Female Society in Greece," *Quarterly Review* 22 (1819—1820), pp. 163—201.

_____ "On the Poetical Use of the Heathen Mythology," *The London Magazine* 5 (1822), pp. 113—20.

Aubrun, Marie-Madeleine. *Aspects du paysage néo-classique en France de 1790 à 1855*, ex. cat. Paris: Galérie du Fleuve (1974).

_____ "Nicolas-Didier Boguet, 'Un Emule du Lorrain,'" *Gazette des Beaux-Arts* 83 (1974), pp. 319—36.

Banier, l'Abbé. *Metamorphoses d'Ovide*. Paris (1742).

Bell, C.F. *A List of the Works Contributed to Public Exhibitions by J.M.W. Turner, RA*. London: George Bell and Sons (1901).

Bell, John. *Bell's New Pantheon*. 2 vols. London (1790).

Bingley, Reverend William. *Biography of Celebrated Roman Characters*. London (1824).

Blunt, Anthony. *Nicholas Poussin*. 2 vols. New York: Pantheon Books (1967).

Blunt, Reverend John James. *Vestiges of Ancient Manners and Customs Discoverable in Modern Italy and Sicily*. London (1823).

Boisclair, Marie-Nicole. *Gaspard Dughet*. Paris: Arthena (1986).

British Institution Minute Book. The National Art Library, London, Victoria & Albert Museum.

Bromley, Robert Anthony. *A Philosophical and Critical History of the Fine Arts*. 2 vols. London (1793—1795), (reprinted New York: Garland Publishing, 1971).

Bryant, Jacob. *A New System, or the Analysis of Ancient Mythology*. 3 vols. London (1774).

_____ *A Mythological, Etymological, and Historical Dictionary*. London (1793).

Bush, Douglas. *Mythology and the Romantic Tradition*. New York: W.W. Norton Company (1963).

Butlin, Martin and Evelyn Joll. *The Paintings of J.M.W. Turner*. 2 vols. Revised ed. New Haven and London: Yale University Press (1984).

Byron, George Gordon, Lord. *Childe Harold's Pilgrimage*. London (1812—1818).

Chubb, William. "Turner's *Cicero at His Villa*," *Burlington Magazine* 123 (1981), pp. 417—23.

_____ "Minerva Medica and the Tall Tree," *Turner Studies* 1, no. 2 (1981), pp. 26—35.

Clarke, Michael and Nicholas Penny (eds). *The Arrogant Connoisseur: Richard Payne Knight*. Manchester: Manchester University Press (1982).

Constable, John. *John Constable's Correspondence*. Edited by R.B. Beckett 6 vols. Suffolk: Suffolk Records Society (1962—1968).

Constable, W.G. *Richard Wilson*. Cambridge, Mass: Harvard University Press (1953).

Coolsen, Thomas. "Phryne and the Orators: Decadence and Art in Ancient Greece and Modern Britain," *Turner Studies* 7, no. 1 (1987), pp. 2—10.

Costello, Jane. "Poussin's Drawings for Marino and the New Classicism: 1. Ovid's *Metamorphoses*," *Journal of the Warburg and Courtauld Institutes* 18 (1955), pp. 296—317.

Eagles, The Reverend John. "The Sketcher, No. 1," *Blackwood's Edinburgh Magazine* 33 (1833), pp. 682—88.

_____ "The Sketcher No. IV," *Blackwood's Edinburgh Magazine* 34 (1833), pp. 529—40.

von Erffa, Helmut and Allen Staley. *The Paintings of Benjamin West*. New Haven and London: Yale University Press (1986).

Farington, Joseph. *The Diary of Joseph Farington*. Edited by Kenneth Garlick and Angus Macintyre (vols 1—6); Katherine Cave (vols 7—16). 16 vols. New Haven and London: Yale University Press (1979—1984).

Feaver, William. *The Art of John Martin*. Oxford: Clarendon Press (1975).

Fehl, Philipp. "Turner's Classicism and the Problem of Periodization in the History of Art," *Critical Inquiry* 3 (1976), pp. 93—129.

Finberg, A.J. *A Complete Inventory of the Drawings of the Turner*

Bequest. 2 vols. London: Her Majesty's Stationery Office (1909).

———— *The History of Turner's Liber Studiorum*. London: Ernest Benn Ltd. (1924).

———— *Life of J.M.W. Turner, R.A.* 2nd ed. (revised by Hilda Finberg), Oxford: Clarendon Press (1961).

Finley, Gerald. "Turner, the Apocalypse and History: 'The Angel' and 'Undine,'" *Burlington Magazine* 121 (1979), pp. 685–96.

French, Anne. *Gaspard Dughet*, ex. cat. Kenwood House, Iveagh Bequest. London: Greater London Council (1980).

Fuseli, Henry. *Lectures on Painting*. London (1801).

———— *Lectures on Painting Part II*. London (1820).

Gage, John. "Turner and the Picturesque," *Burlington Magazine* 107 (1965), pp. 16–25; 75–81.

———— *Color in Turner*. New York: Frederick Praeger (1969).

———— *Turner: Rain, Steam and Speed*. London: Allen Lane (1972).

———— "Turner and Stourhead: The Making of a Classicist?" *Art Quarterly* 37 (1974), pp. 59–87.

———— "Turner and the Greek Spirit," *Turner Studies* 1, no. 2 (1981), pp. 14–25.

———— "Picture Notes," *Turner Studies*, 3, no. 1 (1983), pp. 58–60.

———— *J.M.W. Turner, 'A Wonderful Range of Mind.'* New Haven and London: Yale University Press (1987).

Gerdts, William H. and Theodore E. Stebbins. *"A Man of Genius," The Art of Washington Allston*, ex. cat. Boston: Boston Museum of Fine Arts (1979).

Gessner, Solomon. "Letter to M. Fuselin on Landscape Painting," appended to *New Idylles*. Translated by W. Hooper, London (1776).

Gilchrist, Alexander. *The Life of William Etty*. 2 vols. London (1855).

Goldsmith, Oliver. *The Roman History*. London (1769) Reprinted as *History of Rome*, 2 vols. London (1812).

Gowing, Lawrence. *Imagination and Reality*. Garden City, New York: Doubleday (1966).

———— "Turner and Literature," *Times Literary Supplement* (July 10 1981), pp. 783–84.

Graves, Algernon. *The Royal Academy of Arts*. 8 vols. London: Henry Graves and Co. (1905–1906).

———— *The British Institution 1806–1867*. London (1908),

(reprinted Bath: Kingsmead Reprints, 1969).

Greenacre, Francis. *The Bristol School of Artists*, ex. cat. Bristol: City Art Gallery and Museum (1973).

Grunchec, Phillipe. *Le Grand Prix de Peinture*. Paris: Ecole nationale supérieure des Beaux-Arts (1983).

Hamilton, Jean. *The Sketching Society 1799–1851*, ex. cat. London: Victoria & Albert Museum (1971).

Hazlitt, William. *Complete Works*. Edited by P.P. Howe. 21 vols. London and Toronto: J. Dent and Sons Ltd. (1930–1934).

Herrmann, Luke. *British Landscape Painting of the Eighteenth Century*. New York: Oxford University Press (1974).

———— *Turner*. Boston: New York Graphic Society (1975).

Hoare, Prince. *Dido, Queen of Carthage*. London (1792).

Hoare, Richard Colt. *A Classical Tour through Italy and Sicily*. 2 vols. London (1819).

Holcomb, Adele. "A Neglected Classical Phase of Turner's Art: His Vignettes to Rogers' Italy," *Journal of the Warburg and Courtauld Institutes* 32 (1969), pp. 405–10.

———— "The Bridge in the Middle Distance: Symbolic Elements in Romantic Landscape," *Art Quarterly* 37 (1974), pp. 31–58.

Howard, Deborah. "Some Eighteenth-Century English Followers of Claude," *Burlington Magazine* 111 (1969), pp. 726–33.

J.M.W. Turner, ex. cat. Paris: Grand Palais (1983–1984).

Jones, Thomas. "Memoirs," *Walpole Society* 32 (1946–1948), pp. 1–143.

Joppien, R. *Phillipe Jacques de Loutherbourg, R.A.*, ex. cat. London: Kenwood House, Iveagh Bequest (1973).

Keightly, Thomas. *The Mythology of Ancient Greece and Italy*, 2nd ed. London (1838).

Kitson, Michael. "Turner and Claude," *Turner Studies* 2, no. 2 (1983), pp. 2–15.

Knight, Richard Payne. "A Discourse on the Worship of Priapus." (1786). (Reprinted in *Sexual Symbolism*. New York: Bell Publishing Co., 1957.)

———— *An Inquiry into the Symbolical Language of Ancient Art and Mythology*. London (1818).

Kroeber, Karl. "Experience as History: Shelley's Venice, Turner's Carthage," *English Literary History* 41 (1974), pp. 321–39.

Landseer, John. "British Institution," *Review of Publications in Art* 1 (1808), pp. 78–132.

———— "Mr. Turner's Gallery," *Review of Publications in Art* 1

(1808), pp. 151−68.

Law, Helen. *Bibliography of Greek Myth in English Poetry*. Revised ed. Folcroft, Pennsylvania: The Folcroft Press (1955).

Lemprière, Jean. *Bibliotheca Classica*. 2nd ed. London (1792).

Leslie, C.R. *Memoirs of the Life of John Constable*. London: Phaidon (1951).

Lindsay, Jack. *J.M.W. Turner*. New York: Harper and Row (1966).

_____ *The Sunset Ship*. London: Scorpion Press (1968).

Livermore, Ann. "J.M.W. Turner's Unknown Verse-book," *Connoisseur Year Book* (1957), pp. 78−86.

Long, Basil S. "John Glover," *Walker's Quarterly* no. 15 (London: Walker's Galleries, April 1924), pp. 3−51.

McCarthy, F.I. " 'The Bard' of Thomas Gray, Its Composition and Its Use by Painters," *National Library of Wales Journal* 14 (1965), pp. 105−13.

Manwaring, Elizabeth, *Italian Landscape in Eighteenth-Century England: A Study Chiefly of the Influence of Claude Lorrain and Salvator Rosa on English Taste, 1700−1800*. New York (1925). (reprinted New York: Russsel & Russell, 1965.)

Matteson, Lynn. "The Poetics and Politics of Alpine Passage: Turner's *Snowstorm: Hannibal and His Army Crossing the Alps*," *Art Bulletin* 62 (1980), pp. 385−98.

Miesel, Victor. "Philipp Otto Runge, Caspar David Friedrich, and Romantic Nationalism," *Yale University Art Gallery Bulletin* 33 (1972), pp. 31−57.

Monkhouse, Cosmo. *Turner*. London (1879).

_____ "Ovid, Turner and Golding," *Art Journal* 32 (1880), pp. 329−32.

Morgan, Lady Sydney. *The Life and Times of Salvator Rosa*. 2 vols. London (1824).

Nicholson, Kathleen. "J.M.W. Turner's Vision of Antiquity: Classical Narrative and Classical Landscape," Ph.D. diss., University of Pennsylvania (1977).

_____ "Turner's 'Appulia in Search of Appulus' and the Dialectics of Landscape Tradition," *Burlington Magazine* 122 (1980), pp. 679−86.

_____ "Turner, Poetry, and the Transformation of History Painting," *Arts Magazine* 56 (1982), pp. 92−97.

Omer, Mordechai. *Turner and the Poets*, ex. cat. London: Greater London Council (1975).

_____ "Turner and 'The Building of the Ark' from Raphael's Third Vault of the Loggia," *Burlington Magazine* 117 (1975), pp. 691−702.

Ovid, *Metamorphoses*, Edited by Samuel Garth et al. London (1717).

_____ *Metamorphoses*, Edited by Samuel Garth et al. Amsterdam (1732), (reprinted New York: Garland Publishing Inc., 1976).

_____ *Metamorphoses*. Edited by Samuel Garth et al. 4 vols. London (1794).

Pace, Claire. "Claude the Enchanted: Interpretations of Claude in England in the Earlier Nineteenth Century," *Burlington Magazine* 111 (1969), pp. 733−40.

Parris, Leslie. *Landscape in Britain c. 1750−1850*, ex. cat. London: Tate Gallery (1973).

La peinture dans la peinture, ex. cat. Dijon: Musée des Beaux-Arts de Dijon. 1982−1983.

Pigler, A. *Barockthemen*. 2 vols. Budapest: Akademiai Kiado (1974).

Pope, Alexander. *Pastoral Poetry and an Essay on Criticism*. Edited by E. Audra and Aubrey Williams. London: Methuen & Co. (1969).

Poschl, Victor. *The Art of Virgil*. Translated by Gerda Seligson. Ann Arbor: University of Michigan Press (1962).

Powell, Cecilia. *Turner in the South*. New Haven and London: Yale University Press (1987).

Radcliffe, Ann. *The Mysteries of Udolpho* (1794). Edited by Bonamy Dobree. London: Oxford University Press (1966).

Reynolds, Sir Joshua. *Discourses on Art*. Edited by Robert Wark. San Marino, California: Huntington Library (1959).

Richardson, Jonathan. *An Account of the Statues, Bas-reliefs, Drawings and Pictures in Italy, France & c.* London (1722).

Roethlisberger, Marcel. "The Subjects of Claude Lorrain's Paintings," *Gazette des Beaux-Arts* 55 (1960), pp. 209−24.

_____ *Claude Lorrain: The Paintings*. 2 vols. New Haven: Yale University Press (1961).

_____ *Claude Lorrain: The Drawings*. 2 vols. Berkeley: University of California Press. (1968).

_____ *Im Licht von Claude Lorrain*, ex. cat. Haus der Kunst. Munich: Hirmer Verlag (1983).

Roget, John Lewis (ed.) *Notes and Memoranda Respecting the Liber Studiorum of J.M.W. Turner, R.A. Written and Collected by the Late John Pye*. London (1879).

Ruskin, John. *The Works of John Ruskin*. 39 vols. Edited by E.T.

Cook and Alexander Wedderburn. London: George Allen (1905—1912).

Russell, H. Diane. *Claude Lorrain*, ex. cat. Washington DC: National Gallery of Art (1982)

Schleiermacher, Fr. D.E. "The Hermeneutics: Outline of the 1819 Lectures." Translated by Jan Wojcik and Roland Haas, *New Literary History* 10 (1978), pp. 1—16.

Segal, Charles Paul. *Landscape in Ovid's Metamorphoses: A Study in the Transformations of a Literary Symbol.* Hermes: zeitschriften für klassische philologie, Einselschriften, Heft 23, Weisbaden: F. Steiner Verlag (1969).

Skelton, Jonathan, "The Letters of Jonathan Skelton Written from Rome and Tivoli in 1758," edited by Brinsley Ford, *Walpole Society* 36 (1958—1959), pp. 23—82.

Solkin, David H. *Richard Wilson*, ex. cat. London: Tate Gallery (1982).

Stuckey, Charles. "Temporal Imagery in Early Romantic Landscape," Ph.D. diss. University of Pennsylvania (1972).

———— "Turner, Masaniello and the Angel," *Jahrbuch der Berliner Museen* 18 (1976), pp. 155—75.

Taylor, Basil. *Joshua Cristall*, ex. cat. Victoria & Albert Museum. London: Her Majesty's Stationery Office (1975).

Thomson, James. *The Complete Poetical Works of James Thomson.* Oxford: Oxford University Press (1908).

Thornbury, Walter. *Life of J.M.W. Turner, R.A.* 2nd ed. New York (1877).

Turner 1775—1851, ex. cat. London: Tate Gallery (1974).

Turner, J.M.W. *The Collected Correspondence of J.M.W. Turner.* Edited by John Gage. Oxford: Clarendon Press (1980).

Varley, John. *A Treatise on the Principles of Landscape.* London (1816).

Venning, Barry. "Turner's Annotated Books: Opie's 'Lectures on Painting' and Shee's 'Elements of Art' (I)," *Turner Studies* 2, no. 1 (1982), pp. 36—46.

———— "Turner's Annotated Books: Opie's 'Lectures on Painting' and Shee's 'Elements of Art' (II)," *Turner Studies* 2, no. 2 (1983), pp. 40—49.

———— "Turner's Annotated Books: Opie's 'Lectures on Painting' and Shee's 'Elements of Art' (III)," *Turner Studies* 3, no. 1 (1983), pp. 33—44.

Victoria & Albert Museum Volumes of Press Cuttings from 1686—1835.

Wallace, Marcia Briggs. "J.M.W. Turner's Circular, Octagonal, and Square Paintings, 1840—46," *Arts Magazine* 53 (1979), pp. 107—117.

Wallis, J. *Mythology, or Fabulous Histories of Heathen Deities.* London (1801).

Whitley, W.T. *Artists and Their Friends in England, 1700—1799.* 2 vols. London: The Medici Society (1928).

———— *Art in England 1800—20.* Cambridge: Cambridge University Press (1930).

———— *Art in England 1821—37.* Cambridge: Cambridge University Press (1930).

Wilton, Andrew. *J.M.W. Turner, His Art and Life.* New York: Rizzoli International Publications, Inc. (1979).

———— *Turner and the Sublime*, ex. cat. London: British Museum Publication (1980).

Winter, David. "Girtin's Sketching Club," *Huntington Library Quarterly* 37 (1973—1974), pp. 123—49.

Woodbridge, Kenneth. *Landscape and Antiquity.* Oxford: Clarendon Press (1970).

Wornum, Ralph. *The Turner Gallery.* London (1875).

Ziff, Jerrold. " 'Backgrounds, and Introduction of Architecture and Landscape', A Lecture by J.M.W. Turner," *Journal of the Warburg and Courtauld Institutes* 26 (1963), pp. 124—47.

———— "Turner and Poussin," *Burlington Magazine* 105 (1963), pp. 315—21.

———— "J.M.W. Turner on Poetry and Painting," *Studies in Romanticism* 3 (1964) pp. 193—215.

———— "Proposed Studies for a Lost Turner Painting," *Burlington Magazine* 106 (1964), pp. 328—33.

———— "Turner's Last Four Paintings," *Artforum* 1 (1964), pp. 24—27 (reprinted in *Turner Studies* 4, no. 1 (1984), pp. 47—51).

———— "Copies of Claude's Paintings in the Sketchbooks of J.M.W. Turner," *Gazette des Beaux-Arts* s. 6, 65 (1965), pp. 51—64.

———— "Turner, the Ancients, and the Dignity of the Art," *Turner Studies* 1, no. 1 (1981), pp. 45—52.

———— "But Why 'Medea' in Rome?" *Turner Studies* 2, no. 1 (1982), p. 19.

———— "Turner's First Poetic Quotations: An Examination of Intentions," *Turner Studies* 2, no. 1 (1982), pp. 2—11.

Index

Page numbers in italic type indicate illustrations